Step by Step

The Adventures of Evan Tanner

The Thief Who Couldn't Sleep • The Canceled Czech
• Tanner's Twelve Swingers • The Scoreless Thai
• Tanner's Tiger • Tanner's Virgin
• Me Tanner, You Jane • Tanner on Ice

The Affairs of Chip Harrison

No Score • Chip Harrison Scores Again
• Make Out with Murder • The Topless Tulip Caper

Other Novels

After the First Death • Ariel • Cinderella Sims
• Coward's Kiss • Deadly Honeymoon
• A Diet of Treacle • The Girl with the Long
Green Heart • Grifter's Game • Killing Castro
• Lucky at Cards • Not Comin' Home to You
• Random Walk • Ronald Rabbit Is a Dirty Old Man
• Small Town • The Specialists
• Such Men Are Dangerous • The Triumph of Evil
• You Could Call It Murder

Collected Short Stories

Sometimes They Bite • Like a Lamb to Slaughter
• Some Days You Get the Bear
• Ehrengraf for the Defense • Enough Rope
• One Night Stands and Lost Weekends

Writing for Performance

My Blueberry Nights (feature film)
• Tilt! (episodic television) • How Far *and* Someday
I'll Plant More Walnut Trees (one-act stage plays)

Books for Writers

Writing the Novel from Plot to Print
• Telling Lies for Fun & Profit • Write for Your Life
• Spider, Spin Me a Web

Anthologies Edited

Death Cruise • Master's Choice • Opening Shots
• Master's Choice 2 • Speaking of Lust
• Opening Shots 2 • Speaking of Greed • Blood on
Their Hands • Gangsters Swindlers Killers & Thieves
• Manhattan Noir • Manhattan Noir 2

Step by Step

A Pedestrian Memoir

Lawrence Block

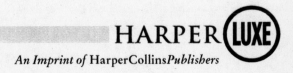

HARPER LUXE

An Imprint of HarperCollinsPublishers

HarperCollins books may be purchased for educational, business, or sales promotional use. For information please write: Special Markets Department, HarperCollins Publishers, 10 East 53rd Street, New York, NY 10022.

FIRST HARPERLUXE EDITION

HarperLuxe™ is a trademark of HarperCollins Publishers

Library of Congress Cataloging-in-Publication Data is available upon request.

ISBN: 978-0-06-177471-3

09 10 11 12 13 ID/RRD 10 9 8 7 6 5 4 3 2 1

For all my companions on all my walks,
actual and metaphorical, whether circling some
unpronounceable lake or trudging the road of happy destiny.
And especially for Lynne, with all my love.

And with thanks to Rocky and the pooch.

You must go on, I can't go on, I'll go on.

—SAMUEL BECKETT, *The Unnameable*

If I Remember Correctly . . .

I've been a professional writer for fifty years, and, with the exception of four instructional books for writers, virtually everything I've written has been fiction. (I did turn out several pseudonymous works of purported nonfiction, ostensibly psychological case studies, but they were entirely fabricated, fiction in sheep's clothing.)

So this is a departure for me. In the pages that follow, everything I've written is as it happened. I realize that this no longer seems to be a requirement in memoirs, that some memoirists apparently feel free to let their imaginations improve on reality, but when I want to use my imagination I sit down and write a novel. A memoir, it seems to me, should confine itself to what the author remembers.

Clearly, this doesn't matter to everyone. When I expressed contempt for one such imaginative memoirist, a contempt shared by Oprah Winfrey, my daughter Amy couldn't understand why I was getting so exercised. "Maybe he made some of it up," she said, "but I have to say I found it very entertaining."

Right. And that Hitler? Say what you want about him, but the guy was one hell of a dancer.

So I've stayed with what I remember, and have avoided doing anything to improve it. My father couldn't tell a story without exaggerating, aiming to make a better story of it. That always bothered me, and I've always erred in the other direction, hewing to the line of the literal truth.

As best I can.

Memory, you see, is an artful Ananias. I've become deeply suspicious of those cases in which a suppressed memory, recovered decades after the fact with the aid of a brilliant hypnotherapist, has resulted in an indictment for child molestation. Even conscious memories, I've found, are overly cooperative witnesses, quick to tell you what you want to hear. How much trust can one place in those wrestled from the unconscious? (And isn't it remarkable how the same therapists keep on dredging such memories from one client after another?)

Sometimes my memory's a liar. Sometimes it's merely asleep at the switch. I'm not inclined to trust it unequivocally, and yet I have to if I'm going to write about early times. Whom else can I consult?

I tell the story, for example, of a walk I took in 1949 with two friends, Jerry Carp and Rett Goldberg. At least I'm pretty sure those were my two companions. That's how I remember the incident.

I can't ask Rett. He's gone, dead of cancer for more than a decade now. I could ask Jerry, we're still friends, but would he remember? And if he did, why should his recollection be any more reliable than my own?

And does it really matter who accompanied me on that walk downtown?

Here's an example of dueling memories. In 1960, I was one of half a dozen people who established a weekly poker game for small stakes. Most of us were writers, honing our skills and earning a marginal living writing paperback trash. And one of us came up with the idea of combining the two activities, to our mutual profit.

Suppose, say, half a dozen poker-playing writers assembled at someone's home. Five would play cards, while the sixth went off to another room and wrote a chapter of a novel. When he was done, he'd return to the game and another player would go write a chapter.

xiv • If I Remember Correctly . . .

And so on.

Twice around the circuit would give us twelve chapters, and that's all we needed. By dawn, if all went well, we'd have a book. We'd present that book to our agent, Henry Morrison, a poker player himself, and he'd peddle it to our publisher, and we'd divvy up the proceeds. It would be the first poker game in history where everybody would come out ahead.

What could possibly go wrong?

Six of us assembled at Mel Fox's house—Mel, Don Westlake, Dave Foley, Hal Dresner, Byrne Fone, and myself. Somebody shuffled the cards, somebody dealt them out. And one of us went upstairs and sat down at the typewriter.

I don't remember who went first, but I do know that Hal, Don, Dave, and I were the first four, and each of us wrote our chapters with all deliberate speed and put them out of our mind upon returning to the game. Then it was Byrne Fone's turn, and he had a request; he was not that sanguine about his ability to stay awake all night, and not much of a cardplayer anyway, so how would it be if he wrote both of his chapters at one stretch—and then went home?

We all agreed that would be fine, and he went upstairs and got to work. And it didn't take very long at all before he came downstairs, with not one but two chapters completed in record time. We wished him the

joy of the evening—though it was probably morning by then, if you want to be technical about it—and he headed home while Mel, our host, climbed the stairs to take his turn.

And time stopped.

It was hours later when Mel finally staggered downstairs and the rest of us discovered the problem. Byrne, concerned that he'd fall asleep at the poker table or the typewriter, had tried to stack the deck by ingesting a handful of amphetamine. That almost certainly had a good deal to do with the pace at which he knocked off his assignment, but it also scrambled his brain beyond recognition, and the two chapters he'd produced were gibberish. Grammatically correct gibberish, perfectly typed gibberish, even highly literate gibberish—but the story got lost completely, and nothing on the page made a particle of sense.

That was only half the problem, and if Hal or Don or Dave or I had been scheduled to follow Byrne, all would have been well; the four of us were old hands in the world of soft-core porn, and would have quickly concluded that Byrne's chapters would be fine for lining the parakeet's cage but for nothing else, and would have tossed them and picked up where he'd started.

But Mel was the group's neophyte, and it never occurred to him to question the work of a veteran like Byrne. So what he tried to do was write the next

chapter, and do so in a way that would make logical sense, and all of that was plainly impossible. Which is why it took him hours, and why he ultimately came downstairs looking as though he'd sustained a massive concussion.

That was pretty much the end of that. Dawn had broken, and so had our spirits. We cashed in our chips and went home.

Years passed. Several of them, during which time Dave Foley came down with leukemia and died at a lamentably early age. And at some point we disinterred the partial manuscript, which we'd taken to referring to as *Lust Fuck;* we shit-canned Byrne's chapters and Mel's heroic attempt at their sequel, and Don and Hal and I took turns adding chapters to what was left until we had, if not a book, at least a book-length manuscript. We gave it to Henry, who sold it to our regular publisher, Bill Hamling, and every cent of the proceeds—$1000? $1200?—went to Sandy Foley, Dave's widow. It was our understanding that Scott Meredith, Henry's employer, didn't even take a commission on this particular sale, and that, I have to tell you, is the single most implausible element in the whole affair.

All these years later, I recall nothing whatsoever about the plot or characters of *Lust Fuck.* The book must have been published, but I never saw a copy, and

never learned what title it bore or under whose pen name it appeared. Were I to read it now—and I must say I hope that never happens—I doubt it would ring the faintest of bells.

While the book as a collection of ill-chosen words has essentially vanished without a trace, it lives on in legend. As an experiment in literary collaboration, *Lust Fuck* was an abject failure. But its anecdotal value was more than adequate compensation for all concerned. I don't know how many times I told the tale over the years, and so did Don, and so did Hal.

But none of us got anywhere near as much mileage out of the story as another fellow. He, like Henry, worked as an agent for Scott Meredith. He too was a frequent player at our weekly poker sessions. And, although none of us knew it at the time, he was supplementing his agent's salary by writing pseudonymous books for Hamling. (He may have kept this last fact a secret to avoid the appearance of conflict of interest.)

I won't embarrass him by telling you his name. He's a fine fellow, an able literary agent, and on balance certainly one of the world's good guys.

And, I have to say, a superb raconteur. He tells the story of *Lust Fuck* in great detail and with great enthusiasm. In his version, he was one of our number

at Mel Fox's house in Queens, an avid participant at the poker table downstairs, an able hack upstairs at the typewriter.

But, see, he wasn't there. He couldn't have been, for Christ's sake. We didn't even know at the time that the sonofabitch was a writer.

Did he simply figure it made a better story if he put himself into it? Or, as one theory about OJ holds, had he told the story his way so many times that he came to believe it himself? I don't know and I don't care. I know he wasn't there. He may or may not know he wasn't there. At this stage—indeed, at any stage—what earthly difference does it make?

Ah, well.

I've had to make a particular effort to avoid overusing such phrases as *If I remember correctly* and *To the best of my recollection* and *As I recall*. The reader can take them to be an unvoiced preamble to every incident I recount.

So: Everything that follows is the truth, as far as I can tell.

There's one other thing I ought to tell you, although you'd probably figure it out for yourself in short order.

This book is self-indulgent.

It seems to me that comes with the territory. How could a memoir be other than an exercise in self-indulgence? One writes it sustained by the assumption that a record of one's own experiences and observations will be of interest to other people. This assumption often proves to be unwarranted, which may explain why such a high percentage of memoirs are self-published, or not published at all.

For my part, I found that the only way I could manage to write this book was to let it be every bit as self-indulgent as it wanted to be. It is, to be sure, a record of my experiences as a walker; if the book itself were a walker, it would be an ambler and a rambler, not terribly intent on racing to the finish line, and inclined to turn off on any path that looks inviting.

Remembering, I've discovered, is curious work. The memory is a house in which there are many mansions; enter into one of them, and a hidden door can spring open, luring you into a portion of the past you haven't visited in years. But there it is, and you slip inside, and another door opens. . .

Step by Step

PART ONE

The forecast was rain all day Sunday.

Marathons are like football games. Weather's not enough to cause their cancellation, unless it's pretty dramatic. A hurricane will do it, but this was February of 2007, the weekend after Mardi Gras, and hurricane season was months away. So it would rain, and we would do what marathoners do when it rains. We'd get wet.

I don't mind getting wet. When I was a boy my mother assured me I wouldn't melt, and so far she's been right about that. Though a year earlier I'd found myself wondering.

That was in Houston, on the last weekend of February 2006, where I participated in a twenty-four-hour race around a two-mile asphalt loop in Bear Creek

Park. The race got under way at seven in the morning, and within an hour or so it started raining, and it didn't entirely quit for eight hours or so. Sometimes it was a drizzle and sometimes it was a downpour, but the rain coming down was the least of it; what drove us all mad was the rain *after* it had fallen. The course didn't drain properly, and great sections of our path were ankle-deep in water. It slowed me down and shortened my stride and messed up my feet and did nothing good for my disposition, let me tell you. More to the point, it led me to retire from the race after eighteen hours or so, with 64.25 miles to my credit. That was enough to top my one previous twenty-four-hour race, but only by a mile. I don't know how far I might have gone in Houston on a dry surface, but I'm fairly sure I'd have managed a few more circuits of the course.

So I really wasn't looking forward to rain at the New Orleans race. But I'd show up rain or shine. I wouldn't melt.

My wife, Lynne, and I flew down to New Orleans on Friday.

(Note, if you will, the commas before and after her name. The sentence would flow better without them, but they're there for a reason. They indicate that Lynne's my only wife. I referred earlier to my daughter Amy,

and was able to do so without the bracketing commas, because she's one of three daughters. If I had only one daughter, I'd have to use the commas. If I didn't use them for Lynne, you'd have every right to suspect me of bigamy. Now this is one of those linguistic niceties like, say, the subjunctive, that seem designed chiefly to make people who are aware of it feel good about themselves. I'd love to leave out those commas, but I don't want you thinking I've got more than one wife. One's plenty.)

Lynne doesn't usually accompany me to marathons— she has a life, even if I don't—but New Orleans is her birthplace and remains very dear to her heart. We'd come down for the Mardi Gras Marathon the previous year, and planned a repeat, but with one signal difference; on Tuesday she'd return to New York, while I'd stay put for a month and get a book written. It was a book I'd gotten absolutely nowhere with for over a year, and I was dreading it, but nowhere near as much as I was dreading the marathon.

Three weeks earlier I'd walked the Pacific Shoreline Marathon, in Huntington Beach, California. It was held on a beautiful seaside course, and the weather was splendid, and I was just cruising along, not pushing the pace, until somewhere around the sixteen-mile point I got a sharp pain in the ball of my foot. It was bad

enough so that I might have stopped but for the fact that this was an out-and-back course and the only way to get back to my hotel was to keep walking. The pain was really quite intense, but I was able to walk through it and maintain my pace, and then after four or five miles like that it just went away. I never knew why it vanished, but then again I never knew why it appeared in the first place. I finished the race, got my medal, ate eight or ten oranges and anything else I could find, and went to my room to shower and put my feet up.

And they weren't in such great shape. My right foot, the one that had given me trouble during the race, had nothing wrong with it where I'd had the pain, not as far as I could determine. But the little toe had taken a beating, and the outer layer of skin on it slipped off like a glove, taking the nail with it. It didn't hurt all that much, and I was confident I could get along without that layer of skin, and without the nail as well.

Still, I'd had the thing for sixty-eight years . . .

A couple of days later I made a guest appearance on *The Late Late Show.* All I wanted to talk about was walking, but Craig Ferguson kept dragging the conversation back to my books. He wanted to know what I was working on, and of course I wasn't working on anything.

That was the first weekend in February, and I spent the next three weeks back in New York, doing precious little to prepare for New Orleans. In 2006 they held the race the first weekend in February, before rather than after Mardi Gras, and it had been the scene of my greatest triumph in the sport. I'd completed the race in 5:17, the best time I'd ever recorded at that distance. (I'd gone faster back in 1981, when I'd done five marathons, but in three of them I ran part of the way. I did walk the 1981 Jersey Shore Marathon in 4:53, but I was forty-three at the time, and I was sixty-six when I resumed racewalking in 2005. That 5:17 in New Orleans was my best time since then.)

Not only did I post a personal record time, but I actually won something. New Orleans is one of a handful of marathons with a judged racewalking division, and in due course I received a plaque for having been the second male racewalker. I'd done the same a month earlier in Mobile, but my triumph was somewhat dimmed by the fact that there were only two of us. In New Orleans I was second of seven or eight, and the young Floridian who took top honors only nosed me out by forty-two minutes.

But that was then, and this was now, and that 5:17 looked out of reach. Especially if it rained. And especially if that foot pain I'd encountered in Huntington

Beach—and had twinges of during my infrequent training sessions—should happen to return.

The weather was all right on Saturday. The day's highlight was a meeting with Glen Mizer, whom I knew only from his posts on the Walking Site message board. At my suggestion he and Carol had booked a room at Fairchild House, where Lynne and I always stay; it's on Prytania Street in the Lower Garden District, and marathoners pass it twice, at fifteen and twenty-four miles. Glen came up to our apartment Saturday afternoon and the two of us hit it off immediately. I didn't have a tape recorder running, but later I would post my best recollection of our conversation on the message board:

"Oh, I'm so out of shape it'll take a miracle to get me to the starting line. I haven't been out walking since my last race."

"You're ahead of me, fellow. I didn't even walk in my last race. Some old boys picked me up and carried me across the finish line."

"I did get out for a few minutes yesterday, but I had to use a cane."

"I had me one of them aluminum walkers."

"I was gonna use one this morning, but I lost my balance trying to get up out of the wheelchair."

"That chair of yours hand-propelled or motorized?"

Glen's also a racewalker, and younger and faster than I. Lately, however, he'd found himself forced by some sort of indeterminate injury to alternate walking with intervals of slow jogging—"slogging," he termed it. Thus he would have to compete as a runner, rather than enter the racewalking category. This news did not break my heart.

We talked about the weather, too. The forecast had changed from rain all day Sunday to rain starting Saturday night and ending an hour or so into the race. We agreed that we'd be out there rain or shine—I suppose Glen's mother had tipped him off, too, that he wouldn't melt—but that shine was better. And we left it at that.

Lynne and I went out for dinner to a pizza joint a block away on St. Charles Avenue. I had a bowl of pasta as a sop to tradition. I don't know that anybody pays a whole lot of attention to carbo-loading these days, and I'm not sure it makes any sense for someone cruising at racewalking pace, but everybody just knows you're supposed to eat pasta before a marathon. And it's not as though it amounts to a great sacrifice. It's pasta, after all, not spiders. What's not to like?

Though if someone proved, or even strongly suggested, that a marathoner's performance would improve if he ate spiders the night before a race, well, you can bet there'd be a whole lot of arachnids swimming in marinara sauce . . .

It rained a little during the night, but not heavily, and it had stopped well before dawn. I got up early, ate an energy bar for breakfast, got dressed, and pinned on my two number bibs. (Racewalkers were issued an extra bib to wear on one's back, so that the judges could tell at a glance who was a walker.) Glen was waiting out front and Lynne drove the two of us to the Superdome, where the race would start and finish.

When it did, Glen slogged off and disappeared into the distance. I took it easy, cruising along at a gentle warm-up pace, and for the first three miles or so everything was fine.

Then my foot started to hurt—the right foot, in the same spot that had bothered me in California. It was nowhere near that bad, it was pain I could live with and in fact walk with, but I'd have been happier without it. I knew immediately what I'd pretty much assumed anyway—that my time last year, 5:17, was way out of reach. But that was okay, and I could still get through the race and finish in decent time.

The race course is west, through the French Quarter and out to City Park, where we turned around and followed the same route back to the Superdome. At that point, the race would be over for the half-marathoners, and half over for the rest of us. Around mile 8 or 9, I decided getting through 26 miles was going to be more than I could stand. I decided what I ought to do was go through the half marathon finish at the 13.1-mile point and call it a day.

Now thoughts of this sort are frequent for me. There's often a point in the course of a race when I decide the hell with it, and the phrase *I'm too old for this shit* echoes like an old song. The thing is, see, that I never give in to it—or at least I never have. Back in my early forties, when I sometimes raced forty times a year, I never once quit short of the finish line. That record is more a testament to determination than to good sense, as there were a couple of races I would have been well advised to abandon, but so far I've always hung in there to the finish line.

(Twenty-four-hour races are a little different, and I'll get to them later.)

Still, just as thoughts of suicide will get a person through a bad night, so will thoughts of dropping out keep a fellow on his feet. I told myself I'd quit at the halfway point, and when it came time for the

half-marathoners to zig left and cross their finish line, I zagged to the right instead along with the rest of the full marathoners.

The course would now head up through the Garden District and on to Audubon Park, where it would make a circuit of the park before heading right back to the Superdome. Prytania Street was the route's main artery, and Fairchild House was right there on our route, at the fifteen-mile mark and again around twenty-four miles. I'd have to get back to Fairchild House even if I dropped out, so I decided to keep going at least until I got there.

That's what I'd do. Hang in until I got to Fairchild House, and then go to our room and lie down, and skip the Anchorage Marathon in late June, and never do another of these damned things for the rest of my life.

Lynne was waiting out front at Fairchild House. I told her I was hurting but said I thought I'd stay with it a while more, as it wasn't getting any worse. So I kept going on Prytania, and I took the little out-and-back detour on Napoleon Avenue, and I was back on Prytania at approximately 17.5 miles, when the little toe on my right foot sent out a spasm of pain unlike anything I'd ever experienced. It hadn't really been bothering me enough to mention, its soreness was minor compared to the ache in the ball of the foot, but now,

with no warning, it felt as though a tank had run over it. It was indescribable (although that doesn't seem to have stopped me from trying) and it flared up anew every time I took a step.

All of a sudden I couldn't do better than a slow and rather pathetic limp. I just stood there for a minute or two, trying to figure out what to do next. If this had happened half an hour earlier, when I was at Fairchild House, the answer would have been obvious. I'd have stopped there and then, no question. But now I was two miles past Fairchild House, and both my choices involved walking; I could walk back or walk on.

And there was the chance that the pain would vanish as abruptly as it had appeared. So I limped on to give it the opportunity.

Didn't happen. I was limping along when Glen showed up; he'd already reached the turnaround in Audubon Park and was on his way back, and feeling pretty lousy himself; he'd had some sort of sports drink that his stomach wasn't happy with. He asked me what I was going to do, and said later that, if I'd said I was going to quit, he'd have accompanied me to Fairchild House and quit himself. But for some reason I said I'd push on for a little while, and I did.

It took me an hour to cover the next two miles. What kept me going was the thought of how I'd feel

if I started back before reaching the turnaround, only to have the pain recede. I'd really have found that infuriating. So I kept on limping, and tried to ignore the people who asked me if I was okay (*No, idiot, if I were okay I'd be walking right*) and the helpful soul who wanted to know if I needed electrolyte replacement tablets (*Thanks, but what would they possibly do for my toe?*). By the time I reached Audubon Park and swung into the 1.5-mile loop around it, I figured out my situation. I was in too much pain to go on and too stupid to stop.

And that became my mantra. *I can't go on*, I told myself. *I'm too stupid to quit*, I replied. *I can't go on. I'm too stupid to quit. Can't go on. Too stupid to quit . . .*

During the park loop, my foot pain lost intensity to the point where I could walk without limping, but still couldn't manage more than a leisurely pace. That picked up a little by the time I was out of the park and up to the twenty-one-mile marker, and it was then that I realized I was probably going to be able to finish the race. The only question was whether I could reach the finish line before the seven-hour mark, when they were scheduled to shut it down. I didn't care if it took me every minute of seven hours, didn't care if I was the last person across the line, but I really wanted to finish.

And the pain backed off. I honestly don't know how that happened. Barring the intervention of a Higher Power, and I have trouble envisioning one with nothing better to do than enable an aging athlete to persist in his folly, the best I can come up with is this: the protesting nerves decided I clearly wasn't getting the message, so why bother sending it? *The fool's best interests would be served by stopping, they realized, but he really is too dumb to quit, just as he's been muttering to himself. So why waste our time on him?*

The anthropomorphism aside, I'm not sure this isn't how it works. Pain, like everything else, exists for a purpose, and the purpose in this instance was to alert the organism to the fact that he'd done damage to a portion of himself. The message had been delivered, and with a vengeance; the message had been ignored; there was accordingly no need to go on sending it, and the transmission ceased.

I tried this theory on a friend, and he shook his head and lectured me on endorphins. My brain started producing endorphins, he told me, and they were better than morphine at drowning pain. Well, okay, but what prompted the brain to send out this tidal wave of endorphins? Exercise? I'd been exercising for hours, and that was what had earned me the pain in the first place. I still like my theory, and there's room to stick

endorphins into it. The mind, realizing that its message was being ignored, ordered up a big batch of endorphins as a mechanism for canceling the message. There!

With the pain gone, I could pick up my pace. I was racewalking at cruising speed by the time I reached Fairchild House, and the last two miles saw me moving at my regular racewalking pace, such as it is. I was going flat out when the finish line came into view, and I sailed across it with a net time of 6:34:25. That was an hour and seventeen minutes longer than the same course took me a year ago, and my slowest marathon ever by a good half hour, and yet it felt like my greatest triumph.

"I honestly don't know what the hell kept me going," I posted in my race report, "outside of a deplorable stubborn streak, but whatever it was I'm grateful for it."

They hung a medal around my neck after I crossed the finish line, and at the top of the stadium ramp there was still plenty of food and drink left. More to the point, there was Lynne, who'd headed for the Superdome after I'd passed her at the twenty-four-mile point. She drove us back to Fairchild House, and in no time at all I was in a chair with my feet up.

It took me a while, though, to take my socks off, because I was afraid of what I would find. I was still surprisingly free of pain, but enough blood had leaked through the sock to assure me that I hadn't imagined the whole thing. I did peel the sock off, finally, and the toe didn't look good, but it didn't look that bad, either, and it was impossible to guess why it had hurt as severely as it had.

I put a bandage on it and got on with my life. We ate in that night, Lynne went out and came home with a pizza, but the next day I was on my feet and walking around, and the day after that, Tuesday, Lynne drove herself to the airport, turned in our rental car, and flew home. And I set myself up at the desk, switched on my laptop, and started work on the new book.

It went well. Wednesday or Thursday I walked a block to the gym on St. Charles Avenue and joined for a month, and for the rest of my stay I got there a couple of times a week to put in an hour or so on the treadmill, along with a brief workout with weights. The weather was good throughout, cool early on and a good deal warmer toward the end, and I could have walked on the median strip of St. Charles, where the trolleys used to run before Katrina put them temporarily *hors de combat*. But that struck me as more of an adventure than I wanted. The treadmill was enough.

I'd allowed five weeks for the book, and was done in just over three. (As I said, it went well.) I stayed out the week, took one day for a walk around the French Quarter and another for a stroll up Magazine Street, then took another long walk up Prytania Street to see a movie at a neighborhood theater. I walked a two-mile stretch of the marathon route, and it was like seeing it for the first time. I'd traversed it twice in this year's marathon and twice a year earlier, and at the time I thought I was well aware of my surroundings, but I never really pay attention to anything but the race. (I don't wear my glasses when I race or train, I only need them for seeing.) It's an attractive street, is Prytania, and I was happy to get a good look at its splendid live oak trees and stately homes.

I paid about as much to change my ticket as it had cost me in the first place, and flew home to New York a week early. Lynne read the new book—*Hit and Run*, my fourth book about a hit man named Keller—and pronounced it terrific, and my agent and editor agreed. Revisions were minimal, and took about an hour. The book was done, and I didn't have another race until the Anchorage Marathon June 21, and I could walk it or cancel it, as I preferred.

Everything was wonderful. This book, I had decided, would be the last one for which I would contract in

STEP BY STEP · 19

advance. From this point on I would simply write books when I wanted to, and submit them for publication after they were complete. Thus I would never be in a position of owing a book to anyone, and that was as close to official retirement as I figured I ever needed to be.

A couple of times a week I put on my sneakers and went out to walk alongside the Hudson. In the past few years they've given the waterfront a makeover, and it's become a wonderful place to train. So I'd go out for an hour or two, and then I'd come home. And read something, or sit in front of the television set.

It was toward the end of March when I came home, and there were a couple of ultramarathon events on the horizon. Earlier I'd been considering the Corn Belt twenty-four-hour, in Iowa, which is held at a quarter-mile track—every four or six hours, I forget which, all the entrants who'd been going counterclockwise switched to clockwise, just to keep the event from becoming boring.

(Actually that's not the purpose. I think it's so that you don't wind up with one leg shorter than the other. And for all that most people I know are gobsmacked by the prospect of the boredom they're sure would accompany such an event, I don't think boredom

would enter into the equation for me. If I managed to traverse Prytania Street four times without seeing the magnificent houses that line it, how much difference does the scenery make to me? There are people who have run a hundred miles on a treadmill—not over time but in one straight shot—and that doesn't sound boring, either. It sounds very goddamn demanding, but it doesn't sound boring.)

Corn Belt takes place the first weekend in May, and I'd thought about it earlier, but never seriously considered it after New Orleans. But a month after Corn Belt was the FANS twenty-four-hour race in Minnesota. (That's an acronym, and rolls rather more trippingly off the tongue than the Family Advocate Network System, for which the annual race raises funds.) FANS had seemed to have possibilities. I thought about it, and decided I didn't want to put myself through that kind of an ordeal. I stuck to an easy walk two or three times a week, and watched some TV and read some books, and slid all too comfortably into depression.

I have friends who are subject to clinical depression, and I don't suffer from anything anywhere near that scale. They can't get out of bed, they can't think of anything but killing themselves, and the only thing that keeps them from following through is lack of energy.

My malaise is worlds lighter than that, so much so that I almost hesitate to use the word, but there's no getting around it. Depression is what it is.

So, depressed, I went through the motions of being alive. It was all I could do to check the two message boards for walkers to which I subscribe; I looked in only every few days, and posting anything was out of the question. When I did force myself to go out and walk, my mind was all over the place, thinking about entering the FANS race, then thinking about canceling Anchorage.

Around the end of April, my friend Andy Cable posted a report of his first multiday race, a six-day Sri Chinmoy event held in Queens. (Sri Chinmoy was a spiritual leader who inspired his acolytes to rather extraordinary athletic feats, primarily in endurance races; his organization sponsors such events through-out the world.)

If I hadn't been depressed I probably would have gone out there to see how Andy was doing. It's only a subway ride away, but the way I felt it might as well have been in Mongolia. (And I've been to Mongolia, and I didn't have a good time.) Andy hung in there for all six days, and logged a total of 235 miles, and posted a race report consisting chiefly of his explanation of why he'd done so poorly, and what he'd learned from

the experience. Six days walking around a one-mile loop in the park! Six days! 235 miles! That's nine marathons in six days. And he was apologizing for his performance? Sheesh . . .

By the time I read Andy's report, I'd already made a decision of my own. On the 26th of April, I printed out the entry blank and mailed off a check to the people running the FANS race in Minnesota.

I had five weeks to prepare myself to walk for twenty-four hours. I didn't know if that was enough time, nor did I have any reason to believe my feet would be up to the challenge. They'd given me trouble at Huntington Beach, and they'd put me through hell in New Orleans.

What I did know, as I was quick to explain to Lynne, was quite simply this: Given the choice, I'd rather be hospitalized for exhaustion than depression.

And it worked.

I signed up one day and went out for a walk the following afternoon. I was out for an hour. I walked two hours the next day, an hour the day after that, then three hours a day later.

Somewhere in the course of those first several days, I stopped being depressed.

Endorphins, no doubt. Exercise, everyone will tell you, induces the brain to produce endorphins, and they in turn engender a feeling of well-being. This is all too frequently described as a "runner's high," and for all the running and walking I've done over the years, and all the feeling of well-being it may have engendered, I've never experienced anything I'd call a high.

But perhaps the folks who use the term neglected to spend their youth ingesting mood-altering chemicals. What do they know about getting high?

Never mind. What's noteworthy here, it seems to me, is not that endorphins were the agent of my ascent from depression, but that essentially the same exercise that produced them had failed to do so in the weeks since I'd returned from New Orleans. I'd been walking several times a week for an hour or two, with nothing to show for it but a deepening suntan and a sweaty headband. Now, all of a sudden, the same exercise on the same course was turning me into Little Endorphin Annie.

It wasn't just the walking. That seemed clear to me. It was the fact that signing up for the race had given my walking in particular and my life in general the illusion of purpose. I was not out there walking to feel better, or walking to stay in shape, or walking to stifle

my inner couch potato. I was walking with the noble goal of preparing myself to—to what, exactly?

Why, to walk innumerable 2.4-mile laps around a blameless lake in Minnesota.

And could I do it? Did I have enough time to get in enough training? And would my feet hold up?

Unanswerable questions, all of them. At worst, I figured, I could train sufficiently to cover 26.2 miles around Lake Nokomis. That's the length of a marathon, and if I did that much I could add Minnesota to my marathon life list. I told myself I'd be satisfied with that, but I knew I wouldn't. I'd been in three twenty-four-hour races since July of 2005, and in each one I'd improved, albeit very slightly, on my previous performance. The most recent race was at Wakefield, Massachusetts, in July 2006, and I'd managed 66.3 miles. So what I wanted in Minnesota was to break that record. And I wanted to break it resoundingly. It would be nice to walk my age and hit sixty-eight miles. It would be even nicer to go seventy.

It would also probably be impossible, but right now that didn't really matter. I was walking, and walking for a reason, and I'll be damned if I didn't feel genuinely good about it.

2

I've been a walker all my life.

Well, wait a minute. That's not entirely true. Before I was a walker I was a crawler, and before that I just sort of lay there like a lump.

Or so I've been told, but I can't say I remember any of that. My conscious childhood memories are all of a time when I'd already learned to walk. I don't even recall the learning process—getting up, falling down, getting up again, falling down again. I don't have any trouble believing it happened, but I can't remember it.

But I can specifically remember crawling, come to think of it. It was after I'd learned to walk, long after, and I think I must have been four years old. I couldn't have been more than that, because we were still living on Buffalo's Parkside Avenue, and I was not yet five

when we moved a couple of blocks to Starin Avenue. And I couldn't have been less than that, either, because I crawled across the living room floor to look at the newspaper. So I was old enough to read, or at least to make out a fair number of words.

So I'd been walking for quite some time, and I was sitting on the floor doing God knows what, and I wanted to look at the paper, and I was about to stand up and walk over there. And then the thought came to me that I didn't have to do that, that I could just stay down there where I was and crawl. I remember thinking that would be fun, and I remember doing it, but I can't remember if it was fun or not. My guess is that it was.

I don't believe I've crawled since, except perhaps metaphorically. But I'm sure I could if I had to.

I'm sorry I can't remember learning to walk. Because it was a miracle.

Oh, not a personal miracle—although, given my own innate clumsiness, it might well have been a marginally greater achievement for me than for the average incipient toddler. No, I've come to believe that learning to walk is a remarkable accomplishment for the entire human species, and not so much a miracle of evolution as a triumph of the will.

Nobody's born knowing how to do it. Grazing animals are on their feet and walking from the moment

their mothers drop them; they have to be, or they won't keep up with the herd. But human infants are born as helpless as hamsters, and walking is something they have to learn.

Or teach themselves, one might say. You can't read the manual, and, except by example, it's not something your parents can teach you. You crawl for a while, and then you stand up, and then you fall down. And you stand up and fall down again, and then the time comes when you stand up and take a few steps before falling down.

And so on.

And here's what makes it a miracle: Every child, but for the severely handicapped, does all this and does it successfully. Some are early walkers, some are late walkers. Some fall a little and some fall a lot. But, sooner or later, everybody walks.

Nobody gets discouraged. Nobody gives up. Everybody stays with the program. And all this with no reward promised or punishment threatened, no hope of heaven or fear of hell, no carrot and no stick. Fall, rise, fall, rise, fall, rise—and walk.

Amazing.

Imagine, if you will, an adult in similar circumstances. Imagine the thoughts running through the adult mind:

The hell with this. What's the point in getting up when I'm only going to fall back down again? If I keep

this up I'm only going to hurt myself. And look like all kinds of a damn fool while I'm at it.

What was so bad about crawling? I was pretty good at it. I got around just fine. Why would God give us hands and knees if he didn't expect us to get from place to place on them?

Who says everybody's meant to walk? It works for some people, but that doesn't mean it works for everybody. You need balance, for one thing, and you need good foot-eye coordination, and some of us aren't gifted in those departments.

I hate falling down. Makes me feel like a failure. Why reinforce that feeling by repeating the process?

It's hopeless.

What's the point, anyway? I mean, it's not as if there's any place I really have to get to. What's so bad about right here?

Screw it. If crawling's not good enough for them, they can pick me up and carry me. Because I've had it.

I quit.

But that never happens. I couldn't begin to guess what goes through a kid's mind when he's learning to walk, but I don't think the possibility of giving up ever enters into the equation. Sooner or later he learns. And, once he learns, he never forgets. Why, it's like riding a bicycle.

And there's the rub.

. . .

I couldn't learn to ride a bicycle.

Let us be clear about this. Being unable to ride a bicycle is very nearly as incapacitating for a boy as being unable to walk. In Buffalo, where I grew up, you rode your bike everywhere. You rode it to school, you rode it to play, you rode it everywhere except for those few places so far away that you needed a bus or a streetcar, or a parent to drive you.

When I was a little kid I had a tricycle, and I could ride that just fine. Nobody ever had to learn to ride a tricycle. You put your feet on the pedals and turned them, and how hard was that? No balancing act was required, because the thing wasn't going to tip over. You'd have to work some to make it tip over.

So I was fine on a tricycle. Then when I was seven or eight, around the time when a lot of other kids were getting their first two-wheelers, I got a four-wheeler, a weird contraption that ran on arm power; you gripped the handlebars, pulling them toward you and pushing them back, and the thing rolled forward at a pretty decent pace. I've never seen another one of these creatures, never knew another kid who owned one, but in recent years I've seen pictures of something that looks a lot like what I had, and it seems to be called an Irish Mail.

I wonder whatever happened to mine. I suppose I outgrew it, and I suppose my folks gave it away, and I suppose it's long since been reduced to rust. And I'm not likely to turn all Citizen Kane about it, either, but I remember it fondly. And I probably rode it longer than I should have, because I couldn't learn to ride my goddamn bike.

It was an orange and black Schwinn, if I remember correctly, and it was a one-speed machine, because that's all that existed at the time. This was 1948, and bikes didn't have gears, or if they did nobody I knew was aware of it. They didn't have handbrakes, either; you braked the thing by reversing the direction of the pedals. They were, I suppose, pretty primitive compared to what kids pedal around on nowadays, and nothing you'd want to take to the Tour de France, but, all things considered, they worked just fine.

For everybody else.

I don't remember getting the bike. It was a major present, certainly, and I would think it must have been given to me on a major occasion, probably a birthday. I was born in June, and that's a logical month to give a kid a bicycle. Buffalo's winters aren't quite as bad as you think, but they're a long way from bike-riding weather, and a Christmas bike would be a deeply

STEP BY STEP • 31

frustrating present. "Here you are, sonny. It's all yours, and sometime in April you'll be able to ride it." Wonderful.

It was my father's job to teach me to ride the thing, and we went out to the sidewalk in front of our house. I mounted the bike, he took hold of the handlebars, and he trotted alongside as I pedaled and built up momentum. Then he let go, and I fell down.

Repeatedly.

For our purposes here, I rather wish I could remember the whole process in more detail. On the other hand, it's probably not such a bad thing that my recollection has blurred a good deal over the years. They say that childhood memories return much more sharply in later life, and maybe this one will, but if it doesn't, well, that's okay with me. Because it was not a happy time.

As it is, I don't know if my dad and I devoted one day or a full week to the process. A man who lived across the street—Joe Rosenberg, who ultimately became my stepfather—told me how it had broken his heart to watch me and my father, going back and forth on the sidewalk, all to no avail. That would suggest that we tried this more than once, but my memory has collapsed the ordeal to a single day, one which concluded with the two of us returning to the house, bowed in mutual recognition that the entire enterprise was

impossible, and that we were best advised to abandon it forever.

And so we did. The bike went in the garage, where it assumed the function of the Elephant in the Living Room That Nobody Talks About. Ours was a wonderful family, and I've always felt myself to have been sublimely gifted with splendid loving parents, but this is not to say that our living room lacked a fair number of unacknowledged elephants.

If, if, if.

If they'd had training wheels in 1948, it might have been a different story. Maybe they did, and we just didn't know about them.

With training wheels, I wouldn't have taken a spill every time I failed to keep my balance. And I wouldn't have needed my father to run along holding on to the handlebars, and run himself out of breath and patience while he was at it. With training wheels I could have taken the bike out by myself, and maybe I would have stayed with it, and eventually maybe I would have gotten the hang of it.

It might have been different, too, if the bike had been the right size for me. My parents were never cheap, but they and the rest of the country had recently emerged from the Great Depression, and it would be fair to say

that they were frugal. They bought me a good bike, but they bought it a couple of sizes too large, so that I wouldn't grow out of it too rapidly.

That made a certain amount of sense with clothes; you could always take a tuck in a sleeve or hem a pants leg, letting out the garment as the wearer grew into it. But you can't take a tuck in a bicycle, and mine was indisputably too large for me. It was in fact just the right size four and a half years later, when I hauled it out of the garage and taught myself how to ride.

But we'll get to that.

Oh, dear. Another thing that might have made a difference, a substantial difference, is if my father had been a good teacher. He was a wonderful man, a very dear and loving man, but a good teacher he emphatically was not.

I'm sure it frustrated him that I didn't just hop on the bike and ride it, as he very possibly did in his youth. As an adult, his sole athletic activity was golf, and that infrequently, but he was a reasonably good golfer with a fine natural swing, and I suspect he was good at other sports, if not devoted to them.

I don't know that he was disappointed in his profoundly nonathletic son, but I do know my inability to ride that bike made him impatient to end the attempt. I wasn't learning, and that meant I wasn't capable of

learning, and wasn't it simpler and more humane all around to cut our losses and stow the bike in the garage?

Years later, when he taught me to play golf, it went okay. I was lousy at that, too, but I could swing the club and hit the ball and walk to where it lay and hit it again. There was no falling down involved, no test of his patience. I don't know how many times I went out and played golf with my father—eight or ten, probably, a dozen at the most—but we always had a good time of it.

He taught me to drive, too, and that didn't go wonderfully. But we both stayed with it, and I passed my test and got my license. I learned a lot more about driving when we took road trips. He was a good highway driver, careful but not timid, and I paid attention and learned.

He was a sweet and loving man, my father was. An attorney himself, he was unequivocally supportive of my decision to become a writer, and disproportionately pleased by my early scholastic and professional triumphs. He was thirty when I was born, and he died the day before his fifty-second birthday. Now, writing about him, I'm already seventeen years older than he was when he died.

And that feels strange. How old was he when he tried to make a cyclist of me? Forty? Two of my three daughters are older than that. His death came four months before the eldest was born.

And it wasn't his fault that I couldn't ride a bike, nor was it the bike's fault. It was, let us be very clear about this, entirely my own.

See, I failed to do what every crawling baby manages to do, which is to keep on trying until you get it right. My father made it easy for me to do this, regarding a temporary failure as permanent; he made it clear that it was all right for me to be unable to ride, and saw it as preferable to continuing frustration for both of us.

And I was happy to accept failure, even eager to embrace it. Part of this, I know, is attributable to the fact that I was an extremely tractable child—which would come as a shock to anyone who has known me only as an adult. I tended almost invariably to accept my parents' view of what was best for me. I took piano lessons for seven or eight years because my mother, an accomplished pianist, thought I ought to; I had no feeling for the instrument, or for music in general, and I was never at all good at it or got the slightest enjoyment from it, but neither did I beg to give it up, or resent that I was stuck with it. She thought it would be good for

me, and I figured she was probably right, all evidence to the contrary notwithstanding.

Beyond that, agreeing that I was hopeless as a bicyclist meant I could stop trying. An unpleasant and frustrating activity could cease. The fact that I would spend years walking while others rode, the fact that I'd be for all those years the one kid in the neighborhood who couldn't ride a bike, was not something I needed to think about.

All I really had to do was keep at it. All I had to do was get back on the bike every time I fell off. Sooner or later I'd stop falling off, and then I'd be riding. I'd somehow known that years earlier, when I taught myself to walk. But somewhere along the way I'd managed to forget.

So the bicycle went into the garage, and stayed there. I didn't pay any attention to it, and before long I pretty much forgot it was there.

Before I close the garage door, there's another story I'd like to tell you about my father. It's one of which I was entirely unaware until very recently.

When I was eleven years old, I was skipped from the fifth to the seventh grade. My fifth-grade teacher, Mildred Goldfus, was a great believer in hurrying along her brighter pupils; one of three fifth-grade teachers

at PS 66, she had in the past been assigned the smarter kids, taught them intensively, and dispatched them all directly to seventh grade at the term's end.

The school's policy had long since changed, but Mrs. Goldfus was still partial to bright kids, and she saw two such paragons in me and my friend Dick Lederman. Accordingly she summoned both sets of parents and proposed that we skip sixth grade. Dick's had the good sense to say no. Mine said yes, and in September I entered the seventh grade, where all my new classmates were a year older than I and not sure what to make of this kid who'd been dropped into their midst.

They all rode bikes, too, but that was nothing new. So did my classmates in fifth grade.

Keeping up with the classwork was no problem. I may have been a dud as an athlete, but nobody ever said I was stupid. And a seventh grade classmate, Jack Dorfman, extended an invitation; he captained a football team, known variously as "Jack's Team" or "The Wellington Tigers." (The Dorfmans lived on Wellington Road.) Would I like to join the team?

I said I would, and learned I'd need a helmet and a set of shoulder pads, which my parents dutifully obtained for me. (They did not, I'm pleased to report, buy them a few sizes too large, so I could grow into them.)

And I played. We played tackle football, with the games very capably and quite impartially refereed by Jack's dad, Phil. I was a lineman, and must have played in three or four games. I think that's as many as we played. I didn't particularly know what I was doing, but I endeavored to get in the way of the opposing team's players when we were running the ball, and move in the direction of the ball carrier when we were on defense.

Three games, maybe four. I wish there had been more of them, and I was sorry when the season ended.

Jack was the president of our grammar school class, and a standout athlete at Bennett High School, where he quarterbacked the football team and played short-stop on the baseball team. After graduation he got a major-league tryout, and an offer to join the Chicago Cubs farm system. He went instead to the pharmacy school at the University of Buffalo; his father owned a drugstore, and Jack would thus be qualified to go into the family business. Because everybody knew you couldn't expect to make a decent living playing baseball.

Different times . . .

Now let's jump ahead half a century, to my fiftieth high school reunion in 2005. Jack Dorfman, looking not that different from his Wellington Tiger days, came

up to me. "I'm going to tell you a story I'll bet you don't know," he said. "Do you remember that football team we had at 66, played pickup games with other teams?"

I said I did.

"Well," he said, "did you know your father called me? He must have looked up the number in the phone book and he called me at home. 'Jack,' he said, 'I want you to do me a favor. When you play your games, don't leave Larry sitting on the bench. Make sure he gets a chance to play. Will you do that for me?'

" 'Sure,' I told him. 'I'll put him right in the middle of the line, Mr. Block. He may get himself killed out there, but he'll play.' 'And Jack, please don't tell him we had this conversation.' And I never did until now. I'll bet you never heard that story, did you?"

No, of course I'd never heard it.

I would have been mortified. I'd have considered his action inappropriate (as it probably was) and deeply embarrassing. But now, fifty years after graduation, fifty-five years after my brief career as a Wellington Tiger, all I could think of was how sweet and loving my father had been.

My sister, Betsy, was five years younger than I; it was shortly before her birth in May of 1943 that we moved from the lower flat on Parkside to the one-family house

on Starin. A year or so after I got my bike, when she was six or seven, she got a bike of her own for her birthday.

(She probably asked for it. I'm sure I'd have gotten a bike earlier than I did, if I'd asked for it. I generally got what I asked for, but, see, I hardly ever asked for anything. God, I was a strange kid.)

My father took Betsy and her bike out to the sidewalk, and she got on and he ran along, holding the handlebars, and within an hour or two she was riding as one born to it.

Now if that happened in a novel, the older brother would almost have to develop a lifelong resentment, but if I entertained any negative feeling toward Betsy, I never got wind of it. Why resent her for being able to do something that everybody else I knew could do?

I didn't resent her for a new ability, nor did I let it spur me into another attempt at cycling. That would have to wait several years—until a point in life when being able to ride a bicycle was no longer terribly important.

I couldn't ride a bike, but I could damn well walk.

It couldn't have been much more than a year after the bike debacle when I first demonstrated an atypical propensity for walking. I don't remember the month or year it happened, but I'm pretty sure it was on a Monday afternoon. That's when the school excused certain students a half hour early for religious instruction.

That meant catechism class for Catholic students, and Hebrew school for Jews. (I can't be sure of this, but I think the Protestants stayed in their seats and studied finance and duck hunting.) At Temple Beth Zion, the Reform synagogue to which my family belonged, boys attended Hebrew school once a week during the two years prior to their bar mitzvahs. (Girls were left out of this; nobody had a bat mitzvah, and I can only hope

the Jewish girls learned something about finance and duck hunting.)

Most of my Jewish schoolmates attended Temple Emanuel, a short walk from the school. But a few of us made the weekly trip together to Beth Zion. It was four or five miles away, on Delaware Avenue between North and Allen. We would take the bus, and generally somebody's parent would show up to drive us home.

So one Monday afternoon I met up with my friends Rett Goldberg and Jerry Carp, and we discovered that our total resources came to ten cents. We needed a nickel apiece for bus fare, and we were five cents short.

It seems so obvious now that all we had to do was get on that fucking bus. If the bus driver wouldn't let himself be persuaded to overlook our shortfall, surely some obliging adult would drop a nickel in the fare box, if only to shut us up and get the bus moving. But of course that never occurred to us. We had ten cents, we needed fifteen cents, and that meant that we were, in the vernacular, screwed.

Of course two of us could have gone to Hebrew school while the third said the hell with it and went home, but that didn't occur to anybody, either, and would have been rejected out of hand it if had. All for one and one for all, right? Didn't that go without saying?

At somebody's suggestion, we invested half our cash to call home to ask what to do. We got no answer at my house, which gave us our nickel back, and reached the cleaning woman at Jerry's house. She was sympathetic, but didn't offer much in the way of advice. Now we had one nickel, and both Rett's parents worked, so even we could figure out that there wasn't much point in calling his house.

So we decided to walk.

See, we couldn't go home, because my mother was going to turn up in front of Beth Zion at five o'clock sharp to drive us home. What was she going to think if nobody was there to meet her? What was she going to do?

I'm not sure which of us suggested walking, but I strongly suspect it was my idea. Whoever thought of it, we all agreed it was our best bet. So we walked, and on the way I believe we got rid of that last nickel. It seems to me we stopped at Van Slyke's drugstore to buy a candy bar and split it three ways. Energy for the journey. It would be nice to report that it was a Three Musketeers bar, which certainly would have been easy to share equitably, but I'm confident it wasn't.

We were certainly in no danger of getting lost on the way. The temple was the center of our social life, and we wound up there a couple of times a week. There was

Sunday school, there was Hebrew school, there were Cub Scout pack meetings and, later, Boy Scout troop meetings. Saturday evening was, God help us, dancing class. Whether we got there by bus or by car pool, we damn well knew the route.

It was, as I said, four or five miles, and if I were in Buffalo now I could clock it, but four or five miles strikes me as close enough for memoir. The school was at Parkside and Tacoma, and we'd have walked on Parkside to Amherst, west on Amherst to Nottingham, then cut over Nottingham to Delaware Avenue. Then we'd have turned left and headed downtown on Delaware, one of the city's main arteries, winding its way through Delaware Park and past Forest Lawn Cemetery before straightening out and continuing all the way to City Hall.

When we drove past Forest Lawn, we used to hold our breath. Someone had once confided that it was bad luck to breathe while passing a cemetery, so none of us ever did, though I don't think fear of some unnamed horror really entered into it. It was something to do. Holding your breath wasn't much of a challenge for the half-minute it might take in a car or bus, but it was clearly out of the question on foot. We gave it a shot, of course, and reeled around gasping for breath in due course, and laughed and joked about it. And walked on.

The whole trip generally took ten or fifteen min-
utes in a car, a little longer in heavy traffic. It's a walk
I haven't taken since, but I can't imagine it would take
me much more than an hour at race pace, perhaps half
again as long if I took it easy. I'm not sure exactly how
long it took the three of us, because I'm not sure just
when we started out, but I know when we got there.
At five o'clock, no more than two or three minutes
before my mother pulled up at the curb. So I guess it
took us something like two hours to walk it, and those
are two hours I remember fondly. I don't recall them
in great detail, but I know they made more of an im-
pression than anything that ever happened in Hebrew
school.

It must have been the following year, when I was in
seventh grade, that I started taking long solo walks
around the city.

I don't remember the impetus behind them. You
would think my inability to ride a bike must have had
something to do with it, and perhaps it did, but not on
a conscious level. Looking back, I think I can recall
a desire to gain knowledge of the city I lived in, and
to do so in the most basic way—not by reading books
about it, not by acquiring information, but by walking
its streets.

Then, too, I got a sense of accomplishment out of those walks. I would walk four or five or six miles at a clip, and then I would get on a bus or trolley and come home. I'd go to my room and unfold my Buffalo street map and look at all the ground I'd covered.

Once or twice my friend David Krantz joined me, and I may have had other companions. We followed a routine I'd established on my own—we stopped at drugstore soda fountains and asked for a glass of water, and we hit every gas station along the way to collect road maps. Service stations gave them away free at the time, if you can believe it, and it was challenging to see what ones you could get. Just about every station had New York and Pennsylvania and Ohio, but, strange as it may seem, not too many gas stations in Buffalo felt the need to stock road maps of Oregon. Go figure.

Where did I go? Well, not to Oregon, and not even to Pennsylvania. I'd pick some big street, big enough to be on a bus line, and stay on it. I remember I walked all the way out Fillmore to Broadway, and I walked the length of Main Street to Shelton Square. I'm not sure I knew anything more about Buffalo at the end of one of these excursions, but I'd had a couple of hours of good exercise and I certainly felt as though I'd accomplished something.

One day I must have told one of my new seventh-grade classmates about my activities, and the next thing I knew we had a hiking club, with six or eight members. Come Saturday, we met at the school and set out. I don't remember what route we took, but I remember that there were enough of us so that soda jerks and gas pump jockeys regarded us less as an eccentric diversion than as a pack of vermin. We wound up walking to Phil Dorfman's drugstore at East Ferry and Wohlers, where instead of free glasses of water everybody got a soda or a milkshake.

That part was okay, but the walk itself really wasn't the same. And the general consensus seemed to be that this was sort of fun, but it would be even better if we did it on our bikes.

And that, as you may imagine, was the end of that.

We hiked once a week at Scout Haven. That's the Boy Scout camp where I spent six weeks every summer for three years. I loved it there, although even then I was aware of the essential strangeness of the experience. Because the camp I went to was a camp within a camp. It was Hopi Village, and it was the Jewish part of Scout Haven.

The whole camp was divided into little subcamps with Indian names, and different troops would come

to the different villages, generally for two weeks at a stretch. But Hopi Village was different. Boys from all of the Jewish scout troops attended, and you could come for two or four or six weeks, depending on what your parents could afford. (It cost my parents $20 a week. I knew kids who went to fancy camps in Canada, and their parents paid around $800 for the season. We got a hell of a bargain, but, to keep things in perspective, the gentile kids in the main camp only paid $12 a week.)

We had our own activities and ran our own program. We swam in Crystal Lake, the same as everybody else, and the main camp's lifeguards made sure we didn't drown, but aside from that we were as isolated as if we'd been in a medieval ghetto. And it goes without saying that we had our own meals in our own separate mess hall.

That, of course, was the justification for this merry little experiment in apartheid. We had to have our own mess hall because of the dietary restrictions that have made being a Jew such a fucking pleasure over the centuries. No pork, no shellfish—but that's the least of it. No milk and meat at the same meal, and, to play the game properly, you need two sets of dishes. There are, I understand, families who have two kitchens, not because you absolutely have to, but because it makes things simpler.

Hey, if you want to make things *simpler*. . .

We were Reform Jews. It's been said (well, by me, actually) that Reform Judaism is sort of like Unitarianism but with better food. The movement arose in Germany in the nineteenth century with the aim of bringing the religion in tune with the times—and, I shouldn't wonder, of facilitating the assimilation of Jews into mainstream German society.

There were no rules for Reform Judaism. Each synagogue worked things out for itself, and so did each family. There was, however, a general disposition to do away with the dietary laws en bloc, and they certainly didn't apply under our roof.

The story was told of my great-grandmother (she was my maternal grandfather's mother) and the kosher chicken. While she didn't keep a kosher home (although I suspect she may have early on) she did continue to patronize a kosher butcher, taking it for granted that the kosher meat was simply better. After my grandfather married, and when he'd saved up a few dollars, he bought a two-family house on Hertel near Shoshone. He moved his wife and kids into the lower flat and gave the upper to his two unmarried sisters, my aunts Sal and Nettie, and their mother.

One day my great-grandmother came home with a chicken from the kosher butcher. And my grandmother,

her daughter-in-law, was in the kitchen preparing to cook a chicken herself. My great-grandmother went in to observe. She looked at the chicken, plump and perfectly plucked, and she took her own kosher bird from its wrapping and considered it. It was a scrawny bird, its color was nothing great, and there were still bits of pinfeathers in it.

"That chicken of yours," she said to my grandmother. "It's not kosher?"

"No," said my grandmother. "It's not."

"Hmmm," said my great-grandmother, looking back and forth, from one bird to the other. And she never bought another kosher chicken for the rest of her life.

I never knew my great-grandmother, who died when I was nine months old, so I can't say what sort of cook she was. But my mother and grandmother were superb, and neither felt constrained by the dietary laws.

We ate a fair amount of ham at home, and no end of bacon. We ate, of course, the many choicer parts of the cow that some curious Talmudic interpretation has proscribed. We rarely had shellfish at home, because my father didn't care for it, but my mother and sister and I ate shrimp and crab and clams at restaurants. There was, I realized many years later, only one forbidden food we never had, and that was anything at all with the name "pork" attached to it.

Now ham is pork, and bacon is pork, and no one in our family was dim enough to think otherwise. But you could buy it and cook it and eat it without ever encountering that particular four-letter word.

And so no one in the family ever had a pork chop or pork sausage or crown roast of pork or indeed any form of *schweinefleisch* that called itself pork. On my own, away from the family table, I continued the practice without realizing it. It never occurred to me to order a pork chop. There was something inexplicably distasteful about it. Far more civilized, surely, to have a bacon cheeseburger, or a ham steak.

It was some years before it dawned on me that we'd been the unwitting observers of an unwritten dietary law, and a linguistic one at that. I thought of asking my mother why we never had pork on the table, but I kept forgetting, and then she was gone, and that became one more question I'd never be able to ask.

A few years ago I was on a book tour for *The Burglar on the Prowl,* and when I got to Des Moines I spent the night at the governor's residence, Terrace Hill, at the invitation of Christie Vilsack, the governor's wife. In the morning she cooked my breakfast. (This sort of thing would make book tours bearable, but don't get the wrong idea; nothing remotely like it ever came my way before or since.)

Breakfast included ham, which she obtained from a local pig farmer who raised his swine organically. It was, I realized, the best ham I'd tasted in years; it was the first ham that was a match for what my Jewish mother used to put on the table on Starin Avenue.

I kept a blog during that book tour that brought me to Terrace Hill—something else I'd never done before, and rather doubt I'll do again. And after my breakfast with Mrs. Vilsack I mused in my blog on the ham I'd eaten, and the ham I had on Starin Avenue, and our family's sole and singular taboo.

I learned we weren't the only ones. "It was exactly the same at our house!" a woman emailed me. "Ham yes, bacon yes, pork no. I always wondered why."

Why? Because Jews don't eat pork, that's why. I thought everybody knew that.

I've no idea what percentage of the kids at Hopi Village came from kosher homes. Enough, surely, to warrant a kosher kitchen, and a separate mess hall, and, ultimately, a wholly separate camping experience, in which we shared the lakefront and the hiking paths with the rest of the Scouts, and nothing else.

Looking back, it seems so antithetical to the whole notion of Scouting. Why were there Jewish troops in the first place? Why weren't Boy Scout troops es-

tablished by neighborhood instead of by religious affiliation?

Well, they were, sort of. But they were generally centered in neighborhood churches, because those institutions had the space available. And . . . well, never mind. We had our little ghetto, our camp within a camp, and barely knew the others were there. And they hated us, and it's hard to blame them.

Eventually matters came to a head. The consortium of Jewish troops pulled out of Scout Haven, bought a tract of land, and established their own camp. But that was years after I'd outgrown the Boy Scouts. The camp I remember is Scout Haven, and I had a good time there, and once a week I got to go on a hike.

Every Friday every Hopi Village camper picked one or two partners, and we all filled our canteens, tied our shoes, and made sure we had a couple of dollars in our pockets. Then we set off for one of several nearby towns.

Scout Haven was south of Buffalo, and its mailing address was the town of Arcade. Arcade was a popular destination for us, because it boasted a restaurant where you could get good short-order food. EAT HERE OR WE BOTH STARVE, proclaimed the sign over the door, and I thought that was as brilliant a marketing device as I'd ever encountered, though I suspect the

people who actually lived in Arcade got pretty tired of it.

Arcade was seven miles away. It took a couple of hours to get there, depending on whether or not you saw any reason to hurry. Eating and loitering took another hour or so, and then we'd walk back. That pretty much did it for the day. The counselors and camp staff got a day to relax, and we got some pleasant exercise, plus a chance to get away from the herd and go off in pairs and trios.

As an alternative to Arcade, we could walk instead to Freedom or Sandusky. One was five miles distant, the other a little closer. Sandusky was on the way to Arcade, as it happened, and there was a store there, catering to the local farm folk; you could buy a Coke or a candy bar, and one time I came back with a straw farmer's hat that set me back half a dollar. I don't remember what they had in Freedom, though it couldn't have been much, and it's possible I never went there.

The roads were two-lane blacktop or gravel, the traffic light. We'd been taught to walk on the left, facing traffic, so that we could see cars coming and move onto the shoulder. Nobody ever got hit by a car, and as far as I know nobody ever got into any real trouble, except for Larry Biltekoff, a camper a few years my senior, who earned his twenty-first merit badge, the one that

STEP BY STEP · 55

would qualify him as an Eagle Scout, and celebrated the accomplishment by going into one of the nearby towns and losing his virginity.

God knows how he managed this. He couldn't have taken his prize by force or he'd have been thrown in jail, and it would have to be easier to find a rich man in heaven than a working girl in Arcade. So he must have gotten lucky with some eager amateur.

For this he was quietly disciplined—no one would come out and say for what—and at the camp's closing ceremony he was denied his Good Indian award. (You stood one at a time before a council of elders, with your fellow campers in a great circle around you. The elders asked you if you accepted the Good Indian; in other words, did you feel you'd been a good camper? If you said no, that was the end of the matter. You resumed your place in the circle. If you said yes, then it became their turn to say yea or nay. If the answer was yea, someone accomplished at arts and crafts painted the profile of an Indian on your webbed Boy Scout belt. If not, not. I think the whole deal was more for the benefit of the counselors than the rest of us. It was their only chance to say a hearty Fuck You to the worst of us.)

Larry Biltekoff, who'd been given to understand what was coming, said nay himself, and there the

matter rested. So Larry got laid but didn't get his Good Indian, and I don't know anybody who wouldn't have cheerfully traded places with him. All the same, I don't think they should have withheld it from him. I think they should have given him a special merit badge, for resourcefulness.

Not every Friday, but every once in a while, the Hike Day options included a cross-country trek to Lime Lake. This was undertaken not in twos and threes but in a body of fifteen or twenty boys led by one or more counselors. (We didn't use that term, incidentally; besides campers, there were junior and senior officers, JO's and SO's. Older campers moved up to JO when they were deemed ready for the responsibility, and I suppose they got the summer for free. SO's were paid counselors, but almost all of them had come up through the ranks.)

Our destination was a lakeside resort, and you got there by going over hill and dale some twelve miles. After a couple of hours eating and swimming and going on the rides, everybody reassembled for the walk back to camp. The Lime Lake contingent left right after breakfast and tried to make it back before the mess hall stopped serving dinner. It made for a good day's outing, and called for a certain

amount of stamina, as the distance was not that far short of a full marathon, and some of the hills were imposing.

We also did some overnight camping, and that involved hiking, since that's how you got to where you were going to camp. The usual destination was Council Hill, and about a dozen of us would go at a time, climbing the hill, spreading our sleeping bags on the ground, building a fire, and cooking meals only a hungry boy would willingly put in his mouth.

Hopi Village was itself divided during each two-week period into six or seven smaller villages, each consisting of three four-person tents under the aegis of a village leader in the person of a JO. (Each tent had a tent leader as well. I was never in the military, but aspects of camp life would have helped prepare me for it.) Sooner or later, each village had its turn to hike up Council Hill, cook out, sleep under the stars, and return to camp the next morning, no doubt the better for the experience.

I did this a few times, and I always enjoyed it well enough, but there wasn't all that much walking involved, and nothing terribly interesting ever happened. Except for the time that my good friend David Krantz, an occasional companion on my walks around

Buffalo, insisted on laying out his sleeping bag on the slope above the campfire.

David was an exceedingly bright fellow; he taught himself math as a hobby, and wound up acing the final examinations in every math course offered at Bennett High, all in his freshman year; by the time he graduated from high school he'd gotten through differential and integral calculus. (I remember the terms; I have not the faintest idea what they mean.) He went on to Yale, picked up his doctorate at Penn in physiological psychology, taught for years at Michigan, did research at Bell Labs, and has of late headed the statistics department at Columbia. David, let me tell you, is no dumbbell.

And he explained why we were mistaken, and why his sleeping bag would be perfectly safe. Because he'd positioned it perpendicular to the fire, not crosswise, and thus gravity would not enter into the picture, and he'd be fine. The way he explained it, we all felt like idiots for not having realized as much. Of course! Perpendicular! What were we thinking?

Then around two in the morning everybody woke up, because David's sleeping bag was on fire. Just the end of it that had been closest to the fire to begin with, and it was merely smoldering. He got out of it before it had a chance to roast his feet.

. . .

The only other noteworthy Council Hill incident that
I can recall was one for which I wasn't present. It was
another village's turn, and shortly after they came
down from the hill next morning, one of their number
packed his trunk and was sent home.

Word got around quickly. One of the seniors in
charge had caught him giving a blow job to another
camper. This got him booted, as the blower, while as
far as I know the blowee escaped any disciplinary action
whatsoever. (Someone may have told him to wipe that
smile off his face.)

It's interesting now to note that I was never too
clear on what they were talking about, nor was I
the only ignoramus around. I remember a couple of
boys speculating as to just what a blow job might be.
There is, I must say, nothing self-evident in the term.
You have to wonder who thought to call it that in the
first place, and how it ever caught on. The term, I
mean.

I could tell you the names of both boys, but you're
not going to hear them from me. While it now strikes
me as manifestly unfair that one of them got punished
and the other did not, I can assure you that no one ques-
tioned it at the time. Obviously, one would have to be

a pervert to perform the act, while anyone might have the ill fortune to be its recipient.

Ah, well. I lost track entirely of the boy who was sent home; he went to a different school, belonged to a different troop, and I never saw or heard of him again. I ran into the other fellow from time to time, and he was a nice enough guy in the limited contact I had with him. Nothing queer about him. But I do remember hearing that his idea of a quiet afternoon at home generally involved jerking off his dog.

4

The summer after my sophomore year at Bennett, when I'd just turned fifteen, there was an international Boy Scout jamboree at the Irvine ranch, in Santa Ana, California. The Buffalo Area Boy Scout Council did something uncharacteristically wonderful; they put together a month-long trip, which would begin with a ride on a private train across Canada and down the Pacific coast, then pause for a weeklong encampment at the jamboree, then back on the train for a ride across the American heartland to Buffalo.

My parents thought it was a wonderful opportunity, and the whole package cost all of $350, including all meals. My good friend Larry Levy signed on as well, and the two of us buddied up for the trip. Our conveyance was a Canadian troop train, with bunk

beds, and it was comfortable enough. The first day out we all had to learn "O Canada" and for the next couple of weeks we sang it often, and with commendable enthusiasm.

At Banff in Alberta everybody got a day at leisure, presumably to explore Jasper National Park. Larry had somehow learned that there was a terrific golf course there, and decided we should play. So we found the place, and realized that we couldn't really afford it. With a little subtle coaxing from the club pro, we came up with a plan. We would pay one greens fee, rent a single set of clubs, and once we were out of sight of the first tee we could each play a ball.

I can still remember two things about the day— the beauty of that golf course, brilliantly green in its Canadian Rockies setting, and the nightmare of our golf game. Larry was a better golfer than I, but that's faint praise indeed, and the two of us made a dog's breakfast of the whole business. We'd bought two three-packs of golf balls, and by the sixth hole we'd knocked five of them to where God himself would have had trouble finding them. We took turns swatting the last ball, and somehow made it last through the remaining three holes (a half round, we figured, was plenty). It was with a certain amount of relief that we got back on the train.

. . .

We got to Seattle on a Friday, and some resident genius decided that this was an opportunity for the Jewish kids to attend Sabbath services at a local synagogue. There were seven or eight of us, and I don't think any of our number felt a great need for spiritual succor, but nobody asked us and off we went.

I mention this not because any aspect of the services made an enduring impression upon me, but because of something I did afterward that I still find remarkable. There was some sort of reception for the congregation, and there was a very pretty girl in attendance, and I announced to somebody—Larry, probably—that I was going to introduce myself. "Oh, sure you will," was the response, or words to that effect.

I was in my Boy Scout uniform, of course, and must have looked like an idiot, but something empowered me, and I strode across the room and presented myself in front of this vision. "You look like someone I'd like to meet," I said, and we began talking, and when we all went back to the train, I had her name and address on a slip of paper in my wallet.

Karen Hochfeld.

I wrote to her from Buffalo, and she answered me, and our correspondence went on for a year or two. Her

father was a doctor, I remember that much, and she was a pretty accomplished golfer. Somewhere along the way one of us left a letter forever unanswered, and that was the end of that.

I wonder whatever became of her. I've often wondered, over the years, but even in this Age of Google I haven't turned up a trace of her. Women's names change with marriage, and that makes them harder to track down. She must have been a year younger than I, maybe two, so she'd have been born in 1939–40.

If you're out there, Karen, I'd love to hear from you . . .

But wasn't I the lad? "You look like someone I'd like to meet." Where did all that self-assurance come from? Somehow I don't think it was the uniform. Whatever brought it about, it had never happened before.

Or since.

We continued on down the coast, saw the redwoods, and wound up in tents in Orange County. My friend Larry had the special pleasure at the jamboree of falling in with a detachment of Puerto Rican scouts. He'd been studying Spanish at school, and was able to speak with them.

This impressed me profoundly. At Bennett you could be a language major or a science major, and for

no particular reason I'd chosen science. I had taken two years of Latin, which I'd continue, and in the fall I was scheduled to study chemistry, with physics on tap for my senior year.

I came home from the jamboree with other ideas, switched to a language major, and took first-year Spanish along with third-year Latin. I never did study chemistry or physics.

Spanish came easily to me. It's not a difficult language, and two years of Latin did a lot to pave the way. I had two years of Spanish when I went off to college, and would have studied it there, but I didn't have the chance. The professor who'd taught it for a couple of years was up for tenure the year before I got to Antioch, and didn't get it, and left—and that was the end of Spanish at Antioch.

At the jamboree, except for those of us who were practicing our Spanish, what you mostly did was swap things. Kids from all over the country, all over the world, brought indigenous crap along and exchanged it for somebody else's indigenous crap. Some kids managed to trade uniforms with foreign scouts, which gave them a terrific souvenir, but left them without anything to wear to meetings. There was a particular shoulder patch that was much esteemed, for reasons I cannot

begin to recall and very likely couldn't fathom at the time. I managed to get a bullwhip, which I thought I'd be able to trade for the patch, but I couldn't. It's hard now to imagine any sort of shoulder patch a sane person would prefer over a bullwhip, but that's by the way. I brought the bullwhip home, but don't ask me what happened to it. It disappeared, but then the patch probably wouldn't have lasted, either.

The really dumb thing I did was send a postcard to Murray Davis's girlfriend.

Murray was in Troop Seven, along with me and Larry Levy, and lived in Kenmore, and for a couple of years he'd been going steady with a girl named Leslie, whose last name was also Davis. They were crazy about each other. And for some reason I thought it would be really comical to write a postcard saying something along the lines of "I know you've been screwing other guys and I'm really mad," sign Murray's name to it, and send it to her.

I have no idea what made me think this was a good idea.

Next thing I knew, the postcard was written and stamped and in the mailbox. And I pretty much forgot about it.

The jamboree ended after a week, and we packed up and boarded our train for a quick return to Buffalo.

The only thing I remember from the trip home was looking out the window as we passed through Kansas and seeing an enormous blood-orange full moon a few degrees off the horizon. Funny what sticks in the mind. A few years later I would write a poem about it, describing the moon as "stroking desperate tides in the liquid land." It's probably a good thing I turned my attention to paperback novels, where all that desperate stroking could be put to good use.

Back home, I told my parents I wanted to study Spanish, and they thought that was fine. I unpacked, and everything went into the washing machine. Except for the bullwhip. I don't know where that went.

And then one evening Gene Davis came over. He was Murray's father, and he was really boiling, and he wanted to talk to my parents. He may have wanted to talk to me as well, I'm fairly sure he did, but he never got the chance. I was sent upstairs, and stayed in my room with the door closed.

He must have been downstairs for the better part of an hour. How did I spend that time? I have no idea. Picked up a book, most likely, and thought as little as possible about what was going on downstairs.

Then he was gone, and my mother came to my room. "That was Mr. Davis," he said unnecessarily. "Murray's father. He had a nasty postcard that someone had sent to Leslie Davis with Murray's name signed to

it. He was very upset, especially because the mailman and anybody else at the post office could have read it."

"Oh," I said.

"He was certain you were the one who wrote it. We looked at it and told him it couldn't possibly have been you. For one thing, it wasn't your handwriting. And we knew you would never have done anything like that."

"Oh," I said.

"I don't think he believed us," she said, "but he gave up and left. What I can't understand is how you could be so stupid as to write something like that on a post-card. What were you thinking?"

Good question. I didn't have an answer, nor did she wait around for one. Nor did any of us ever say a word about the matter again. For a day or so it was one more elephant in the living room, and then it lumbered off and secreted itself in a far corner of the garage, where that poor old bike of mine had spent so many years.

In fiction, events have antecedents. Significant developments don't just happen out of the blue. Something happens, and because of it something else happens, and then something monumental occurs.

I'm not sure that's truly the way the world works. Sometimes it seems to me that things do happen out of the blue. Perhaps there is a gathering of forces, like the seismic activity that produces a volcanic eruption, but there are no meters sensitive enough to register those vibrations.

This is a long and overly dramatic preamble to a simple statement of fact: To wit, in the spring of 1953, a couple of months before I would turn fifteen, I got my bike out of the garage and took it down the driveway to the sidewalk, where, within an hour or so, I learned to ride it.

I cannot recall a single prefatory thought. I was in the garage, I took note of the bicycle, I had the impulse to try to ride it, and, once I'd moved enough debris out of the way to get to it, that's precisely what I did. Just like that, and just a little less than five years after my parents had given it to me.

Because God is, after all, the Supreme Ironist, I'd managed to wait until the ability to ride a bike no longer made much difference in my life. I was in my second year at Bennett, and no one rode bikes to high school. One walked to Hertel and took the Number Twenty-three streetcar, which stopped right in front of the high school. Or, more often than not, one walked over to Dick Lederman's house and his father gave us both a ride in his new Cadillac. (It was always a new Cadillac, because Israel Lederman traded his car annually. He loved those cars, and I didn't blame him a bit.)

After school, one walked home.

Or, in rare instances, drove. I was getting on for fifteen, and my classmates were on average a year older than I, so the ones who'd had their sixteenth birthdays were already learning how to drive their fathers' cars. Girls in my class, dating boys a year or two older, were riding around in cars all the time.

And I was learning to ride a bicycle.

. . .

Here's something as puzzling as the fact that I did it without thinking about it beforehand: I didn't really think about it much after the fact, either. I'd just accomplished something without much effort, and how could it have failed to strike me that I might as easily have done so years ago? You'd think, wouldn't you, that I'd have smacked myself in the forehead and said some cyclist's version of, "Gee, I could have had a V-8!"

And I could have, surely I could have, years before I did, back when it would have made a considerable difference in my life. True, the bike was no longer too big for me, was if anything a little small for me, and when balance became problematic I could extend my feet and use the pavement to support myself and the bike. True, I was bigger and stronger and not quite so ungainly. Still, how hard would it have been for me to do this two years earlier? Or three? Or four?

Well, hell, I'm not going to brood about it now. But I'm surprised I didn't brood about it then.

The bike, or more precisely my new ability to ride it, got me my first actual job. I'd always been an enterprising child, ringing the neighbors' doorbells and

offering my services at whatever chore was in season. I shoveled walks and driveways, raked leaves, mowed lawns. I went around with a wagon and purchased beer and pop bottles for half the deposit. (I'll bet if I'd proposed to haul them away for free, most of my neighbors would have found that acceptable. But I offered to pay for them, and nobody ever once told me to keep my money.)

Funny what comes to mind. I can still remember a big bottle that once held Coleman's Ginger Ale. It was worth five cents—or would have been, if I'd ever managed to find a store that would take it back. The lesson it taught me was worth more than the two and a half cents I was out. I learned, not for the last time, that nothing is ever quite as profitable as you think it's going to be.

But now I had a bike, and I could leave my wagon in the garage. And, almost immediately, I had a job, handing out catalogs for the Fuller Brush Man.

His name was Mr. Speier, and he was a European refugee who was grabbing his chunk of the American Dream by selling brushes door to door. His territory when I went to work for him was in Tonawanda, a couple of miles north of my house. That would have taken a while to walk, but I had a bike, and a whole new world had thus opened itself to me.

I would ride my bike to Tonawanda and meet Mr. Speier at some predetermined intersection, and he would give me a stack of catalogs and tell me where to go and what bells to ring. I would walk up one side of a block and down the next, ringing the bells, and telling each housewife who came to the door that I had a catalog for her, and when my employer visited in a couple of days he'd pick up the catalog and give her a free gift.

Just about everybody took the catalog. I don't recall anyone slamming the door and telling me to go to hell. Nor did I encounter anyone a youth of today might characterize as a MILF. In years to come I would write scenes in which a young man went door to door—conducting fake termite inspections, in one novel—and the fellows in my fiction always had remarkable sexual adventures. It pains me to admit it, but nothing like that ever happened to me in Tonawanda.

But maybe I should have given it a little more time. I can't be positive of this, but it seems to me I only worked for Mr. Speier for a single week.

It really wasn't much of a job. I was paid two cents for every catalog I distributed, and I could only leave a catalog if someone was there to accept it. Then I noted the house number on a sheet of paper, secure in the

knowledge that I was another two cents to the good. The next day I would meet Mr. Speier and hand over the sheet, and he would count up the numbers, make sure the count matched the number of catalogs he'd given me, pay me what I'd earned, and give me another batch of catalogs for distribution.

First time out I'd tried to make my route more efficient by going back and forth across the street to save steps. But he didn't like that because he wanted the numbers in order for later on, when he would go up one side of the block and down the other. So from then on I did it his way.

It was tedious beyond description, but it wasn't terribly difficult. The problem was that I couldn't make any money at it. He'd give me thirty or thirty-five catalogs, and if I got rid of them all I'd make is sixty or seventy cents, and for this I had to peddle my bike a couple of miles in each direction.

Now sixty cents for an afternoon's work may not sound like a lot of money nowadays, but let me tell you something—it wasn't a lot of money back then, either. Hell, I did better than that in the pop bottle business.

And if it rained, the day was a washout. One day it was fair weather in Buffalo, but raining by the time I got to Tonawanda, so I got to ride all the way out there

and turn around and go home. I didn't pass Go, and I didn't collect sixty cents.

So one week was enough.

That fall I got a real job. It paid seventy cents an hour, minimum wage at the time, and as much as a kid could expect to earn in a part-time job. I worked at Parker Pharmacy, owned by Mr. Pearlstein, an acquaintance of my father's. I did various stockboy chores, and when there was a prescription to be delivered, I hopped on my bike and delivered it. Sometimes a delivery meant a tip, but you might be surprised to learn that more often than not it didn't. The tips, when they came, were a nickel or a dime. One man gave me a quarter once and I still remember it.

More often than not, I spent the tip money on candy bars. I never wasted any money on cigarettes. I was a confirmed smoker, I'd started swiping butts from my parents' ashtrays two years earlier, but like every other kid I knew who ever worked at a drugstore, I stole cigarettes. I tried every brand we carried, brands nobody ever heard of. Virginia Rounds. Wings. Phantoms, which were one and a half times the length of a Pall Mall, and furnished with a cellophane tip. Murad, Helmar, Piedmont. Did anybody ever buy the damn things? Or were they just there for kids to steal?

I worked after school, and Saturday mornings, and I made ten or twelve dollars a week. I never could have got the job without the bicycle.

And by now it was a different bicycle. I don't know when that happened, but I guess that orange and black Schwinn must have been a rusty mess when I hauled it out of the garage, and a little small for me in the bargain. It seems to me that by the time I was passing out catalogs for Mr. Speier, and certainly by the time I was delivering prescriptions for Mr. Pearlstein, the old Schwinn had morphed into something else, with hand brakes and gears as well. That's what I rode around the streets of North Buffalo, obeying traffic laws, waiting for traffic lights to change, and even signaling my intention to turn left or right. You'd have thought I was behind the wheel of the family Chevy.

While there were, alas, no eager MILF's— Milves?—meeting me at their doors wearing a negligee and a smile, there was nevertheless a loss of innocence that came with the job. I wasn't a kid who noticed a lot, but some things were hard to miss.

Like the day when Bob, the pharmacist and store manager, took a prescription over the phone and sent me to the shelves for a bottle of Cepacol, an over-the-counter cough remedy. I brought it to him and he soaked off the label, typed out and slapped on a pre-

scription label, raised the price from sixty-nine cents to ten dollars and change, and sent me off on my bicycle to deliver it.

That was an eye-opener. And my eyes stayed open wide enough to take notice at the first of the month, when the outgoing mail held eight or ten small envelopes, all addressed to neighborhood physicians. Even I could work out what that was all about.

It was during my junior year in high school that it dawned on me that I wanted to be a writer. I'd had various careers in mind over the years, without really developing anything close to a passion for any of them. When I was four or five years old I wanted to be a garbageman, until my mother told me they got chapped hands. Later I liked the idea of veterinary medicine, probably because I liked animals. My father would have liked for me to become a physician, he thought they had good lives while performing a useful service, and I entertained the idea but couldn't really see myself pursuing it. I might have been inclined toward law, I had the right sort of mind for it, but my father was an attorney who practiced infrequently over the years. He'd soured on the profession, and actively dissuaded me from entering it.

In third-year English, an early assignment led to my writing a paper on my career choices, from garbageman on. I had fun with it and took a light tone, and ended with something to the effect that, on reviewing what I'd written, one thing at least was clear: I could never become a writer.

At the bottom, Miss May Jepson wrote: *"I'm not so sure about that!"*

And the die was cast. Before the moment I read her comment, I had never had a single conscious thought of becoming a writer. I had a frame of reference for it, I had lately begun reading grown-up fiction (one hesitates to call it adult fiction, as that has somehow come to mean something else) and was making my way through the giants of American realism—Steinbeck, Hemingway, James T. Farrell, Thomas Wolfe, etc. I enjoyed the books and greatly admired the men who wrote them, but the notion that I might seek to do likewise never entered my mind.

Once it did, I never seriously entertained the idea of doing anything else.

I went on writing compositions for English class, and I suppose I showed off some therein. I wrote poems, too, and showed them to Miss Jepson, and basked in the praise I received. (The poem about the moon over Kansas was not among them. I wrote that, desperate tides and all, in my sophomore year at Antioch.)

I was going to be a writer, and that's what I told anyone who asked. "Oh, you'll be a journalist," they said. "Oh, you'll work on a newspaper."

No. I was going to be a *writer.*

In June I didn't go off to writing camp, as I suppose a similarly inclined teenager might do nowadays. What I did was get on a Greyhound bus, and forty-eight hours later I got off in South Florida. In Dania, specifically, where Doc Marshall picked me up and drove me to Juniors Lodge.

Dr. Marshall A. Marshall, né Marshall Gubinsky, was an extraordinary man. He'd been the scoutmaster of Troop Seven from the time I joined, until he and his wife and kids departed for Florida two years before I got on that bus. Doc was a dentist who specialized in making and fitting false teeth, and he'd fallen in love with Florida and wanted to live there, but the state dentists' association had established strict rules to protect themselves from carpetbaggers, and Doc couldn't practice his profession.

So he bought some land and decided to build a camp for kids. He did the construction himself, with some help from his wife, Ada, and the kids, Bonnie and Mike, building a serviceable dormitory out of concrete block.

He'd never done anything like this before, but the man had a penchant for tackling new tasks and figuring out how to perform them competently. He'd been in scouting as a boy, but hadn't gotten all that far with it; when he was appointed scoutmaster, he decided he ought to set a good example, and he went through the laborious process of earning the requisite merit badges and becoming an Eagle Scout. If you apply yourself, I think you can probably learn more in this process than in four years of college, and Doc went to each task with the enthusiasm of an amateur and the precision of a pro. And, because he didn't want to be a hotshot, he stopped at the requisite twenty-one merit badges— but he never stopped trying new things and developing new skills.

I'd come down to be his camp counselor. There was a young woman as well, a swimmer with Olympic dreams; she was a couple of years older than I, and in charge when we took the kids swimming. The camp wasn't much, just a summer-long babysitting service for parents who couldn't wait to get rid of their kids, and not without reason. They were, pound for pound, as hopeless a lot of spoiled whining little bastards as I'd ever had to put up with.

I don't remember what the hell we did to amuse them day after day, but the days passed and nobody

went home, so I guess we all got through it okay. (They may well have reciprocated their parents' feelings—once again, not without reason.) But as far as I was concerned, the day began when the rotten little snots went to sleep.

That's when Doc and Ada and I sat around the kitchen table and smoked cigarettes and talked. Their Irish setter, Copper, would generally join us. Copper was the smartest and best-behaved dog I'd ever met, and as a result I came to think highly of the breed. (Years later I had one of my own, Maxine by name, not that the dizzy bitch answered to it or to anything else. She was as stupid as an oyster and as tractable as a cyclone.) We'd smoke and talk and smoke and talk and smoke some more. I don't remember what we talked about, and what difference did it make? I was in heaven.

It was a wonderful summer. I had one day off, and took a bus to Miami, where I went to the movies and saw *Gone With the Wind*. On the bus back to camp, a driver gently reprimanded me for taking a seat in the rear. That was for colored, he told me. They got plenty of ignorant Yankees in that part of the state, so I guess he had to do that a lot.

Some years later I heard of or read about a fellow in a similar situation, who'd lowered his head at the driver's admonition and murmured significantly that his father

was white. The driver left him alone. Later, as he was getting off the bus, the guy called over his shoulder, "I forgot to tell you—my mother was white, too!"

I never would have thought of that, and even if I had I'd never have done it. What I did was change my seat.

Hiking wasn't part of the agenda at Juniors Lodge. At home, I don't think many of those kids ever walked farther than the distance from the television set to the dinner table, and summers in Florida were too hot even if they were up for it. I don't remember working up a sweat myself, aside from the sweat one worked up just by being there, but somehow in the six or eight weeks I worked there I must have lost twenty pounds, maybe more.

I was always a fat kid—not the morbidly obese sort one sees nowadays, but what clothing salesmen called *husky*. I took my huskiness as a given and didn't pay much attention to it, and when my parents and sister drove down to collect me—there'd be no return trip on the Greyhound, thank God—a miracle had occurred. I was no longer husky.

The four of us spent a week living it up at a Miami Beach motel, then drove home. I went off to my senior year at Bennett, and got another drugstore job.

Back in Buffalo, I tried corresponding with Doc and Ada. Oddly, I still remember the mailing address: Box 507, Hollywood, Florida. I sent a couple of letters there and never heard back. They were both far too busy for correspondence.

Then I did get a letter from them, and it was some sort of form letter, soliciting families and businesses to hold events at Juniors Lodge. (If it was a lousy name for a kids' camp, it was an even worse name for a catering hall.) They'd put me on their mailing list, and I resented this.

A few years later there was an obituary in the *Buffalo Evening News*. Ada had died of lung cancer. She couldn't have been fifty when she died. I thought about writing a letter, but I always think about writing letters on such occasions, and hardly ever get around to it. Nor did I this time.

Then, twenty-one years after my summer at Juniors Lodge, I looked for Doc and I found him. I was on a curious ramble; I'd given up my apartment in New York, moved in with a woman in Buffalo, moved out a few days later when she came to her senses, and found myself with all my possessions in the back of a treacherous Ford station wagon. I decided to drive around and see where I wound up.

H. L. Mencken wrote somewhere that the Lord had seized the United States by the state of Maine and lifted, so that everything loose wound up in Southern

California. That's what I was and that's what I did, but it took me four or five months to get there, and on my way I passed through the town of Dania and thought of Doc.

So I went looking for him, and amazingly enough I found him. I reached his dental office—evidently if you lived in Florida long enough they had to let you be a dentist again—and the woman I spoke to told me Doc had retired because of illness. I found out where he lived and went to see him.

He had emphysema, and walked around sucking oxygen out of a tube. He knew me, and remembered me as clearly as I remembered him. And he brought me up to date on his life since I'd known him. He'd had two marriages after Ada's death, each one worse than the last. He'd gone back to dentistry and managed to build a practice. He told me about his kids, but if what he said registered at all I've long since forgotten it.

And he told me what a struggle he'd had in Buffalo with the Beth Zion establishment, who hadn't wanted an East Side boy, a Russian Jew like Marshall Gubinsky, leading their Boy Scout troop. And he'd had his troubles with some of our parents, as well—not mine, he had nothing but good to say about my folks, but several others.

And he talked about his emphysema. He didn't say it was going to kill him, but he really didn't have to.

"You know," he said, "when you're working with the kind of chemicals we use in my branch of dentistry, well, you're breathing in fumes for hours on end. I think that's probably what caused it." He sucked on the oxygen tube. "Though I suppose all those Luckies may have been a factor."

Gee, ya think?

It was an unsettling experience, to say the least. At another period in my life I'd have walked out of there and immediately lit up a cigarette, but I'd quit them a little over a year earlier. So what I did was go have a drink. There's always something.

They would have taken me back at Parker Pharmacy, but I really didn't like Bob, the pharmacist, and I think I felt constrained by the fact that my dad had lined up the job for me. So I went to Day's Drugs, at North Park and Hertel, about as far from my house in one direction as Parker had been in the other. I'd heard that their delivery boy had gone off to college, and I applied for the job.

It paid seventy-five cents an hour, which was a nickel more than I'd been making at Parker. The nickel was beside the point, but I was quick to mention it to my folks. "And," I said, "I'll be making five cents more an hour."

My boss was a fellow named Frank Stein, whom everyone who ever worked for him inevitably referred

to as Frank N. Stein, though there was nothing about him suggestive of either the scientist or his creation. He and his wife, both of them short and stout, were the entire staff of their small store, along with whatever high school kid was working for them that year. I was on my bike a lot in Frank's service, because I not only had to deliver prescriptions; a lot of the time, I had to go out and fill them first.

The store wasn't much more than a hole in the wall, and the backroom stock was limited. Consequently Frank often got a prescription calling for something he didn't have in house. "Sure, we've got that," he'd say, and then he'd call around to other drugstores until he found somebody who did in fact have the item in question. I'd go there and pick it up, and he'd put his own label on it, and I'd go out and deliver it.

It was also my job to sell cigarettes. They were a loss leader for us, so we did a big business in them, and I remember what they cost—$1.93 a carton for regular-size cigarettes, like Camels and Luckies and Old Gold, and $1.95 a carton for king-size. (That extra two cents a carton never caused me to wonder at the time, but now it strikes me as incomprehensible. What minuscule increment could the wholesaler have charged that led us to price Pall Mall a fifth of a cent a pack higher than Lucky Strike?)

I sold cigarettes, many of them to customers who came to us for their smokes and for nothing else. And I stole cigarettes, too, though our selection was less vast and I was pretty much limited to the common brands. I didn't sell condoms, you had to go ask for those at the prescription counter, and once in a while somebody paused at my cash register with a puzzled expression on his face, and I'd just point him toward the back. But I did steal a condom, and it remained unopened in my wallet forever. It said right on the wrapper that its sole purpose was to prevent the transmission of venereal disease, and I'd have to say it worked.

At the end of the school year, I introduced my friend Symmie Jacobson to Frank; Symmie was a year behind me, and glad to take over my job. I walked off with my last pack of free cigarettes, and shortly thereafter I graduated from Bennett. Remarkably enough, I was one of the officers of my senior class.

It was far and away the least significant office, and the only one that wasn't largely a popularity contest. The post was Class Poet, and there was a competition for it. You submitted a poem, and a panel of three English teachers read the entries without knowing whose they were. I submitted two entries, one in declamatory blank verse (Four years have passed since first we called you Home . . .) and the other something more

impressionistic, written in a free verse that owed a lot to American Imagist poets of the early twentieth century, like Alfred Kreymborg, whom I admired greatly.

The blank verse epic won, and was printed in the school yearbook. I may have had to read it on stage at Class Day, but maybe not. I can't remember.

"The free verse poem was everybody's second choice," Miss Jepson confided. "Of course I knew right away it was yours. I knew they were both yours."

The night I graduated I got drunk for the first time in my life. I found my way home and went to bed, and when the bed started spinning I leaned over the side of it and vomited. Then I passed out and slept like a lamb. The next day my mother told me she hoped I'd learned something from the experience.

Yeah, right.

I spent the summer as a counselor-in-training at Camp Lakeland. I didn't walk much at Camp Lakeland, and I certainly didn't run, but I saw something there that I never forgot. One of our campers was a fellow named Barry who was really too old for camp, but they took him out of a need to do something for him. He was, I gather, kind of disturbed, and when I heard his story I figured he had plenty to be disturbed about. His family were European refugees, but they'd managed

to stay out of the camps. They hid from the Germans in the woods, and subsisted on roots and berries, and somehow lived to tell the tale. Most of them, anyway.

Barry was about as well socialized as a wolverine. Every now and then he'd run away from camp, just take off down the highway and disappear. I suppose he went back to Buffalo. That was one interesting thing he would do, but another far more interesting thing he did was run. He was this big lanky kid, tall for his fifteen years, and he'd go out to a field and just lope around it for fucking hours on end. When he got thirsty he'd tear a leaf from a tree and chew on it. Then he'd spit it out. And throughout it all he'd keep on running along.

Damnedest thing I ever saw.

If I had to, I figured, I could probably live on roots and berries. My Boy Scout experience had taught me how to recognize edible wild plants. I could do that, at least for a while, if I had to.

But the running? Not a chance, not if my life depended on it.

When camp was over I went home. A couple of weeks later my dad drove me to Yellow Springs, Ohio, where I was to begin my freshman year at Antioch College.

I only applied to two colleges, Cornell and Antioch. Both my parents attended Cornell—that's where Arthur Block from New York City met and married Lenore Nathan from Buffalo—and so did my two uncles, Hi and Jerry Nathan. I'd been there several times for football games, and I knew the words to all of the college songs. (I still do; learn that sort of thing young enough and it's yours for life.)

In the ordinary course of things that's where I'd have gone, whatever I wanted to study. They even had a veterinary medicine school, in case that old ambition should return. All those relatives would have helped induce the college to find a place for me, but I wouldn't need their aid. I had the grades, and the smarts. All I had to do was send in my application and

I'd be set for four years in Ithaca, far above Cayuga's waters.

> *Far above Cayuga's waters*
> *With its waves of blue*
> *Stands our noble alma mater*
> *Glorious to view—*
> *Lift the chorus, speed it onward,*
> *Loud her praises tell*
> *Hail to thee, our alma mater*
> *Hail all hail Cornell*

Instead I went to Antioch, where the only song was an unofficial one that went like so:

> A *is for the* A *in dear old Antioch*
> N *is for the* N *in dear old Antioch*
> T *is for the* T *in dear old Antioch*
> I *is for the* I . . .

Well, you get the idea.

I'd never heard of Antioch, but then I'd never heard of any colleges except the ones that fielded a football team. My parents learned about it from Ruth and Jimmy Gitlitz. Jimmy, a lawyer in Binghamton, was my dad's closest friend from Cornell, and the Gitlitzes knew

about Antioch because the son of friends of theirs—I believe the family name was Singer—had gone there and liked the place. So had another Jewish boy from Binghamton, Rod Serling, who went on to be the host and creator of the TV show *The Twilight Zone.*

The salient fact about Antioch was that it had a work-study program—not so that students could earn money, as it was a rare student indeed who finished a co-op job with more money than he'd had when he started it—but to provide Antiochians with practical experience in their chosen field, and indeed to help them toward an informed vocational choice. Students spent half the year at jobs the college found for them and the other half in classrooms (except for freshmen, who had the option of spending the entire year on campus, as about half of each entering class chose to do).

The other significant fact about Antioch, although I never knew it until I got there, was that it tended to draw nonconformists. Maybe that's why my parents thought I'd be happy there. They were sold on the work-study program, but part of their enthusiasm may have stemmed from the notion that this might be a place where I'd actually fit in, and feel at home.

I applied to both schools and was accepted right away at each. I'm sure we would have been eligible for some sort of financial aid package, my dad wasn't making

much money, but he was unwilling to fill out the requisite forms, so we never applied for scholarships. I did take the New York State Regents exam, and scored high enough to qualify for $600 a year toward tuition at any school in the state; additionally, my placement was close enough to the top to earn me an additional $200 annually as a specific Cornell scholarship.

Eight hundred dollars a year was substantial. Antioch, not an inexpensive institution, charged an annual unit fee of $1400, which covered room and board as well as tuition. It represented a certain financial sacrifice for my parents to send me to Antioch, and God knows I'd have gone off to Cornell willingly enough, but there was never any question. "You'd rather go to Antioch, wouldn't you?" Well, uh, yeah, I guess. "Then that's where you're going. It's the right place for you."

It's an interesting time to be writing about Antioch, as the school has been much in the news lately. The board of trustees has announced that the school will not reopen for at least four years, because applications for admission are insufficient to allow the school to function. How closing for four years will increase applications is something no one has managed to explain, and it looks as though the old school is going out of business.

I think my parents were right, I think it was indeed the right place for me, though I sometimes wonder what course my life might have taken if I'd gone to Cornell instead. (Such speculation, I should point out, has precious little to do with Antioch or Cornell, and more with my state of mind at the moment. A couple of years ago I was at Avery Fisher Hall for a concert of the New York Philharmonic. From our seats I had a good view of Philip Myers, the principal French horn player, and I had the following extraordinary thought: *Maybe I should have studied the French horn, maybe that would have made all the difference.*)

I spent three of the next four years at Antioch. I spent all of my first year in Yellow Springs. In the summer I went off to New York for three months in the mailroom at Pines Publications. I shared an apartment on Barrow Street in Greenwich Village, not five minutes from where I live now. I went back to school for a semester, then took a job my father got for me at the Erie County Comptroller's Office—the idea was I could live at home and save money, but anything I put aside I spent on a weekend trip to New York. In the spring I returned for the second semester of my sophomore year, and come summer I again passed up the school's job offerings, worked briefly in restaurants on Cape Cod, and then went to New York, where I was

lucky enough to land an editorial position at the Scott Meredith literary agency.

It was the best possible opportunity for someone who wanted to be a writer, and I dropped out of school to keep it. I'd already placed a story with a crime fiction magazine, and I wrote and sold many more stories during the year I worked there; more to the point, I learned a tremendous amount about writing, and about the business of being a writer.

A year was enough, and at the end of it I quit the agency—though I remained a client—and went back to Antioch for a third year. But it was the farm, and I'd seen Paree. I'd caught on with a paperback publisher and was able to write novels and get paid for them, and that made it very hard for me to assign a very high priority to classes in the eighteenth-century English novel.

The drinking and dope-smoking may have had something to do with it, too.

I withdrew after a month or two, then rescinded my withdrawal under emotional blackmail from my parents. I stayed in Yellow Springs for the rest of that academic year, spending my work period on campus as the editor of the college paper, and in the summer of 1959 I went to New York to devote my next job period to writing books. I was living in the Hotel Rio, on West Forty-seventh Street, and that's where I was when I got

a letter from the Student Personnel Committee. They had concluded, they wrote, that I would be happier elsewhere. It was the sort of expulsion notice one could probably talk one's way out of, with only the occasional mouthful of crow, but I found nothing in their words to argue with. I agreed with them entirely, I would indeed be happier elsewhere, and I've been elsewhere ever since.

Antioch was a hotbed of a number of things, but athletic activity was not among them. There was no intercollegiate competition, in football or anything else, and thus few occasions for the singing of "*A* Is for the *A* in Dear Old Antioch." In my first semester, my freshman dorm fielded a team to play two-handed tag football against other dorms, and in the appropriate semesters we did the same with basketball and football.

Every spring there was an event held called the Beer Ball Game, a baseball contest in which the pitcher drank a beer before delivering the ball, the batter drank a beer before running to first base, the infielder drank a beer before throwing to first, and so on. I suppose most schools have an event of this sort, and I suppose few of them get beyond the first inning. Ours never did.

My alma mater has a distinguished alumni roster for a college with an average total enrollment of a thousand.

We've turned out leaders in public service and the arts, and for years produced a wildly disproportionate number of Woodrow Wilson scholars. But as far as I know we've never graduated a future Olympian, and it's not hard to understand why.

My walking at Antioch was just a way to get from one place to another. It was a small campus in a small town, and there was no place one couldn't walk to in ten or fifteen minutes at the most. Still, when I returned for my final year, the first thing I did was buy a car. It was a deep blue 1950 Chevrolet coupe, and it had a lot of things wrong with it, but I was uncommonly fond of it. I named it Pamela, for Samuel Richardson's epistolary novel, which was assigned reading in my eighteenth-century novel class. I never actually read the book, but naming my car after it seemed the next best thing.

A certain number of semesters of physical education were a requirement for graduation at Antioch. All you had to do was attend, there were no examinations, not even a grade of Pass or Fail. The initial course, which everybody took first semester, was general, and all I remember was that I took it, and that it was held in the gym. I must have attended it just enough to get credit for it.

The second half of the year you could take something specific, and Paul Grillo, my freshman hall advisor, suggested the two of us sign up for golf. The school didn't have a functioning course; what had once been a golf course was now just a stretch of the campus, where courting couples were apt to be strewn hither and yon in seasonable weather. They still called the area the golf course, but anyone who actually wanted to hit a ball with a stick had to go to a nearby course, which I think may have been in Xenia.

Paul and I would go there, and we'd dutifully tee off, and each of us would hit his ball as many times as we had to in order to get it into the woods. There, out of sight of everyone but the squirrels, we'd stretch out and smoke cigarettes and tell each other stories. Then at the appropriate time we'd find our way back to the clubhouse, turn in our rented clubs, and get on the bus to go back to campus.

That was as much phys ed as I had at Antioch, and I'm afraid it was neither physical nor educational. I'd have needed a few more semesters in order to graduate, and eventually I might have found myself in the awkward position of a few legendary Antiochians, who'd completed all of their course work while neglecting the physical education requirement. The poor bastards would have to come back for another term, during

which they'd load up on phys ed and nothing else. That might well have been my lot, but I was spared all that when they expelled me.

I took some interesting courses at Antioch, both English and history. I cut a lot of classes and gave a lot of assignments short shrift, but I picked up a thing or two in spite of myself. My experience in Nolan Miller's writing workshop probably equipped me to land the job at Scott Meredith.

And, of course, I learned more outside the classroom than inside. Met some unusual people, formed some enduring friendships. Fell in and out of love, and occasionally in and out of bed. And I smoked a lot, primarily tobacco, and I drank a lot. Beer, wine, whiskey. Hey, whatever you've got will be fine . . .

And most of that continued for the better part of twenty years after I said goodbye to Yellow Springs in 1959. I spent a lot of those post-Antioch years in New York, so I did a fair amount of walking, because that's how one gets around in our city. But I never made a conscious effort to walk fast, or to cover great distances. I didn't racewalk, or even know what racewalking was.

And, God help us, I certainly didn't run.

PART TWO

8

It was the spring of 1977, and I was living in a second-floor rear tenement apartment on Bleecker at Sullivan Street. I walked up Sullivan two blocks to Washington Square Park, stood on the sidewalk alongside the park facing east, and began to run.

I proceeded counterclockwise around the little park. It's not microscopic, the circumference comes to just about five-eighths of a mile. (In other words, a kilometer, but I wasn't thinking in metric terms. Later, when I ran races measured in kilometers, the word would have more meaning to me.)

I couldn't run the whole way around. I ran as far as I could, until I had to walk and catch my breath. I walked until I felt I could run again, and ran until I had to walk again, and so on. I circled the park five times, which I

figured came to three miles. Then I walked home, and took a shower that no one could have called premature.

I did this every morning.

My running wasn't much more than a shuffle, and I'm not sure I even called it running. I may have used the term *jogging,* which was getting a lot of use at the time. I wouldn't use it now. There is, it seems to me, something both patronizing and trivializing about the term. If you're jogging, you're taking it easy. You're plugging away at it to keep in shape. It's good exercise, it'll help you keep your weight down, and if what they say is true, it'll work wonders for your cardiovascular system.

But it's not exactly athletic, is it?

Dr. George Sheehan, a distinguished runner, writer, and physician, was once asked the difference between a jogger and a runner. A race number, he replied.

Whatever it was, I did it every day. It wasn't like learning to ride a bike, or even like learning to walk in the first place, because there was no falling down involved. I ran until I had to walk, walked until I was able to run.

The day came when I ran all the way around the park, a full five-eighths of a mile, before I had to walk.

And there was another day, not too long afterward, when I was able to run for the whole three miles. Five laps, three miles, running all the way.

Who'd have thought it?

. . .

In a word, nobody.

For almost thirty-nine years, if you saw me running you knew I had a bus to catch—and that I'd probably miss it. I was born overweight and out of breath, and by the time I slimmed down some I'd been smoking cigarettes for several years.

Back in seventh and eighth grades, they had a citywide running competition. At PS 66, the gym teacher, Mr. Geoghan, stood there with a stop watch and had us run the length of the playground. He timed us in the seventy-five-yard dash, and I wasn't the very slowest in my class, but I came close.

(Remember Jack Dorfman? Captain of the renowned Wellington Tigers? Quarterback and star shortstop at Bennett High? In both seventh and eighth grades, Jack won the seventy-five-yard dash almost without effort. Then he went on each time to the district semifinals, which he also won. From there he went to the citywide finals, and three black kids sailed past him like he was standing still.)

My freshman year in high school, my friend Ronnie Benice announced that he and another fellow, Ron Feldman, were going to try out for the cross-country team. I didn't even know what that was. "Come on along," he suggested. He explained what cross-country

was, and I thought he was out of his mind. Run? Over hill and dale? Me? You're kidding, right?

Both Rons ran cross-country in the fall and track in the spring. I spoke with Ron Feldman at a reunion a couple of years ago, and he said he still ran on a regular basis. Ron Benice is living in Florida, but I haven't been in touch with him in twenty-five years, so I have no idea if he's still running.

And then, twenty-two years after high school graduation, I was running around Washington Square Park. How the hell did that come to pass?

It was in 1959 that I was sent down from Antioch. (That's how the British would say it, and it sounds so much nicer than "expelled.") I'd spent the next eighteen years getting married, siring daughters, writing books, moving around—back to Buffalo, out to Wisconsin, then to New Jersey. To say I drank my way into marriage isn't much of an exaggeration, and it's none at all to say I drank my way out of it. My first wife and I separated in 1973, and I moved to a studio apartment on West Fifty-eighth Street. A year later, when I began chronicling the fictional adventures of Matthew Scudder, his hotel room was just around the block from me. How's that for coincidence?

He spent twenty years or so in that hotel room, but I was out of my apartment in two years. I moved back

to Buffalo again, and that didn't work, and I got the feeling I'd be better off without a fixed address, on the principle that a moving target is harder to hit.

I've mentioned the *wanderjahr* that took me to Florida and a reunion with my old scoutmaster. It would have been in December of 1975 that I tracked down Doc Marshall, and it was the following February by the time I got to Los Angeles. I lived there for six months at the Magic Hotel in Hollywood, and my kids flew out and spent the last month with me at the hotel. Then we piled into the Chevy Impala I'd bought when the Ford wagon died, and we spent a wonderful month seeing something of the country on the way back to New York.

I thought I'd turn around and drive right back to California, but instead I went to visit a friend in South Carolina, and stayed there long enough to finish the book I was working on. I called it *Burglars Can't Be Choosers*, and it turned out to be the first of a long series about a light-fingered fellow named Bernie Rhodenbarr. I returned to New York, and I came very close to taking a room at Scudder's hotel, but instead I wound up signing a lease on that little apartment on Bleecker Street.

I'd stopped smoking in September of 1974. I had stopped many times over the years, but this time it took. I never did go back to it.

And, after several months on Bleecker Street, during which I put in some long hours at the Village Corner and the Kettle of Fish, I stopped drinking.

I'm sure that had a great deal to do with the running, although I never made the connection at the time. There couldn't have been more than a couple of weeks between my last drink and my first shuffling steps around the park, but when I was trying to work out the chronology the other day, I had trouble determining whether I was still drinking when I started running. Until then, I'd never thought of one thing as having led to the other.

But of course it did. All of a sudden I had all this nervous energy and nothing to do with it. I didn't think in those terms, not at all. I just had the thought one day, out of the blue, that I'd like to try running around the block. I didn't go to the park, just ran up Sullivan to West Third Street, turned left, went to MacDougal, turned left again . . . and so on. Running for as long as I could, then gasping as I walked, then running. Somewhere along the way I gave up on the running altogether and walked the rest of the way home.

I did this in street clothes—jeans, a long-sleeved sport shirt, a pair of leather dress shoes. God knows what I looked like. People probably thought I'd stolen something, or perhaps killed someone, and was trying

to escape. But they left me alone. It was New York, after all, and why interfere?

After a day or two of this I picked up the phone and called my friend Philip Friedman. I'd met Philip through our mutual agent, and he seemed like an interesting guy, but the one extraordinary thing I knew about him was that he was a runner. He lived on the Upper West Side, and ran every day around the reservoir in Central Park. And he'd actually run a marathon. He was from Yonkers originally, and he'd run the Yonkers Marathon, and that impressed me.

(It would have impressed me even more if I'd known anything more about the event than its name. The Yonkers race is one of the country's more difficult marathons, generally blessed with wilting heat and humidity, and boasting a couple of positively oedipal hills. I've never participated myself, and with any luck at all I never will.)

I told him I'd started running, and I wasn't sure if I knew how to do it. He said there wasn't all that much to it, aside from remembering to alternate feet. Did I have running shoes? I said I didn't, and he recommended I go to a store that specialized in athletic footwear and let them sell me something.

I found the right sort of store and came home with a pair of shoes by Pony. I remember that they were blue

and yellow, and the most comfortable things I ever put on my feet. I went out and circled Washington Square a couple of times, and when I came home I took off my new shoes and noticed that they had a couple of broken threads in the stitching.

So I went back to the shoe store, and they pointed out that the shoes were now used, they showed the effects of a few laps around the park, and they couldn't take them back. And I threw a fit, and to get rid of me they let me exchange them for a pair of Adidas.

That's a good brand, but the shoes I took home were singularly unsuitable. They were running flats, and offered about as much cushioning and support as a pair of paper slippers. They were also a little too small overall, and a whole lot too small in the toe box. It was months before it dawned on me that they were the wrong style of shoe and the wrong size, and that they consequently were so damned uncomfortable to wear. I just thought it was a matter of having to get used to them, and I wore the silly shoes for months, ran all over the place in them, and never failed to luxuriate in the feeling of sheer relief that came over me every time I took them off.

But I didn't let them stop me. I got out every day for my five laps around Washington Square Park. When I went out of town for a couple of weeks in the summer, I

found places to run—in parks, on highways, wherever I could get in a half hour to an hour of alternating feet. I never allowed myself to miss a day, because I had the feeling that once I did I'd give it up forever.

I must have missed days when it poured, or when there was ice underfoot. And I remember a snowy day around Christmas when I was sane enough to stay indoors, but nuts enough to lace up my Adidas and run in place in my living room.

I was a runner.

It astonished me that I could do this. It's not as though I'd ever spent any time thinking of running as something I might do if I ever got around to it. I can't say I thought much about running at all—for myself or for other people. I knew there were people who ran, I would see them out there doing it, but I also knew there were people who belonged to something called the Polar Bear Club, whose members went out to Coney Island in the middle of the winter and charged like lemmings into the freezing surf. There was no end of people who did no end of stupid things, and what did any of that have to do with me?

I remember standing on Bleecker Street one afternoon, a few doors from my apartment, when someone went tearing past me, running for his life, while

someone else—a shopkeeper?—stood on the sidewalk shouting for him to stop. I realized that it was within my power to chase this fellow, that I could quite possibly run him down. After all, I was a conditioned runner. He'd gone by at a good clip, but how long could he keep it up? I could lope along for a half hour, and by then he'd pull up gasping.

Of course I didn't run after the son of a bitch. I mean, suppose I caught him. Then what? But the realization that chasing him was something of which I was physically capable was remarkably empowering in and of itself. A couple of months ago I couldn't have done it, and now I could, and that struck me as pretty amazing.

I suppose there were physical benefits. This was 1977, which was just about the time when the media were overflowing with the purported benefits of getting out there and jogging. If you put in half an hour three times a week, you were presumably guaranteed immunity from no end of unfortunate conditions, heart attacks foremost among them. Doctors with impressive credentials were going so far as to state that anyone who ran marathons (or, as someone phrased it, anyone who lived a marathoner's lifestyle) never had to worry about coronary artery disease. He might not quite manage to

live forever, but when he did die, it wouldn't be a heart attack that killed him.

This sort of hyperbolic ranting lost some steam when Jim Fixx, a fine runner and a very prominent writer about running, did in fact suffer a myocardial infarction and die in early middle age. It was clear he had a genetic predisposition to coronary artery disease; he'd lost close male relatives to it. He'd lasted longer than the others, and one could argue (and several did) that running had in fact extended his lifespan.

Still, it was Fixx's misfortune not merely to die young but to live on as an object lesson for antirunners. For years, any mention of the benefits of running was apt to be met by a raised eyebrow and an allusion to poor Jim. A couple of years ago, a good quarter century after the fellow sprinted off this mortal coil, I was one of several guest speakers at Mohonk Mountain House, in upstate New York. I put in an hour or so on the treadmill one morning, then joined the other speakers at breakfast. One of them, a forensic pathologist of some renown, had evidently noticed me on my way to the gym and began taking me to task for it.

"Tell me something," he said. "Do you plan on living forever?"

"No," I said, "though I'm hoping to make it to dinner. I understand there's venison on the menu."

"You people run because you think it's good for you," he went on. "Let me ask you something. Do you remember Jim Fixx?"

"Anyone who ran a marathon . . . or lived a mara-thoner's lifestyle . . ."

When I was circumvolving Washington Square Park, or trotting along some country lane or suburban boulevard, I wasn't trying to live forever. I appreciated the fact that running would take off weight, or at least enable me to eat more without gaining. Since those pounds I lost during my Florida summer had come and gone and come again many times over the years, this alone seemed reason enough to put on my shorts and shoes and get out there.

Still, the phrase echoed, and began to do its subtle damage. Not the promise so much as the premise. The one word, really.

Marathon.

To run a marathon. To be a marathoner.

I didn't know much about the marathon. I knew it was 26.2 miles long, and I knew they held one every spring in Boston. I knew there was one in Yonkers, too, because my friend Philip had run it, and one in New York as well. I also knew that 26.2 miles was far longer than I could possibly run.

And what did I care about races, anyway? I was in this for the exercise, and for empowerment, and the attendant sense of accomplishment. Running was a pastime, certainly, but it wasn't a sport for me. There was nothing competitive about it, nor was it something I sought to do in the company of others. At Washington Square, I shared the sidewalk with others, but I wasn't trying to get around the park's perimeter faster than anyone else. I might have considered us comrades in some collective endeavor, but I don't really think I did. It seems to me I never paid much attention to anybody else.

Then I picked up a running magazine. *Runner's World,* most likely, but it may have been *Running Times.* I soon became a regular reader of both magazines, eager for more information on this new pursuit of mine. Maybe I could become better at it, maybe I could feel more a part of it.

There was plenty of instructional material in both magazines, but from my point of view it didn't add much to Philip's initial advice to alternate feet. I learned a great deal about various methods of training for races of various lengths, along with tips on hydration and nutrition and supplementary exercise. And I read reports on the results of important races, and interviews with their winners, and profiles of prominent runners.

Gradually, my view of running began to shift. You didn't just do this to be doing it, or for the good it was presumably doing you. You didn't do it in a heroic effort to amass endorphins, either, despite the "runner's high" both magazines nattered on about. (I'd spent the previous two decades ingesting various mood-altering substances, and I damn well knew what it was to be high, and that you couldn't manage it by running around in circles.)

The daily running you did was training. You trained as preparation for racing. You trained, and then you raced, and after that you rested and trained again. To race again.

And why did you race? What was the point of it?

Well, if you were one of perhaps a dozen elite runners in a field of a few hundred or a few thousand, you raced in the hope of victory. You were out there trying to finish ahead of all of the other runners. If you actually won the race, you might get mentioned on the network news (if the race was, say, the Boston Marathon) or in your hometown newspaper (if your father was friendly with the editor). You wouldn't get any prize money, not in the late 1970's, and if you did it would jeopardize your amateur standing, and shut you out of the Olympics.

You'd get some glory, among the relative handful of people who paid attention to that sort of thing.

But some elite runners didn't even want the glory, and it wasn't uncommon for a couple of lead runners to deliberately adjust their pace at the end and breast the tape hand in hand, demonstrating that this was a sport without winners and losers, that everyone who finished was victorious.

And that, of course, was what brought the vast majority of runners to the starting line, and carried them through to the finish. A race was by definition a competitive event. You might time your training runs, might try to go all out and cover the distance in the shortest time possible, but it was never the same as participating in a race with other runners. Even if it was what they called a fun run, even if no one was recording the times, when you were one of a group of runners, when they blew a whistle or fired a pistol to signal the start, when there was a finish line to be crossed, it was a race.

But you didn't have to win it to be a winner. All you had to do was finish. You would try to do better than you'd done in your last race—and, as a way of delivering your best possible performance, you might make a special effort to overtake the fellow running a few steps ahead of you. But that didn't really matter, and you'd forget him the moment you passed him, even as you'd forget the runners who ran past you.

You and the others were in this together, but your competition was not with them but with yourself. You pinned a race number on your singlet, repinned it a few times, tied your shoelaces, retied them a dozen times, peed and peed and peed again, and finally took your place at the start and waited for the race to begin.

Remember what George Sheehan named as distinguishing a runner from a jogger? A race number.

I read the magazines, *Runner's World* and *Running Times*, and the message began to soak in. What I was doing every day was not an end in itself. It was preparation, and I was preparing to race.

I found the prospect very exhilarating, and I also found it terrifying. Looking back, I can understand the excitement, but what was I scared of? That others might finish ahead of me? I knew they would, virtually all of them, and so what?

That I would have a heart attack and die? That a bear would escape from the zoo and run me down and kill me? No, none of that.

I was afraid I'd embarrass myself.

Now I was realistic enough to realize that, if a few hundred people joined me in this race, every last one of

them was going to be concentrating on his or her own performance, and paying no attention whatsoever to me. I could finish dead last, and the only person likely to be aware of this would be the person who finished immediately ahead of me. And how would he feel toward me? Would he hold me in contempt? Hell, no. He'd be grateful, hugely grateful, for wouldn't I have just spared him the ignominy of a last-place finish?

I knew all this, and it didn't help a whole hell of a lot. I was desperately afraid of failing at an event in which there was no such thing as failure.

It didn't hold me back forever. There came a time when I had a trip to Buffalo coming up, and discovered that *Running Times* carried a listing for a race that very weekend in Orchard Park, a Buffalo suburb. Here was a perfect opportunity; no one would know me, no one would recognize me, and no one back in New York would learn what I'd done. If I disgraced myself, it would be my little secret.

The real trick, it seemed to me, lay in finding Orchard Park. I borrowed my mother's car and drove there, paid an entry fee of a couple of dollars, pinned a number on my shirt, and began worrying about my performance. I had two goals: to finish the race, and to get across the finish line ahead of at least one other person.

In due course they signaled the start and I took off. I'd read enough to know that neophytes all made the same mistake. They invariably started too fast, and did so without realizing it; the excitement of the race caught them up, and what felt to them like their usual easy pace was actually a good deal speedier. They kept this up as long as they could, and then they burned out, and wound up in trouble. But I knew this, see, and so I knew to guard against it.

And did it anyway.

The race was an odd distance, 6.55 miles. The course was an asphalt loop 1.31 miles long, and we were required to go around it five times. I ran along, establishing what felt like a brisk pace but certainly not pushing it, and by the time I was a little ways into the third lap my heart was pounding and I was gasping for breath.

I felt like someone who'd just failed a stress test. I also felt like a low-grade moron, because I realized instantly what had happened, and that it had all been my fault. I'd gone out too fast, and the result was just what I'd so often read in the books and magazines. I'd outrun my capacity, and I couldn't keep going. I couldn't continue at that pace, nor could I gear down and jog along more slowly. I could no longer do any running at all.

So I did what I'd done during those first circuits of Washington Square. I walked, feeling like an abject

failure. It was a race for runners, for God's sake, and that's what I was, a runner, and what was I doing? I was walking.

But at least it would move me along toward the end of the race. And after I'd walked for a while I was able to run again. I didn't run well, I'd done too good a job of exhausting myself, but I was running now instead of walking, and that seemed to matter to me. I kept going until I'd finished the fifth lap and completed the race, and then I watched as, remarkably, quite a few people came in behind me.

One of their number, not last but not far from it, was a fellow who looked to be about twenty-five or thirty, and who'd walked the entire race. I thought that was pretty curious—a walker in a race full of runners?—but at least I'd beaten him. As much as I'd sabotaged myself, as poorly as I'd run the race, at least I'd come in ahead of the walker.

How ignominious if I hadn't!

My time in the Orchard Park 6.55-mile race was 59:33.

And how do I know that? Well, I wrote it down. In 1979 I bought a book called *Run Farther, Run Faster* by Joe Henderson. Sometime in 1980, when I started racing more frequently, I began logging the results of

each race on the blank pages at the end of the book. I entered my eight 1980 races as they occurred, and then I found a space on another page and noted the four races I'd done the previous year, along with my official time in each. (For one, a fiercely hilly 10K in Upper Manhattan, I knew the minutes but not the seconds; my notation reads *Heights-Inwood 10K—53:??*)

I went on entering each race as I ran it, through late October of 1982. When I remembered, I included the date. Almost invariably, I noted my race number as well, though why I thought that information worth preserving is quite beyond me. Keeping track of my races was evidently important to me, and when I knocked around the country in the summer of '81, toting a backpack that was as light as I could make it, I made room in that backpack for Joe Henderson's book. I ran eight races in six states, and logged them all.

The last race in the book was an 8K in Central Park on Halloween in 1982. I was living in Brooklyn at the time, on Manhattan Avenue in Greenpoint, and I went home and entered the race in my book, noting my time and bib number. And then I put the book away and didn't enter a race again until January 9, 2005.

It was a five-mile race, held on the same course as that Halloween race, and when I got back to my Greenwich Village apartment one of the first things

I did was go to the bookshelf and take down the Joe Henderson book. It was the only running book I still owned, and I'd kept it only because it had my log in the back. I opened it up, found the final 1982 entry, and drew a line under it. Under the line I wrote "*2005*" and under that I entered all the data from the new race—the date, the name of the race, my race number, and my official time.

My second race in 1979 was the New Harlem 10K. It was sponsored by New York Road Runners, and held on the streets of Harlem, streets I ordinarily had no reason to visit. Someone—I believe it was Jimmy Breslin—wrote a day or two later about the bemused response of the neighborhood's residents to the presence that Sunday morning of "a thousand skinny white guys running around in their underwear."

I'd learned from Orchard Park, and when the race started I set out at a sane pace and had no trouble maintaining it all the way to the finish. My time was 51:49, and the number I wore was #2156, but what was really great was that I got to take something home besides my time and race bib. I got a shirt.

Well, so did everyone else who entered the race. This particular shirt was a cotton singlet, with the name of the race on its front. The shirt was white, the lettering red and blue. I wore it with pride.

I ran two more races that year, the Heights-Inwood 10K (with a steep and nasty downhill stretch in Fort Tryon Park; the uphills tire you, but the downhills wreck your knees) and a 7.6-mile race in Bennington, Vermont, about which I remember nothing beyond the fact that I combined it with a week's vacation in that state. (And my time, of course: 1:08:18.) They didn't give out shirts in Bennington, but I got a T-shirt at the Heights-Inwood race, and at most of the eight races I ran the following year.

All eight were in the late summer and fall. It must have been around that time that I joined New York Road Runners. Members paid a dollar or two less to enter races, and I'd reached a point where I was likely to save more than the cost of my membership. There were other activities offered to members as well, group training runs and various sorts of instruction, but they were all held on the east side of Central Park, at Ninetieth Street and Fifth Avenue, and I was then living on Greenwich Street in the Village, and getting from one point to the other was, well, not exactly a walk in the park. (Most of the NYRR races started there as well, but that struck me as worth it.)

The last race of 1980 was my longest to date, ten hilly miles in Central Park on December 14. And it was around that time that I started dreaming marathon dreams.

They'd held the New York Marathon in November, but of course I hadn't even considered participating. I knew I wouldn't be able to go the distance, but I also knew it was something I wanted to do eventually. And around that time I read in my running magazines that the first London Marathon would be held the end of March. I'd been to London a year or so earlier, it was a city I'd visited a few times over the years, and I thought it would be exciting to go back again, this time to participate in the first running of the marathon.

According to what I'd read, I had enough time to train for the distance. All I wanted was to be able to finish, and that seemed a reasonable goal.

And, happily enough, the NYRR race schedule would assist me toward that end. Along with a few shorter races, the club's winter schedule included 15K and 20K races in consecutive weeks in January, and 25K and 20-mile races in February. That 20-mile race was held five weeks before the marathon, and would be a mere 6.2 miles less than I'd have to go in London. That made it a perfect stepping-stone, and I figured I could get there, step by step, so I mailed in my registration for the race, booked my flight to London, and got down to the serious business of training.

I figured I could do it. And, like that first race in Orchard Park, it was a long way from New York, in

a city where nobody knew me. If I screwed up, who'd know?

As 1981 got under way, I increased my training mileage. By this time the city had closed the old West Side Highway, an elevated stretch of road that had begun to crumble and was scheduled for demolition. For now, though, there was a stretch of it in Lower Manhattan, extending from the Battery to Fourteenth Street, that was closed to cars but open to runners.

(And to roller skaters, too. One time I was up there on the empty highway, heading north and knocking off the miles, when two southbound skaters hove into view. As they came closer I saw they were a man and a woman, and as they drew abreast, so to speak, the woman's face lit up with a blinding smile even as she opened her shirt wide to show me her breasts. Then they were gone, and I never saw them again, though I never entirely lost hope until the city knocked the highway down.)

I trained every day, upping my mileage each week, as recommended. And I raced every weekend, which was manifestly not recommended. But the club kept scheduling races and handing out T-shirts, and I couldn't resist.

The longer races were probably a good idea, preparing me to go the distance in London. The shorter

races, four and five and six miles, were probably not a good idea, but they didn't seem to be hurting me. And I don't know that they did me any damage, nor did the long miles of training.

I was averaging nine-minute miles in the shorter races, and my time wasn't that much slower in the longer efforts. I logged 1:28 in a 15K race, 2:01 at 20K. On February 8, my log tells me, I covered 25 kilometers in two hours and forty-five minutes. I remember that race, and I recall that I was in pain during it, but I finished it. That may have been a mistake, but it was nothing compared to the mistake I made the following week during a training run.

I was on my way to the West Side Highway, and as I ran across West Street toward the ramp leading up to the elevated roadway, I put a foot wrong and did something bad to my right knee. It hurt—Christ, it hurt— and if I had it to do over again I'd stop then and there, walk slowly and carefully home, ice the knee, take the rest of the week off, and then start training again, slowly and carefully.

That's not what I did.

Instead, I forced myself up the ramp and onto the highway, and I ran for a while. And by the end of that day's workout my knee hurt a lot worse than it had before, and it still hurt when I got home and when I

STEP BY STEP · 129

woke up the next morning. For a day or two I kept trying to run through it—because I had a marathon coming up, and I needed to get the miles in, didn't I?

You know, you'd expect this sort of stupidity in a kid, but I was forty-two years old at the time. What the hell was I thinking?

Whatever I was thinking, after a couple of days I had to stop thinking it. My knee was really hurting, and every time I went out and ran I only managed to make it worse. It would fool me from time to time, because it only hurt when I ran. The impact of my weight coming down on a bent knee was extremely painful, but when I walked I experienced at worst a slight ache and, most of the time, no pain whatsoever.

At first all I could think of was that the London Marathon was a washout. The entry fee I'd paid was really the least of it. I don't remember how much it was, but it couldn't have been more than twenty-five dollars or so. The several hundred dollars I'd paid for a plane ticket represented a more substantial loss. But it too was less significant than the fact that I'd really been looking forward to this experience, and now my own ignorance and stupidity was going to deprive me of it.

Unless I just went and walked it.

At that first race in Orchard Park, my feelings toward the race's single walker had hovered somewhere between puzzlement and contempt. Walking, after all, was what I'd done before I taught myself how to run. In a race, where the object was to get from the start to the finish as rapidly as possible, why would someone deliberately select a slower gait? What sense did that make?

Since then I'd learned to view walkers differently. There was a walker contingent in every NYRR race, and the first three across the finish line qualified for trophies. They were not just walkers, they were racewalkers, and when I watched them I had to admit they looked good. There was something amusing at first glance about that hip-wiggling form, but it didn't take long to get used to it, and once you did you stopped seeing it as funny-looking.

More impressive, though, was how racewalkers looked at the end of a race. The slower and less well-conditioned runners tended to reach the finish line looking like the wreck of the *Hesperus*. Their backs would be curled in one direction, their necks bent the other way in a heroic attempt to hold their heads up. They held their limp hands up in front of them like dogs begging for a treat. Many of them really looked awful, and if those back-of-the-packers were the only

runners a person ever saw, it would be hard to convince him that the enterprise was good for you.

The racewalkers, on the other hand, strode toward the tape with their heads held high, their posture impeccable, and their arms swinging resolutely at their sides. They might be finishing days behind the leading runners, but they'd cross the line ahead of many of the real schleppers, and they'd look damn good while they did so.

So I'd come to respect the racewalkers. I didn't want to be one, but that didn't mean there was anything wrong with them or what they were doing.

If I could racewalk, I could go on training over the next several weeks without further damaging my knee. I'd stay in condition, and if my knee mended quickly enough, I might be able to run London after all. Failing that, maybe I could walk it.

But first I had to learn how to racewalk.

I'd had to learn to run, too, during those early laps around Washington Square, but I hadn't needed anybody to teach me. But racewalking was different. It involved a curious stiff-legged stride that never came naturally to anyone, except perhaps an early-stage robot.

Now some people might be capable of picking up the technique of racewalking by watching others and

duplicating their movements, but I'd have been as likely to learn to fly by watching a bird. Did I mention that I was the only kid in my kindergarten class who couldn't figure out how to skip? (I did learn, though, because my mother taught me. Years later, when Mrs. Goldfus shouldered me from fifth to seventh grade, my mother took a certain poetic satisfaction in the fact that the boy who couldn't skip had managed to skip all of sixth grade.)

Fortunately, I didn't have to pick up racewalking on my own. Every Saturday morning Howard Jacobson, the chief poo-bah of New York area racewalking, held an instructional class in Central Park, at the very East Side location where most NYRR races began. The classes were free, and all you had to do was show up, which is what I did on the Saturday after I wrecked my knee.

I showed up, along with twenty or thirty others. After a few minutes of basic instruction, we all set out on a six-mile circuit of the park, moving at whatever pace we chose. I wound up walking with a man and woman around my own age, both of whom had done this before. We walked at what the man estimated at a thirteen-minute-per-mile pace, and I pumped my arms and kept my knees locked and seemed to be doing pretty much what everybody else was doing.

I don't know that it was easy. Compared to runners, racewalkers work harder, go slower, and create more amusement for onlookers in the process. I was putting too much effort into it for it to be easy, seeking to do it correctly, striving to keep up with my companions. By the time we'd got back to where we'd started, I certainly felt as though I'd had a decent workout. But I didn't feel exhausted, or even as tired as I often did at the end of a brisk six-mile run.

And my knee felt fine.

From that point on, went I went out for my daily hour or two, I did so with my knees locked and my arms swinging. A week or two later, I got my first field test as a racewalker in the Mike Hannon Memorial, a twenty-mile race in Central Park. It would be my longest race to date, four and a half miles longer than that 25K, and it was by no means a foregone conclusion that I could complete it. Still, if I dropped out after one or two loops instead of going the distance, I'd still take the same bus home, so why not take a shot at it and honor the memory of Mike Hannon?

(Whoever he was. The club held a few memorial races, and never bothered to tell you anything about the person whose memory we were presumably perpetuating. All these years later, I still remember the name Mike Hannon, and I still don't have a clue who the guy was.)

I don't remember too much about the race. I remember it was cold and clear, and I remember the field was small, because not that many people found the prospect of twenty miles in February irresistible, especially with a course of the same old Central Park loops. They didn't even give out shirts for this one. For the love of Mike.

We made four circuits of a five-mile loop—with various cutoff options, Central Park loops can be four or five or six miles—and somewhere toward the end of the third loop I realized that I was going to be able to finish the race. And I did, and without having to drag myself across the finish line, either. I finished in good form (or as good as my form was going to get) and did so, my records tell me, in 4:09:31. That works out to twelve and a half minutes a mile, and if I maintained the same pace in London I'd complete the marathon in something like five hours and twenty-five minutes.

I could do it.

It would take me more than twice as long as the person who won the thing, but what did that matter? Even if I ran the race, even if I somehow maintained for twenty-six miles my best five-mile pace, I'd still hit the finish line an hour and forty-five minutes behind the winner. When I got to London, I wouldn't be competing with any of the other participants. I wouldn't

even be competing with myself. I would be battling the distance, and I now had reason to believe I'd be up to it.

I took a bus home from the park, and a few blocks from my apartment I ran into a fellow I knew. I must have looked jubilant, because he commented on my unaccustomed buoyancy. "I have found my sport," I told him.

I had found my sport. And it was an odd one.

And how is one to discourse upon racewalking without acknowledging its undeniable oddness? It's a genuine sport with a lengthy history, and has been an Olympic event since the early years of the twentieth century. Those of us who do it with even the slightest degree of seriousness don't care to have what we do mislabeled as *speedwalking* or *powerwalking*. I've not been able to determine what either of those terms means, and as far as I can tell they're catchalls for any form of rapid walking that doesn't conform to racewalking's rules.

And they certainly do seem to irritate me. I never correct anyone's grammatical mistakes (though I'm not above noting them with a full measure of satisfaction)

but I can't seem to avoid calling people to account when they refer to what I'm doing as powerwalking. "Racewalking," I say, though you'd think I might know better. They're going to go on calling it what they will, and I'll go on correcting them, and it makes about as much sense as trying to blow out a lightbulb.

The nomenclature's simple enough, for all that some people have a hard time with it. It's the sport itself that's odd, not so much in appearance (you get used to that) or that it's an unnatural gait (what, pray tell, is natural about the high hurdles?). The essential oddness lies more in its rules, and a quick look at its evolution will show how they came about, and why they are required, and how they doom the whole business to eternal quirkiness.

The business of walking substantial distances in competition with others has been with us for a long time, and in the nineteenth century, much as it may strain credulity, the six-day walking race was a spectator sport. There were races held from one city to another, and occasional races that spanned the entire country, and I can understand why residents of Hare's Breath, Nebraska, might gather at the stop sign to see a walker passing through, but a more typical event was held in a stadium, with walkers circling a quarter-mile cinder track for 144 hours. (Keep in mind that this was around

the same time that Victorian novelists were required by publishers to turn out three-volume novels; I think it's fair to say that our forebears were desperate for diversion, and, God bless them, rather easily amused.)

Pedestrianism was a term devised for this sort of activity, and it wasn't specifically confined to walking. More often than not, these races were go-as-you-please events, and a participant was free to run as much of the time as he chose.

I don't know how much running the participants did. If television had existed back then, we could look at the tapes and find out—but then if they'd had television, pedestrianism wouldn't have been able to command much of an audience. The closest thing nowadays to nineteenth-century pedestrianism would be the twenty-four-hour and multiday races (of which more, far more, later). In my experience, a small number of entrants will run all of a twenty-four-hour race, while the greater portion will be runners who mix in a certain amount of walking, less in the early hours, more toward the end. And, of course, there is generally a handful of ultrawalkers, who will walk the whole thing.

I'd guess they walked more and ran less back then, but because there was no distinction in the rules between one gait and another, a contemporary judge would probably deem some of their walking to be running.

And there's the rub.

Because walking had become not merely a pastime but a competitive sport, the desire arose for events that would pit one walker against another without requiring either the participants or the spectators to invest six days in the business. Shorter races already existed, on a true go-as-you-please basis, but everyone ran them because running was so much faster. So couldn't you simply bar running and have short events for walkers? Surely everyone could distinguish between walking and running, couldn't they?

Well, no. It wasn't that simple. First you had to come to agreement on just what constituted walking, and what crossed the line and could only be called running. I imagine the evolution of this distinction was a fairly complicated business, but I also imagine that most of you reading this are no more interested than I in how racewalking got to be what it is.

So let's cut to the chase. Walking requires two elements to distinguish it from running. First, the leg must be straight at a certain point in the stride. Second, one foot must be in contact with the ground at all times.

The first requirement, the straight leg, has changed somewhat in the quarter-century since I learned to racewalk. I was taught that the knee of the advancing leg had to be locked when the heel made contact with

the ground; now the rules have changed, and the knee has to be locked at the midpoint of the stride, when the body is directly above the foot. (Don't knock yourself out trying to visualize this. It is, I must say, easier to do all of this than to explain it comprehensibly.)

If you break this rule in a judged racewalk, the judges will call it *creeping*.

The second rule—one foot in contact with the ground at all times—is much easier to understand and to explain. (And no, it doesn't have to be the same foot all the time.) If you break this one, they'll call it *lifting*.

If lifting is easier to understand, that doesn't make it easier to avoid. The better you are at racewalking, the faster you go; the faster you go, the more likely you are to break the rule against lifting—without knowing that's what you're doing. That's why Olympic race-walkers so often find themselves getting disqualified. It's not because they're cheating. There are judges all over the place, and you'd have to be out of your minds to cheat on purpose. But if you go fast enough there's a good chance that one foot will leave the ground before the other foot returns to it. That's lifting, and the judges will DQ you for it.

But only if they spot it. It's not that easy to spot, and they have to be able to spot it with their naked eyes in

order for it to count against you. Because, see, if you film elite racewalkers, and slow the film down and examine it frame by frame, you discover the unsettling fact that everybody lifts.

So they tweaked the rule accordingly, and lifting has to be visible to the unassisted eye in order to constitute a violation of the rules. (And that eye, let us note, need not be entirely unassisted. Eyeglasses or contact lenses, to correct myopia and astigmatism and the like, are acceptable. Binoculars are not.)

Most racewalkers don't have a problem with the rules. Those who do tend to fall in one of three categories, which for convenience we could label the Good, the Bad, and the Ugly.

First, the Good. Every once in a while an Olympic racewalking event is marked by the disqualification of a country's whole team. Some years ago that happened to the Mexicans; they were the fastest contingent, and they all got tossed for lifting. Around the same time, a team of Italian bridge players was disqualified for cheating in an international competition, but this was different. When you cheat at bridge, you know it. The Mexicans thought what they were doing was legal. The judges thought otherwise.

In hang gliding, as I understand it, the pastime becomes more dangerous the better you get at it. As you

progress in the sport, you place yourself in increasingly precarious situations that a lesser participant would be unable to achieve. Then, if something goes wrong and an updraft suddenly vanishes, say, all you can do is fall to earth.

That's a harsher penalty than a disqualification, to be sure.

Next, the Bad. Walkers who are new to racewalking, and who embraced the sport without adequate instruction, may be disqualified because they haven't learned to walk in a way that the sport finds acceptable. More often than not, they're bending their knees when they shouldn't be. If such a walker draws a warning or a disqualification, it may encourage him to learn more and correct his technique.

Finally, the Ugly. Not everyone is physically capable of racewalking in proper form. One friend of mine, an enthusiastic participant in twenty-four-hour and multiday races, has a knee he can't straighten completely. Another fellow I met in Texas is one of a handful of certified Centurions; he's walked over a hundred miles within twenty-four hours in a judged race. He doesn't racewalk anymore, he said, because he can't maintain a straight knee for great distance. He walks, and nothing about his gait would lead you to call it running, but it's not racewalking.

In the world of ultradistance walking, there's general agreement that racewalking rules shouldn't apply. In Europe and Australia, many ultrawalkers have never learned specific racewalking technique in the first place, and merely walk as rapidly as they can in a manner that comes naturally to them. In the U.S., most of us employ racewalking technique insofar as we can. Judges in Centurion events don't worry about a soft knee, and the pace in these races is such that lifting is not an issue.

At one such event, my friend Ollie Nanyes was exhausted and in agony in the late hours of the race. "I wish you'd go ahead and disqualify me," he told a judge. "I can't," the judge replied. "I could only DQ you for running, and right now you couldn't run if you had a bear chasing you."

11

With the twenty-mile Mike Hannon completed, the finish line of the London Marathon seemed like an eminently attainable goal. And so I went out every day and trained, and every weekend I entered a race. Ten kilometers and five miles in Central Park, five miles in the Bronx, a half-marathon in Brooklyn. My time in the Bronx race was 51:40, in Brooklyn 2:22:25.

But by the end of the Brooklyn race, my feet were a mess. All these years later, a glance at my race schedule is enough to confirm that I was overdoing it, but all I knew at the time was that my feet were in bad shape. Blisters, soreness, pain. My knee was fine, racewalking really did avoid stressing the knees, but my feet were taking a beating. I waited for them to get better,

and they didn't, and by the time I got on the plane for London I was concerned that I wouldn't be able to finish the race—and would probably be well advised not to start it.

I landed at Heathrow and found a bed-and-breakfast in Paddington. I went to race headquarters and picked up my number and souvenir T-shirt, which showed a feisty bulldog wearing the Union Jack. I took it back to my room and wondered if I'd ever get the chance to try it on.

Because I'd long since decided that one had to earn the right to wear a race shirt, and I never put one on until the race was over. This had never been a problem, as I'd so far finished every race I signed up for, but how could I expect to finish this one? And why would I even bother to start it?

I had a few days in London to think about it, and I spent them seeing the city. My museum visits included the Wallace Collection, a small museum devoted largely to the work of nineteenth-century French artists who painted idealized bucolic scenes. This was supposed to divert me from anxiety about the impending race, but I realized it wasn't working when I found myself noticing that every last one of those barefoot shepherds and shepherdesses had second toes substantially longer than their big toes.

Which is to say that they all suffered from Morton's Foot, a structural peculiarity well known to runners and their podiatrists.

My feet didn't get any better in the days leading up to the marathon. It rained the night before the race and was still at it come race time.

The race started somewhere south of London—the halfway point would come at Tower Bridge—and I found my way there knowing it would be impossible for me to cover twenty-six miles, or anywhere close to it. I couldn't even work up a good fantasy in which I managed to finish the race.

What got me to the start was a little bargain I made with myself. I figured I could manage three miles, and I decided that would entitle me to wear the goddamn shirt. My feet were wet already, and it hurt to walk, and I couldn't see how walking would get a whole lot better in wet socks.

(Cotton socks, of course. There was widespread agreement at the time that natural fibers were universally preferable to artificial ones, and that real men didn't wear polyester. There are a lot of good things about cotton, but most of them disappear in a hurry when you work up a sweat. Nowadays all athletic socks are either man-made fibers or wool, and runners favor

"technical" shirts designed to wick perspiration away from the body. Cotton socks, a cotton shirt, ill-fitting shoes—oh, I was in great shape.)

Still, three miles. How hard could it be to walk three miles?

I walked the whole thing.

I don't really know what kept me going. Some kind of stubborn determination, I suppose, but if so it was operating entirely on an unconscious level, because when the race started I had no intention of staying with it for more than three miles or so. I didn't aspire to anything beyond that.

Nor did the pain suddenly abate, enabling me to change my mind. My feet were sore and they stayed that way.

The organizers of the race were well aware that not everyone would be able to go the distance, and they had a bus or two that swept the tail end of the field, picking up whatever stragglers had sensibly concluded that enough was enough. Once you were past the thirteen-mile mark, the midpoint of the race, you were on your own; if you wanted to drop out, you could hop on the Underground or hail a cab.

I kept walking, past the three-mile mark, past the five-mile mark, and on. I kept telling myself I'd drop

out soon, and as I got closer and closer to Tower Bridge, I knew it was time to give up.

Then I saw the bridge, and realized I was halfway there. I kept going and crossed the bridge, and it struck me for the first time that I might actually be able to finish this thing. Because my feet didn't feel any worse than they had at the start, and they couldn't get any wetter than they already were, because even cotton can only hold so much water.

Two miles beyond Tower Bridge, we had a loop of about six miles around the Isle of Dogs. There weren't any dogs to be seen, or much of anything else; it was in those days an unappetizing patch of urban wasteland. It was also the last part of the course that I can remember. The finish was at Constitution Hill—they changed that the following year—but I don't know how we got there. I paid just enough attention to the route to stay on it.

There was one point very near the end where the course led across a vast intersection, and traffic controls at that stage of the race were somewhat lax. In the interest of self-preservation, I forced myself into a raggedy-ass run across that fifty-yard stretch of pavement, but with that exception I walked all the way.

A mile or so from the finish I heard my name called, and looked up to see my good friend Pat Trese; he was

in town on business and showed up to cheer me on. That helped me pick up the pace, and I crossed the line with an official time of 5:22:37.

I was sore the next couple of days, but not terribly so, and on Wednesday I took a train and a bus to Glastonbury, where I spent a couple of days walking around and climbing the High Tor. Then I flew home and got back to the business of racing.

I must have done other things that year. I wrote a monthly column for *Writers Digest* and ghosted a first draft of a screenplay, I contributed four songs to an off-Broadway revue, and in the fall I wrote a long novel, *Eight Million Ways to Die*. I got out of one relationship and, after a brief interval, got into another. I flew to Europe and back twice, took a batch of westbound buses, and flew home from Los Angeles. It was, all things considered, a fairly busy year, but when I look at the record it seems to me that all I did was race.

In 1981 I took part in forty races, including five marathons and adding up to 374.5 miles.

One of the first things I did after returning from London was sign up for the Madrid Marathon. New York Road Runners was offering a package tour, including airfare, a week in a downtown hotel, and race

registration. I entered, and took along my daughter Jill, who would turn eighteen a week or two after the race. There were eight or ten other members of the New York contingent, including two elite runners, Gillian Adams and Odis Sanders, whose entries were sponsored by NYRR.

I managed to fit in seven races between London and Madrid. I walked four of them and, because my knee seemed to have recovered, ran three. Walking, after all, was something I'd embraced out of need, and if the need no longer existed, why not run? It was certainly faster, by around three minutes a mile in a short race.

In Madrid I trained some in the Retiro, a well-landscaped park that smelled uncannily like a cat box. Jill, who'd run a few races in Central Park, had thought she might try running the marathon, but decided watching it was enough of a challenge, so Sunday morning she remained a spectator while I lined up with the other entrants.

My keenest memory of the race was the utter bafflement of the few Madrileños who actually got a glimpse of it. Madrid is a city where the bulk of the population sits down to dinner around midnight before partying until four or five in the morning. Consequently we ran through empty streets, lined not with crowds of cheering spectators but with essentially empty sidewalks.

Now and then there'd be a few people on a corner wait-
ing for the light to change, but all they did was stare at
us. This was the fourth year of the Madrid Marathon,
but it hadn't yet caught on with the general public, and
you could see these folks didn't have a clue what we
were doing, or why we were doing it.

That was okay with me. I wasn't really any more
interested in them than they were in me. I ran past
some imposing public buildings, but I didn't care about
them, either. I just kept on running, and then my knee
started to hurt.

So I ran for as long as I could, and somewhere around
the sixteen-mile mark (though it would have been posted
in kilometers) I switched to racewalking and wrapped
up the final ten miles that way. My time was 4:43:23,
which was thirty-nine minutes faster than London, but
you couldn't really compare the two times because one
was pure walking and the other was a run-walk mix.
Still, it was a faster time than I'd had before, and a second
marathon completed, and I felt good about it.

Gillian and Odis were the marathon's two winners,
which was no huge surprise; they were the event's
world-class entrants, and fulfilled expectations. We all
celebrated their victory and our collective triumph, and
then Jill and I treated ourselves to two days in Barcelona
before flying back to New York.

On May 31, I took the subway to Queens and ran a 10K race in Forest Park. Then I went home and packed my suitcase, and shortly after midnight I showed up at the main post office at Eighth Avenue and Thirty-fourth Street and dropped an envelope in the slot. It contained my entry for the New York City Marathon, which had to be postmarked on or after June 1. Entry was by lottery, and having the earliest June postmark didn't do anything to assure acceptance, but as soon as I mailed my application I was free to leave town.

I went directly from the post office to the Greyhound station, sat on a bench for two hours, and then boarded a bus for Columbus, Ohio.

I'd been living with a woman since the fall of 1977, and after three and a half years it was pretty clear that we were done with each other. In New York City, however, it's easy to postpone the final break in a relationship, especially when there's a rent-stabilized apartment involved. A kind of inertia comes into play, with each party perfectly willing to have the other move out, but neither much inclined to move on one's own.

That spring we received a notice that our building was going co-op, and that we would have the opportunity to either buy our apartment or stay on as statutory tenants. I couldn't afford to buy anything, and it seemed like the

right time to make a break, so we agreed that she would stay on in the apartment while I would leave my worldly goods there until the fall, when I would remove them to whatever new lodgings I'd manage to find.

As of the first of June, I'd no longer have a place to live, or rent to pay. Nor would I have any pressing reason to hunt for a new apartment for the next three months or so. What a perfect opportunity, then, to go see something of the country—and, while I was at it, run across as much of it as possible.

Running Times was quick to assure me that there were races every weekend all over America, including those parts of it I'd not yet managed to visit. I didn't have a car, but neither did I need one. I was perfectly happy to leave the driving to Greyhound, as their commercials suggested I do, and I even used the line in a song:

I'll leave my Smith-Corona
With the fellow who repaired it
I'll leave my Village apartment
To the woman who shared it
I'll leave the keys in the mailbox
Where they'll be easy to find
I'll leave the driving to Greyhound
I'll leave New York behind.
I'm leaving

On a bus heading west
What doesn't fit in my knapsack
I'll leave with the rest
I'll leave my shirts and collars
And all of the ties that bind
I'll leave the driving to Greyhound
I'll leave New York behind.

The song was one of four I contributed to a revue called *Applesauce,* and together they earned me $58 the following year when the show had a string of off-off-Broadway performances. But I wrote it without dreams of wealth or glory. It was, like all my songs, just something to sing to myself, off-key and out of tune, while I rode around the country.

Aside from Alaska and Hawaii, both of them off Greyhound's route, there were four states I'd managed to miss over the years—Iowa, North Dakota, Montana, and Idaho. I sat down with *Running Times* and a map and worked things out, and once I'd mailed in my marathon application, I was on my way.

My first bus took me to Columbus, Ohio, where I fit in a run before boarding a connecting bus to Chicago. I got a room at the Y and ran an 8.9-mile race in Lincoln Park. (For some reason I ate nothing but fruit for the week before the race, and this particular

nutritional experiment turned out to be a disaster; I ran utterly out of gas during the race, and realized afterward I'd probably been perilously close to collapse.) My time running was no better than I might have managed on a good day racewalking, 1:35, and I was lucky to finish at all. (On the other hand, that's my PR for the distance, and will likely remain so until another 8.9-mile race comes along.)

I went from Chicago to Iowa City, where I stayed a few days in some sort of hostel. I met a fellow there around my age who was also working things out after a relationship had failed. "These things take time," he said. "You can't rush them. I'm not ready to get back into things yet, but I can tell I'm making real progress." And when exactly had his relationship fallen apart? A little over five years ago, he said, and my heart sank.

I hitchhiked to Des Moines, where I stayed overnight with my old friend Ken Bressett. In 1964 he'd hired me as an editor in the coin supply division at Western Publishing, and I spent an enjoyable year and a half in Racine, Wisconsin, until it dawned on me that I had other things I'd rather do in my life. Now, seventeen years later, Ken had relocated to Des Moines, where he was working for a major coin dealer, and he surprised me with a job offer. That was heartening, but there

were still other things I'd rather do with my life, and after breakfast I went to the bus station to do them.

My next stop was Fort Dodge, where I ran a five-mile race, then caught a bus to Sioux City. I tried for a room at the Y but the front desk was closed, and a fellow outside pointed me toward the downtown hotels. "But you don't want the Swan or the Bus," he said, "because there's nothing but drunken Indians there." I went straight to the Hotel Swan, and when they proved to be full I tried the Bus Hotel, where my room cost me $6 for the night. If there were any Indians there, they must have already been passed out. I didn't see them, or anybody else, and in the morning I went out for a look at the Missouri River and then got on a bus to South Dakota.

I stayed a couple of days in Brookings, spent a memorable afternoon with the Harvey Dunn paintings in the South Dakota State collection, then thumbed a couple of rides to Clark, where their centennial celebration was to include a 10K race. The little town was packed, every living graduate of the local high school had evidently returned for the occasion, and there were no rooms to be had. I slept the night before the race on the big lawn in the center of town, and still turned in a decent performance in the race.

A few years later I got to know Harold Adams, a Minneapolis resident who wrote a fine series of mys-

tery novels set in Clark in the 1930's (although he called it something else in the books). I mentioned my own connection to Clark, and later on he reported that he'd checked, and the locals still remembered me.

"There were hundreds of people there," I said, "and I didn't do anything remarkable. Why would they remember me?"

"Well," he said, "as far as they could make out, you were the only person there who showed up for no discernible reason."

My next stop, for no discernible reason, was Fargo, where I managed to find a room for $7 a night—or $20 a week. Years later I read a scrap of Internet flotsam that told of some poor fool who'd subsisted on a diet of nothing but beans and cabbage; he lived in a room without windows, and allegedly farted himself to death. The Snopes Urban Legends site assures me that this never happened, but when I read it all I could think of was my room in Fargo. It was tiny, and it didn't have a window, and a person wouldn't need too much in the way of beans and cabbage to replace all the room's oxygen with methane.

Windows or no windows, I couldn't resist a bargain, and took the room for a week. I stayed for five days, and spent most of each day on the streets of Fargo,

preparing myself for the upcoming marathon an hour or two north of there in Grand Forks. I ran through attractive residential neighborhoods for as long as I could, then went back to my bargain paradise and rested up.

The North Dakota Marathon was to be my long race that summer. All I knew about North Dakota was that it was flat, and I figured that made it the perfect place to run a marathon. The course turned out to be as flat as I could possibly have hoped. It was an out-and-back race; we ran out on a two-lane blacktop highway for around ten miles, turned left and kept going to the 13.1-mile halfway point, then turned around and retraced our steps to the finish. Every last bit of it was straight as a die and flat as a fritter. There may have been a wind blowing, there almost always is in that part of the country, but I can't say I remember it. Nor do I recall anything you could classify as scenery, beyond the endless fields filled with what must have been amber waves of grain. (No purple mountains' majesty, however, not even off in the distance.)

While I'm sure many runners would decry the course as monotonous, I was too busy running it to miss uphills and downhills and glorious vistas—or cheering spectators, for that matter. I was able to run for twenty miles before my knee forced me to change my gait, whereupon I switched to racewalking and pushed

through the remaining six miles. My time was my best yet, 4:26:23, seventeen minutes faster than Madrid and fifty-six minutes better than London.

I went straight from the finish line to the local Y, where shower facilities were made available to marathoners, and from there to the bus station; I just had time for a meal before boarding a bus to Fargo, where I switched to another heading west. I positioned myself so that my legs were as comfortable as possible, and I looked out the window at a huge purple cigar-shaped cloud that I remember more vividly than anything about the race itself. I watched it until darkness rendered it invisible, and then I fell asleep and didn't wake up until we rolled into Billings, Montana, early the next morning.

Iowa, North Dakota, Montana. I'd now been to three of my four missing states, and had only Idaho to go. I took a room at the Hotel Nevada and trained for three days on the roads north of Billings, in the shadow of the rimrocks. I went to Great Falls, where the race listed in *Running Times* turned out to have been canceled. From there I went to Missoula, and that's where I spent the Fourth of July, with some new friends who invited me to a picnic.

I checked off Idaho without quite setting foot in it; my bus passed through the panhandle, on a trip that

ultimately let me off in Coos Bay, Oregon. I ran a 4.8-mile race there, spent a couple of nights on a mattress on the floor of a Presbyterian church there—it was listed as a youth hostel, but what it was, really, was a floor—and then switched to a $25-a-week room downtown. This one had windows, and was actually quite spacious.

I toured a sawmill in nearby North Bend, then rode a bus to Cottage Grove, where they were hosting the Bohemian Mining Days Half-Marathon. I signed up for it, and when I asked about budget accommodations, the race director and his wife insisted I stay at their house. I did, and ran in an absolutely idyllic race the next morning. It was cool, with a misty runner's rain falling intermittently, and the course was point-to-point and perceptibly downhill, and it was a pleasure from the start to the finish, and I notched 1:54:46 for 13.1 miles. Afterward I got to talking with another runner, and he turned out to be from Coos Bay and on his way home, and I got a ride with him.

What a perfect weekend.

And so on.

In Great Falls, I'd come close to teaming up with another fellow and continuing my trip in a car. We'd met on the bus to Great Falls, and bumped into each

other a couple of times in the few days I spent in that town. (While the race had been canceled, they had a wonderful rubberized track in a public park, an ideal running surface.) I forget what had brought my new friend to Great Falls, but it hadn't been the promise of a footrace, and whatever it was proved insufficient to hold him. He was ready to head west, and wanted me to join him.

In a car. He went shopping and bought one and showed it to me with pride. It was his idea that we would split the driving and share the expenses and see something of the country together. The idea was not entirely without appeal, and in the end there were just two things that stopped me.

First was the car. It looked okay, and the engine sounded all right to my untrained ear, but it was hard to overlook the fact that the door on the passenger side was held shut by a few loops of wire. It wasn't hard to imagine scenarios in which that could prove problematic.

That was the bad thing about the car. The good thing was that it was equipped with automatic transmission, which would come in handy during my friend's stints behind the wheel. Because, see, he had only one arm.

That I gave serious consideration to climbing into this rolling death trap tells me more about my state of

mind than I'd prefer to know. And how could I disappoint my new friend? Suppose, like that brave chap in the Iowa City youth hostel, it wound up taking him five years to get over it?

In the end, though, I found a way to break the news to him that I'd go on leaving the driving to Greyhound.

In Coos Bay, I found myself considering not a car but a bicycle. I had encountered cyclists in the hostel there, catching a few hours of sack time on the floor before resuming their two-wheeled journey south. It seemed I was on the very route favored by bicyclists seeking to cross the country north to south, the direction of choice because of the net decline in elevation. I wouldn't start at Washington's border with British Columbia, nor would I keep going all the way to Tijuana, but I was on Route 101 already anyway, so why not hop on a bicycle and share the route?

A couple of things helped dissuade me from this course. One was the appearance of the cyclists—the ones I met at the hostel, and those I saw zipping by on the highway. They all looked exhausted, and if they were having a good time they were careful not to let it show.

It struck me, too, that it wouldn't be all that relaxing to have a constant stream of cars and trucks coming up behind me. Bicycles, unlike pedestrians, were required

to go with the flow of traffic, keeping on or near the shoulder and relying on motorized traffic to avoid running them down. I wasn't that happy with the thought of trusting the good judgment and quick reflexes of a driver I couldn't even see. Suppose he was drunk, or wired on amphetamines? Hell, suppose the poor sonofabitch only had one arm?

If I went ahead, though, I'd have to buy a bike. And that brought to mind the last time I'd done so.

It was back in the early spring of 1967, and I was in Ireland. I'd been married, and living in New Brunswick, New Jersey, and the marriage was starting to fall apart, so I flew to Dublin to Think Things Over. (Does a subtle pattern begin to emerge? Oh, shut up.)

I spent a month in Dublin, finishing a book I'd brought with me. (My third book about Evan Tanner, it was set in Eastern Europe, with a pivotal sequence taking place in Latvia, and in a bookstore on O'Connell Street I managed to buy a copy of *Teach Yourself Latvian*. The bookseller must have been astonished to see that one walk out of his store.) I lived and worked in a bed-and-breakfast in Amiens Street, where I learned as much about chilblains as I did about the Latvian language, and then I left Dublin with the intention of getting to West Cork and Kerry.

I hitchhiked, with very poor results; just a week or so earlier a hitchhiker had pulled a knife on a motorist and forced him to drive out of his way, and that was enough to constitute front-page news in Ireland. So for a week or two drivers were stifling their more generous impulses, and it took me forever to get to Wexford Town, where I bought a bicycle.

What a mistake that turned out to be. There wasn't a level patch of highway anywhere around, and I was always either walking the bike up a hill or clinging to it, terrified, as it sped downhill out of control. I was lumbered with a heavy backpack, which didn't help, and the skies, while all of this was going on, were dealing out a seemingly inexhaustible supply of rain.

I did this for a few days, and wound up in Enniscorthy, a nice enough village but one whose charms wore thin by the third day. The only thing that kept me there was a reluctance to get back on the bike. I tried to sell it to my landlady, whose son greatly admired it, but she was canny enough to wait me out, and finally I told her she could have it outright in exchange for the lodging debt I'd already incurred. She agreed, and I left there feeling I'd pulled a fast one.

And here I was actually contemplating the purchase of another bicycle. Coastal Oregon wasn't as hilly as County Wexford, but neither was it as pancake-flat as

the North Dakota Marathon. Nor was its climate anything you could label Saharan. Rain, when it came, was never a great surprise.

Buy a bike? No, I don't think so.

I wonder why it never occurred to me to walk.

Not in races, I was doing fine running them, and in the shorter ones I could get from the start to the finish without hearing from my knee. But why, when I had reached a point where risking my life on a bicycle in highway traffic, or with the one-armed man from *The Fugitive*, seemed like a viable alternative to Greyhound, did I never even consider the notion of getting from one place to another on foot?

You'd think I might have tried it for a day or two. Looking back, I can't imagine I'd have walked from Coos Bay all the way to San Francisco, let alone Los Angeles. But I might have walked to Bandon, a coastal village twenty miles or so south of Coos Bay. I had to stop there to pick up my mail, and it would have been no great challenge to spend a day walking there. If I liked it, I could walk some more the next day, and the day after that.

But it never even entered my mind. When I left Coos Bay it was on a bus, and when I left Bandon a day or two later it was on another bus.

. . .

I spent a week or so in San Francisco; my cousin Jeffrey, who was living north of the city in Santa Rosa, kept a pied-à-terre on the edge of the Tenderloin, and he let me stay there. It was a chance for me to find out what Mark Twain meant when he said the coldest winter he'd ever spent was a summer in San Francisco.

I kept warm by running in the Gay Run, a 5K race in Golden Gate Park, and the souvenir orange tank top would become a treasured possession, albeit one I couldn't wear just anywhere. A couple of days later I got on another bus and got off in Los Angeles.

I participated in one race while I was in L.A., another 5K, this one in aid of St. Joseph's Medical Center. I'd notched a time of 23:51 in San Francisco, and trimmed that to 23:50 in L.A. I figured I'd stay a week or so—I had friends to visit in the area—and then I'd head east.

The idea of another three thousand miles on buses was not very appealing. I didn't want the ordeal of a nonstop bus ride across the continent, nor did I feel like breaking it up and taking two or three weeks to get back to New York. I'd been traveling a long time, and I was ready to be home. What I really wanted to do was fly, but I couldn't really afford the airfare.

And then a friend of mine, a film and TV writer, popped up with a proposition. He'd managed to take on more work than he could get done on time, and proposed that he hire me to write the first draft of a made-for-television film. It was a project he was pretty sure wouldn't get greenlighted anyway, and he'd get paid for delivering the first draft, even as I'd get paid for delivering it to him. He'd be guilty of a gross infraction of Writers Guild's work rules, but I wasn't a member, so that wasn't really a problem for me. And, as long as we both kept our mouths shut, it wouldn't be a problem for him, either.

So I took a suite for two weeks at the Magic Hotel, where I'd lived for six months on an earlier sojourn in L.A., and I hammered out the screenplay, and got paid enough so that I could forget about Greyhound and fly back to New York, with enough money left over to find myself a place to live.

12

The apartment I found was on Jane Street, in the basement of a back house—i.e., a house situated immediately behind another house that actually fronted on the street. You had to go through a narrow little passage to get to it, and then you went down a flight of steps, and then you were there, and God help you. It was as Bohemian and romantic as any dewy-eyed arrival from Oshkosh could possibly have wanted, and it was dark and smelled of mold and mildew, and it managed to make me nostalgic for that windowless $20-a-week palace I'd had in Fargo.

I stuck it out for two months there, then moved in with a girlfriend in Washington Heights. I entered four NYRR races, the 10K New Harlem I'd run back in 1979 and a trip of five-milers, two in Queens and one

in Central Park. My times in the five-mile races were remarkably consistent, ranging from 39:22 to 39:50.

When I wasn't racing, or working on a book, I was in the park bordering the Hudson, running down to Seventy-second Street and back. Because one of the first things I'd found out on returning to New York was that my 1981 New York Marathon entry had been accepted, and on the last Sunday in October I'd be participating in my fourth marathon of the year.

The course then was essentially the same as it is now, with the start on the Staten Island side of the Verrazano Bridge. I started out running, and I was still running at the halfway point, in the Greenpoint section of Brooklyn, when I heard my name called and looked up to see Pat Trese and his girlfriend of the moment; he had once again showed up to cheer me on.

My knee would have been hurting by then, but not enough yet to make me change my gait. I'm not sure just when I switched to racewalking, but it seems to me I must have made the switch around fifteen or sixteen miles, shortly before crossing the Queensboro Bridge into Manhattan. I walked the rest of the way, except for the last hundred yards, when I forced myself into a run—not to get to the finish line faster, but to keep any of the scorers from listing me as a walker. The marathon had a special division for walkers, with prizes awarded;

my time of 4:39:38 wasn't anywhere near good enough to put me in contention for a prize, but I didn't want to leave anything to chance.

4:39:38.

My time was four minutes faster than Madrid, thirteen minutes slower than North Dakota. You couldn't really compare one performance with another, New York was certainly a much more difficult course than Grand Forks, but it was even harder for me to compare the three races because the most important element, it seemed to me, was how much running I was able to do. The more I ran, the less time it took me to cover the distance.

It seemed unlikely that I'd ever be able to run the entire 26.2 miles of a marathon. I could run shorter races—sometimes with pain, sometimes without—but sooner or later in the course of a marathon my knee would announce that it was having no more of this, thanks all the same. The more I pushed it, the more I was risking doing lasting damage.

Nowadays a whole host of marathoners combine walking and running, and one running maven, Jeff Galloway, prescribes a regular routine of walking breaks, not only to enable new runners to reach the finish line of a marathon, but as a way for more

experienced runners to increase their overall speed. He swears it works, and there are plenty of run/walk racers who swear by Galloway, while other runners and walkers swear at him, irritated by all those Galloweenies who rush to edge in front of them only to switch abruptly to a walk.

Back in 1981, though, it seemed to me that one was either a walker or a runner. Walking breaks had got me around Washington Square at the beginning, but the day I knew I was a runner was the day I didn't have to take them anymore.

So what was I now? If I was a runner, I ought to be able to run the whole race. And if I couldn't, then maybe I ought to *walk* the whole race.

I had one more marathon on my schedule for the year. It was the Jersey Shore Marathon, coming up on the first Sunday in December. I thought about it, and I decided to walk it. All of it, start to finish, and I wouldn't even cheat and run fifty yards across an intersection, as I'd been forced to do in London.

The course, from what I'd read, was not appreciably hillier than the one in North Dakota, and the weather figured to be ideal for racing. There was only one problem. I was going to have to finish in under five hours.

See, that was the cutoff time if you wanted a jacket.

Virtually every race gave you a T-shirt, and all you generally had to do to get one was enter. They handed it to you when you picked up your number, and nobody cared if you finished the race, or even started it.

But Jersey Shore gave out these jackets. Windbreakers, I guess you'd call them, and they were pretty nice, handsome blue jackets of some sort of shiny material, with the race logo on it. I'd seen people wearing last year's jackets, and of course I wanted one.

But they gave them to you when you finished, and you had to do so in under five hours to qualify. (It has since occurred to me that this was probably not the strict requirement it seemed at the time, that the reasoning was that the finish line might shut down at the five-hour mark, or not long after it, and that they thus couldn't *guarantee* you a jacket if you didn't make it home under the wire. If they were still hanging out at the finish line fifteen minutes past the hour, and if some poor bastard came limping across the line, and they still had jackets left, do you suppose they'd tell him he was out of luck? Probably not—but all I knew back then was that I damn well had to make it in five hours if I was going to get that fucking jacket.)

Well, how hard could that be? I'd done four marathons already, and three of them had beaten that five-hour cutoff with plenty of time to spare.

But I ran more than half of each of those races. And the one marathon I'd walked, in London, I'd gone over the five-hour mark by almost a full minute per mile.

This wasn't going to be a walk on the beach.

In order to qualify for the jacket, I'd have to walk the Jersey Shore at a pace a little faster than 11:30 per mile. Did I have a shot at it?

A week after the New York Marathon, I entered an 8K Halloween race in Central Park. It was the same race I'd run the previous year, in 46:50, and this time I walked it in 55:47. Eight kilometers is about as close as you can get to five miles, so my pace was roughly 11:10 minutes per mile, which would bring me across the Jersey finish line with a few minutes to spare.

But that assumed I could sustain my five-mile pace for a whole marathon. The thing about a marathon is that it's long enough for its sheer distance to be a factor. I wasn't worried about hitting the wall. Unless you're an elite runner, stacking up five-minute miles, there's no wall out there for you to hit; that only happens to runners who move fast enough to deplete their glycogen stores, while the rest of us are burning a certain amount of stored fat in our less highly tuned engines. But you don't have to hit a wall to slow down some over the course of that long a race.

The longest race I'd walked start to finish was the Mike Hannon Memorial, that twenty-mile effort that had been my first race as a walker. My time of 4:09 worked out to a little over twelve minutes a mile, a pace that would get me across the finish line twenty minutes too late for a jacket.

Hmmm.

Well, that had been my first race as a walker. A month later I'd walked from Coney Island to Prospect Park in the Brooklyn Half-Marathon, and my time had been a brisk 2:22:25. I didn't have to calculate the pace; all I had to do was double the time, and I'd knock off the marathon in 4:44:50.

Suddenly it was all looking very achievable. On the other hand, my best time running a half marathon was 1:54 in Oregon, and did that mean I could run a full marathon in under four hours?

Not too likely. What it boiled down to, really, was that I didn't know how long it would take me to walk the marathon, and wouldn't know until I did it. I'd have to push all the way, I'd have to maintain for the entire distance a pace not much slower than I could manage in a short race. All I could do was try, and five hours after the race began I'd find out whether or not it worked.

I had two more races coming up before the Jersey Shore, a 10K in Buffalo's Delaware Park and a five-mile

Turkey Trot Thanksgiving weekend in Washington, D.C. Most of my training all that month consisted of racewalking along the Hudson, but I ran in both of those races, and in the Turkey Trot my time was 39:05. That was the fastest I'd ever run at that distance.

And it was a mark that would stand up. Because, as it turned out, it was my final race as a runner.

Right up to the start of the Jersey Shore Marathon, I wasn't entirely sure whether I'd run or walk. Common sense suggested that I play it safe. If I started out with ten or twelve miles of running, I could pretty much guarantee that I'd go home with a jacket. I'd been well under five hours in my last three marathons, and I could expect to do as well in this one.

First things first, I told myself. *Just do what you have to do to get the jacket. There will be other marathons, other chances to prove yourself as a walker.*

But I wanted to walk this race, wanted to respond to the challenge. Because that's what it was—a challenge, a test. How could I fail to accept it?

So I took a bus to Red Bank, spent the night at a hotel, showed up at the start the next morning, and set out walking. I don't remember much about the race. I pushed hard from the beginning, and there was a point where it seemed to me that I had a shot at finishing in

under five hours, but it was never a foregone conclusion. I was under two and a half hours at the 13.1-mile point, but not by much.

I didn't get faster toward the end of the race, but I didn't get all that much slower, either. There were a few other walkers in the race, some of whom I recognized from Central Park, and one thing I remember vividly is passing one of them—a faster, stronger racewalker than I—with two or three miles to go. He gave me a wave and a thumbs-up, and I passed him and kept going and began to think I was actually going to make it.

I did, with an official time of 4:53:28. They handed me a jacket, and I put it on and took a bus back to the city.

I wonder whatever happened to that jacket. I don't think I wore it more than three or four times over the years, but I liked having it, even during all those years when the only walking I did was down to the corner to mail a letter.

Now and then I'd come across it in a closet, and I'd recall the circumstances of earning it, the urgent push to the finish line, the sense of triumph that came of having done what I'd set out to do. So of course I kept the jacket, and I'm sure I own it now, although I'm damned if I know where it is.

. . .

It was around this time that I first became aware of the twenty-four-hour race.

I was beginning to realize that there were longer races than marathons, and that some runners actually put themselves through events of fifty or a hundred kilometers or fifty or a hundred miles. That seemed crazy to me, but no crazier than a marathon had seemed to me not all that long ago.

And then I read about a twenty-four-hour race, and how walkers who completed a hundred miles or more within twenty-four hours could achieve recognition as Centurions. Such a race, I learned, was held annually on a quarter-mile oval track. You circled it four hundred times and the prize was yours.

That prize, the article went on to report, was apt to go to an older competitor. Youth seemed to be less and less of a factor the greater the distance raced, with marathons frequently won by runners who'd be too old for top honors in a shorter race. This was even more pronounced in ultras, and the racewalker who then held the U.S. record in the twenty-four-hour event had taken up the sport in his late fifties, and was over sixty at the time of his record-setting performance.

In fact, the writer suggested, a younger person might be at a considerable psychological disadvantage. When you're twenty years old, and when you've walked ten times around a track and realize you have 390 laps to go, it's only natural to say the hell with it and figure you can always try again next year. But when you're past sixty, you realize you've got a limited number of next years, and you're by no means getting stronger by the minute. So you're that much more inclined to stay with it while you've still got the chance.

It was appealing, I must say. I wasn't fast and I wasn't strong, but I did seem to be reasonably good at finishing what I set out to do. You'd have to average a little better than fifteen minutes a mile to cover the distance in the allotted time, and my cruising pace in marathons was a good deal faster than that. Of course this meant doing three marathons and most of a fourth, one right after the other, and somewhere in the course of doing all that, some alarmist might see fit to rush me to the hospital. But if I started training now, and built up the miles slowly but surely. . .

Well, I didn't start training for a Centurion event. I figured I had plenty of time before I hit sixty. But you'd think, wouldn't you, that my performance in the Jersey

Shore race would have had me racing more than ever in the months that followed.

That's not what happened. I did fit in a ten-mile race in Central Park later that month, and racewalked it, but in 1982 I didn't enter a single race until the middle of June. I managed two races in July, three in August, and three in October, racewalking all of them—and I didn't participate in a single race after that for over twenty years.

It's funny, really, the way things happen, and the way they don't. I'd done five marathons in the course of a year, and had ended on a high note, and I certainly expected to do as many marathons in 1982, if not more.

One thing I did, not long after the first of the year, was move from Washington Heights to Greenpoint. The apartment I found, a fourth-floor railroad flat, was on Manhattan Avenue, just a little ways past the midpoint of the New York City Marathon. I'd taken note of Greenpoint while running through it, and was impressed enough to choose it for the secret residence of Matthew Scudder's client in *Eight Million Ways to Die,* and that's where I looked when I decided to get a place of my own.

I liked living in Greenpoint. It's become very trendy since then, though it doesn't look all that different.

While I was living there, I found the dated feel of the neighborhood very appealing. It was situated, I told friends, in a different time zone from the rest of the city. "When it's eight-thirty in Manhattan," I explained, "it's 1948 in Greenpoint."

It was an easy place to live, and it should have been a good place to train. McCarren Park was five or ten minutes from my apartment, and the oval asphalt path was ideal for racewalking.

Or it would have been, if it weren't for the goddam kids.

There was a high school on Bedford Avenue across from the park, where a few hundred of Brooklyn's finest young men were presumably engaged in studying auto or aviation mechanics. I could see where a knowledge of auto mechanics would come in handy when the little bastards went into business as car thieves and chop shop bandits, but the airplane portion of the curriculum struck me as impractical.

Evidently it struck some of them the same way, because a substantial portion of the student body spent much of their time outdoors, in or around the park. And they seemed to believe—not, I grant you, without some justification—that a middle-aged man racewalking was as funny a sight as you could see this side of the Cartoon Network.

I was sustained by the notion that, if you ignore people who are jeering at you, sooner or later they'll stop. They, on the other hand, had figured out that if you make sport of some poor bastard long enough, sooner or later he'll give up and go home—and the longer he lasts, the more amusement he'll provide.

I'll tell you, it took a lot of the joy out of my training.

Still, I could have managed. If it had been important to me, I could have found a way to get the miles in.

I joined the Greenpoint YMCA, just a block or two from my apartment, and went there a couple of times a week to work out with weights. I stopped using the sauna when some of the junior members discovered the lasting impact they could achieve by pissing on the hot rocks. It was enough to keep a person out of the sauna—and, before too long, out of the Y altogether.

They may have had a treadmill at the Y. I don't recall one, and at the time cardiovascular equipment was by no means standard in neighborhood gyms. If they'd had one I doubt I'd have used it. Running and racewalking, as far as I was concerned, were things you did outside.

If you did them at all.

And it was becoming increasingly easy not to bother. The conventional wisdom held that running

was addictive, but it seemed to me that not running was a good deal more addictive. It was an easy habit to acquire, and a hard one to break.

And so it wasn't until June that I finally entered a race, and in October the 8K Halloween race was my ninth and last of the year. I walked all nine races, and my record book shows that I averaged eleven-minute miles. There were three four-mile events, a couple of 10Ks, and one half marathon. (There was also a six-mile race held right in Greenpoint, and my time of 1:04:03 would be more impressive but for the fact that the course measurement was off by a substantial distance.)

There was a five-mile race in Central Park on October 17; they called it a Computer Run, because they used the occasion to test the computerized scoring system that would be in use a week later at the NYC Marathon. I never even tried to register for the marathon, never even considered it, and I'm sure I wouldn't have had the training base for it. A week later was the Halloween 8K, and my time was a little over two minutes slower than the previous year, so a year of light training hadn't cost me all that much. I could still do this.

But I didn't, not for more than twenty-two years.

In July of 1982, I started spending time with a woman I'd met the previous fall, shortly after my return from California. We'd become friendly, but we were both involved with other people at the time; by July we had both found our way out of those relationships, and discovered one another.

One thing that was clear to both of us was that we were not interested in a relationship. Yeah, right. The following February we became engaged—engaged!—and in October of 1983 we were married, and we've been remarkably happy ever since.

It's tempting to make the case that I'd taken up running (and eventually walking) out of discontent with my circumstances. Any dimestore Freud could nod sagely at my odyssey in the summer of '81, stroke his

beard, and pontificate: *Ah, so. And what were you running away <u>from</u>, eh?* And then, he'd point out, once Lynne and I began keeping company, I no longer had to run away from anything, and so I stopped.

Well, maybe. It's hard to argue the point, but it seems to me there were other factors operating.

One was a matter of overload. I'd done far too much running and walking in 1981—forty races, for God's sake, and five of them full marathons. I was tired of it, mentally and emotionally, certainly, and very likely physically as well.

Just as important, I had a lot more demands on my time. Besides my writing workload, which picked up around then, I developed an interactive writing seminar, and for a couple of years Lynne and I were in the seminar business, flying around the country every weekend. (We called the seminar *Write For Your Life,* and what a mistake that turned out to be; a surprising number of venues thought it had something to do, pro or con, with abortion, and didn't want to have anything to do with us.) The seminar was enormously satisfying in every respect but financially—I think the return on our time amounted to something like fifty cents an hour—and we put a lot of time and effort into it for about three years.

Meanwhile, in the summer of 1985, we gave up our apartment in New York and moved to Florida. We

bought a house right on the Gulf, and the first day I took a walk on the beach, heading north. The next day I did the same thing but headed in the opposite direction. The day after that I stayed home.

A couple of times during our Florida years I tried running on the beach. (Racewalking on the sand didn't really work.) But it was too hot, and I was out of shape, and it didn't take me long to abandon the enterprise. Running, or walking, or whatever you wanted to call it, seemed to be something I had embraced for a while, and something with which I was finished. Once in a while I would wear a race T-shirt and remember what I'd done to earn it. Now and then I would recall, in contemplation or conversation, that I had in fact run marathons, that I'd done five of them in the course of a single year. When I reported this to acquaintances, they seemed impressed; I was impressed as well, and a little wistful. All of that was a part of the past now, as impossible to recapture as any of the rest of it, and all of it, as the song had it, *Gone, alas, like my youth, too soon.*

I was sitting in the living room of our house in Fort Myers Beach when, out of nowhere, I envisioned a man walking eastward across America. As he walked, other people joined him.

It was the summer of 1987. We had been living in Florida for almost two years. I'd been writing regularly during that time—a book version of *Write For Your Life*, a film novelization that never got published because the publisher hadn't cleared the rights sufficiently, a collaborative nonfiction venture that didn't quite work out. I managed a couple of short stories, and I'd written the opening chapters of a couple of novels that were fated never to have second chapters, and it was past time for me to sit down and get a new novel written, and I couldn't think what to write.

On an impulse, I'd contrived to book myself into a writers' colony for the month of July. I'd never stayed at a colony before, but I'd read about them, and understood they provided room and board and a sort of communal solitude presumably conducive to creative effort. For years I'd been in the habit of going off somewhere when I was having trouble getting something written, and the Virginia Center for the Creative Arts struck me as a happier choice than a Motel 6 on the outskirts of Abilene, so I applied and was accepted. I didn't know what I'd do when I got there, but I figured it couldn't be less than I was doing at home in Florida.

Maybe I'd write a book about Bernie Rhodenbarr. I'd written five lighthearted books about the light-fingered fellow, and I really wanted to write a

sixth, but the couple of attempts I'd made in that direction had gone nowhere. I liked the notion of a story about baseball cards—somebody could collect them, and Bernie could steal them— and I'd bought a couple of books and read up on the subject, but that didn't mean I was ready to write the book, or even that there was a book to be written.

All that might come together, I decided, by the time I was settled in at VCCA. I'd be there for four weeks, and that ought to be time to get something started, if not finished. And that was all I needed, really—a good start on a book. If I managed that much, I could get the rest done back home in Florida.

Then, perhaps two weeks before I was to get started in Virginia, I got this vision of a guy walking across the country.

Over the next few days more and more of the story came to me. The fellow who started the whole thing was a bartender in Oregon, I decided—or realized, or whatever it was. And another character was a woman who was losing her eyesight. And she had a young son. And—

Bits and pieces. And, along with these folks, I sensed that there was another story line running alongside, involving a serial killer who was roaming the Midwest and murdering women. I couldn't imagine

what he had to do with this other story, or how the two plotlines might intersect, or if they even belonged on the same library shelf, let alone in the same book. But I sensed that what was happening to me was a rather extraordinary case of literary ferment, unlike anything in my prior experience, and the last thing I wanted to do was get in its way.

It was also very much evident that the book I was going to write was to be a very complicated affair, a large multiple-viewpoint novel, with a few dozen characters and a great body of incident. It would need considerable advance plotting, probably an elaborate outline, and it would be a long time before I'd be ready to write it. More than two weeks, certainly—which meant I'd better think of something else to work on at VCCA.

By the time I got in my car for the drive north, I realized I didn't have any choice. There was only one book in my mind, and it wasn't going to go away. I didn't think I could actually start writing it, but maybe I could do some of the preliminary work on it, cobble up some sort of an outline that would serve me when I got back to Florida. Toward that end I took along a Rand McNally road atlas; it would help me with the geographical research, and might also keep me from getting irretrievably lost en route to Virginia.

I took two days to drive there, with a stop in Knoxville to attend a custom-made knife show. (I bought a nice little folding knife. I wonder whatever happened to it. Maybe it's in the pocket of my Jersey Shore Marathon jacket.) On arrival at VCCA, I found my way to my dormitory room, and from there to my studio in the barn complex a quarter-mile away. I set up my typewriter, placed the road atlas to one side of it and a stack of blank paper to the other, and went to the dining room for dinner.

Come morning, I went to my studio, sat down at the typewriter, and wrote twenty pages. And I did the same thing every morning for twenty-three days, by which time I had completed a 460-page manuscript. I spent a day editing it, and another day getting it photocopied at Sweet Briar College, and then I got in the car and went home.

Writers sometimes say that a particular piece of work wrote itself, although in my experience nothing ever does. From a distance, though, *Random Walk* would seem to come close. An idea had come to me, apparently from out of nowhere, and two weeks later I'd sat down and begun writing, and three weeks and two days after that I was done. If the damn thing hadn't written itself, then who, pray tell, was responsible for it?

Well, I guess that would be me. I was the one tapping the typewriter keys, and I was the one getting to my studio early each morning and emerging ten or twelve or fifteen hours later.

Nor was it a simple matter of taking down celestial dictation. I've read about people who've "channeled" books, and for whom the writing process consisted of little more than transcribing the sentences that unreeled in their brains. (If Mozart is to be believed— and God knows he's always been reliable in the past— composition was rather like this for him. "There's nothing to it," he's supposed to have said. "All I do is write down the music I hear in my head.")

I'm not sure what channeling amounts to, for Mozart or for the woman who produced *A Course in Miracles;* I don't know whether the actual source at such times is within or outside oneself. I'll allow that my own experience had something in common with channeling, in that the initial idea came from no apparent source, and that ideas continued to come to me throughout the writing process, so that I was never at a loss for what turn in the narrative ought to happen next.

And that was no small gift. E. L. Doctorow has likened the process of writing a novel to driving at night— you can see only so far as the headlights reach, but you can get clear across the country that way. My characters,

led by that bartender from Roseburg, Oregon, were walking by day, not driving by night, but each morning I went to my studio knowing just enough about their journey to carry them along for one more day.

I didn't have an outline, of course, because I could never really see more than a day's work into the book's future. What I did have was my road atlas, and there wasn't a day that I didn't spend a substantial amount of time poring over it, working out the walkers' route, determining what turns they would take and where they would stop. My serial killer, meanwhile, was driving all around the Midwest doing his evil deeds, and I was tracing his route in the atlas as well. Much of the book's action was unfolding in places I had never been, but that didn't bother me. I wasn't entirely sure what I was writing, but I knew it wasn't a travel book.

If one were to attribute such things as will to inanimate objects, one could say that *Random Walk* had shown an overwhelming desire to be written. It had virtually insisted on it.

Alas, it proved a good deal less eager to be read.

My regular publisher, William Morrow, was willing to bring out the book, but only if I cut it severely and reshaped it beyond recognition. I didn't even consider complying, and my agent sent the book to two other

publishers, both of whom wanted to do it. We went with Tor, and I made one small change to make the editor happy, adding a crystal that gets handed around among the walkers. (I'm not convinced it was a good idea, but I can't see that it hurt anything.)

Then the book was published, whereupon it promptly vanished without a trace. No one knew what to make of it, and the line on the cover—"A New Novel for a New Age"—couldn't have helped a whole lot. Nor did the cover art, which made the thing look like science fiction. Reviews tended to be negative, to the extent that the book got reviewed at all. Few copies found their way onto bookstore shelves, and fewer still found their way off those shelves.

A year or so after its hardcover publication, *Random Walk* had a second life in paperback—and that didn't work, either. This time the cover managed to make the book look like some epic novel of the westward migration. Somehow prospective purchasers managed to find it within themselves to pick up something else instead.

It's tempting to blame the publishers, and God knows I did at the time, but I don't know that anyone could have made *Random Walk* work commercially. The experience of writing it had been extraordinary, and I was happy enough with the way the book had turned out, and if its destiny was to vanish without a trace, well, I wasn't a twenty-two-year-old with a first

book. I had written a lot of books, and many of them had vanished without a trace, and so what?

Well, not entirely without a trace.

One way or another, some copies must have found their way into readers' hands. And over the years I heard from some of those readers.

"You know," someone would say at a book signing, "I've read just about everything you've written, the light books and the dark ones, and I've pretty much liked all of them, but there was one book of yours I picked up a while back that I couldn't make head or tail out of, and I can't figure out what you were getting at or why you wrote it in the first place, and—"

And I'd know right away he was talking about *Random Walk*.

Or I might hear something along these lines: "I've read all your books, and I like them all, but there was one book of yours that I've read seventeen times, and I swear it changed the way I look at the world, and my life just hasn't been the same since, and every year I read it again and get something else out of it, and—"

Random Walk.

The book went out of print quickly enough, and sometime in the mid-1990's I was given the opportunity to make it available again through iUniverse, the print-on-demand publisher. They brought it out in trade paperback format, and for a while they had a

relationship with Barnes & Noble that got the book on the store's shelves. And it remains in print, and every six months or so I get a four-figure royalty check. Two of the four figures are after the decimal point, but at least the book is out there, and every once in a while somebody buys a copy.

One of these days I probably ought to persuade HarperCollins to publish the book, in mass-market or trade format, to give it a chance to find its audience. But when the thought occurs to me, I find myself thinking of an incident in Tom Robbins's fine first novel, *Another Roadside Attraction.*

One of the book's characters is upset over the fact that the life span of the butterfly is so short. So she goes into a trance to meditate on the phenomenon, and emerges therefrom with the insight that the life span of the butterfly is precisely as it ought to be, neither too long nor too short.

And so I wonder if one might not make a similar observation about *Random Walk.* Perhaps I don't need to take any action so that the book might find its audience. Perhaps it has already found—and continues to find—as much of an audience as it deserves or requires. An audience that is neither too large nor too small, but precisely as it ought to be.

*R*andom *Walk* didn't have much impact on the world of American letters. And, notwithstanding the occasional hyperbole of the occasional fan, I don't know that it changed many lives.

But it did change mine.

It was in the weeks immediately after my return from Virginia that Lynne and I realized our Florida experiment was a failure. Fort Myers Beach was a nice enough place, and the people we met were decent folks, but it just wasn't where we belonged. We'd come, we now realized, because our life in New York had been an exhausting one; Lynne was running a demanding bookkeeping and accounting practice, I was writing books and a magazine column, and together we were flying around the country on weekends, putting on

writing seminars. We were tired out, and one weekend back in 1985 we visited my aunt and uncle in Pompano Beach, Florida, and were struck by how much more relaxed their life was than ours.

Well, no kidding. My Uncle Hi was essentially retired, working maybe fifteen hours a week. My Aunt Mim was playing a lot of golf. We looked around and decided Florida was the answer, and the next thing you knew we were living there. But not in Pompano Beach. We picked the west coast, because we'd heard it was quieter there.

Right.

Two years later, we were pretty sure we didn't want to stay. But where else would we go? Back to New York?

Maybe. But maybe not. We weren't really ready to make that decision yet.

But suppose we were to close the Fort Myers Beach house and hit the road. Suppose we tried life without a fixed address, just breezing along with the breeze. It was a fantasy we'd both had for some years, and it looked as though we were now in a position to give it a whirl.

We set about packing things up, giving some of them away and putting the rest in storage. We planned our departure for early in 1988, but still didn't know where

we'd be heading. And I picked up that road atlas, and remembered the hours I'd spent with it in Virginia.

One thing I'd noted at the time was the great profusion of towns and villages named Buffalo. Growing up in that city, I'd been aware that it was not the only Buffalo in the nation. There was one in Wyoming, I knew, and it seemed to me there was one in Texas, and perhaps there were others.

While writing *Random Walk*, I learned that there were far more Buffalos than I'd ever suspected. The atlas's index yielded quite a few, but I was soon to find out that there were far more places on the state maps than found their way into the index—and my list of Buffalos began to grow, including of course such permutations of the name as Buffalo Grove and Buffalo Gap and—eureka!—New Buffalo.

I reported all this to Lynne. "There's something like twenty of these Buffalos," I said, "and they're mostly in the western part of the country, but there's a batch in Pennsylvania and Virginia, and one in Alabama. What I was thinking, see, was when we're driving around, with no place we absolutely have to get to, well, maybe just for the hell of it we could go to some of these Buffalos."

"What a remarkably indulgent wife you have," I've been told repeatedly. "To put up with your madness,

and chase around the country after towns named Buffalo."

It is, I suppose, a natural reaction for people to have. And mine is, to be sure, a remarkably indulgent wife in any number of respects. So I nod and smile and let it go.

But here, for the record, is my remarkably indulgent wife's response to my tentative suggestion that we might, *just might,* try visiting some of those dots on the map:

"*I* think," Lynne announced, standing up very straight, and speaking in a tone that brooked no argument, "we should go to *all* of them."

Well, we certainly tried.

In the months before we left Florida, I spent some time at the library, where I happened upon what I took to calling an industrial-strength atlas. Consequently, by the time we hit the road, our list of Buffalos had grown from around twenty to just over forty.

Now, almost twenty years later, we've been to eighty-four of those towns, and know of about a dozen more.

You know, it reminds me of what they used to say about Rembrandt—that in the course of his life he produced three hundred canvases, of which four hundred are in Europe and the remaining five hundred in the

United States. The analogy holds only so far. With the paintings, the implication would seem to be that there are a lot of counterfeit Rembrandts floating around, while it seems rather unlikely that anyone is producing bogus Buffalos.

So how to explain the numbers? The answer, I've come to believe, lies not in the realm of geography at all, but in the more unsettling world of modern physics. The best I can do is to theorize that, in accordance with Heisenberg's principle, Buffalos are like subatomic particles; the mere act of looking for them causes new ones to spring into existence.

Our first Buffalo was in Alabama, and Rand McNally knew about it, so finding it was a simple matter of driving there. But it seemed to have gone out of business; there were no highway signs welcoming one, and the word BUFFALO hand-lettered on a wall was the only indication of where we were.

A local tradesman advised us that people still called the place Buffalo, and that the name had originally been Buffalo Wallow, because once upon a time there had been bison wallowing there. They were long gone, but then so was just about everything else.

We put on our Buffalo shirts—we had a batch of these, products of New Buffalo Graphics, our favorite

showing the noble animal and the civic motto, *Buffalo, City of No Illusions.* Then, suitably attired, we took Polaroid photos of each other in front of the sign on the wall, and next to a sign we found at a half-acre lot next to a general store. The sign didn't have a Buffalo reference, but what it did have was a message sternly advising one and all that the lot was a private club, restricted to members, and that trespassers would be prosecuted. It was, for God's sake, a vacant lot, sprouting rank weeds and strewn with trash. Who would want to trespass? Who would care to be a member? And what was the point of the sign?

"It's to keep out the Jews," Lynne said.

Buffalo, Mississippi, was our second conquest. And it began to give us an indication of what lay ahead of us. Because it wasn't on any of the maps, and it hadn't shown up in any of the volumes I consulted, not even the industrial-strength atlas. In all the years since then, I've never seen a reference to the place anywhere. It was pure happenstance that we had any reason to look for it.

Or perhaps it was the agency of a Higher Power, operating in this instance through the medium of a CB radio. Lynne had insisted that we obtain this device, but when I was in the car I wouldn't let her turn it on,

because I couldn't stand the thing. But after we'd logged our Alabama Buffalo we had moved on to Mobile, where I hung out for a day while Lynne tended to some family business over in George County, Mississippi.

I stayed in our motel room, writing my monthly *Writer's Digest* column, and I'd just wrapped it up when she came in, telling me it was a damn good thing we'd bought the CB. "Because two truckers were talking," she said, "and one of them mentioned Buffalo, Mississippi. I didn't even know there was a Buffalo in Mississippi."

"There isn't," I said.

"Well," she said, "there is now. I got all excited, and I cut in and called 'Breaker One-Nine,' the way you do."

"The way I do?"

"The way people do. The way CBers do. I asked about Buffalo, Mississippi, and how you get to it, and one of those old boys said it's near McLain."

In the morning we drove to McLain, which is on the road to Hattiesburg. A fellow at a gas station steered us toward the road to Buffalo. "There's not much there," he said. "Why do y'all want to go there?"

Why indeed? We followed his directions, and right where it was supposed to be we found an old graveyard, with a sign proclaiming it to be the Buffalo cemetery. That was the sole indication that there'd ever been a

community here, but it was plenty. On with the Buffalo shirts, out with the Polaroid, and our Buffalo collection had doubled in size.

"That's pretty amazing," Lynne said. "How many people do you figure have ever been to Buffalo, Mississippi?"

"We're not the only ones," I said. "But all of the rest of them seem to be dead."

The Buffalos were never the point. What they did was provide the illusion of purpose for an essentially purposeless odyssey. We'd left Florida with the intention of seeing something of the country, but if that's all you've got in mind, it's impossible to decide where to go next. The Buffalo hunt was always ready to tell us whether to turn left or right. We'd just head for the nearest Buffalo, and along the way we'd probably find something interesting.

The Buffalos themselves were sometimes interesting and sometimes not. Buffalo, Mississippi, was only the first of a whole slew of ghost Buffalos, towns that had once been actual communities but had failed to thrive. Buffalo Gap, Saskatchewan, was one of these, with only a cemetery to give proof of its former existence, while others lacked any population whatsoever, living or dead.

Buffalo, Texas, was situated at an Interstate exit, which made it one of the few Buffalos with a motel where we could stay overnight. The town also boasted a really good lunch place, the Rainbow Café. And Buffalo Gap, Texas, not too far south of Abilene, was home to Judy's Gathering Place, where the food (and Judy's company) was so good it was worth a detour on another drive across Texas.

But most of these towns were just there to be checked off the list, not much more than photo ops. Some of them were right where the map said they'd be, but others proved elusive. I remember spending half a day driving around looking for Buffalo Cove, North Carolina, and I'm not sure we ever did find it; we took a picture at some cove or other, and I don't suppose anybody could prove it wasn't the right spot, and I don't suppose it matters, either.

And what did we do, while looking for Buffalo?

We drove around, and spent our nights in budget motels. The road atlas, and the prospect of one Buffalo or another, pointed us in a certain direction, and a set of Mobil travel guides let us know what diversions we might find along the way. We hit our share of national parks and monuments, including such big attractions as Yellowstone and Grand Canyon and Glacier, but also including Big Bend and Zion and Arches and Badlands

204 • LAWRENCE BLOCK

and Crater Lake. We rode mules at the Grand Canyon and horses at Zion, but at most of the parks we hiked a few miles on the trails.

The Mobil guides pointed us to some interesting places we'd never have thought to look for. I remember a morning in western Kansas when we found our way to a house that had served as a hideout for the Dalton brothers, a place to hole up between bank robberies. There was, we were given to understand, an escape tunnel leading from the house to the barn in back, but we had to take that on faith. Still, it was an interesting stop.

From there we drove south into Oklahoma, where we picked up Buffalo, Oklahoma, before heading east through Ponca City and Bartlesville. There was a museum in Bartlesville, where an oilman's collection of Western art was on display, and from there we drove north across the Kansas line once again, to Coffeyville, where a museum commemorated the day when those same Dalton brothers held up two banks at once.

It wasn't the brightest move they ever made. The law was waiting for them, and pretty much riddled them with bullets. (Emmett Dalton survived his wounds, served his time in prison, and moved to Los Angeles, where he wrote a couple of films before building a successful career in real estate. You can't make this stuff

up—but if you drive aimlessly around the country, you can find out about it.)

Coffeyville would have been well worth a detour, but none was required. Because, after we'd seen all there was to see in the museum, and mused on bank robbery as a preparation for dabbling in Hollywood real estate, we just kept on going north on U.S. 169 to Chanute, turned west on State Highway 39, and a few miles down the road we were in Buffalo, Kansas.

We spent the night in a motel in Fort Scott, Kansas, that had more houseflies than we'd ever encountered anywhere. We changed our room, and the new room was just as bad. We swatted the little devils until our arms ached, and eventually we went to sleep, and in the morning we drove across into Missouri and passed through the towns of Nevada and Bolivar on our way to, yes, Buffalo.

Funny what you remember. I can trace our route—parts of it, anyway—because I highlighted it in yellow in that road atlas. And when I do, things come back to me that I haven't thought of in years. Not those two Dalton sites, I've thought often enough of them, and Keller visited them both in *Hit Parade*. (On that same trip, Keller also managed a visit to a John Dillinger museum, in Nashville, Indiana. We went there, too,

but in a different phase of the Buffalo hunt. It wasn't when we crossed the northern part of the state to pick up Buffalo, Indiana, but on a later visit, after we'd paid a visit to Buffaloville, Indiana, a little ways east of Evansville.)

But I'd forgotten that fly-infested motel in Fort Scott, and the dim proprietor thereof, who seemed implausibly astonished to learn that our room was buzzing with them, but quick enough to offer us a flyswatter. All of that had slipped my mind, as well it might, but it came back to me as I studied the atlas and followed the yellow line toward the Missouri border.

Buffalo, Wyoming, was an obvious destination. With a population of almost four thousand, it was the largest Buffalo but for my birthplace, and one I'd been aware of since boyhood. It was large enough to offer us a choice of restaurants and motels, and after we'd eaten and slept we got back in the car and drove to Cody.

Where we stayed a week at the Hotel Irma, named for the daughter of the establishment's founder and first owner, Buffalo Bill Cody. I'd been commissioned to write a lengthy autobiographical essay for a library reference work, and a week was time enough to do it, and Cody a pleasant venue for it, with several fine museums.

After Cody we visited Yellowstone, and continued north into Montana, first on 81 and then on 191. We were on the latter road because it would take us to Buffalo, Montana, but before we got there we came to the town of Harlowton, where we visited an unassuming little museum that, all things considered, had a lot to be unassuming about.

We spent a pleasant hour there, looking at stuff. Of all the wonders we saw, only one sticks in my mind, but it may be enough to give the flavor of the place. Some soft-drink manufacturer—Pepsi, I think it was, but it may have been 7-Up—had launched a promotion a few years back featuring a different commemorative can for each of the fifty states. The idea was that you could buy the cans, drink their contents (or pour the stuff down the sewer, as you preferred), and then you could collect the empties, displaying them proudly until the day came when your mother made you throw them out.

Well, one fellow had collected all fifty, and instead of throwing them out he'd donated them to the local museum, and there they were, all fifty of the little darlings, looking for all the world like, well, like empty aluminum soft-drink cans. There was something magnificently postmodern about them: They were a wonderful sight to behold, and the wonder lay in the fact that they were there. By themselves they were nothing;

displayed as they were, they remained nothing, but nothing on a grand scale.

One could make fun of the museum in Harlowton—indeed, I seem to have done just that—but here's something to ponder. I've been to no end of museums over the years, large ones and small ones, but over time they and their contents tend to merge in memory. Or drop out of memory altogether.

Not Harlowton, Montana. I'll remember those empty cans forever.

After a peak experience of that sort, Buffalo, Montana, figured to be anticlimactic. Not so. It was a first-rate Buffalo, every bit as memorable as a row of empty cans.

It was, alas, pretty much out of business. There were still people living there, but the place they were living had largely ceased to be a town. Once, though, it had been able to support a school, and the imposing red-brick building (or red stone; red, at any rate) was still standing, although most of its windows were gone.

And the schoolyard was now given over to the grazing of sheep, and there stood the abandoned school, its front door gaping, with sheep wandering in and out of it. One had to think of Mary, and her little lamb. On with the Buffalo shirts, out with the Polaroid. *Click!*

. . .

Periodically we interrupted the Buffalo hunt to leave the trail altogether. At one point we flew to Cairo to join a group tour of Egypt, climaxing in a Nile cruise. In some English novel or other a Colonel Blimp type had complained of something he called Gyppo tummy, and by the time I got off that boat I knew what he meant.

Later that same year we combined two invitations, the first to an Italian film festival in Cattolica, the second to a Spanish crime festival in Gijón. We parked our car somewhere out west and flew first to New York and then to Milan. We got off there, and so did one of our three bags. When it became clear the others had plans of their own, we took a train and a bus and got to Cattolica, where we lived out of our remaining suitcase for a week. (Oddly, whichever one of us had done the packing had mixed things up, so our single bag contained something for each of us.)

At the week's end we flew from Milan to Madrid and carried our bag on and off the plane. In Madrid we and forty or fifty other American and British crime writers boarded the Andalusian Express, a luxurious private train that took a full day to carry us a couple hundred miles north to the industrial port city of Gijón. The ride was quite wonderful, and somewhere in the

course of it they served us lunch, and we shared a table with Don and Abby Westlake.

And Don, looking out the window at the Spanish countryside, told us about a friend of his named Jack Hitt, who had some years ago walked across all of this terrain to follow the course of an ancient pilgrimage over the Pyrenees to the city of Santiago de Compostela. There was this route, we learned, and pilgrims had walked it for over a thousand years, and they were still at it, schlepping from village to village in the sacred steps of St. Francis and St. Clare, and there were refuges for pilgrims where you could stay, and—

Lynne and I were sitting next to each other, with Don and Abby seated side by side opposite us. I remember this, because I remember that there was a point in the story where Don paused, for breath or wine or whatever, and just then Lynne and I turned as one, so that we were looking right at each other when we said, in a single breath, "We've got to do that."

15

In the first week of May 1991, Lynne and I flew from New York to Toulouse, in the south of France. We stayed overnight at a hotel, and in the morning we hoisted our backpacks and started walking south. We were on our way to Santiago de Compostela, and intended to arrive there by the 25th of July, because we knew that pilgrims ideally reached the city by that date to celebrate the Feast of St. James.

We also knew that the traditional pilgrim route led through the French border town of St. Jean Pied-de-Port and its Spanish counterpart, Roncesvalles. But we'd decided to take a different route over the Pyrenees so that we could walk through Andorra. We'd never been to Andorra, and this seemed like a perfect opportunity to add it to our list, even if there wasn't a single Buffalo in it.

And so we walked, out of Toulouse and on toward Andorra. I don't know how far we went the first day, or indeed on any of the days during that first week. We walked to a café, and got something to eat, and then we walked until we found a hotel, and took a room. And we got up the next morning and did it again.

We must have been out of our minds.

Before our Buffalo hunt, I'd spent hours in libraries, and more hours with Rand McNally. We'd be in familiar terrain, and within easy reach of friends and family.

Our preparation for the pilgrimage, in contrast, consisted of a single lunch with Jack Hitt, the fellow who'd told Don and Abby about the whole business in the first place. Jack turned out to be a splendid fellow, with a great supply of anecdotes and a fine sense of local color, but all that lunch really did was convince us to go.

And so we'd gone—without reading a single book about the pilgrimage, in modern or contemporary times, without doing a lick of research, and without undertaking any training for the physical ordeal we were about to undergo. We were living in New York now, we had moved back just over a year ago, on St. Patrick's Day in 1990, and as New Yorkers we were of course in the habit of walking a couple of miles a day,

because that's how one gets from place to place. And I'd joined a gym upon our return, and got there two or three times a week, working with weights and dutifully slogging away on the StairMaster.

Lynne assumed walking would be no problem; after all, she'd been doing it all her life. I figured it might be slow going at first, but that we'd get stronger as we went along, and would eventually be able to take the physical side of the trip in stride, so to speak.

Some long city walks during the months before our departure probably would have been a good idea. They'd have been good practice, especially if we'd worn our backpacks. But we didn't even *have* back-packs until a week or so before we set out.

We bought them in a rush one afternoon, along with a pair of sleeping bags and a tent. We took back the tent the following day, having realized it was just going to be too much to carry, and it's a good thing, because otherwise we'd have thrown it overboard sometime during the first week in France. Because, even without it, our packs were too heavy.

I don't know what they weighed. After the first day, mine was the heavier of the two, because we shifted much of the load from Lynne's backpack to mine. That was essential, because I was stronger and better able to manage the weight, and because she'd brought more

with her. We'd both kept clothing to a minimum, but she'd brought along her full complement of Erno Laszlo skin preparations, and those little jars weighed a ton.

So my backpack was the heavier of the two, but both of them were heavier than we'd have liked. The clerk at Paragon had tried to sell us aluminum-frame back-packs, and they'd struck us at the time as cumbersome; if we'd taken his advice, we'd have been better off. Our packs weren't designed to distribute the weight, and the straps cut into our shoulders.

Before long, Lynne decided her backpack was the problem. It hurt, it tired you out, it slowed you down. There was, she realized, a far better way to transport one's possessions.

"I want a shopping cart," she announced.

I had the hardest time trying to explain to her why this wasn't a good idea. It did no good to point out that people who did this sort of thing all the time always wore backpacks and never pushed shopping carts. All that meant to her was that she'd thought of something that hadn't occurred to anyone else.

A loaded shopping cart, I told her, would be very difficult to push up a hill. And it would be at least as hard to hold on to on the downhills. And it would probably lose a wheel or fall apart altogether before too long, because those things were designed to move at a

leisurely pace up and down supermarket aisles, with no surface under their tires more abrasive than a parking lot. They didn't roll up a whole lot in the way of mileage, and none of it was apt to be on dirt roads or trails, and—

But I wasn't getting anywhere. Several times a day she'd resume whining about the shopping cart.

Everything I'd told her was the truth, and what good did it do me? So I switched to fiction. Maybe a shopping cart wasn't that bad an idea, I told her, but it just didn't sit right with me. See, I'd be deeply embarrassed to be seen in the company of somebody pushing a shopping cart.

"Oh," she said. "Oh, okay."

Because once it was a question of style, she could accept it.

Nowadays I'll frequently see young parents trotting along while pushing an infant in a three-wheeled Baby Jogger. (Once, in perhaps the eighteenth hour of my first twenty-four-hour race in Wakefield, Massachusetts, I saw a woman jogging along behind a triple stroller, its three compartments filled with triplets. I'm still not entirely certain she wasn't a hallucination.)

The Baby Jogger, I've since learned, is the vehicle of choice for a good number of solitary cross-country

runners and walkers, those hardy souls who choose to cross a state or a region or the whole of America on foot, and without benefit of a support crew in a camper. The first time I saw footage of someone so engaged and so equipped, I was struck by his resourcefulness and ingenuity; then, when I'd had a chance to think about it, I realized what I'd just seen—Lynne's shopping cart, God help us, reborn in its ideal form.

Of course the folks with the Baby Joggers didn't have to deal with much in the way of hills, let alone the Pyrenees or the mountains of Galicia. And those joggers were built for the task at hand, and they weren't boxy crates last seen in a checkout line at the local Safeway.

Still, credit where it's due and all that. Maybe my bride was on to something.

The first day out of Toulouse it rained some, but after that the weather was pleasant, and the days were not without their satisfactions. Each night found us at a two- or three-star inn, and the rooms were comfortable and the meals more than acceptable. The walking gave us an appetite, and afterward we didn't have trouble sleeping.

In the morning we'd have breakfast, and then we'd reclaim our passports from the desk and set off again. One morning, after a night in a very nice inn in the town

of Foix, we omitted the reclaim-our-passports step. That was my job, and we'd walked the better part of an hour before I realized my error. I left Lynne at the side of the road, shucked my backpack, hurried back to Foix, collected the passports, and hurried back to Lynne.

She sympathized with me, having to do all that extra walking, and I told her it hadn't been so bad. It was a nuisance having to cover the same ground again, but at least I hadn't had all that weight on my back. And, before she could put in another word for shopping carts, I sympathized with her, having to stand around all that time.

"It was okay," she said. "I didn't have the backpack on, and I didn't have to walk anywhere. I could just sit in the shade. It was very pleasant, actually."

The route got worse as we went along. Because we were getting into the Pyrenees, and while they are not right up there with the Himalayas, they are nevertheless mountains, and that meant that the road we were walking was going forever uphill.

It was on a Sunday, our sixth day on the road, that the elevation became most pronounced. The terrain was steep enough that the road had been built with switchbacks, to make the angle of ascent more manageable. From a physical standpoint the switchbacks were

essential—otherwise we really would have felt as though we were climbing a mountain—but this was somewhat offset by the psychological effect; we would walk south for fifteen minutes, then turn and walk north for fifteen minutes, and it felt as though we were working very hard and getting nowhere.

It was also getting colder, because we'd gone far enough into the mountains so that there was still snow on the ground, and from time to time there'd be an avalanche off to the side. It would have been nice to stop somewhere and get something to eat, but that was never an option, because in each of the few villages we passed, everything was closed up tight. Which is why I happen to remember that it was a Sunday.

I don't know what time it was when we finally came upon an inn, but it was already getting dark. The proprietor had enough English to assure us that she did indeed have a room for us, and could provide an evening meal. And where had we parked our car? Because she hadn't heard us drive up.

We said we'd walked. She looked at us. "We've been walking all the way from Toulouse," Lynne told her, "and we're going to walk over the mountains, and then we'll walk all the way across Spain."

"Ah," said the woman, eyebrow arched. "*Très sportif.*"

. . .

Sportif indeed.

It's been sixteen years since we walked across Spain, and what strikes me now as most remarkable about the experience is not so much the physical demands of the ordeal, or the sights we saw and the people we met along the way, or even the spiritual results of such a pilgrimage, whatever they may have been. All of that somehow pales beside the astonishing fact that we dropped out of our lives entirely and spent a little over three months in total isolation. Our whole world during that stretch of time was the world of our immediate environment, the world of the Camino.

In today's world of cell phones and Internet cafés, it's hard to grasp the extent to which we were cut off from our lives back home. No one had any way of getting in touch with us, and we had made the decision before our departure that we would not even try to contact anyone. We could probably have made phone calls from several points along the way, but to what purpose? To establish that the people we'd left behind were alive and well?

If anything was wrong, there was precious little we'd be able to do about it. Even if some family emergency were to call for an abrupt return, abruptness wouldn't

come easy to a pair of pedestrians in a remote area of rural Spain. Wasn't it simpler to assume everything was all right back home?

Simpler, but by no means certain. Because the last time we'd been in Spain, we'd received a call from the States that put us on the next plane home.

Let's return to the Andalusian Express, where we first heard about the pilgrimage and knew at once that it was something we had to do. In our own minds, we had signed on for it then and there. But it took us almost three years to start walking.

In Gijón, our contingent of international crime writers spent a week as window dressing at Semana Negra, a Spanish festival with dark film and literature as its theme but simple revelry as its clear purpose. We participated in a couple of panel discussions, where we took turns bloviating on literary and political topics, with a couple of harried translators waiting to turn what we said into something the audience might possibly comprehend. This works best when one speaks in sound bites, so the translator can take in and process a couple of sentences at a time rather than have to hold long paragraphs in his mind; few of us were adept at this, however, and it wasn't hard to guess why the audience looked puzzled most of the time.

At one point Don Westlake quoted some Russian who'd observed that he and his colleagues were all mice in the pocket of Gogol's overcoat. I thought the poor translator was going to kill herself.

Lynne and I were having a fine time, dining late (though rarely by Spanish standards) at fine restaurants, with Don and Abby Westlake or Ross and Rosalie Thomas or Em and Martin Cruz Smith for company. And the week was drawing to a close, when we got word that my mother had been in a serious auto accident. (My cousin David Nathan managed somehow to track us down, a neat trick given that no one on earth knew where on earth we were.)

We flew home the following morning, with no way of knowing whether we'd find her alive or dead. She was alive, but just barely, and shortly after we got there she slipped into a coma and remained unconscious in Intensive Care for a full month. We moved into her apartment and spent our days at the hospital, until it became clear that her condition had stabilized and there was nothing we could do for her.

We drove west, and picked up a Buffalo in Ohio, and visited friends in Yellow Springs. And came back, and were there when she came out of the coma and was transferred to another ward.

Her return to consciousness was very disconcerting, though no more so for us than for her. At some point, unconscious, she had decided to live, and now, conscious, she was clearly not entirely happy about that decision. She didn't much want to be here.

All I could think of, spending time at her side, was a novel of Stephen King's called *Pet Sematary*. In the book's titular graveyard, those interred can return to life, but they're not really the same as they used to be. And it seemed for a while there as though my mother had come back from just such a place, with a different personality than she'd had before—and not a very nice one, either. She snapped at her nurses, and was altogether unpleasant to be around.

Return to consciousness, I came to see, wasn't just a matter of flicking a light switch. It was a more gradual process, and in fact constituted not only a return to consciousness but a return to oneself. As the days passed, she did in fact become increasingly herself. Her intellect returned, and her personality, and even her humor.

In respect to that last element, I made an awful mistake. I went to a bookstore in search of something that might amuse her, preferably something that wouldn't involve a whole lot of reading. I picked up a collection of Gary Larson's *The Far Side* cartoons, and after I gave

it to her I came to realize what a bad choice that was for someone who'd just spent a month with her brain on lockdown. Cartoons that would have been catnip for the woman were now incomprehensible; they didn't strike her as amusing, and she couldn't figure out what was supposed to be funny about them.

Nor could I do much to explain them. Larson's off-beat humor wasn't going to work for her, not until she was a good deal better, and I wanted to take the book away from her so that she could stop using it to make herself crazy. But she didn't want to give it up, because she was afraid her inability to get what the rest of the world regarded as funny was a sign that her deepest fear had come true, and that her mind was not working properly.

Well, it wasn't, not entirely, but it was getting there. The improvement was evident on a daily basis, even if *The Far Side* was still murky. And it wasn't long before she picked up a book of Double-Crostic puzzles and knocked one off in her usual twenty minutes. Once that happened, we all relaxed; it was evident that she was going to be fine.

Three years later, when we were preparing for the pilgrimage, I could hardly avoid recalling what had happened on our last trip to Spain. This time around,

not even a chap as resourceful as my cousin David could be expected to find a way to reach us.

I was concerned that something would go wrong, and that Lynne and I would be powerless to do anything about it, that we wouldn't even know about it until it was far too late for us to take any useful action. My mother's health was good, although she would never get around as well as she did before the accident. But she was almost eighty years old, and so was Lynne's mother, and—

I talked it over with a friend, who asked what specifically I was afraid of.

"Well," I said, reluctant to give voice to my fear, "well, uh, that one of them might die."

"It's a possibility," he or she said. (And I'm not being coy; I remember the conversation vividly, but not with whom I had it.) "But there's one thing you should keep in mind."

"Oh?"

"If one of them dies, she'll still be dead when you get back."

I found the logic of that observation unassailable, and was quick to report it to Lynne, who liked it as much as I did. And so we set out for Spain, and bade our everyday lives—well, if not goodbye, then certainly *hasta luego*.

. . .

Being out of touch, giving up the need to be in touch, may have been the most important lesson of the walk. I think what we let go of was the illusion of control. We couldn't control what went on in our absence, and that would have been no less true were we to call home five times a day. There are people who believe contact gives them a measure of control, just as there are those for whom reading the newspaper is a way of playing a role in international politics.

And, when we reached our destination on July 23rd, the first thing I did was call home from our hotel in Santiago de Compostela. Nothing much was new, I learned. Everybody was fine.

We could never do it again. The Camino is still there, it's been going strong for over a thousand years, and I don't imagine people will quit walking it. Even if the Church should disappear, pilgrims would go on making their way to Compostela. (While some of the walkers we encountered were religious, most were not; many were there for the sheer adventure of the thing, while a substantial number didn't seem to know why they were on their way to Santiago, but, like us, just felt it was something they wanted to do.)

So the road's still there, and there are still pilgrims on it, and refugios to accommodate them. So you'd think we could do it again readily enough, if we felt so inclined. If anything, it ought to be simpler for us. Our mothers are both gone, and our daughters older and more self-sufficient than ever. We're in better shape financially, and readily able to afford three months without doing any income-producing work. We're older, and discernibly less energetic, but that's offset to a degree by the physical training each of us has been doing, I walking and racing, Lynne working out regularly at the gym. We'd treat ourselves to better backpacks, and be more sensibly outfitted overall. If the hills took a toll at first, well, we'd toughen up as we went along, just as we did sixteen years ago.

Then why couldn't we do it?

Because we could never manage the isolation. Oh, we could endure it. But we couldn't sustain it, because of the way the world has changed.

It would be easy enough to leave our cell phones home. I rarely bother to carry mine, unless I'm going out of town, and ours wouldn't work in Spain anyway. Of course there'd be cell phones for sale over there, in every town we walked through, but maybe we could discipline ourselves sufficiently to pass them by.

But each of those towns would have an Internet café, too, and how long would I be able to go without

checking my email? It wasn't until three or four years after we got back from Spain that I even had email, and now it's hard to believe that there was ever a time when I got along without it.

If the world has changed, well, so have I. I'm used to being in more or less constant touch with a slew of friends and acquaintances. I'm accustomed to being able to find out almost anything—and locate almost anyone—via Google. I'm not crazy about the idea that I'm so dependent upon the cyber world that I couldn't stand three months away from it, but I'm afraid it might be true.

Oh, I suppose we could do it if we had to. But the fact of the matter is that we don't have to, and that we already did it back in 1991.

I'm glad we went when we had the chance.

I'm not entirely sure why, but it's difficult for me to write about the Spanish walk.

This is not the first time I've tried. I was commissioned to report on the experience for the travel section of the *New York Times*, and produced an article not long after our return. It was more work than I'd thought it would be, and the editors weren't crazy about it. They wanted photos, and of course we hadn't taken any; we'd decided our packs were quite heavy enough

without adding on film and a camera. (And we'd actually quit carrying a camera years ago, having decided we got a better look at the world without squinting at it through a viewfinder. The sole exception we made was the Polaroid that served to document our triumphs during the Buffalo hunt.)

So could I suggest photos they might seek to obtain? And talk about places to stay and sights to see? And, uh, maybe do something to make it more of a travel piece?

I thought about it and decided I couldn't do any of that. I felt they were well within their rights to ask for changes of that sort, and had to admit that the piece as they envisioned it might better serve the interests of their readers than what I had provided. But our pilgrimage, I was discovering, was very much a personal matter. I barely wanted to write about it at all, and I certainly didn't want to write about those aspects of the experience that hadn't greatly concerned us.

One nice thing about writing for newspapers is that the money's so small to begin with that it won't change your life to give it up. I forget what I was supposed to get, but I took a kill fee of 20 or 25 percent instead, and we let it go at that. No harm, no foul, and no hard feelings.

Now, of course, I can write about it however I want, and that ought to make it easier. (I could even splice in

what I wrote for the *Times*, and work from that, but it was written a couple of years before I got my first computer, so it's not hanging out somewhere on my hard drive. There's almost certainly a hard copy somewhere in the Stygian swamp I call an office, but I wouldn't know where to start looking, and I'm not sure I really want to find it.)

Writing about it, I suspect, may be like the walk itself, or like any walk, random or otherwise. If I can just stay pointed in the right direction and keep putting one foot in front of the other, I should get there. I may lose my way from time to time, but that's nothing new; it happened more than a few times en route to Compostela.

Where were we? Oh, right. In the French Pyrenees, at an inn run by a woman who was just a shade too well bred to say that we were out of our minds.

She fed us well, or at least as well as a Frenchwoman could be expected to feed a pair of *sportif* vegetarians. I believe she served us cauliflower, and I remember that it was good, but we were hungry enough by then to savor Styrofoam.

Here's a thought. A chronological account of our journey seems beyond my abilities, and I'm not sure what purpose it would serve. Since I'm evidently going

to digress, let me make digression my structure, and organize my narrative, if that's what it is, by topics. If that's what they are.

FOOD

In one respect, we'd have an easier time on the walk today than we did back then. Lynne and I both stopped eating meat and fish back in the late 1970's, and didn't resume until shortly after the turn of the century. It was occasionally a nuisance, and never more so than on the pilgrimage. If the French regarded vegetarians as pitiable lunatics, the residents of rural northern Spain didn't even have a frame of reference for us, much less anything to feed us.

Somewhere along the way we found out that *bocadillos de queso* were cheese sandwiches, and it's hard to imagine the relief we felt when they were available. It's not as though there was anything particularly good about them—the cheese was pretty ordinary, the rolls plain white bread, and stale as often as not. But they were, thanks be to God, something we could eat. Add a salad—iceberg lettuce, inevitably—and we called it a balanced meal.

We learned to pick up provisions at stores along the way. Nuts and olives were both tasty and portable, and

delivered a good nutritional payload. Bakery-fresh bread ranged from pretty good to excellent, and we learned to point at the whole wheat loaves until we learned what they were called. Lynne remembered that Hemingway had somewhere observed that you could always tell a poor country, that the whores were young and the bread was still good. Permutations of that line became a part of our argot; a street scene might prompt one of us to remark that the bread in this particular village was sure to be wonderful, while the occasional loaf of compressed sawdust would call up a vision of geriatric working girls.

There were times when good food was available. Some cafés had soup, and it didn't much matter to us if the base was a meat stock. Our vegetarianism was never religious in nature. (In fact it's impossible to say what the basis of it might have been. It wasn't PETA-style ethical vegetarianism, as neither of us stopped wearing leather, and, while we both thought it was probably good for us physically, I can't say it stemmed primarily from health concerns. It just intuitively seemed right for us at the time—and, some years later, it seemed to be time to give it up.)

In the city of Burgos I remember eating a rich stew, after carefully picking out and setting aside the larger pieces of meat. More recently I spent some time on

the Atkins diet, and if I'd then been presented with that very same bowl of stew, I'd have limited my consumption to the very portions I rejected the first time around.

Pizza was always a good choice, when we could find it. It was abundant in France, but we only encountered one pizzeria on the Spanish side of the Pyrenees, and that was in Catalonia. The fellow who owned it was fluent in English, and we got to talking with him; he'd learned the language in England, where he'd also learned to make pizza. He met an English girl there, married her, and brought her back to Catalonia, where they'd opened a pizzeria.

In Huesca, we had a hell of a time finding a place to eat. There were a couple of restaurants that were priced beyond our budget, and if there was anything cheaper, it was well hidden. Then we found this large restaurant housed in what seemed to be some sort of inn, and we had a decent lunch there at a reasonable price. Something was odd about the place, and somewhere in the course of our meal we noticed that Lynne was the only woman in the place, and not because we'd somehow wandered into a monastery.

It was, we realized, some sort of gay house of assignation. It was also the best place to eat in Huesca, and we took all our meals there for the rest of our stay. Now

and then we'd see a youth we recognized, leaning on a fence and looking flagrantly available. Lynne called out a cheerful greeting to one such lad, and the poor son of a bitch turned scarlet, as embarrassed as if his mother had caught him in a men's room with a senator from Idaho.

In Galicia, the province where Santiago de Compostela is located, we encountered a local pub specialty called Pimientos de Padrón. These were little green peppers, perhaps an inch long, roasted with garlic and salt, and I ate plate after plate of them.

THE ROUTE

Early on, the route was very much our own creation. After we left Mme. Très Sportif, we continued on toward the Andorran border as far as the town of Aix-les-Thermes, where we had to wait for three days because the road ahead was closed by an avalanche. When they opened it, we walked on to and through Andorra, and there's something special about walking in one end of a country and out the other end a day or two later.

The little country has long been jointly administered by France and Spain, and this had the effect of turning much of it into a shopping mall for tax-free cameras and electronic gear. While the shopping held no attraction for us, the views were pretty spectacular.

It was during our transit of Andorra that Lynne first began to believe that she'd actually be able to go the distance. Up until then she figured that what she was going through was only going to get worse, and that eventually she'd have to quit and go home; the only thing that was keeping her going was that she couldn't figure out how to break the news to me.

I knew she was having a tough time, but I'd anticipated as much. I was having a difficult time myself, contending with the weight of the backpack and the steepness of the terrain and the sheer burden of mile after mile after mile. What kept me going was the certainty that it would become easier once my body had conditioned itself to meet the challenge. I could recall those laborious circuits of Washington Square Park, by means of which I had gradually turned myself into a runner. In much the same fashion I was now transforming myself into a hiker, and so was Lynne.

Except she didn't know it. And, when I told her, she didn't believe me.

As far as she was concerned, I was just shining her on, dangling the notion of improved physical conditioning like a carrot while I kept in reserve the stick of disapproval. She didn't believe me for a moment. It was just a nice story I was telling her, something to lure her into continuing this impossible journey, and if I could

make up such a story she could pretend to believe it. But she wasn't buying it, not for a minute.

So she soldiered on, knowing it was hopeless, and sustaining herself by holding imaginary conversations with her girlfriends, in which she pointed out my obduracy while lamenting the fact that she couldn't go on and didn't know how to tell me.

I wish she'd had some of those conversations with me, because as it was I really had no idea what she was going through. Then again, what if she had? All I could do was offer the same assurance I'd been extending all along, and all she could do in turn was nod and smile and know in her heart that I was full of crap. So on we walked, and I wondered why this game and good-hearted companion had morphed into a whiner, while she wondered why she'd ever been persuaded that marrying me was a good idea.

And then, somewhere in Andorra, things changed.

I don't suppose it hurt that we had crested the Pyrenees, and that we were now going down instead of up. But more important was the fact that the walking we'd been doing had made us discernibly stronger. I think, too, that this strengthening process was mental as well as physical, that we were both getting used to the idea of spending our days walking substantial distances.

When Lynne told me that she was indeed stronger, that shouldering her pack and walking for an hour or two, while still challenging, was no longer the horror it had been, I was relieved but not surprised. "That's great," I said. "I told you that would happen."

"I know," she replied. "I didn't believe you."

And, after we'd batted that one back and forth, I frowned, puzzled. "If you honestly didn't believe me," I said, "and if you were convinced it was never going to get better, what kept you going?"

She gave me a look. And, a mile or so down the road, she found us a shortcut.

We were approaching Andorra La Vella, the principality's capital and largest city, and the road into town consisted of an elaborate series of descending switchbacks. From where we stood, we could see the town way down below, and the way the road resembled a meandering river, or perhaps a snake. Lynne pointed to our right, where a steep and little-used footpath plunged straight down toward the center of town.

"Come on," she urged. "We can go straight down and save all that walking."

And so we did. Staying upright was no mean task, given the declivity of the path and the heft of our packs, and it was almost as hard to keep from running as it was to keep from falling, but we managed somehow. And

it was exhilarating, dashing down that mountainside, crossing and recrossing that winding ribbon of road, and finishing up, flushed and breathless, in the very center of town, surrounded by no end of establishments eager to sell us cigarettes and stereo components.

"See?" she said. "It was a shortcut. Wasn't that great?"

"The best part," I said, "is that we're still alive."

"That was fun! And look at all the walking we saved. It was a shortcut."

"A rabbit shortcut," I agreed.

It was not our last rabbit shortcut, though it was certainly the most dramatic. Lynne, who as you might gather is not a slave to convention, would often choose a direct if untried route rather than walk in the footsteps of others. Sometimes we saved a few steps. Sometimes we had to turn around and walk back, persuaded of the wisdom of those who had gone before us. But whenever my companion fixed her sights on a rabbit shortcut, we always gave it a shot.

THE ACCOMMODATIONS

Early on, we stayed in hotels. The refuges for pilgrims—refugios—were only to be found along the traditional route. Each little village had a few hotels, the more

reasonable labeled *hostal*. A room was generally ten to twelve dollars, and while I don't suppose you'd mistake any of them for the Sherry-Netherland, they were generally clean enough and comfortable enough for a pair of Americans who'd spent the whole day walking dusty roads.

The villages were rarely more than ten miles apart, and my map was reliable when it came to letting us know where the next village was likely to be, so it wasn't hard to walk far enough to find lodging for the night. The whole system worked fine, until the day it didn't.

That must have been a day, or maybe two, after we left Huesca and its charming gay restaurant. We were walking in Aragon, heading west, and for the first time we were unable to find a place to stay. The one hostal we managed to locate was fully occupied; a construction crew, temporarily employed in the area, had booked all its rooms for the next two weeks.

The proprietor couldn't offer a suggestion; as far as she knew, there were no rooms to be found for twenty miles or more. It was far too late in the day for us to cover another twenty miles, and we'd be doing so with no guarantee of a room at the end of the day.

We could sleep in a field, we did have sleeping bags, and I might have given that a shot if I'd been on my own, but I didn't want to put Lynne through a night

under the stars. The sky was clear, so rain wasn't likely, but it would be uncomfortably cold, and I wasn't entirely convinced it was safe.

So we hitched a ride. If we'd passed a hostal I might have asked the driver to drop us off, but we didn't, and he took us clear into Zaragoza. We hadn't planned to swing this far south, but it was supposed to be a pretty interesting city, with a famous pillar where the Blessed Virgin had made a miraculous appearance on one of her whirlwind retirement tours, so we figured it was worth a look. And it sure beat wandering around all night with no place to stay.

We found a room right away, and we kept it for four days while we had a look around Zaragoza. The room seemed perfectly fine, but as one day led seamlessly into the next, we began to notice, bit by bit, just how filthy that particular room was. The place was a sty, and it took us all that time to realize it, at which point we got the hell out of Zaragoza.

CHEATING

By the time we left Zaragoza—a perfectly pleasant city, our accommodations notwithstanding—we had come to realize the wisdom of hooking up with the traditional route, the famous Camino de Santiago. While we didn't

regret crossing Andorra or walking through Catalonia, it was time for us to get with the program.

So we cheated.

And not for the first time. You'll recall that we hitched a ride into Zaragoza. And I've neglected to mention another ride we took, just a couple of miles, en route from Aix-les-Thermes to the Andorran border. (That was before Lynne was able to believe that walking would get easier; when a car pulled up and the driver offered us a ride, it would have taken a harder man than I to wave him off.)

This time what we did was catch a northbound train out of Zaragoza. I'd worked it out that our best bet was to join the Camino at Puente la Reina, in Navarre, and we could take the train to a town along the way that boasted a parador, one of a group of inns housed in historic properties and operated by the Spanish government. After that pigpen in Zaragoza, we were ready for something a little nicer.

But we were riding a train, and that was cheating.

When I thought about it, it struck me that the whole idea of cheating on a pilgrimage by choosing a faster or easier form of locomotion than walking was wildly anachronistic. A thousand years earlier, when pilgrims from all parts of Europe made their way to Compostela, they didn't choose a deliberately slow and antiquated

method of getting there. On the contrary, they covered the ground as quickly and as comfortably as they could. Most of them walked, not because it was good for the soul but for lack of a horse to ride or a carriage to ride in. The object, after all, was to arrive at the sacred destination and get their sins expunged, not to wear out as many pairs of sandals as possible in the process.

But that was then, alas, and things were different by the time we took off on foot. You could still go to any holy site and call your journey a pilgrimage, and how you get there doesn't necessarily enter into the equation. The hadjis who make their way to Mecca every year don't walk there from Indonesia or Pakistan or Dubai. They don't even ride camels. They take airplanes instead.

For us, though, and for every peregrino we encountered along the route, the destination was the least of it. Santiago de Compostela is a beautiful city, and well worth a visit. But subtract the ordeal, take the long walk out of the picture, and we'd have had no reason to go. Getting there wasn't just half the fun; for us, it was the whole point.

The train made sense; if we walked from Zaragoza, we'd have a long walk through uninteresting terrain and be unable to find places to stay along the way. Still, it wasn't what we'd set out to do. It was, well, cheating.

And, from the time we got off that train, we never went anywhere other than on foot until our pilgrimage was complete. Then and only then did we board another train that carried us south from Santiago de Compostela, first to Vigo and then, a day later, to Lisbon.

When the Camino led us to Logrono, for example, we walked in one end of that town and out the other. When we stayed in a city for a few days, as we did in Burgos and León, we passed up cabs and local buses and toured the place on foot. When we were ready to move on, we picked up our packs and walked. Trains, buses, cars, trucks, ox carts—we saw them all, and waved, and kept on walking.

And we never mentioned the cars or the train, not to our fellow peregrinos, nor to our friends and family back home. "You walked all the way?" they'd marvel. "On foot? All the way?"

"Every step of the way," we agreed.

It was just simpler that way. Why launch into a tedious story of our passage into and out of Zaragoza? All in all, we covered more miles on foot than we would have if we'd started out at Roncesvalles, as most people do, and walked right on through to Compostela. We had all those extra miles from Toulouse, and the great detour through Andorra and Catalonia. All told, we covered something like 650 pedestrian miles. That was

plenty, so why bother putting an asterisk in the record book?

But it must have bothered us. Otherwise why would I be writing about it now?

SIGHTS

The cathedrals at Burgos and León were quite spectacular, though I can't begin to remember anything specific about them. We gave them a long look at the time, and spent at least a few minutes in virtually all of the churches we encountered along the way.

Early on, every village church had a stork's nest on its top. Sometimes we'd see the birds visiting the nests, but at the very least we'd spot the big nest, crowning the steeple. All through Catalonia and Aragon, all through Navarre—

And then, somewhere along the way, we stopped seeing either the birds or their nests. And we never could figure out why.

Had the storks, for presumably sound reasons of their own, never nested atop the churches of Castile and León? Or had some human agency contrived to drive them away? Had the municipal or ecclesiastic authorities dispatched men with brooms to sweep the nests away? Were chemical pesticides at the root of the

problem? Or—and here's a thought that never occurred to us at the time, but seems inescapable now—could it be global warming?

The birth rate in Spain, as in much of Western Europe, has been declining in recent years. But that has to be a coincidence, don't you think?

I'm sure the trip would have been a birder's delight, not least because we did so much of our walking in the early morning hours when early birds are loading up on tardy worms. But we didn't pay much attention to the birds, except when they were impossible to miss. Like the storks, which we saw all the time until we stopped seeing them at all, and like the eagles.

We only saw eagles once, but they made an impression. We were walking on a road through a field, somewhere in Navarre, when we saw a flight of enormous birds hovering over a flock of sheep. The Basque shepherd was scurrying around, brandishing his staff, flailing at the birds with it. They were eagles, though it took us a moment to realize that; they lacked the white heads of the American Bald Eagle, and they looked too large to be eagles, although they could hardly have been anything else. We didn't count them, but their number clearly ran to more than a dozen, and there may have been as many as twenty of them, all swooping around in a manner that was so graceful it took you a minute to realize how menacing they were.

They wanted a lamb or two, and the poor shepherd clearly wanted an AK-47. All he had was his shepherd's crook, and all he could do was wave it around while his dog did all it could do, which was bark. It seemed to work, at least for the moment; the eagles soared off, leaving him with his sheep. And we walked on, by no means convinced he and the sheep had seen the last of those birds.

We had, however. Never spotted them again. More recently, we saw quite a few bald eagles in the Aleutians, and they're spectacular birds. But I think the species we encountered in Spain ran larger.

It was poppy season when we began our walk, and the fields of Catalonia and Aragon were a vast sea of scarlet. They took us entirely by surprise. I knew they had poppies in Europe, and specifically in Belgium. I remembered the John McCrae poem:

In Flanders fields the poppies blow
Between the crosses row on row,
That mark our place; and in the sky
The larks, still bravely singing, fly
Scarce heard amid the guns below.

We are the dead. Short days ago
We lived, felt dawn, saw sunset glow,
Loved and were loved, and now we lie
In Flanders fields.

Take up our quarrel with the foe:
To you from failing hands we throw
The torch; be yours to hold it high.
If ye break faith with us who die
We shall not sleep, though poppies grow
In Flanders fields.

So I knew there were poppies in World War I cemeteries, but I guess I figured someone planted them there. And when we saw the poppy fields in Spain, I assumed someone must have planted them, too—but why? As far as I knew, there was no large-scale cultivation of opium in Spain.

Well, duh, nobody plants those poppies. They plant themselves, self-seeding year after year, like dandelions in the United States, but if there are places back home where dandelions turn a whole hillside blindingly yellow, I've never seen them.

I'd never seen anything like those poppy fields. I wonder if the people who live among them pay any attention to them. Probably not. When something's always there, you stop noticing it.

And what other sights did we see? One that made an indelible impression upon me was, in a sense, nothing at all remarkable. It was, in point of fact, something that happens everywhere, every day of the year. Yet it was fair to say we'd never seen anything like it.

I don't remember the name of the town, but I happen to know the date when it occurred. It was June 25th, and I know that because the night before we were walking back to the refugio after our evening meal when we fell into conversation with a trio of teenage Spanish girls. They heard us talking and initiated the conversation, thinking it would be a fine opportunity for them to practice their English. And indeed it might have been, if they'd had any English to practice. Alas, they didn't, so I seized the opportunity to practice my Spanish, and groped around for something to say.

"*Hoy es mi cumpleaños,*" I managed. How I remembered *cumpleaños,* which is Spanish for *birthday,* is beyond me; I'm pretty sure I'd never even spoken the word aloud before. The three little maids from school— *las tres niñas de la escuela?*—thought this was a wonderful thing—that it was my birthday, not that I'd managed to come up with the word for it—and they wished me well, and we wished them well, and that was about as far as either language would take us, so we left it at that.

They were in town, and speaking with strangers, because it was indeed a feast day, St. John's Day, the festival of John the Baptist, who was the patron saint of the village. Back at the refugio, we went to sleep while the party was just getting started, and it was still dark, and some of the revelers still partying, when we woke up and got dressed and on our way.

We found our way out of town and resumed walking the Camino, and we hadn't gone too far before we found ourselves with a mountain to climb. It wasn't a mountain the way Kilimanjaro is a mountain, and I suppose I might more properly refer to it as a big hill, but there was a lot of it and it was fairly steep, and it took an effort to scale it, especially with heavy packs on our backs.

But we kept going, and eventually we stood at the top, and something prompted us to turn around and look back toward where we'd been. And just at that moment the sun broke the horizon, and we stood on that mountain peak—okay, hilltop—and watched it come all the way up.

As I said, it's the sort of thing that happens all over the world, every day of the year. But right then and right there, it was one of the most wonderful sights either of us had ever seen.

LANGUAGE

The Boy Scout Jamboree in 1953 had got me interested in Spanish, and I'd taken to it in high school like a *pato* to *agua*. Given the opportunity, I'd have continued with it in college, but Antioch had ceased to offer it by the time I got there, and that was that.

Two years of high school Spanish had penetrated more deeply than one might have supposed, and all it ever took was a week or two in a Spanish-speaking country for much of my Spanish to return to me. I was a long way from fluent, however. My vocabulary was limited—though it amazed me how words would keep coming back to me like *golondrinas* to Capistrano, just popping back into my consciousness from some chamber of memory. I was pretty much confined to the present tense, if I'd ever learned the other tenses they hadn't stayed with me, but you can conduct whole conversations in the present tense. Or write whole books, if you're Damon Runyon, say, or some poseur from Iowa City.

From time to time I would get the urge to improve my Spanish, and now and then I would buy some book in Spanish, pick up an English-Spanish dictionary, and try to work my way through the thing. I could browse Garcia Lorca's poetry with some enjoyment, but I never got anywhere with the fiction I attempted, possibly because I didn't stay with it long enough. I'd give it up, and then a few days in Mexico or Spain would bring back a flood of half-remembered vocabulary, and stir up old longings.

I always assumed that a few weeks or a month in a Spanish-speaking country would leave me with a

command of the language, and so I took it pretty much for granted that I'd achieve that in the course of three months spent walking through Spain. Nor would I have the option of retreating into English, as I might in the more cosmopolitan areas of Madrid and Barcelona. The folks living along the route of the pilgrimage hadn't been spending a lot of time studying English as a second language. They had one language, and that's all they needed to talk with one another, and they evidently figured that was plenty.

No problem. I'd do just fine in the old Español. Right?

Well, not exactly.

The first problem was that nobody was speaking the sort of Spanish I'd been taught. I should have realized I was in trouble three years earlier in Gijón, where all of the locals sounded to me as though they were speaking through a mouthful of broken teeth. The one person I could almost understand was the Russian writer (and putative ex-KGB agent) Julian Semyonov, who addressed the assembly one afternoon in my idea of perfect Spanish. He was speaking Castilian, and I established later that he'd been taught by an American woman from the Midwest. That's why he sounded just like Miss Sherman back at Bennett High.

That's not the way they talked in Catalonia or Aragon or La Rioja or Navarre. In Catalonia they didn't even use the same words, in that they were speaking not Spanish but Catalan. Some of the words were almost the same, and others weren't even close. *Open* is *abierto* in Spanish, *obert* in Catalan. It's not hard to work that one out. *Closed,* on the other hand, is *cerrado* in Spanish and *tancat* in Catalan.

Tancat became a part of our working vocabulary, and remains the one word of Catalan we know. I'm not sure how it's pronounced, because we never heard anyone say it, but we read it often enough for it to be deeply imprinted upon us. A sign bearing that single word hung in the door of one shop after another as we made our way through Catalonia. It didn't take us long to work out its meaning.

And, all these years later, we'll still find ourselves using the word now and then. "Did you pick up the Sunday *Times*?" "No, I'll get it tomorrow. The fucking deli was *tancat*."

In the Basque areas they speak Basque, understandably enough. (Well, it's understandable that they speak it, but what they speak is understandable to no one but another Basque. And, from what I know about the language, it's remarkable that they can understand one another.) And in each region where Spanish is nominally

the language, the vowels and consonants do things very different from the Castilian Spanish I was taught.

Even if they'd spoken what I was used to, I'd have been in trouble. See, I could speak the language (after a fashion, and only in the present tense). But I couldn't understand it. I could formulate a question and phrase it rather neatly, especially if I had a minute or two to go over it in my mind first. And, regional accents aside, the person to whom I addressed my question was almost invariably able to understand it.

Then he'd answer me, and I wouldn't have a clue what he was saying.

Well, I could work it out if he said *sí* or *no*. And if I asked where the men's room was, there was almost always a gesture to accompany the reply. But if he came back with a whole sentence, I would stand there trying to recall what he'd just said and trying to puzzle out what the words meant.

By the time I began to get used to a particular accent, we would have walked far enough to reach a place where people were speaking something discernibly different—though *discernibly* may not be quite *le mot juste* here. We managed to make do, we bought what we needed and found our way to the bathroom, but I was not finding the ease with the language for which I'd hoped.

In Castile, finally, they spoke something I was used to, if not with the clear Western New York accent of Miss Sherman. But all that really meant was that they had a little less trouble understanding me. I still couldn't catch what they were saying, because my ears, alas, were far slower than my lips. I could speak Spanish okay. I just couldn't understand it.

Lynne was the reverse. She had a sort of cavalier attitude toward languages other than her own, feeling that a close approximation of the requisite word damn well ought to suffice. Mark Twain, you'll recall, once observed that the difference between the right word and the almost-right word was the difference between lightning and the lightning bug, to which Lynne would likely reply that the person you were addressing ought to be able to make out what you were getting at. " 'Oh, look, thunder and lightning bugs!' Yeah, right."

At the same time, she was sufficiently intuitive so that she could generally get the sense of a sentence spoken to her, whether or not she knew what the individual words meant. Consequently the two of us together almost amounted to a person capable of carrying on a conversation. I could cobble together a sentence and fling it out there, and she could translate the response for me.

This system worked best if we didn't switch roles. If I tried to work out what somebody was saying, well, the worst thing that might happen was that I'd miss it. But when Lynne tried to talk, strange things could happen.

I'm reminded of a beastly hot day when we walked for hours under a relentless sun. I'm not sure where we were, but it was probably in León. (One problem with the pilgrim route was that it hadn't been designed with climate in mind. In order to arrive in Santiago de Compostela in time for the Saint's Day celebration on July 25th, you had to cross the Pyrenees while they were still snow-covered—viz., the avalanche that had delayed us. And by the time you got to the central plains, it was summer, and the heat was hard to bear. There was something to be said for starting in Santiago in the spring and traversing the route in the opposite direction, and I'd heard of people who did it that way, but not many of them. It was just too weird.)

On this particular occasion we'd walked a long way on a hot day, and when a café turned up it seemed heaven sent. We got a couple of coffees and went to a table, and I dropped my pack on the floor and collapsed into a chair. Lynne asked if there was anything she could get me.

More days than not, I'd buy a Spanish newspaper, generally *El País,* sometime in the afternoon, and read it over a cup of coffee. My eyes were okay with the language, it was my ears that had all the trouble, and with the aid of a pocket dictionary I could at least get the gist of most of the news stories. So what I told her was that I'd love it if she could rustle up a paper.

And how should she ask for it? "*¿Tiene usted un periódico?*" I said. She repeated the sentence a couple of times to make sure she had it down, and then she went over to the bar, and a moment or two later she came back, looking very troubled.

"I think I said something wrong," she reported. "He got all flustered and blushed and everything."

"What on earth did you say?"

"What you told me to say."

"Say it," I said, and she did, and I sighed. "I can't be entirely sure," I said, "but it sounds to me as though you asked him if he was having his period."

"Oh, God. I'll bet that's why he turned red."

"I imagine it is."

"I feel terrible," she said, and left the table, only to return a moment later looking even more disconcerted. "I went to apologize," she said, "and I think I just made it worse, and I can't understand it."

"What did you say?"

"Just, you know, that I was sorry if I embarrassed him."

"You said that whole sentence?"

"Well, no," she said. "Of course not. I just pointed at him, you know, and said '*Embarazada.*' What's wrong? Why are you looking at me like that?"

"First you asked him if he was having his period," I told her, "and then you told him he was pregnant. Drink your coffee, will you? I think we'd better get out of here."

The real reason our Spanish never improved was we only used it when we had to. We saw a lot of it on signs, and got reasonably good at making out what they said. And I developed a certain proficiency at reading *El País,* or at least those articles on subjects with which I had some familiarity. (I couldn't have made sense of the financial reportage or the essays on Spanish politics if they'd been written in English, so how could I expect to grasp them in Spanish?)

But as far as the spoken Spanish language was concerned, we weren't that much more adept at the trip's end than at its onset. And that's because we rarely had occasion to speak Spanish. We used it to order food, to secure a room for the night, to determine whether to go left or right, and, one memorable afternoon, to get directions to a pharmacy. (After a night in one of

the less salubrious refugios, I'd acquired head lice. I didn't know what to call the little bastards, so I made do with pantomime, which I'll leave to your imagination. Worked like a charm—and so, thank God, did the stuff they sold me.)

All of that rarely amounted to more than a few sentences per day, and they tended to be the same sentences over and over. The rest of the time, when we weren't getting a room or ordering a meal, we were walking with only each other for company. We did a lot of talking while we walked, but, curiously enough, the lingo we employed was English.

And when we talked with other pilgrims, other peregrinos walking the Way of St. James, we spoke English with them, as well.

PEREGRINOS

After we left the train we'd taken from Zaragoza, and after a night of unaccustomed luxury at the parador, we walked on toward Puente la Reina, where we could connect with the traditional pilgrimage route. Halfway there, we stopped for the evening at a roadside inn, after a long and arduous morning on the road. There was a TV in the dining room. We walked in on a news bulletin on the most recent ETA bombing, which threw an

eloquent hush over the room there in the Basque country, and then the feature resumed, and we gazed up at the screen, where Jeff Bridges seemed to be speaking Spanish.

It was a dubbed version of *Eight Million Ways to Die,* the lamentable film made from a book of mine and released in the States (as into a sea of popular and critical indifference) five years earlier. Around us, people resumed their conversations and paid no attention to the movie. I can't say I blamed them.

At Puente la Reina the next day, we officially became peregrinos, and found out what we'd been missing. Someone steered us to an office where we were supplied with official peregrino passports, yellow cardboard affairs designed to be stamped at the various refugios we'd pass through along our way. When we reached our destination, this would serve as proof to the church officials that we had in fact traversed the route from point to point, and thus deserved the promised plenary indulgence.

(That, back in the day, had been a major selling point of the Camino de Santiago. Get there and all your sins would be washed away. You'd have a clean slate—which, given the history of human behavior along the pilgrim route, would very likely be covered with fresh celestial chalk marks by the time you were back home.)

Our particular party, composed as it was of a lapsed Catholic and a secular Jew, hadn't made the trip in fear of hell or hope of heaven. All the same, we shared a pragmatic view of the prospect of a plenary indulgence—to wit, Nu? What could it hurt?

If any of our fellow pilgrims had come seeking a remission of sins, they kept their hopes to themselves. We met a good many of them over the next two months, and had brief or lengthy conversations with a fair number of them, and I can't recall a single one whose motivation was traditionally religious. Typically, our fellows felt impelled to walk the walk, and did so without talking the talk; they were only occasionally Catholic by birth or upbringing, attended any church infrequently if at all, and had become peregrinos in response to some inner prompting which they were hard put to define.

Still, one did hear of pilgrims whose motivation was religious, and who were seeking something in the nature of absolution. We were told more than once of a priest who walked all the way from his church in Germany, crossing the Alps en route to the Pyrenees, and then continuing all the way to Santiago—barefoot. I couldn't begin to guess what he'd done to justify imposing such penance upon himself, but I suspect there's a whole generation of altar boys who could shed light on the subject.

I can't say we got to know any of the peregrinos terribly well, and I find it difficult to summon up any names or faces. I remember a pair of Englishmen who were covering the route by bicycle. They were in no great hurry, which explains how we were able to keep up with them for a while, but eventually they got a day or two ahead of us, and after that we never saw them again. I think they were the ones who first told us that a special church council had established that bicycle pilgrims would receive absolution for half of their sins.

There were quite a few Dutch heading for Santiago, and of course they were all fluent in English, as well as French and German. (And, I would have to suppose, Dutch.) Dutch pilgrims didn't fly anywhere, or begin the trek with a train ride. They just packed up their things, walked out the front door and down the well-scrubbed stoop, and kept on walking.

As did the two Swiss priests, two brothers who might even have been twins, who had walked all the way from Switzerland. They were well up in their sixties, tall and thin and enviably fit, striding confidently over hill and dale. We never spoke with them, but we had heard tell of them a few days before they caught up with us, most likely from the English cyclists. Then one day we saw the two of them, and then that day or the next they passed us, and we never ran into them again.

Lynne likes to characterize our great stream of pilgrims as a sort of fluid community, flowing toward Compostela. In many of the refugios we'd find a guest book, not unlike what one finds in, say, a twee bedand-breakfast in Bucks County, where visitors could inscribe their names ("Henry and Claudine Thorpe") along with their addresses ("Pratt, Kansas") and their comments ("Loved the chintz bedspread—and oh, those cranberry muffins at breakfast!!!"). There were precious few chintz spreads or breakfast muffins at the refugios, but the guest ledgers were to us as fire hydrants to dogs, affording the opportunity to sniff out the spoor of those who'd preceded us while we in turn left our own calling card for those following in our wake.

In addition, a form of bush telegraph kept us current on other fellow travelers. Before we'd passed the central plains of Castile, we began to hear about a Welsh family, a couple and their two children, who would have been remarkable enough in any event—they were, as far as we knew, the only pilgrims brave enough to bring their kids along—but who became genuinely famous, in an admittedly limited circle, because their party included a donkey. They'd bought the poor creature when they crossed the border, and reports indicated it was doing a fine job of toting their gear, and occasionally their

children. Sort of like a shopping cart, Lynne observed, but one that ate grass.

Inevitably, the rest of us called them the Holy Family.

The Welsh turned up in Santiago de Compostela a few days after we arrived there, and it didn't take us long to run into them, or any time at all to dope out who they were, as they still had the donkey. We told them we'd heard a lot about them, and they confided that they'd read our entries in the refugio ledgers; if their fame had preceded them, ours had evidently trailed along behind us.

Like everyone else, we asked if they'd be able to bring the little donkey home with them, and they said it was probably going to be impossible. The UK had rather draconian regulations regarding the importation of livestock, and pet dogs and cats were subject to something like a six-month quarantine to prevent the introduction of rabies, so what chance did a donkey have?

So they'd probably have to sell it, the man said, or find a home for it. And it would be a wrench for the kids, the woman added, but she didn't see how it could be helped.

"You can always buy another donkey once you get home," Lynne suggested. And the two of them stared at her as if she had lost her mind.

MEETINGS

Life became a good deal more collegial from Puente la Reina on. We ran into other peregrinos on the trail, at roadside cafés, and in the villages where we'd end the day's walking. We spent even more time with them at the refugios, where sleeping accommodations were often dormitory-style, and a shared wait for the shower gave people a chance to talk—and, if the wait was long enough, something to talk about.

But most of the time Lynne and I had each other for company. We didn't walk side by side every step of the way; my natural pace was faster, and sometimes I'd wander off ahead while she trailed along behind me, until I'd drop my pack and sit down and wait for her to catch up with me. For the most part, though, we walked together, and it was generally just the two of us on the trail. When a larger group chanced to form, it didn't stay together very long.

As a result, the trip became a remarkable bonding experience for the two of us. We'd already evidenced a curious ability to tolerate each other's company in close quarters, all those months driving around in search of Buffalo made that abundantly clear, but this was an exponentially more intense phenomenon. There we were, cut off from everything, with yesterday ten or fifteen

miles to our rear and tomorrow as many miles in front of us, and both of them well out of sight. We weren't always chattering away, and the shared silences were as intimate as the continuing dialog.

I can't remember what we talked about, but neither can I point to anything we didn't talk about. From its beginnings, our relationship had been characterized by a degree of candor far removed from our prior experience, so we'd been talking intimately for years. Still, this was different, because there was so much of it, and so little of anything else.

And we didn't just have conversations. Every once in a while we had a meeting.

In 1977, as I mentioned earlier, I stopped drinking. Lynne underwent the same life change four years later, and in fact we first became acquainted at a meeting of a group of people who had all stopped drinking and using drugs, and who convened regularly to share a dark little room in the West Village, along with their experience, strength, and hope.

Attending such meetings had become a regular part of our lives. We went to them separately or together, and we went often—on average, several times a week. Meetings of this sort are held all the time throughout the world, and we'd gone to them during our sojourn in Florida, and during our years of driving back and forth

across America. We'd even sought out meetings during trips abroad.

They wouldn't be available to us in Spain. There are meetings held in Spain, and I'd even been to English-speaking meetings in Madrid and Barcelona when I'd come over for the Madrid Marathon. But we weren't going to be in either of those cities, we were going to be in hamlets and villages strung across rural Northern Spain, where no one spoke English, and where it would be virtually impossible (and profoundly inconvenient) to find a meeting. And even if we did find one, we wouldn't understand a word anyone was saying. (And what could we say? "*Me llamo Lorenzo, y soy un puerco borracho.*" "*Hola, Lorenzo!*" Terrific.)

It's not that we were worried we wouldn't remain sober. We felt reasonably confident of our ability to stay away from a drink at that stage in our lives. But while the primary purpose of the meetings is to help members maintain their sobriety, that's not their only function. In a way I don't entirely understand, they make it easier to maintain one's emotional equilibrium, to be comfortable in one's sobriety.

But all it takes to have a meeting is two members gathered together for that purpose. And so we established what we wound up calling the Peregrino Group, and either of us could call a meeting simply by

declaring one to be in session, reading the designated preamble, and calling on the other to give a talk.

Meetings back home typically consisted of a speaker who talked for twenty minutes or so, telling what his life used to be like, what had happened, and what it was like now. We'd heard each other many times over the years, but at our Peregrino Group meetings we wound up exploring parts of our past we'd never gotten around to recounting before, in a meeting or in our private conversation. Aspects of childhood, of family history. Incidents from our drinking years that might have seemed inappropriate in a larger assemblage. Anything, really.

These sessions were not just intimate conversations, because we maintained the formality that prevailed at a meeting. The speaker talked, and there was no back and forth; the other person listened without interrupting. When the speaker was done, the other would talk for a while—about what the speaker had said, or about anything else that came to mind. And then we'd recite the Serenity Prayer and conclude the meeting.

The cumulative effect of these two-person meetings was quite extraordinary. They helped remind us of our commitment to sobriety, not a bad idea given the amount of time we were spending in bars and cafés. (In one refugio, the chap in charge was buzzing around the place the night we were there, brandishing a bottle of

colorless liquid which he identified as *aguardiente* and offering it to all comers. All the efforts of the Peregrino Group notwithstanding, that bottle was not entirely unappealing.)

Beyond that, the meetings did what meetings at home did. They made us more comfortable, and improved our dispositions. Calmed us. Settled us down.

And this was particularly useful the day we got seriously lost.

GETTING LOST

Everybody got lost now and then. I don't know that it's an inevitable part of any pilgrimage, although I can see where it might be. I do know it was part of ours.

We'd picked up a guidebook in Puente la Reina, with a pretty decent map of the route. But here's the thing about the Camino—much of it is an off-road event, with marked paths inaccessible to wheeled vehicles.

This enhanced the whole experience beyond measure. Walking on a two-lane highway isn't unpleasant, in the ordinary course of things, but there were stretches in Catalonia where we had to share narrow roads with large trucks. Sometimes the roads had no shoulders, and sometimes there was a sheer drop-off at the side of the road, and that wasn't much fun.

When you were on a path through the fields, you didn't have to dodge trucks or inhale carbon monoxide. And it was a lot easier to forget you were still in the twentieth century. The hills and the trees and the sky were, after all, not that different from what peregrinos might have seen ages ago.

(And, thanks to the Fascist dictatorship that had kept Spain backward and impoverished for decades, the villages hadn't changed that much, either. We walked through some of them—in Galicia, especially—just as they were beginning to change; we would see farmers plowing with oxen, and then a mile away we'd spot Japanese cars parked in a village that still hadn't been wired for electricity. If we'd walked the Camino a few years earlier, those cars wouldn't have been there; if we walked it today, I expect we'd find tractors had replaced the oxen.)

The Camino, steering clear of roads and wending its way on ancient paths, was a great improvement, but it wasn't always a simple matter to stay on course. It's in the nature of paths to wander around, crossing one another more or less at will, and unless a trail's well marked, a hapless peregrino can zig when he should have zagged.

Various local bodies were charged with the responsibility of maintaining the trails, and some of them

were more diligent than others. The first time we got lost, however, it wasn't the fault of the locals. They'd done a good enough job of posting the trail, if only we'd known what to look for.

The trail had led us to and through a village, but once we were out of it we couldn't figure out where to go next. There were no signs to help us out, and a woman eventually noticed us wandering to and fro and asked us a question, which of course we couldn't understand.

I said or tried to say that we were pilgrims, and were looking for the Camino to Santiago. "*Flechas!*" the woman said.

"Fletchers?"

"*Sí. Flechas!*"

That didn't help. We wandered some more, half-looking for a sign saying FLETCHER'S. You won't be surprised to learn that we couldn't find it. Another helpful local said the same curious thing, but chose to elaborate. "*Flechas! Flechas amarillas!*"

"Fletchers again," I said, "but yellow ones this time. I wonder what the hell he was trying to tell me."

"I don't know. What's a fletcher, anyway?"

"In Spanish? Beats me. In English it's one of those old occupational surnames. I forget what a fletcher did. *Fleisher* means butcher in German, you know, as in

flesh, but a fletcher's something else. Oh, I remember. A fletcher is an arrowsmith."

"It's a rock band?"

"No, it's a guy who makes arrows. I guess there used to be more call for that sort of thing, but—oh, fuck me with a stick."

"Yellow arrows."

"We've been seeing them all day," I said. "Remember? We were trying to figure out if they were making some sort of political statement."

"And what they were saying was, 'Follow me.'"

Flechas amarillas.

So that was a new word for us, and a useful one. The yellow arrows didn't entirely eliminate the possibility of a wrong turn; there were often more turns than arrows, and some of them were so arranged as to lend themselves to more than one interpretation. And before long we learned another new Spanish word, *senda*, which means path.

It was easier to remember the word than to avoid straying from it, or to find it once it had been lost. And more than once Lynne sang:

Return to senda
Address unknown
No such number
No such zone. . .

We got lost repeatedly, but most of the time it wasn't too bad; we'd find our way back to where we'd gone wrong and pick up where we'd left off.

Until the day that prompted this entry, the Day from Hell.

It started out like any other day, and the weather was certainly favorable, the sun shining away in a cloudless sky. We were out of the hills now and entering the flat plains of central Spain, which made for easier walking. And so we walked, and kept on walking, until we realized we'd lost our way, and didn't know where the hell we were.

It wasn't entirely our fault. We'd crossed an invisible boundary from one province to another, and the Yellow Arrow Brigade in the new place turned out to be a bunch of slackers. The route wasn't marked the way it was supposed to be, and we were by no means the first people to lose our way.

As we found out when a woman popped out of her front door and regarded us with some alarm. "*¿Peregrinos?*"

"*Sí,*" we said, proud of our command of the language.

"*¡Ay! Perdido!*"

Perdido was another word we knew. It means lost.

And she'd evidently had occasion to use it before. She clued us in on where we were and how to get back

to where we ought to be, and we'd gone a good distance out of our way, and the sun was higher in the sky now, and there was no shade along our route, and if we were not exactly disgruntled, well, you couldn't say we were gruntled, either.

It got worse. I don't remember all the details, but one thing after another was going wrong. Our spirits were sagging, and it seemed like a good time for an emergency meeting of the Peregrino Group, so I recited the preamble and Lynne talked for a while and then I talked for a while and we said the prayer and walked on.

And, of course, things continued to go wrong. We'd skimped on breakfast and couldn't find anyplace to have lunch, so we went without. And we'd missed an opportunity to fill our water bottles, and another opportunity had not come our way, and we were running out of water. That's never a good idea, particularly when you're walking in the heat of a blazing sun.

Earlier, on our way through Andorra, we'd discovered the importance of drinking enough water. If your water intake's not sufficient, your mood turns nasty.

We found this out empirically, when we realized we were snarling and snapping at each other for no discernible reason. I couldn't figure out why, and then it struck me that I hadn't peed in hours, and neither had Lynne. So I drank some water, and suggested Lynne

do the same, and our mood lifted and the snapping and snarling stopped. From there on in we made sure we had water, and made a point of drinking enough of it to keep from killing each other.

But now, on what was perhaps the hottest day thus far, we were running out of water. We'd be able to fill our water bottles at the next village, wherever it might be. As far as we could tell from our map, the next human settlement was a long ways off.

On a day like this, a little surliness was the least of our worries. I didn't really think we were going to die for lack of water, but people did just that from time to time, and not only in the real world. Think of all the film actors you've seen crawling across the Sahara or the Mohave or the Gobi, crying out "Water!" through cracked lips, their tongues swollen, their makeup caked.

We thought of them, I'll tell you. And, while we were thinking of them and other unpleasant prospects, we did what we were getting so good at doing in trying circumstances.

We got lost again.

I don't know how it happened, but I can guess. The same swine who'd failed to provide *flechas amarillas* early on had failed once more. And we'd missed a turn, and here we were, hopelessly *perdido*.

At least we didn't have to worry about walking around in circles. As long as we kept the sun in front of us, we'd be walking west. And it wasn't hard to know where the sun was, because there it was, grinning furiously down on us, glaring right into our eyes, baking our brains.

The Spanish army saved us. We weren't on anything resembling a road, just a path running across the center of a vast stretch of open ground, so we were not expecting to hear a car coming up behind us. We turned, and there were a couple of open jeeps filled with young men in uniform. We'd managed somehow to find our way onto a patch of land that the military used for maneuvers, and it was just our good fortune that their day's agenda called for a lot of driving around and saluting, instead of, say, artillery and mortar practice.

We told them that we were peregrinos, which didn't appear to surprise them, and they told us we were *perdido*, which was no news to us. And they gave us, God bless them for it, a full bottle of water, and explained in detail exactly where we had to go in order to be where we were supposed to be. There were smiles and handshakes all around, and then they drove off to continue their essentially pointless maneuvers in the middle of nowhere, while we set out to resume ours.

I can't be sure exactly when the Peregrino Group held its unprecedented second meeting of the day. It may have been before the soldiers rescued us, or it may have been shortly after. We sat down for this meeting, instead of walking as we talked. We dropped our packs and sat on them, and one of us said the preamble, and we dove in. I couldn't tell you what we said, but I'm pretty sure our sharing this time around was centered a lot less on personal history and a lot more on the present moment.

When we'd finished, we got up and resumed walking.

And the day went on and on and on, and the sun stayed in our eyes and went on frying our brains, and when we finally reached a village it was getting on for dinnertime, and there was no refugio in or near this particular village, and no chance we could reach the next one down the line before full dark. We looked around for an inn or hostal, and it didn't look as though the village could boast of one, and then someone steered us to this very pretty little house, painted in vivid colors, where a handsome young man responded to our knock with a smile and a little welcome speech in English.

Astonishing. There were vases of flowers all through the house, and pastel walls, and the aroma of sandalwood candles. He ushered us to an immaculate and well-appointed bedroom, pointed out an equally

immaculate bath down the hall, and told us to make ourselves at home. He didn't have to tell us twice.

We took baths, and not a moment too soon, and back in the bedroom we remarked on the array of scented soaps our host had provided, and the deep-toned towels. "I can't believe this place is here," Lynne said. "Maybe we didn't get water in time."

"You think we're hallucinating?"

"I think we died," she said, "and they let us into heaven, even if we didn't get our plenary indulgences yet. What on earth is that perfectly charming fellow doing running this perfectly charming inn out here in East Jesús, Spain?"

"All those flowers and candles. And did you happen to notice the scented soap?"

"How could I miss it? Little cakes of French-milled soap, all in different shapes and colors."

"You don't suppose—"

"No question. He's wearing keys."

"You're kidding."

"Nope. Pressed jeans, and he's wearing keys."

"Well, he's in the hotel business," I said. "There's all those doors he has to be able to open. And maybe wearing keys means something different here than it does on Christopher Street."

"Yeah, right."

"But what on earth is he doing *here*?"

"Where should he be? Huesca?"

"Jesus," I said, "how do we do it? I guess you can take us out of the West Village, but you can't take the country out of Salem. I'll tell you something. I don't care how he got here, and I don't care how we got here. I'm just glad he's here and we're here and this goddamned day is coming to an end, because I don't think I could have taken another hour of it. What a miserable day! I was losing it, I was coming unglued—"

"Well, I can't understand why," Lynne said. "Don't forget, you did get to two meetings today."

REFUGIOS

If we hadn't gotten lost time and time again on the Day from Hell, we probably would have missed spending the night in Gay Heaven. We'd have gone right on through that particular village and walked on to the next refugio.

The network of refugios all along the Camino certainly made it a lot easier to be a peregrino. The sort of no-room-at-the-inn debacle that led to our Zaragoza detour was no longer a concern. There was always room at the refugios, and all we had to do was follow the guidebook to be sure of a place to sleep.

While the level of creature comfort never rose to floral arrangements and scented soap, some of the refugios were more than acceptable. I remember the one at Santo Domingo de Calzado; everyone who'd been there pointed it out as an example of what a refugio could be. It was, I suppose, comparable to any better-than-average youth hostel, but on the road to Santiago it was outstanding.

The village where it was situated, I should point out, was renowned as the site of a chicken miracle. We heard several versions of the story, but the gist of it was that someone had appealed to some local potentate, who was sitting down to dinner at the time. The pooh-bah pointed to the roasted chicken on the platter in front of him and announced that he'd grant the supplicant's wish "when that chicken hops off the table and crows." Whereupon the headless bird contrived to do just that, as depicted in a mural in the local church.

I thought it was a pretty good story, and a terrific mural. Lynne agreed, but she went on to assume it was true. Lynne has never met a miracle she hasn't been able to believe in—and, after our rescue by the Spanish Army and our eventual deliverance unto the Gay Guest House, I have to say I can understand her point of view.

Her enthusiasm for this particular legend didn't diminish when someone pointed out that chicken

miracles abound throughout Europe, that every coun-
try seems to have one or more of them, all featuring a
bird, roasted a golden brown, who saves some blame-
less person's life by rising from the platter and cock-
a-doodle-doing its heart out. Didn't she think it was
unlikely that all of these miracles had taken place all
over the continent?

"It just shows," she said, "the awesome power of the
chicken."

Another refugio, the very one where *aguardiente*
was on offer, had a feature that was both eco- and
peregrino-friendly—rooftop water tanks, heated by
solar power, provided a good supply of hot water for
showers. Most of the refugios had showers of one sort
or another, but few of them had enough hot water to
go around, and a combination of luck and good timing
was necessary if you wanted more than a deluge of cold
water.

Once in a while a refugio had one or more private
rooms, and as a couple we were apt to draw one on the
rare occasion that one was available. More often I'd
take an upper bunk and Lynne a lower in a room with a
whole row or two of bunk beds.

And when we did have privacy, it brought no guar-
antee of a comfortable night's lodging. One village
was supposed to have a refugio, but we had to go to

the church and hunt down the priest in order to find it. He gave us a key and a set of directions; the key let us into a room some twenty feet square, with assorted debris in its corners and incomprehensible graffiti on its cinder-block walls. The place had once been a garage, and now it was a refugio, though the only indication of its new status was a large bare mattress in the middle of the concrete floor. We got a better night's sleep than we expected, but figured one night was plenty; in the morning we returned the key and hit the road.

With time, we found that two or three consecutive nights in refugios were about as much as we could take. Every third or fourth night we'd contrive to stop at a commercial establishment of some sort, where we'd be certain of a room to ourselves and access to a working shower. Sometimes, if the hotel and the room and the village were sufficiently attractive, we'd stay a couple of nights, but more often than not we were on our way in the morning.

ACTIVITIES

When we weren't walking or eating or sleeping, how did we pass the time?

I can't say we watched much television. The refugios didn't have sets, and neither did the budget hotels. Some-

times, though, we'd eat in a café with a TV set. Once we walked into a convenience store, the local equivalent of a 7-Eleven, and were startled to hear Peter Jennings; the French station Canal-Plus was carrying the *ABC Evening News* in English, and we stood there transfixed. And I've mentioned watching *Eight Million Ways to Die* in Basque country, where the locals seemed to be inventing a new way of their own every week or so.

But the program that always seemed to be playing when we were around was *The Flintstones*. I was never a big fan of the show when I could understand what Fred and Wilma were saying, and I can't say it gained a lot in translation. The only other program I can recall was the Spanish equivalent of *America's Funniest Home Videos*. We'd never watched it back home, and I don't know that we'd have been watching it over there, either, if we'd had any choice.

But I could be wrong, because the Spanish version had something you'd never see in the States. Along with all the usual Stupid Pet Tricks and Rotten Little Kid Antics, they elected to show us this astonishing video of—I'm sorry, it's more trouble than it's worth to search for a polite way to say this—of a rabbit fucking a chicken.

All conversation stopped around us. Everyone stared at the screen, and then everyone roared with laughter

and offered up verbal encouragement that didn't require translation. "I hope you were paying close attention," I told Lynne, "because you're not going to see anything like that ever again."

But I was wrong. At the end of the program the audience votes for their favorite, and of course the rabbit and chicken won, whereupon they gave us another look at it. And the next time we found ourselves in a room with a TV set was precisely a week later, so what program do you suppose was playing? And of course last week's winner was entered again this time around, and of course the damn thing won. If the show's still on the air, I would have to assume it's still winning.

I hate to admit it, but I wouldn't mind seeing it again . . .

What else did we do? Well, we did a little sightseeing, when there was a sight to see. And we spent time reading. Along with my regular attempts at getting the gist of the stories in *El País*, we plugged away at the few books we'd brought with us. The couple of novels didn't last; we'd read and discarded them before we were out of France. But I'd packed a Bible, and neither of us was in danger of knocking that one off in a night or two. Nor were we likely to get all caught up in it, but it somehow seemed like the right sort of thing to dip into in the course of a journey like ours.

I'd also packed Chaim Potok's *History of the Jews,* figuring it might counterbalance the undeniably Christian nature of our adventure. If I was going to tag along after St. Francis and St. Clare, and treat myself to a dip of holy water in every church along the way, the least I could do while I was at it was refresh my memory of the history of my own people.

This might be a good time to point out something about Lynne and myself. We were not so much a mixed marriage as a marriage of two rather mixed individuals. After a proper Catholic education at Ursuline Academy in New Orleans, she took a bus to New York, where she fell in with a crowd of artists. I was by no means the first nice Jewish boy in her life.

For my part, after my first marriage ended I found myself seeking out the church around the corner as a source of peace and quiet amid the Manhattan hubbub. In the books I wrote about ex-cop Matthew Scudder, I had him do much the same thing, and light memorial candles there for departed friends.

By the time we began keeping company, it would be fair to say that each of us was a little bit country and a little bit rock and roll. And the extent of our religious cross-pollination had become evident to us two years earlier, when some moron cut us off on an icy stretch of highway in northern New Mexico.

"Oy, gottenu!" cried the pride of St. Elizabeth's. While the boy from Beth Zion said not a word while making the sign of the cross.

Well, it worked, didn't it? We didn't crash the car. And it happened just that way, swear to God. Whatever God you want . . .

Still, I figured Potok's history would be a good choice, and I'd have to say it was, but it made for some curious moments. Everything was fine until I got up to the fifteenth century, and suddenly we couldn't walk through a town without my reading that night how it had figured prominently in the Spanish Inquisition, with its synagogues sacked and its Jewish population burned alive.

Oh, well. All that aside, the book was good company. I was talking about it with Lynne, and we agreed that Potok was a good writer, and that we'd both enjoyed his novel, *My Name Is Asher Lev*, about a young artist from an ultra-Orthodox family. "And there was a sequel," I said, "but I can't remember what he called it."

"*Now My Name Is Allen Lewis*," said Lynne, without a moment's hesitation.

WALKING

There were lots of good times, as I hope I've managed to suggest, and even the worst moments weren't so bad

once we'd had a day to walk away from them. And we didn't lack for interesting ways to pass the time. But what we mostly did, and what was certainly the central feature of those months in Spain, was walk.

There are, as I've mentioned, people who make the trip on a bike. There are paths that you can't negotiate on a bike, but there were always roads the bicycle pilgrims could take to get from one refugio to the next.

One contingent of Spanish equestrians covered a portion of the route—from León to Santiago, as I recall—mounted on horseback, and a fine figure they cut. If it had been up to me, I'd have cheerfully given them plenary indulgences, along with grain and water for their steeds.

There are also a certain number of sightseers every year who cover the route in a car, winding up in Santiago de Compostela in time for the festival. (I don't suppose they call themselves peregrinos, or expect to cut short their time in Purgatory for having made the trip, but what do I know?) And some of the adventure travel companies have taken to offering escorted trips along the Camino, with a support vehicle to carry the luggage and a wuss wagon for those whose feet can't take it, along with an abbreviated itinerary and some bus transportation over parts of the route.

Not that there's anything wrong with that . . .

But here's the thing. If you're not going to walk, really, what's the point?

There was something transformational in covering vast distances, true geographic expanses, on foot. Who looks at the map of Spain and sees a country it would be possible to walk across? And yet by the time we were done we had done precisely that, one day at a time, one precious step at a time.

I don't think there was ever a day when we covered more than twenty miles, and that long stretch came in Castile, where there was an empty expanse of flat land through which the Camino headed north, toward León. We knew it was coming, and we made a point of getting an early start that day and carrying the requisite food and water. It was a long day's walk—we generally seemed to average around three miles an hour, less over difficult terrain—but we got to the end of it without difficulty, and there was a refugio waiting for us.

As the miles piled up, they brought us a great sense of empowerment. For all our lives we'd had to rely on something other than ourselves in order to get from one place to another. Whether our transportation was public or private, whether we had to depend on a bus or a plane or were driving a car that we'd bought or rented, we were being moved around by something we didn't really control. We weren't going anywhere; the

car or bus or plane was going somewhere, and we were hitching a ride in it.

In Spain, we were quite literally getting around under our own power, and that we could actually do so was something we found stunning during those infrequent moments when we stopped to think about it. Ten years earlier, when I'd decided against buying a bike in Oregon, it had never even occurred to me that I could walk. Some years later I'd sent my little band of fictional characters traipsing across the Cascades in *Random Walk*, and it worked just fine in a novel, but when Lynne and I traced the *Random Walk* route during our Buffalo-hunting days, we did it in a car. We could imagine ourselves doing something like that, but there's a difference between imagination and action, no matter what the self-help gurus would like you to believe, and we never dreamed we could really get out there and do it.

We weren't walking to gain fitness, or to lose weight, but both were almost inevitable consequences of our peregrination. I'd assured Lynne that walking would make her stronger, and thus able to go the distance, and even if she didn't believe me, it damn well worked. We were both much stronger by the time we got to Santiago, and slimmer, and in better shape all around. And we were thoroughly sold on the virtues of

walking, as an enjoyable activity in and of itself and as one that brought enormous benefits. It was, we assured each other, something we wanted to make an ongoing part of our lives.

There was no reason, we agreed, that we couldn't walk in the city as we had been walking in Spain. What better way to spend a day than to ride the Number One train, say, to 242nd Street and Broadway, and walk home from there? Let's see, twenty blocks to the mile, 242nd Street to West Thirteenth Street, comes to what? Ten, eleven miles? Hey, piece of cake. Nothing to it, and it would be a lot easier to find food and water on Broadway than it had been in some of the places we'd walked.

Lynne wondered if we should take backpacks. "Not that we'd need them," she said, "but maybe it would be better exercise with our packs."

"We could try it both ways," I suggested, "and see which we prefer. Or you could try it with a shopping cart."

"I ought to," she said. "Just to drive you crazy."

Besides exploring the city, we could figure out ways to take walking vacations. How hard would it be to pick out some state with towns every ten miles or so and just go out there and start walking? If we picked a flat state, it shouldn't be that hard to walk clear across it.

And another thing—we'd walk the Camino again. Not next year, that would be too soon, but maybe the year after. We'd get the right sort of backpacks this time, and know what to put in them, and we'd start at Roncesvalles like everybody else. And maybe we'd time our trip to match the weather, and cross the Pyrenees in late summer so that it would be autumn by the time we hit the Castilian plains.

And maybe I'd try the route alone one year. Walking it with Lynne had been wonderful, and would be wonderful a second time, but it might be an interesting and entirely different experience to walk it alone. I'd go faster, of course, and I wouldn't stay put for a few days of sightseeing, and I might sleep under the stars from time to time. More to the point, the solitary nature of it might turn my mind inward in a useful way.

Oh, we had no end of ideas. But one thing was clear. From here on in, we'd make sure walking was a regular part of our lives.

And so we spent a few pleasant days in Santiago de Compostela, eating well, encountering pilgrims we'd met along the way and others, like the Holy Family, whom we knew only by reputation. Jack Hitt, whose conversation with Don and Abby Westlake started the whole thing, turned up; word had filtered down that he was somewhere behind us, walking the route a second

time ten years after his first pilgrimage, and here he was in Santiago. He'd go on to write *Off the Road,* a very entertaining book about the Camino.

From Santiago we took the train to Lisbon, breaking the trip for a night in Vigo. It had figured prominently in the War of the Spanish Succession, back in Queen Anne's reign, and in my numismatic days I'd acquired a contemporary silver medallion, a handsome thing that showed the bombardment of the French fleet in Vigo harbor. I'm sure that's why I picked Vigo for an overnight stop. I'd long since ceased to own the medallion, but I remember it now far more clearly than I remember anything we may have seen during our visit to Vigo.

We were scheduled to spend a week in Lisbon, and liked the city well enough, but in our minds our trip ended the day we walked into Santiago, and all the churches and tile factories and fado music in Lisbon wasn't enough to hold our attention. We stuck it out for four days, then changed our tickets and caught a flight back to New York.

We unpacked and showered and dealt with jet lag, and did all the things you do after a long absence, and we knew it was just a matter of time before we resumed our new career as long-distance walkers.

Funny thing: It never happened.

. . .

I guess it's often that way. An activity is particularly gratifying, and one wants to hang on to it and make it an ongoing part of one's life. It's been so important, so essential, that it's impossible to believe it won't stay that way.

That's why visitors to a foreign country come home with cookbooks, convinced they'll want to be able to prepare all those dishes they've enjoyed in Bangladesh or Togo or the Trobriand Islands. And maybe some of them do, but I have a feeling a lot of them do what Lynne and I would do, which would be to give the cookbook an honored place on our shelves, and never look at it again.

That, after all, is what we used to do with photographs, before we quit weighing ourselves down with a camera. We took no end of pictures in West Africa, and had them developed and printed, and they sat unexamined in a box for a couple of years. Then one day Lynne got inspired and bought an album and mounted all of them, and she put the album on the shelf, and neither one of us has looked at it yet.

A photograph is an attempt to hang on to an experience, to freeze a moment in time and have it forever. And is walking home from 242nd Street all that

different? We'd have been trying to hang on to an experience, one less of seeing than of doing, but it wouldn't really work. You can take pictures, even as you can take long walks, but in either case the experience is a transitory thing, and when it's done, well, it's done. Trying to keep it alive is like trying to keep the high school band together after graduation.

So we came home and went back to our lives.

PART **THREE**

16

Life, it's been said, is a series of choices, and to choose one action is to choose not to undertake another. For every road taken, one leaves no end of roads untraveled.

I've known a few people who realized early on precisely what life they were destined to lead, and who followed a single clear-cut path to the end of their days. One of my closest friends was endowed with this sort of self-knowledge, and he'll be the first to tell you that he hasn't changed much over the years. He hasn't lived in New York for twenty-five years, but still roots passionately for the Knicks and the Giants. He still gets his hair cut the same way he did fifty years ago, still wears the same sort of clothes, still listens with devotion to the same music, and still holds pretty much the same

political views. You might think this would make him dull company, or at the very least that he'd have had a routine and predictable life. You'd be mistaken; he's a great companion, and enjoys a rich and satisfying life.

My life, too, has been rich and satisfying, but it hasn't stayed the same over the years. Enthusiasms have come and gone, passions have waxed and waned.

You'll recall that I'd completed five marathons in 1981, along with thirty-five shorter races, and that within a year I'd quit racing entirely. And, while we never deliberately abandoned the Buffalo hunt, it had pretty much stalled out by the time we moved back to New York in 1990. Our lives had changed, we weren't driving around much and in fact no longer owned a car, and after the Spanish walk we found ourselves more interested in adding new countries than unearthing new Buffalos. We had just picked up Andorra and Portugal, and in the years that followed we spent a good deal of time traveling, and reached some fairly remote parts of the planet.

Sometimes walking was involved. We spent two weeks with my three daughters on an escorted walking tour of Tuscany, with our bags transported from inn to inn and each day's walk interrupted by a splendid picnic lunch that would materialize magically in front of us when we rounded a bend in the path. Another

walking tour on another summer, with a daughter and a granddaughter in tow, consisted of more rigorous hiking in the Alps, and added Switzerland and Liechtenstein to our country list.

A couple of years before that, in 1993, I was thinking about taking another crack at the Camino. I'd go by myself, and I'd cross the Pyrenees in September, and I figured I could cover the route in five or six weeks. But I had time to mull it over, and before I booked a flight or went shopping for a better backpack, I realized with a mixture of relief and regret that I didn't really want to go. I didn't much like the idea of being away from Lynne for that long, and the more I pictured myself sleeping in refugios and foraging for *bocadillos de queso*, the less appealing the prospect became. And, dammit, I'd been there and I'd done that, and maybe once was enough. Either it wouldn't be as I remembered it, in which case I'd resent the changes, or it would be exactly the same—so why go through it all over again?

It's not as though I let my legs atrophy after we flew home from Lisbon. A New Yorker typically walks a couple of miles a day without giving it much thought. That's how one gets around, and it's why Lynne, without any advance preparation, was able to acquit herself capably as a peregrino.

I continued to go to the gym, though my attendance was inconsistent; sometimes I got there three times a week, and sometimes it was more like three times a month. Gyms come and go, and when mine closed it sometimes took me a while to find another and join it.

At one point Lynne responded to some pretty broad hints and bought me a stair climber. We installed it in my office, an apartment two flights up from our residence, and I used it daily at first, the way everybody does who gets one, and then I stopped—like everybody else. When I tried to get back to it, the machine sputtered and quit working, and it was easier to use it as an extra clothes rack than to find somebody who'd make a house call and fix it. It's a good thing we didn't have a garage, or it would be there to this day, but instead we found a building employee who was willing to take it off our hands. I suppose he fixed it up and sold it, or else it's in his garage, because I haven't noticed that he looks any fitter for owning it.

At the gym, I mostly worked with weights, but now and then I'd hop on a treadmill and work up a sweat for twenty minutes or so. I would walk, to save my knees, and my gait was a racewalker's, with my arms swinging at my sides. I couldn't do this without being reminded of the year when I'd been a marathoner, but I never gave any thought to returning to those golden days.

If I'd thought about it, I probably would have told you it was impossible. I'd been having a little trouble with my feet lately, and my right foot in particular tended to go partially numb now and then, and to ache from time to time. Sometimes I'd be walking along on the street and I'd get sharp pains in my foot; they'd bother me for a while, and then they'd go away.

A doctor told me it probably had something to do with my sciatic nerve, and that I should try stretching. That's not what it was, and while stretching didn't do me any harm, neither did it do any good. I didn't know what was wrong, and didn't really want to find out. I got on the Internet and read about intermittent claudication and diabetic neuropathy, and the symptoms sounded about right, but I didn't think either of those was what I had.

And it wasn't that bad. My foot would feel a little numb and tingly in the morning, but that passed as the day wore on. And I was still doing what I always did, and getting around as much as ever. All it really meant was that my marathoning days were over, but they'd been over for years, and I didn't really miss them. And it probably meant, too, that I wouldn't be able to walk the Camino again, but I'd already decided I didn't want to do that, either.

Well, hell, I was getting older. I was past sixty. Pretty soon I'd be lucky if I could walk at all. Or remember how to find my way home.

My eldest granddaughter, Sara Reichel, has a pronounced and longstanding affinity for penguins. Accordingly, in December of 2001 Lynne and I celebrated Sara's bat mitzvah by taking her and her Aunt Jill to Antarctica, to see her totem animal in its natural habitat.

Then in the spring of 2004 I was scanning the Earthwatch catalog. That worthy organization provides opportunities for volunteer travel in aid of some environmental goal; for a not-too-steep fee, one might join an expedition to count the endangered red pandas in the Trobriand Islands, or distribute free flyswatters in a malarial swamp, or build a dam somewhere to take the burden off the beavers. Lynne and I had been getting their catalogs for years, and had reluctantly begun to conclude that we just weren't sufficiently high-minded to sign up for one of their trips; if only we were better human beings, we'd be eager to inoculate villagers in the Cameroun against dengue fever instead of, say, knocking back on a cruise of the South Pacific. But I always made myself take a quick look through the catalog before throwing it out—I felt it was the least I could

do—and the next thing I knew I'd signed up Sara and myself to rescue penguins in South Africa.

I hadn't even known they had any. But they did, in great profusion, until an oil spill a couple of years earlier decimated the population and threatened its ultimate survival. Robbin Island, the prison colony where Nelson Mandela had been the most famous inmate, was home to many of the birds, and as Earthwatch volunteers we'd be joining an ongoing project designed to monitor the little guys.

We'd be flying to Cape Town in August, and I got a rude awakening when I started packing for the trip. It would be their cold season, which meant long pants. I'd been wearing shorts all summer, and when I tried on my long pants I found they didn't fit. I'd put on weight without quite realizing it, having bought shorts at the start of the summer, and . . . oh, never mind. I was fat and my pants didn't fit.

All that meant was a trip to our basement storage cupboard, where a box of my fat clothes filled a large carton, waiting patiently for me to grow into them. But it certainly didn't make me feel very good about myself, and the day before we left I ran into a friend and found myself carping about the whole business.

"Hey, so you'll do something about it when you get back," he said. "Remember when we first knew each

other? One day you went into the Attic Gym on Twelfth Street, and you didn't come back out for three years. You'll do the same thing again."

And it turned out he was right.

The trip itself was mostly good, though much of the day-to-day activity with the penguins was tedious. There were several chores we shared, one of which involved dividing up into twos and threes and going from nest to nest, duly noting whether a particular nest had a chick present, and, if so, estimating the maturity of the chick. ("Well, she was cute, but I don't think she was old enough to drink.") Some nests had been abandoned, and we'd note that, too. All of the nests reeked to the heavens, but we didn't have to write that down.

We also did roadside surveys, during which we would spend an hour standing at the side of the road, counting penguins. The birds would walk to the ocean in the morning, and every afternoon they returned to the land and crossed the road to their stinking nests. We'd wait for them and make pencil marks in our notebooks. We'd watch two penguins cross the road, and make two marks. Then a single penguin. Then four would cross, but then one would go back. Then another penguin would cross the road, and then—

Back at our shared lodgings, Sara would enter all this data into the computer. She was a whiz at data entry,

which earned her big props from the other volunteers, all of whom were at least a couple of years older than her, while being upward of a generation younger than I. I took great pleasure in being Sara's grandfather, but there in Penguin Heaven I felt like everybody's grandfather, and that wasn't all that much fun.

The program one day called for picking up a penguin from its nest, holding it upside down by its feet, and causing it to vomit. (I forget how this end was achieved. If it had been up to me, I'd have made them watch *Eight Million Ways to Die* in Spanish.) Then the regurgitated stomach contents were sent off somewhere to be analyzed.

But it wasn't all penguin puke. We spent a busy afternoon walking the beaches and filling trashbags, and another riding around taking a survey of local wildlife. The best part of the experience, as far as I was concerned, was the chance to spend some time with Sara, and we managed to fit in a couple of days on our own in Cape Town after we were done herding penguins.

Then we flew home, and I went to the gym.

I was already a member, but now I was determined to use the place in a disciplined fashion. I decided I'd go every day, and I determined that my first order of business would be a half hour on the treadmill. After that

I'd do some weight work three or four times a week, but the treadmill was going to be the core of my program. I wanted to burn some calories, and I only hoped my feet wouldn't stop me.

Early that July, a freak accident with a rubber sandal tore the pad of the big toe on my right foot, and I'd had to limp over to St. Vincent's to get it stitched up. It had healed perfectly, but that foot continued to give me grief. It was often numb and tingling in the mornings, and I had a long-standing touch of arthritis in that same toe that I'd torn open. I could live with all that, it was part of being an old man, but I was concerned that it might interfere with my treadmill regimen.

To my surprise, the walking seemed to help the foot. I don't know why this should have been the case, it's not as though I hadn't been walking a fair amount before I got anywhere near the treadmill, but I wasn't going to argue with this particular success. I kept on keeping on, and I hit the gym every morning, seven days a week.

I'd been doing this for about a month when I got my first actual job in almost forty years. Two friends of mine, Brian Koppelman and David Levien, hired me as a staff writer and assistant story editor for a dramatic show about the world of big-time poker that they were developing for ESPN. All of a sudden I had an office in

Midtown to go to five days a week, and regular hours to keep.

That would have been a perfect excuse to give up the gym, or at least reduce my visits, but I was getting too much gratification from the routine I'd established, and all I had to do was hit the gym before I went to the office. The gym opened at five, so how hard was it to fit in an hour or so before I showered and dressed and caught the E train uptown? Not hard at all, as it turned out, and working on *Tilt!* never made me miss a single session at the gym.

At first I put in a daily half hour of racewalking on the treadmill, capped by a five-minute cooldown. After a few weeks I started extending occasional sessions to an hour, with a ten-minute cooldown.

Treadmills allow you to choose your pace, and I started out at fifteen-minute miles, kicking it up a notch every five or ten minutes. I worked out a formula for increasing the overall speed of my workout by almost imperceptible increments, and within a couple of months I'd be finishing each daily session around the twelve-minute-mile mark. I kept a water bottle handy and drank water at regular intervals, and it was a good thing, because these sessions were sweaty work. I was always dripping by the time I was done.

I would see other people reading a book or newspaper while they used the treadmill, and I couldn't figure out how they managed it. It seemed to me that if you were able to read at the same time, you weren't working hard enough. And I was working as hard as I could.

And it was paying off. I was seeing results—on the scale and in the way my clothes fit. My fat pants returned to the basement storage bin, where they are even now biding their time until I need them. I was in good shape and I felt terrific, and, if I still had arthritis in my toe and some neuropathy on some mornings, on balance my foot was a good deal better.

Of course I couldn't leave well enough alone.

It was on the last day of the year when everything changed dramatically. Lynne and I took the easy way out for New Year's Eve, spending the evening at home after an early dinner in the neighborhood. Later we'd turn on the TV and watch the ball come down, but first we found ways to amuse ourselves, and I sat down at the computer and Googled my way into trouble.

A couple of days earlier, I'd finished a long session on the treadmill, an hour plus a ten-minute cooldown, and one of the machine's dials helpfully pointed out that I'd gone 4.8 miles, or 5.2 miles, or whatever the hell it happened to be. I think it must have been just over five

miles, because the thought that came to me was that I'd just gone the equivalent of a five-mile race.

Race. A dangerous word, that.

Well, was there any reason I couldn't enter a race? I wouldn't be very fast, but then I'd never been fast, so what difference did it make? I dismissed the idea, but I guess it must have decided to hang around, because what I Googled on New Year's Eve was NEW YORK ROAD RUNNERS.

That was the club I'd belonged to in my racing days. I hadn't renewed my membership when it expired back in 1982, and I'd certainly had no contact with the organization, but I knew it was still going strong. Fred Lebow, the inspired monomaniac who'd essentially created the modern urban marathon singlehanded, had lost a long battle to brain cancer some years ago, but the organization he'd spearheaded now owned the East Eighty-ninth Street brownstone where it was headquartered, and still ran the New York City Marathon over the same course I'd covered almost twenty-five years earlier. It stood to reason they'd have a website, and indeed they did, and twenty minutes later I was a member and had signed up for two races.

Now that's the trouble with the damned Internet. It makes everyone an impulse shopper. Just a few years

ago, if I read about a book that sounded interesting, I had to remember to look for it the next time I was in a bookstore, and by then I may have already determined that I could live without it. Or they might be out of stock, or I might sport-read a few pages and decide the hell with it.

But now in an instant I'm on Amazon or Alibris, and in another instant I've bought the book, and before I've had time to think it through I've bought two more books I don't want or need just to save on shipping charges.

Now all of that is fine when it happens to somebody else, and they're buying my books. So I suppose it evens out, but I'm still not sure how I feel about it.

If I'd had time to think about it, if I'd had to make out a check and write a letter and address an envelope, and then go hunt for a stamp, well, maybe the outcome might have been different. But all I had to do was tap a few keys and click my mouse a few times and suddenly I was a member in good standing of New York Road Runners, with my registration prepaid for a five-mile race on January 9 and a ten-miler three weeks later. And, because I was over sixty-five (though evidently not old enough to know better) I joined as a senior member, and got a reduced senior rate on my race entry fees. Such a deal!

. . .

Lynne was very supportive. She thought it was a great idea, and asked if they'd be giving out shirts. I said it seemed likely, and she said that was terrific, a free T-shirt. I told her there was no such thing as a free T-shirt.

Nor was my investment going to be limited to what I'd spent online. I'd been walking up to five miles at a clip, but I'd been doing every bit of that training indoors, on a treadmill, and they weren't going to be so considerate as to hold the race in my gym. I'd be walking in Central Park, with its renowned hills, and it was January, which meant it would be cold and there might well be snow on the ground. I had to go to a sporting goods store and pick out things to wear, high-tech gear that would keep me warm while allowing perspiration to escape. I could have stocked up on T-shirts for what I shelled out.

I emailed my kids with news of my upcoming adventure, and my daughter Jill surprised me by signing up for the five-mile race; she lives near the club's headquarters, and offered to pick up my number bib and T-shirt. I met her at her apartment on Sunday morning, and after I'd spent ten minutes getting my number pinned on just right, we walked over to the park in time for the race.

And it went fine. It was cold, but it turned out I was dressed fine for it, and my legs were up to the challenge of the park's hills. I hit the big hill at the northern end of the park about a mile into the race, and it was challenging, but I was pleased to note that I passed a lot of back-of-the-pack runners on the long steep ascent. They found themselves forced to break stride and walk, and as a racewalker I was able to breeze right by them.

Breeze may not be the word I'm looking for here, as it suggests a degree of effortlessness that was not at all in evidence. The race took all I had to give it, and when I was done Jill was waiting at the finish line, having run across it a few minutes ahead of me. We went out for breakfast, and back at her place I changed into street clothes, and put on the shirt I'd just earned. The race was the Fred Lebow Memorial, and the shirt bore a likeness of the man himself, and I wore it with pride.

Then I went home, and without having to think about it I went right to the very bookshelf where my copy of Joe Henderson's *Run Farther, Run Faster* had been waiting all this time. (Well, actually, it had been waiting in that spot for a mere eleven and a half years, because that's how long we'd been living in our apartment. Before that, it had followed me from place to place.)

I took it from the shelf and flipped to the once-blank pages at the back, where I'd logged all of my old races. The final entry for my last event in 1982 read: *8K Halloween—58:05—racewalk—#1265.*

One line down I wrote 2005, and on the line below that I printed *5 mile Fred Lebow—9 Jan—1:00:21—racewalk,* then added my bib number (*#5203*) and my pace per mile (*12:04*).

Wow.

The weeks went by and the list began to lengthen. Ten miles in Central Park on January 29. Five kilometers in Las Vegas a week later. Another race in the park, 15K, on February 13, and then a 5K in the streets of Washington Heights the first week in March.

Two weeks later came a race I'd completed once before. It was the Brooklyn Half Marathon, and I'd been in its inaugural edition in 1981; it was my fifth race as a walker, and my final race before the London Marathon. The course was as I remembered it, starting with an out-and-back couple of miles on the Coney Island boardwalk, then following Ocean Parkway through the borough to Prospect Park, where Lynne was waiting to greet me. Coming home, they let us all on the subway for free. A free shirt, a free ride home—how could you beat that?

But when I logged the race in my book, I compared my time of 2:36:04 to my 1981 time of 2:22:25. I was a little more than a minute a mile slower, and I couldn't understand it. Back then I'd just been learning to race-walk, it was only my fifth race, and my form these days was greatly improved, and—

"Honey," Lynne pointed out gently, "you're twenty-four years older now."

"Oh," I said.

Now I knew well enough that age, all by itself, was enough to knock the edge off any athlete's game. It takes a few miles per hour off a pitcher's fastball, it keeps a wide receiver from racing clear of a corner-back, and on the golf course it shortens tee shots and even makes putts a little less likely to find the cup. And of course it slows runners down. That's why they award prizes by age groups, and why runners with milestone birthdays can draw some consolation from their new status. On the day you turn forty, you stop competing with the thirty-five-to-thirty-nine crowd and set your sights on the forty-to-forty-four year olds. Cold comfort, perhaps, but better than no comfort at all.

I knew all that, but evidently shrugged it off as one tends to dismiss mortality; yes, sure, everybody dies, but I'm different.

While I wasn't quite ready to abandon the notion that I was going to live forever, I had to acknowledge that an additional minute per mile after a quarter of a century was only to be expected. In fact, all things considered, it wasn't that bad at all.

Besides, I was improving, wasn't I? Training longer and harder, working on my form. It stood to reason that I could trim a few minutes off my half-marathon time. I might not quite get it down to what it had been in 1981, but I could at least move in that direction, couldn't I?

Not that speed really mattered all that much to me. It was a way to check on how I was doing, but it wasn't important in and of itself.

What I really cared about was being able to finish a marathon.

This time I couldn't even blame the Internet. It was in a copy of *Running Times* that I learned about the Fallsview Casino Marathon, scheduled for the 23rd of October. The race would begin in Buffalo, at the Albright-Knox Art Gallery, and after a few miles in a neighborhood I knew intimately it would cross the Peace Bridge into Canada and skirt the Niagara River all the way to the Falls.

The race was on a Sunday, and the following weekend members of the Bennett High School Class of 1955

would be celebrating their fiftieth reunion. Lynne and I were planning to attend, I wouldn't have missed it for the world, and how would it feel to walk into the reunion after having just days before completed a marathon right there in Buffalo?

By the time I found out about the race and signed up for it, I had a good six months to prepare for it. That seemed as though it ought to be ample time—if in fact a 26.2-mile race was within the realm of possibility for me. I didn't know that it was, not at this stage of my life, not on these feet and legs. And as far as I could make out, the only way to find out if I could go the distance was to try.

During the cold months, I'd continued to do all my training on the treadmill. Come spring, I discovered Hudson River Park. I went on using the treadmill a couple of days a week for speed workouts, but most of the time I went to the park instead, and gradually increased my weekly long walks—ten miles, twelve miles, fourteen miles, sixteen miles. I walked to the Battery and back, I did lap after lap on the piers, and the miles began to add up.

And I kept entering races and picking up T-shirts. Five kilometers on Randall's Island, ten in Central Park. Eight in Washington, D.C., with my daughter Alison keeping me company. (My eldest daughter,

Amy, has thus far managed to avoid all of this, but lately has begun walking home from her job in Astoria to her home in Forest Hills, and taking multihour walks around town, often accompanied by her sister Jill.)

Two four-milers in Central Park, on consecutive weekends, and five miles in Summit, New Jersey. (Along with the inevitable T-shirt, every entrant received a TheStreet.com baseball cap, courtesy of Summit native Jim Cramer, the guy who does all the screaming on CNBC.)

A 5K race on Rikers Island, with the prisoners calling out to us from their cells; we had our hands stamped before the start, so that they could make sure nobody slipped out of jail and escaped in our midst. A half-marathon in Queens, starting in College Point, in which I clipped five minutes and change off my time two months earlier in Brooklyn. I was elated, my time in Queens was just eight minutes slower than my Brooklyn time in 1981, and maybe I could actually become as fast as I'd been back then. Who was going to tell me I couldn't?

Three more races in Central Park, a 10K and two five-milers. Then the Bronx Half Marathon, two minutes slower than Queens, but the course was hillier and the July heat a factor. Then three weeks without a race.

And then, the last weekend in July, Lynne and I rented a car and drove to Wakefield, Massachusetts, just west of Boston, for my first twenty-four-hour race.

Well, I'd always wanted to try one. When I first heard about it I'd told myself there'd be time enough for that sort of thing when I turned sixty. Now, seven years past that marker, I was ready to give it a shot.

I did wonder at the wisdom of attempting a twenty-four-hour race before I'd managed a marathon. I thought of the fellow who apologized for writing a long letter, explaining that he hadn't had time to make it a short one. It was a nice turn of phrase, but I'd always figured the guy was full of crap, because I've written short and long letters, short and long stories, short and long novels, and in my experience the long ones take more time. And more thought, and more energy, and more out of you.

And wasn't the same true of races? And, if I was by no means certain of my ability to finish a marathon, what was I doing signing up for something that—if you were doing it right—amounted to four marathons?

"Except I won't be trying to do four marathons," I explained to Lynne. "I'd love to go a hundred miles someday and make my bones as a Centurion, but it'll be a long time before I reach that level of proficiency,

STEP BY STEP • 317

and it may never happen. I won't be shooting for a hundred miles at Wakefield, or even half of that. But I ought to be able to cover 26.2 miles, especially if I've got twenty-four hours to do it in."

That's how I looked at it. If I could do the equivalent of a marathon, no matter how much time it took me, I'd leave the course knowing that the October marathon in Niagara Falls was within my reach. And, if I had to quit before I got that far, I'd know just how much I needed to improve in order to show up at my reunion as a marathoner.

All I can say is it made perfect sense at the time.

The Wakefield course is a 3.16-mile clockwise loop around Lake Quannapowitt, an Indian word for *You've got to be kidding.* The start is in the parking lot for the Lord Wakefield Motel, which did make life easier. We got there on Thursday, with our room booked for three nights, and at seven Friday night they got us started with an informality that made a refreshing change from the horns and gunshots that begin most races. "Okay," said the woman in charge. "Five, four, three, two, one. Go." And we went.

The organizers stage two races at once, the twenty-four-hour event (which can be entered individually, as I did, or as a relay team) and a standard marathon. The

marathoners begin with a short out-and-back run so that eight circuits of the lake will bring them to precisely 26.2 miles. Then, after three or four or five hours, they pick up their medals and go home, while for the rest of us the real race is just starting to get interesting.

Except for the very beginning, when each lap begins with a steeply downhill thirty-yard cross-country run, the Wakefield course is scenic enough, with the un-pronounceable lake forever on one's right. One stretch consists of an asphalt path through parkland, while the rest is city sidewalks, mostly concrete, running through an attractive town. For several hundred yards in the latter portion of the loop there's a cemetery between the course and the lake, but you don't have to hold your breath on your way past it.

They had a food tent near the start, and a drinks table with water and Gatorade, and a little more than halfway around the course they'd placed a second drinks station. Volunteers staffed these posts, and others sat at tables recording your number whenever you completed a lap. Since an unrecorded lap would be an uncounted lap, I made a point of calling out my number loud and clear as I came across the line. "Three-oh-four," I'd cry, and someone at the scoring table would echo me for confir-mation, and I'd drink the cup of water Lynne handed me and head out on my next lap.

In the early going the course was cluttered with marathoners, some of them reeling off six-or seven-minute miles, and the slowest of them still much faster than your average geriatric racewalker. I bore them no ill will, but it was a pleasure to see the last of them.

They all finished their marathon long before I finished mine, which I did somewhere in the course of my ninth lap. But here's what I wrote the week after the race, in a report I posted on a marathon walkers Internet board:

LAP SEVEN: 11:46 P.M. 22.12 MILES.

A mind, we've been told, is a terrible thing to waste. Well, maybe, but it's even worse to listen to. Mine is telling me two things—that I'm going to be able to finish the marathon, and that maybe that's enough. After all, I haven't gone this far since 1981. What am I trying to prove?

I set three goals before the race—to finish a marathon, to extend it to 50 kilometers, and maybe with divine help and a good tailwind, to log 50 miles. Not only did I set these goals, but I went and told people about them. How can I stop now?

LAP EIGHT: 12:29 A.M. 25.28 MILES.

There's an indication on the course of where the marathon finish line is for ultrarunners, but I only

learn about this later. My best calculation is that I clock 26.2 miles in roughly 5:50. Faster than I'd planned. Too fast?

LAP NINE: 1:13 A.M. 28.44 MILES.

I never consider stopping after nine laps. Just one more lap and I've made 50 kilometers, my second-stage goal and significantly farther than I've ever raced in the past. All I have to do to get there is keep going, and that's what I do. "One more makes 50 K," I tell Lynne, and off I go.

But it's getting difficult. My body's holding up well enough, but my mind is giving me trouble— and I can recognize the problem as such. What stops people in races like this, I remind myself, is very often a lack of mental toughness. And right now I lack mental toughness. I'm trying to find a reason why I should stop.

LAP TEN: 1:55 A.M. 31.6 MILES.

I've done 50 kilometers in seven hours, and I want to sit down. Actually I want to stop. I don't feel sleepy, it's not that kind of exhaustion, but something gets me over to the chair and I sink gratefully into it. I gulp Gatorade and chase it with water, and decide to change my socks.

I'm wearing two pairs, a thin pair of toe socks to keep the toes from rubbing against one another and an outer pair for cushioning. I take off both and replace them with fresh ones, and I think Lynne brings me something from the refreshments table, but I can't remember what. And I just sit there. Lynne asks me if I'd like to go to the room so I can stretch out, and I'd love to, but I'm not really ready to stop.

There's a New York Road Runners race in Central Park in late November, a 60K, and I've been planning on doing it. Two more laps would give me 60K now. Can't I manage that? Sheesh, just two laps.

I get up and head out. Of course everything hurts now, all I can do is hobble, with my calves and hamstrings all knotted up. I pause in the parking lot and use a car to support me while I stretch out my calves, and that helps, though not much. I take a few more steps and realize that my right foot is not happy. The toes are horribly crowded. I take off that shoe, peel off the outer sock, put the shoe on again, and press on.

That's better.

During this lap, I exchange greetings along these lines with a passing runner. We'd talked before the race, and now he mentions that he's

back after having stopped and slept for an hour. God, imagine stopping. Imagine sleeping . . .

LAP ELEVEN: 3:04 A.M. 34.76 MILES.

I've finally worked out how to slow my pace. Just keep going for 55 kilometers and it slows by itself. The tenth lap, as I'll find out later from Lynne's careful record keeping, took 42:05; the eleventh takes 47:15.

And it's hard to keep going, hard to do it right. I can feel that I'm bending forward and struggle to maintain proper posture, but it's difficult, and my back's not up to it. It's also difficult to maintain the arm swing that facilitates the hip pivot and lengthens the stride. There are stretches during this lap when any racewalking judge would DQ me without hesitation.

But I keep going. And my form and posture improve markedly when I turn the last corner and head for the finish line, where there'll be people to watch me.

Ah, ego. Only avarice can match it as a motivator.

Lap Twelve: 3:50 a.m. 37.92 Miles.

Sixty kilometers completed, and I go straight to the chair and lower myself gingerly into it. I've gone ten kilometers beyond my second goal, and

am only four laps from my dream of fifty miles. I remember the fellow who took a nap and got back on the course. If I stopped now, would I come back? Do I give a rat's ass? I tell Lynne I want to lie down, and we go to the room.

I'm in desperate need of a shower. It's cold and clammy outside; you sweat and it doesn't evaporate. But all I want to do is lie down. I leave my shorts and singlet on, shuck my shoes, leave my socks on. And stretch out.

Lynne asks if she should set the clock and wake me in an hour. I tell her to make it an hour and a half. I close my eyes, and I'm gone.

5:20 A.M. RESUME SPEED.

Remarkably, I hear the clock; even more remarkably, I hop out of bed immediately, knowing that I want to do my four laps. That will bring me to fifty miles. I never really believed I could go that far, and I don't entirely believe it now, but it's only four more laps. Lynne is ready to go out there with me, but that's carrying support to an absurd level. I convince her to go back to bed, that I'll be fine out there on my own. She's not all that hard to convince.

After a sponge bath, I get out on the course again. Earlier, I'd looked forward to watching the

324 • LAWRENCE BLOCK

sky lighten as I walked on through the night and into the morning, but it's too late for that; it's already light out. And it's like, well, duh, night and day. I'm walking with good form, standing tall, and zipping along, and I feel uncommonly good about the whole enterprise. I don't have my lap times for the next four laps, as my record keeper's getting a well-deserved rest. But I think my pace is about the same as it was at the start of the race.

I do two laps and stop to bandage a couple of blisters. While I'm at it, I put Band-Aids over my nipples. As a child I'd wondered why men have them, and now I know: it's so they'll get rubbed raw from friction with the fabric of your shirt. This never happened in the past, but then I've never walked this far before.

At the food tent, I discover a boundless capacity for junk food, which they have in good supply. In real life I stick with Atkins, which works perfectly for me, but an ultra strikes me as a perfect excuse to gorge myself like a pig, and I do. Oreos? Peanut butter and jelly? Oatmeal cookies? Doughnuts? Bring it on! And, *mirabile dictu,* they've got coffee! And I can take my time eating, because all I've got to do is two more laps and I'm done, with

fifty miles in the bank. I have a second cup of coffee and get back on my feet.

LAP SIXTEEN: 8:57 A.M. 50.56 MILES. DONE.

It's fourteen hours and two minutes since the start of the race, and I've gone around that lake 16 times, and that's fifty miles. (50.56 miles, to be precise.) I'd figured it would probably take me a good thirteen hours to go that far (assuming I could manage it at all) but I hadn't allowed for a nap.

I feel wonderful. Sheesh, I just walked fifty miles.

I go to the room, where Lynne is awake. I strip, shower, get in bed. She asks when she should wake me. I tell her not to bother.

It's almost one o'clock when I wake up. There's over six hours left in the race, and no real reason why I can't add to my mileage total. After all, another four laps would bring me to 100 kilometers.

I never mentioned this to anyone, never even said it out loud to myself, but before the race it seemed to me that 100K—62 miles—might actually be possible. And now I'm pretty sure I can do it.

Outside, the sun's blazing away. At 9 a.m. it was completely overcast, but now there's not a cloud in the sky, and it's pretty hot out there. I decide to wait until at least two before I go out, and wind up hanging out in the room until closer to 2:30. I'd just as soon not spend that much time under the midday sun, as there's virtually no shade on the course.

I remember some words of advice in another ultrawalker's prerace email. He talked about the difficulty in getting through what he called the mental twilight of hours 16–18. No problem for me—I just slept right through 'em.

2:30 P.M.

I pin my number to my shorts, leave my singlet in the room, and head on out barechested. I'm stiff and sore at first, of course, but able to walk, and I have to say the sun feels good. And four laps seems a manageable distance. But I find myself letting my arms drop from time to time. My legs turn over at about the same speed as before (I know this from step-counting; I gave up keeping a running total back in the eighth or ninth lap, but still find myself counting breaths on each lap more often than not; it gives the mind something to do, and

also gives me a sense of where I am in the lap) but my stride is shorter, and it takes me more breaths (which is to say more steps) to finish a lap.

Interesting.

Interesting, too, that my lats are sore now from the arm pumping. Never happened before. Chalk it up to the distance.

LAP SEVENTEEN—53.72 MILES.

I polish off the lap and keep on going. Early on I move up on a runner, and he matches my pace, and for the first time in the entire race I'm walking side by side with somebody. His name is Paul, and we get to talking, and it's fascinating. This lap, #18 for me, is #28 for him. He's been at it without a break, but this is the last lap for him, because he has to leave early in order to get to the airport in time to catch his flight to San Francisco, where he's entered in the San Francisco Marathon in the morning.

Two weeks ago he finished Badwater. That's the one across Death Valley where you have to run on the painted lines on the road so your shoes don't melt. And now he's running 28 laps, which is something like 88 miles, and then he'll fly across the country and run a marathon.

Later, I check him out and find out he's just a kid. That explains a lot. I mean, the guy's only 58.

He compliments me on my pace and says he's afraid he's not going to be able to keep up with me. I tell him I've been pushing myself to keep up with him, and that I don't know how long I'll be able to hold the pace. There's a point where I tell him I'm going to let him go ahead, and he does, and I walk along in his wake, impressed by the easy economy of his running style. Then there's a point where he switches to a walk, and although I've dropped out of racewalking form at this point, I still walk faster than a walking runner, and I pass him. I wind up resuming racewalking for the last mile or so, and wait at the finish line to wish him well; he comes in two or three minutes after me, and while he collects his medal and looks around for a ride to the airport, I swig some more Gatorade and get back on the course.

LAP EIGHTEEN—56.88 MILES.

Two more laps. On the nineteenth lap I mix walking and racewalking, pumping the arms for a while, then letting them drop for a while. There's really no hurry at this point. My legs are sore, and my feet hurt some, so it'll be good to stop, but

there's no rush. All the same, I'm not about to slow down and smell the flowers, or anything else.

Perhaps half a mile from the end of Lap 19, the thought comes to me that, if this is as bad as it's going to get, I'm not going to have a problem knocking off one more lap after this one. And, swear to God, within fifteen seconds of having this thought, all of a sudden I'm getting a pain in the little toe of my right foot unlike anything that's preceded it. It just plain hurts like murder with every step I take.

It doesn't really stop, but it doesn't get any worse, and it gets easier to bear as I keep going. Besides, nothing's going to stop me now.

LAP NINETEEN—60.04 MILES.

I stop to drink something, then announce, "The gun lap!" and start in again. Again, I mix walking and racewalking, but it's mostly racewalking this last time around, and when I turn the corner for the homestretch I'm racewalking all out, and really pumping, and am purely delighted that I've got enough left for a finishing kick.

LAP TWENTY: 5:38 P.M. 63.2 MILES.

"You've got time for one more lap," a race official tells me. That strikes me as the funniest

thing I've ever heard. I laugh and pass him, go to the scorers' tent, tell them I'm through for the day, and get my finisher's medal. I engulf some more food, suck down a packet of PowerBar Gel, eat an energy bar, grab some candy, and otherwise do what I can to make Dr. Atkins spin in his grave.

Back in the room, Lynne tells me one of the officials asked her if she thought I'd be back next year. "Well, there are two possibilities," she said. "either you'll never see him again or he'll be back every year. It could go either way."

How well she knows me.

After a shower and a little downtime we go out again to watch the finish. There's a photo op, a trophy being presented to the overall winner, a guy in a singlet with flames on it who ran straight through without a break and clocked 40 laps in the time it took me to do 20. I can believe it, as he seemed to pass me every lap or so. I never did catch Flame Guy's name, but I tell Lynne there were no flames on his singlet when he started out. It was his incendiary speed that did it.

I wonder if there's anyone my age or older who covered as many miles as I did. Lynne says one fellow who looked older logged 21 laps, and I tell her it's just as well I hadn't known that, or I

probably couldn't have kept myself from going around one more time.

We stay over that night, and visit friends in Connecticut on the way home. They steer us to a celebrated ice cream place, so I can replace fat and carbs expended during the race. Actually, I've replaced enough of both to sustain me for another thousand miles, but the ice cream here is supposed to be special, and it seems silly to pass up something good after all the garbage I've ingested in the past 48 hours.

It lives up to its billing. "Some sins are worth the price," Lynne says.

TUESDAY AFTERNOON

I've never felt a greater sense of accomplishment than I did at the conclusion of the race, and it hasn't faded. I wound up with bad blisters on my right heel, but the cushioning I applied kept me going, and I didn't have to break them after the race was over; by now they're absorbed. I did have to do some surgery on a few toe blisters, and one toe's a mess, but it's manageable. Yesterday I was hobbling around, and didn't even attempt a training walk, but I couldn't see any reason not to go to the gym, where I did an upper body workout

that did me a world of good. I also got on the elliptical trainer, because I was surprised to discover in the course of the race how much of a beating my quads took. (In training walks and shorter races, my quads are just fine. Chalk up another one to distance.) Turned out using the elliptical trainer (ET?) was utterly pain-free. I've used it a little in recent months, and it does work the quads nicely, so I'm going to try to put in more time on it in the future.

Today I'm not limping anymore, and might try a short walk now. We'll see.

I do natter on, don't I?

And now I see a post on the Ultrawalking board from Ollie, who has convinced the folks at an end-of-November 24-hour race outside of Dallas to include a walker category, thus conveying Centurion status on anyone completing 100 miles in the 24 hours. There'll be judges, but the only requirement will be that one foot is in contact with the ground at all times. (Most of the time, I've got both feet in contact with the ground.)

It's been said of marathons, as of childbirth, that you're ready to do it again when enough time has passed so that you've managed to forget how

horrible it was the first time. And that clearly hasn't happened yet. And there's no way I could manage a hundred miles in 24 hours.

But my form would pass the judging. And I ought to be ready for another long 'un about then.

I have to say I'm tempted . . .

It was not quite three months later when Lynne and I drove up to Niagara Falls and checked into a hotel on the Canadian side. On Sunday morning, a fleet of buses carried the entrants across the border to Buffalo's Albright Knox Art Gallery, perhaps a mile from the apartment where my mother spent the last twenty-some years of her life. A few hundred men and women in shorts and singlets spent an hour looking at abstract paintings, pausing now and then to tie their shoes or dash to the bathroom. Then we went outside and lined up in the cold rain, listened to two national anthems, and began the running of the Fallsview Casino Marathon. The course looped around one of the city's more attractive neighborhoods for a couple of miles before taking us across the Peace Bridge to

Canada; then it hugged the shore of the Niagara River all the way to the Falls.

I crossed the start line, and in due course the bridge, and, after five hours and forty-five minutes, the finish line. It was an ordeal; I pushed myself, hoping to come in under six hours, and the wind and rain took a lot of the joy out of the day. But I was never in any doubt that I'd finish. It was, after all, just a marathon.

Why would anyone be masochist enough to take part in an ultramarathon? Why put in the interminable hours of training, only to punish oneself for still more hours over fifty or a hundred kilometers, or fifty or a hundred miles? Why trace endless circles around a lake for twenty-four hours?

(Or even longer. There's another whole category called multiday races, and the meaning of the term is easier to make out than the motivation of the participants. Forty-eight-hour races, seventy-two-hour races. A six-day race in a park in Queens. A 3,100-mile race—yes, you read that correctly—also in Queens; a friend of Andy Cable's participated one year, and Andy reported to me that although the winner had already crossed the finish line, his friend still had a little over five hundred miles to go. Think about that, will you? The race is over, the winner's lying down with his shoes

and socks off, and this chap's still got to run from St. Louis to Kansas City and back again.)

Why subject one's body and soul to this sort of thing? Ultramarathoners have tired of the question, but if you get one to respond he may tell you that the requisite discipline gives direction to his life, that pushing beyond his own barriers expands his sense of the possibilities, that the long hours on the course are a veritable spa session for his spirit. Flowery and/or cryptic explanations are commonplace; the loneliness of the ultrarunner does seem to put one in touch with one's inner poet, one's inner philosopher, one's inner Hallmark card.

You need a reason? Here's one. Complete one ultra and you can drop this three-word phrase into conversations for the rest of your life:

Just a marathon.

The Wakefield race gave me a lift unlike anything else I can recall. I have never in my life had a greater sense of accomplishment. A friend gave me a look when I told him as much. I'd published all those books, he reminded me. I'd traveled all over the world. Those, it seemed to him, were real accomplishments, and I actually thought a night and a day walking around an unpronounceable lake somehow put them in the shade?

Well, yeah, and I think I know why. I had vastly exceeded my own expectations, had done considerably more than I believed I was capable of. I'd expected to cover marathon distance, intended to go fifty kilometers, dreamed of somehow covering fifty miles. But I never even entertained the fantasy of a hundred kilometers, and yet I'd somehow reached and passed that distance. I told him as much, but I'm not sure he got it.

But he was by no means the only person I told. You know the story about the elderly man in the confessional, reporting in vivid detail about his affair with a young woman a third his age? "Excuse me," the priest says, interrupting, "but from the way you express yourself, it's my impression that you are Jewish."

"I am," says the old man.

"Then why are you telling me this?"

"Father, I'm telling *everybody!*"

I too was telling everybody, partly out of pride, but as much out of a need to tell myself. Because my mind kept doing what it could to minimize the accomplishment. An inner voice kept telling me that I hadn't really done what I thought, that I'd stopped to sleep, that I'd quit the course when I still had time for another lap, that I'd just gone through the motions. I had in fact gone through those motions for 63.2 miles, but the

voice remained unimpressed. If I'd done it, how hard could it be? And what could it possibly amount to?

I came home from Wakefield with sore muscles and blistered feet, but nothing that didn't mend in fairly short order. I eased back into training, and entered two half-marathons as a run-up to the marathon, one in Jersey City in September and another in Staten Island a week before the Niagara Falls race. The Staten Island race was just a long training run as far as I was concerned, my last before the marathon, and I took it at an easy pace.

After the marathon, Lynne and I hung around in Buffalo for my fiftieth reunion. I don't suppose I hid the fact that I'd completed a marathon a week earlier. I might even have dropped the phrase *just a marathon* into a conversation or two. It wouldn't surprise me.

My Wakefield race report notwithstanding, I didn't give serious thought to the November Ultracentric race in Texas. That same weekend, New York Road Runners was holding a 60K race in Central Park, and I decided to take a shot at that instead.

I showed up for it on a cold Sunday morning, and the crowd at the start provided a pretty good indication of the difference between ultramarathons and shorter

races. The club holds races in the park all through the year, most of them ranging between four and ten miles, and there are always several thousand men and women who show up for the challenge and the T-shirt. Just three weeks before the 60K, some thirty thousand people had massed at Fort Wadsworth in Staten Island for the New York City Marathon, and they constituted the mere fraction who'd either qualified for the race or won the lottery; there'd have been well over a hundred thousand runners if they'd been able to accept all applicants.

There were perhaps fifty hardy souls gathered at Fifth Avenue and Ninetieth Street for the start of the Knickerbocker 60K.

Isn't that remarkable?

Granted, the New York Marathon has a lot going for it. It's an important race with an international reputation, held on a scenic course that traverses the five boroughs and draws enthusiastic spectators throughout its route. The Knickerbocker, in contrast, consists of nine four-mile loops of the Central Park course, plus a brief out-and-back at the start to make up the 37.2-mile distance. There was no press coverage, no TV cameras at the start, no crowd support, no band playing. A drink table at the start and another halfway around the loop provided water, Gatorade, and the ultrarunner's favorite, flat Coke.

You didn't even get a T-shirt.

Still, wouldn't you think that a few of the tens of thousands denied entry to the marathon would have chosen to run eleven miles farther for a tenth the entry fee?

For me, the Knickerbocker was more of a challenge than I would have preferred, because time was a factor. The crew would cease manning the finish line after eight and a half hours, and if you took longer than that, you wouldn't get your time officially recorded. It's a little difficult in retrospect to figure out why this mattered to me, but it did at the time, and I was determined to get in under the wire.

Now that's not a terribly stringent time limit for a runner. If you're in shape to run the distance, you can certainly do so in the allotted time. For a walker, and a geriatric one in the bargain, covering that many miles at a 13:30 clip takes some effort. My pace had been faster in all the year's previous races, and was 13:10 at Niagara Falls, but this race was almost half again as long, and the colder weather meant more clothes, which ate up time whenever I stopped to pee.

The result was that I had to push myself more than I would have liked. The most pleasant part of a long race is the time spent at cruising speed, when you can

just relax and go with the flow. I couldn't allow myself to do that, I had to walk at the leading edge of my comfort zone, and that took the joy out of it. But I crossed the line at 8:21:50—and, remarkably, there were a few souls who took even longer than I did.

A week later I was back on that same park loop for a four-mile race. That wrapped up 2005, and my records indicate I took part in twenty-five races, with a total distance of 277.2 miles. On the second Sunday in January I returned to the park for the Fred Lebow Memorial five-mile race, the same race that I'd started off walking a year earlier. Then my time had been 1:00:21; now I was able to cut that by almost three minutes, to 57:36. And a week later I flew to Mobile, Alabama, for what promised to be an interesting race . . . even though it was, after all, just a marathon.

Why Mobile?

Well, what I read about the race sounded good. And it came at the right time, three weeks before the Mardi Gras Marathon in New Orleans. And it was in Alabama, and if I intended to rack up a marathon in every state, I'd have to include Alabama sooner or later. It was, after all, first alphabetically. I couldn't start there, I'd already logged three states (all of them beginning with *N*) a quarter of a century ago, but I could certainly kick off 2006 with Alabama.

And did I intend to knock off marathons in all fifty states?

There was, I had to admit, a certain appeal to the notion. I'd read about runners in the grip of this particular obsession, and I have to say they sounded like

my kind of people. They'd organized a club, which promptly schismed itself into two clubs, one for runners trying for fifty states, the other adding the District of Columbia to the mix. (Most of the Fifty-Staters seem to belong to both clubs.)

Here's one thing these folks managed a couple of years ago. Frustrated by the lack of a marathon in Delaware (The First State, according to the license plates) they drummed up local support and managed to organize one. At its first running, a handful of Delaware residents turned up, and so did a vast crowd of maniacs from all over the country, thrilled at the opportunity to add this elusive state to their list.

How could a man who'd spent a couple of years driving from Buffalo Gap, Saskatchewan, to Buffalo Corners, Pennsylvania, by way of Buffalo Springs, Texas, and New Buffalo, Michigan, fail to be moved by all this? I found their pursuit a laudable one, and in fact I seemed to recall that it had occurred to me back in my first marathon year of 1981, when along with England and Spain I'd nailed North Dakota, New York, and New Jersey. I'd thought then that I might add other states until I had them all—but instead I gave up the pastime altogether.

I don't know how committed I felt now. Was the goal realistic for me? Could I hang in there long enough to

get all the states? If I managed five races a year, I was looking at a ten-year project. Would I still be capable of covering twenty-six miles in my late seventies? Would I feel like trying?

There was no way to answer those questions. In the meantime, though, if I was going to be entering marathons anyway, why not pick ones in different states? And why not start in Mobile?

Mobile had another thing going for it. It was one of a handful of marathons with a racewalking category. In both of the day's races, the marathon and the half-marathon, judges would be stationed on the course to make sure that entrants in the racewalking division adhered to the rules of the sport, and the fastest male and female walkers would be awarded prizes.

I'd thus far been careful to avoid racewalker contests in New York, suspecting that my form would get me disqualified in a dedicated walking event. For all I knew, that might happen at Mobile, but if it did I'd simply be bunched with the runners in the scoring, and it would still be a marathon, and I'd still get the T-shirt. And I had the feeling the judging wouldn't be as strict as it might be in a race exclusively for walkers.

It was a very enjoyable race; the weather was good and the course an attractive one. Some people com-

plained about the hills, but I found them manageable after all those races in Central Park. My performance pleased me; I'd wanted to trim a little time off Niagara Falls' 5:45, and had wistful hopes of breaking 5:30. I finished in 5:21:10, good enough for second place in the male racewalker division . . . but there were in fact only three walkers, two men and one woman, so it's not as though I actually beat anybody. (A dozen or more walkers participated in the half-marathon.)

I didn't have to beat anybody to feel elated with my accomplishment. I went home in triumph, and eventually my award arrived, a sort of abstract collage of colored paper. It came framed, but the glass was broken by the time it arrived, because it had simply been tucked into a manila envelope and dropped in the mail.

"What kind of moron would do that?" Lynne wondered.

"A bona fide one," I told her, explaining that the awards had been handmade by the residents of a home for the retarded, one of the race's beneficiaries. She felt awful. I, on the other hand, felt proud, and found a spot on a shelf for my prize.

A week after Mobile, I walked a ten-mile race in Central Park, and followed that a week later with the Manhattan Half-Marathon. Then Lynne and I flew to

New Orleans for her first look at her hometown since Hurricane Katrina . . . and for my first shot at the Mardi Gras Marathon.

Katrina had severely reduced tourism in the city, but you wouldn't have known that from the turnout for the race. Like Mobile, it recognized walkers with a separate section, and at registration I received not one but two numbered bibs; racewalkers were to wear them fore and aft, so that they could be readily distinguished from runners by the officials and judged accordingly.

I didn't expect to win anything this time. There were more entrants, so I couldn't pick up a prize just by showing up and reaching the finish line. Nor did I expect to beat my time in Mobile. Everything had gone right at that race, and I'd somehow managed to clip fifty-five seconds per mile off my Niagara Falls time, and I doubted I could do that well again.

Still, the course here was flatter than Mobile. So maybe I could stay under five and a half hours.

When I try to remember the race, what I recall most is how often I had to stop to pee. I greeted the dawn, as I often do, with a cup of yerba maté, and I didn't have any breakfast, and consequently for the first two hours of the marathon I had a tougher time passing a tree than a German shepherd with a kidney ailment. They had Porta Johns set up along the course every mile or so,

but during the first half of the race there were always a couple of people waiting in line, and that struck me as an insupportable waste of time.

I mean, this is a race, isn't it? Do you see anybody standing in line for the trees? Like, do the math.

In a line for the Porta Johns at the staging area for a race in Staten Island, I heard one young man announce expansively to his companion, "The whole world is my urinal."

When I remember the races I ran a quarter-century ago, I can't seem to recall a single occasion when I paused somewhere between the start and the finish line to relieve myself. To be sure, memory is a selective process, and it's certainly possible that I've simply forgotten the pit stops my early marathons required.

But I remember the imperative need to pee in the minutes before a race. That was something everybody evidently needed to do, even more urgently than we all had to tie and retie our shoelaces. Much of that was probably attributable to anxiety, and whatever its cause, the starter's pistol put a stop to it. Once it went off, I was done tying my shoes, and no longer noticed that they were too loose, or too tight, or whatever I'd decided they were a moment before the gun went off. And, as far as I can remember, I was done peeing, too.

But is it possible that I ran and walked whole marathons without being interrupted by a call of nature? London, Madrid, North Dakota, New York, New Jersey—I'll tell you, I'm pretty sure I finished them all without once stopping for a pee.

Actually, the length of the race hasn't got that much to do with it. There's a point in the course of a long race when that particular system seems to shut down. The dehydration resulting from perspiration may have something to do with it. Even now, I'm generally able to sail past the Porta Johns during the second half of a marathon.

But by then I may already have christened any number of trees.

Ah, the special pleasures of the golden years.

For all the stops, I was making good time on the streets of New Orleans. I was very much aware of the race-walkers who were my competitors, and pushed myself to keep pace with this one and edge ahead of that one. It was frustrating the way I would gain ground by pressing and give it back when I made a pit stop. There was one walker I kept overtaking time and time again.

More than half of the walkers were entered in the half-marathon, and left the field after 13.1 miles, upon returning to the Superdome. The rest of us kept going,

pushing up Prytania, circling Audubon Park, then backtracking on Prytania to the finish line. On my way up Prytania, I spotted one walker who was already on his way back. There were a couple of others out in front of me, and in the final quarter of the race I began to overtake them. I wasn't going faster, but their pace had slowed more than mine had, and I was now able to pass them.

In the final mile, I caught sight of a walker a little ways ahead of me. I pressed, and picked up speed, and drew even with him, whereupon he kicked it up a notch. We raced side by side for fifty or a hundred yards, and then I surged and pulled away from him, and somehow knew I wasn't going to see him again that side of the finish line.

I finished with a net time of 5:17:26, almost four minutes faster than Mobile. Once again I'd taken second place in the male racewalking division, but this time around I was second of eight or nine, not second of two. (To keep things in perspective, the winner was a young man from the Florida panhandle who beat me by about forty minutes.)

It had been a wonderful race, and I came home suffused with a sense of accomplishment and great hopes for the future. My last marathon in 1981 was the Jersey Shore; that, you may recall, was the one I had

to finish in five hours in order to be sure of a jacket. I'd racewalked the whole distance in four hours and fifty-three minutes, a mark I never expected to hit again.

But who was to say it was forever out of reach? If I could reduce my time by a minute a mile, I'd get all the way down to 4:51 and change. A minute a mile was a lot, and might well prove impossible, but it seemed to me I had room for improvement. My pace at New Orleans was 12:07 minutes per mile, and back in June I'd managed a pace of 11:18 in a five-miler in Central Park, and my pace in the Queens Half Marathon was only ten seconds a mile faster than that. I'd finished that Queens race with a time of 2:30:22, and the same pace would put me less than a minute over five hours.

Maybe I could break five hours, maybe I could even break 4:53 and set a new personal record for the distance. It seemed impossible, but less so than it had before New Orleans.

Why, the pure deep-down recognition of one's potential makes possible the realization of that potential. Consider the four-minute mile, an impossible barrier until Roger Bannister broke it. And then, almost immediately, no end of other runners found themselves breaking that impossible barrier. Because they knew it could be done.

5:21 in Mobile, 5:17 in New Orleans. I might never break 4:53, or even five hours, but I could certainly get closer, couldn't I? I could certainly keep on improving. I could train harder, concentrating on both speed and distance. And I could skip the yerba maté on race mornings, and put something in my stomach. Something salty, say, that might encourage my system to hang on to water instead of sprinkling it on every convenient tree.

I could keep my weight down, and maybe even trim it a little. I'd read somewhere a marathoner's rule of thumb: one pound equals one mile. Lose ten pounds and you'd shave ten minutes off your time in the marathon. Obviously this only works up to a point, you can't drop a hundred pounds and challenge the Kenyans, but it's hard to argue with the premise that the less weight you carry, the more rapidly you can carry it.

There's a notion that marathoners are thin, and you'd subscribe to it if you should limit your marathon-watching to the first group across the finish line. The winners range from fashion-model lean to anorexically gaunt. Stick around for a look at the back of the pack and you'll see men and women a lot closer to the national average. There may not be anyone morbidly obese, but a good number of runners will qualify as chunky, and you'll see Fifty State T-shirts on some of them. Some

races even have separate categories for heavier runners, with prizes to the fleetest. (The men are identified as Clydesdales, the women as Athenas, and you have to wonder who thought that one up. A heavy man's a plow horse, you say, and a heavy woman's a goddess? Well, okay, I guess. Whatever you say. But who knew the original Athena was a porker in the first place? Sprung full-blown from the brow of Zeus, wasn't she? Must have been a load off his mind. *Rim shot!*)

Running can take off pounds, but eating can easily balance the equation, and it's possible to knock off a couple of marathons a month without ever losing an ounce. Run a few miles, eat a pint of Ben & Jerry's. Hey, no problem.

But if I knocked off the miles and skipped the Cherry Garcia, I could show up a few pounds lighter and walk a few seconds per mile faster. Age was supposed to be a factor, but I'd continued to grow older since I'd resumed racewalking a little over a year ago, and my times were dropping in spite of it. I was already down to 5:17, so who's to say just what my limit might be?

Ah well. The mark I set in New Orleans, as it turned out, was one I would never surpass.

When I flew home from New Orleans, I was delighted with my performance even as I dreamed of trimming my time. But when I flew to Texas three weeks later, I wasn't thinking about time. This race was all about distance.

The Houston Ultra Weekend consisted of a whole menu of races, all taking place on a comfortingly flat two-mile asphalt loop in Bear Creek Park. In addition to the twenty-four-hour race, there were six-, twelve-, and forty-eight-hour events, as well as a 100K run. I was signed up for the twenty-four-hour, scheduled to start at eight Saturday morning, and when I got to the course Friday afternoon to pick up my number, the forty-eight-hour race was already under way, and its eight intrepid participants were dutifully putting in

the miles. They'd pitched their tents in the infield, so that they could take periodic sleep breaks. I had a hotel room, and went to it.

Saturday morning I met my fellow twenty-four-hour entrants, and there were seven of us—six walkers and a solitary runner. Two certified racewalking judges were on hand to make our race a Centurion event, and Jens Borello had come all the way from Denmark in order to qualify as an American Centurion. (He'd already achieved this distinction in the UK and on the European continent, and has since managed the feat in Australia.)

I knew three of my fellows, although I'd only met one of them before in person. That was Beth Katcher, whom I knew from an online message board, and who'd been on a family trip to New York the last weekend in January. We met by arrangement Sunday morning for a walk along the Hudson, and shortly thereafter she signed up for Houston. I knew Andy Cable and Ollie Nanyes from the boards, too, but was meeting them for the first time.

Just as the forty-eight-hour race hit its halfway mark, ours began.

An hour or two later, so did the rain.

It would have been a perfect race without the rain. It was cool, but not cold enough to require extra clothing.

The course was as flat as the North Dakota Marathon, and the park was an ideal setting, private and scenic and entirely free of traffic. The relative abundance of walkers made us feel like full-fledged participants, not like curious slow-moving drones in a hive of runner bees.

I hadn't had any races since New Orleans, and my legs and feet were in good shape. I got off to a good start and set a fairly brisk pace, on the high edge of my cruising speed. If nothing went wrong, I stood a good chance of achieving two of my three goals.

My first goal was to win an Ulli Kamm award, the designated prize for any walker who reached one hundred kilometers within twenty-four hours. I'd done better than that at Wakefield in July, and if I did it again I could get a plaque for it. My second goal was to circle the track thirty-two times, log sixty-four miles, and thus improve on Wakefield's 63.2 miles.

My third goal was the same as Jens Borello's, the same indeed as every walker's. I wanted to go a hundred miles. I wanted to become a Centurion.

Did I have any realistic hope of going that far? It seemed to me that the question could only be answered out there on the course. I'd need an average pace of just under fifteen minutes a mile, and a good cruising speed for me was somewhere between thirteen and fourteen

mpm. Mathematically, then, it seemed feasible, until you took into account the extent to which fatigue would take its toll in the latter portion of the race.

I didn't really think I stood much of a chance. And any hope I might have had was quickly washed away.

The previous day, a race official had warned me about rain. It was a perfect course, he said, or would be except for one small flaw. Rain pooled up on it instead of running off. If it rained hard or long, standing water could become a problem.

It rained long, and some of the time it rained hard, and believe me, the standing water was a problem. It formed puddles several inches deep, and there were places where they blocked the path completely. You had no choice but to splash right through them.

My shoes and socks got soaked. It's a good deal more enjoyable to walk with dry feet than with wet ones, but that's the least of it; enjoyment, after all, doesn't really enter into it in a twenty-four-hour race. More to the point, it took longer for my wet feet to carry me around the course.

I found this out almost immediately, once I'd sloshed through a few puddles. My leg speed stayed the same, as far as I could tell, but my stride was shorter, and I was thus taking more steps to cover the same distance.

And how, you may ask, did I know this? Well, see, I was counting my steps.

It pains me to admit this. Back in the fall of 2004, when I was starting each day on the treadmill at the gym, I got in the habit of counting my steps. (More accurately, I was counting my breaths. Ever since those mid-1970's sessions in Washington Square Park, I'd synchronized my breathing with my stride, six steps to a breath—inhale *left right* exhale *left right left right*. And so I would keep a running tally in my head—in-hale *one-thir-ty-two* in-hale *one-thir-ty-three*. And so on.)

I'm not entirely sure why I took up this clearly aberrant behavior. I was on a treadmill, for God's sake, with a set of gauges to keep me constantly informed of my time and distance. It seemed to give my mind something to do, and yet the process soon became sufficiently automatic to allow my mind to entertain other thoughts without losing track of my count. There was an exception; if I became caught up in some sort of arithmetical computation, that new set of numbers might knock me off my step count. Otherwise, though, I could hang in there with Rain Man himself, able to tell you when it was five minutes until Wapner.

When I moved from the treadmill to the streets, my curious habit actually served a purpose, acting as a

built-in pedometer. When my count reached three hundred, I knew I'd gone a mile. On long training walks over an unfamiliar course, I was able to estimate how far I'd gone, and to know when I'd reached my goal for the day. Admittedly, a glance at my wristwatch would have given me an adequate ballpark figure, and eventually I was to abandon the step count, forget about distance, and concern myself only with the time I spent training.

In races, my step count started as I strode across the starting line. Courses typically have mile markers to let you know where you are, but my count let me know how close I was getting to the next mile marker. Once, in an eight-kilometer race on Randall's Island, I knew the markers had been misplaced when I reached a count of 350 between two of them; others were worried about their pace, but my count provided reassurance. Another time, in a longish race in Central Park, the volunteers began closing up shop while some of us were still on the course and snatched up the mile markers before we reached them. My count let me know where they used to be. I can't say it got me across the finish line any faster, but it was a comfort to know where I was.

I counted in long races, but modified my approach. In marathons, I started my count anew at each mile marker. At Wakefield, I stopped keeping a total and just counted each lap. That's what I was doing in Bear

Creek Park, and that's how I knew my stride was shorter with my feet soaked. My feet were sliding around in my shoes, and my shoes were getting less traction on the wet pavement. I was using something like twenty or thirty more six-step paces to the two-mile loop.

Either my watch or the official clock would have told me it was taking me a little longer to circle the route. My count told me why.

I'd brought an extra pair of shoes, and a couple of pairs of socks, but I couldn't see the point of changing them. There was no avoiding the puddles, and dry shoes would be waterlogged before I'd gone a mile.

I kept going. Until the rain changed things, I'd been on pace to hit fifty miles a little before the twelve-hour midpoint of the race. That didn't mean I had a shot at a hundred miles, because I couldn't possibly sustain that pace through hours thirteen to twenty-four, but it suggested that the Ulli Kamm award was a sure thing and I might improve on Wakefield to the tune of fifteen or twenty miles.

The rain continued. Night fell, and so did my pace and my spirits. My wet feet slid around in my wet shoes, and my two big toes bumped up against the front of the toe box, and when I took off my shoes and socks I didn't like what I saw. The nails on both big toes were loose,

and had turned a shade of gray rarely seen on anything living. I had brought a Swiss Army knife along, and I used the saw blade to cut away the first couple of inches of the upper portion of each shoe, put them back on, and got going again.

Everything hurt. I had blisters, surprise surprise, and I had aches and pains, and it was awful. I began stopping in the food tent every two laps, and instead of pausing just long enough to grab a sandwich or a fistful of M&M's, I'd sit down and rest for a few minutes. I was forcing myself through the laps, I was covering the miles, and in fact it was somewhere around two o'clock when I finished the thirty-second lap. That gave me 64.26 miles—the loop was a few yards beyond an even two miles—and that meant I'd earned an Ulli Kamm award and had passed, though just barely, the 63.2 miles I'd managed in Wakefield.

And I had five or six hours left, plenty of time to add to my total. It might take me upward of twenty minutes to go a mile, and I might have to stop every two miles in the food tent, but even if I only managed two miles an hour, I could hit seventy-five miles. That would be a huge improvement on Wakefield, and a number to be proud of even in good weather.

It didn't happen. After Lap Thirty-two, I sank into a chair in the food tent and couldn't seem to rise from it.

I stayed put for fifteen or twenty minutes, and that was much too long; it gave my muscles a chance to tighten up, allowed my feet to shake off their protective numbness and report eloquently on their condition. When I stood up and hobbled back onto the course, every step was insupportably painful.

It would have become less so if I'd forced myself to start walking. That's how it works, as I'd discovered back in July at Wakefield. Taking a break gave the pain a chance to flower; walking through the pain forced it to recede.

But this time I couldn't make myself do it. Besides the pain, I was profoundly fatigued. I didn't want to walk anywhere. I wanted to be in bed. I wanted to sleep.

I got in my rental car, drove to my hotel, and called it a night.

When I left, Beth and Andy had also both packed it in after thirty-one laps and 62.25 miles. (There were a couple of cots in a rear section of the food tent, and Beth crawled onto one of them and passed out. After a couple of hours she woke up, went back onto the course, and circled it twice, edging me by a lap. If I'd known she was going to do that . . . well, never mind.)

I got a shower and a few hours' sleep, returning to the park a few minutes after Jens hit the Centurion line

at 7:15. That left him with plenty of time for another full lap, but he didn't even want to walk the several hundred yards from the hundred-mile mark to the start/finish line. He'd set out to go a hundred miles, and he'd paced himself with that goal in mind, and he'd done it—and as far as he was concerned, that was that.

It was a glorious morning, cool and crisp and clear, and if they'd held the race a day later it would have been vastly different. It occurred to me that I had time for another lap myself. Ollie was out there, finishing a lap that would bring him to 76.3 miles. I could join him on the course, and join Beth at 66.26 miles.

I never seriously considered it. I was wearing jeans, but even if I changed to running shorts I wouldn't be in any kind of shape to get back out there. My race was over.

When I flew home the following day, I had an Ulli Kamm award in my suitcase. It was a handsome wooden plaque, eight inches by ten inches, with the effigy of a bear carved into it. (For Bear Creek Park, of course; that the bear is my totem animal is coincidental.) HOUSTON ULTRA WEEKEND, the inscription reads. IN RECOGNITION OF WALKING 100 KILOMETERS WITHIN 24 HOURS, THE ULLI KAMM AWARD IS PRESENTED TO— And then there's a blank space, with two screws on

either side of it to affix the brass nameplate, which I was to receive in the mail.

I'm still waiting for the nameplate, but that's okay. It's a fine trophy, and I don't need my name on it to know whose it is. Nor am I in any danger of forgetting what I went through to earn it. I was happy to have it, proud to show it off to Lynne.

But it was never quite enough to offset my disappointment.

At Wakefield I'd gone 63.2 miles and felt an unprecedented glow of accomplishment. In Houston I'd gone a mile farther, and had slogged through puddles to do it, and I felt like a failure.

I could have done better, rain or no rain, toenails or no toenails. I could have stayed on the course, could have gone around a few more times. Three more laps would have taken me past seventy miles. Instead I'd lingered in the food tent long enough to make it truly painful when I tried to resume walking, and I'd embraced the pain as an excuse to give up.

The pain had been real enough, and so had the fatigue. But pain and exhaustion are inevitable in that long a race, and I knew it, and knew how to push on through them.

And didn't.

The souvenir T-shirt from the Athens Marathon is one of my favorites. It's long-sleeved, and the cut is good, and the color a good warm brown, but that's the least of it. ATHENS MARATHON, it says. 2006. And, within a classic laurel wreath, there's the representation of a helmeted Greek warrior, running.

You'd never guess they meant Athens, Ohio.

The race was held April 2, and I flew to Columbus the day before and drove to Athens. The field was small, with 135 finishers, and the course was beautiful—a flat asphalt path through the countryside, closed to bike traffic during the race. The finish line was in the Ohio University football stadium, and the final quarter-mile was a lap around the oval track.

My time of 5:41:08 was a good deal slower than Mobile or New Orleans, but I hadn't expected to break any records that day. I went back to my hotel and ate pizza, and the next morning I put on my new shirt and went home happy.

I continued walking local Road Runners Club races while I worked out my schedule for marathons and ultras. Between Houston and Athens I raced twice, a 5K in Washington Heights and a return engagement in the Brooklyn Half Marathon. My time in Brooklyn was almost four minutes slower than it had been in 2005, and I found that surprising; with all the training and racing I'd done in the intervening twelve months, you'd think my time would have come down a little. But I chalked it up to lingering effects of the Houston Ultra.

After Athens, I had three more local races leading up to my next marathon, coming up the first weekend in June in Deadwood, South Dakota. The longest of the three was the Queens Half Marathon, and my time of 2:37:55 was seven and a half minutes slower than the previous year's.

Hmmm.

Lynne and I made a real trip out of Deadwood, enjoying the town before the race, then spending the

following week driving around the state. During the Buffalo hunt we'd taken Polaroid snapshots of each other, wearing Buffalo T-shirts and posing in front of pertinent signage, and now we took photography to another level by inaugurating a virtual photo collection. In front of some suitable attraction—our favorite was the World's Largest Pheasant, in Huron, South Dakota—one of us would strike an appropriate pose, while the other would aim an invisible camera, frame the shot perfectly, and click an invisible shutter. The best part of this was the baffled reaction of onlookers, but the aftermath was almost as good; back home, we had no film to develop, no prints to frame, no digital images to bore our friends with.

The race itself was challenging. It was a point-to-point race on the Deadwood-Mickelson Trail, an old railroad right-of-way that had been converted for recreational purposes. (Rails to Trails, they call this sort of thing, and I'm all for it.) Buses took us to the start, where I stood in the Porta John line until I reached my goal, peed, and then, recognizing the inevitable, got right back into line again. I'd made the round-trip several times before it was time to get in line for the start.

If the Athens course had been an out-and-back, Deadwood was an up-and-down. We started out at around five thousand feet, had a straight shot uphill for

the first fourteen miles, then went downhill all the way to the finish. Overall, there was a net loss of altitude of around a thousand feet.

The mile-high altitude and the relentless uphill march made the first half of the race demanding, and the first part of the downhill was steep enough to make it hard for a walker to keep from breaking stride. Early on in the downhill I bowed to the inevitable and tried switching to a jog, but that was so hard on my knees I gave it up after fifteen or twenty yards.

I knew my time wasn't going to be anything special, and I didn't really care. I was enjoying the vistas, and I cruised to the finish, getting there with a net time of 6:08:08. Nothing to brag about but nothing to be ashamed of, and I now owned a shirt with Calamity Jane and Wild Bill Hickok on it. And I'd added South Dakota to my marathon list.

21

There were plenty of races in and around New York during June and July, but I passed them up. I eased back into training after we'd returned from Deadwood, and upped my mileage along the Hudson, hoping for a good performance at Wakefield. The Houston race, my disappointment notwithstanding, had carried me from 63.2 to 64.25 miles, and I felt I ought to be able to manage at least one more lap than I'd walked a year ago.

And was it only a year since I'd been unable to dream past fifty miles? Now I was dreaming of eighty. It didn't seem out of the question. I'd have reached eighty in Houston, if the puddles hadn't gotten in my way. I'd have still gone well over seventy, rain or no rain, if my own will hadn't failed. The Wakefield

course was less user-friendly, with its little patch of cross-country downhill and its long stretches of concrete, but it wasn't all that bad, and it had the virtue of familiarity.

We rented a car on Thursday, drove up, checked into the Lord Wakefield. This time we took along a folding chair for Lynne and a card table for all the supplies I hadn't thought to bring the first time. (The one thing I forgot was a table knife. The food tent at Houston, besides providing me with an all-too-comfortable place to dawdle, had shown me what a food tent ought to be, and how short Wakefield fell in that department. Aside from a lot of sugary crap, the best thing on offer was peanut butter. You had to make your own sandwiches, and you couldn't, because all they gave you to dig the peanut butter out of the big jar was a dinky little white plastic knife. It barely reached far enough into the jar to get to the peanut butter, and bent and sometimes broke in the process. You couldn't even hijack a plane with a knife like that, let alone make a sandwich. I had promised myself I'd pick up a couple of thrift-shop knives and donate them, but it slipped my mind.)

The poet Randall Jarrell famously defined the novel as a long work of prose fiction with something wrong

with it. Well, a twenty-four-hour race is a long run—or walk—in which something goes wrong. And in this case, as in Houston, it was the weather.

It was warm and humid on Thursday. That seems to be the default setting for Wakefield that time of year. It was no different Friday morning, but the forecast advised that a thunderstorm was on its way, and as the day wore on the sky darkened and the winds picked up. And you could smell the rain that was coming. A Dust Bowl farmer on the parched central plains would have fallen to his knees and given thanks to God. I did not.

It began raining lightly around the time I picked up my number at the sign-in tent. Now there's nothing wrong with a light rain, and in midsummer it's often more help than hindrance. I had a hooded Gore-Tex windbreaker along; it had served me well in Texas, although it couldn't do anything for my feet, and I wasn't worried about a light rain. But a light rain wasn't what we got. We got a downpour, and by the time we should have been massing at the starting line, we were instead diverted to a meeting room in the adjacent motel. It wasn't just a storm, it was a full-blown electrical cloud burst, and they didn't dare send us out onto the course until it had passed through.

The start was postponed a half-hour to 7:30; at 7:15 they announced a further postponement, to 8:00. Any delay beyond that hour would cut into the time of the race, because they were required to close down by eight Saturday night. So if we got under way at nine, say, we'd be starting a twenty-three-hour race. That sounds as though it ought to be long enough for anybody, but it's not, and we were not a happy bunch.

Beth was there—her home was a half hour's drive from Wakefield—and so was Andy. It was good to see them again, and good to recognize faces I'd seen the year before; it was nice to have my own face recognized by the people who were putting on the race. Or trying to, if the storm would only move on through.

Lynne heard two young runners griping about the delay. "Like I'm gonna get struck by lightning," he said. "I mean, what are the odds?"

The storm, as it turned out, was no problem. It passed overhead just in time for the race to begin at eight o'clock. A light rain continued to fall for the first hour or so, but it really wasn't anything to complain about. It cooled things off after a hot day, and spared us the swarming gnats I'd had so much fun aspirating the previous year.

Remember the spiritual?

God gave Noah that rainbow sign . . .
Won't be water—be fire next time.

Houston was water. Wakefield was heat.

For the first ten hours or so, the race was as idyllic as something that effortful can be. There were no large puddles to step in, and the course was virtually dry except for the fifty-yard cross-country downhill plunge near the start. That was pretty soggy, but there wasn't that much of it and it wasn't that hard to skirt the watery spots. That stretch was going to be a minor nuisance anyway, and the rain hadn't made it that much worse.

I walked side by side with Andy Cable for most of the first six hours. Because Wakefield wasn't a judged race, and didn't have a walkers category, he felt free to mix in a sort of shuffling jog (or a jogging shuffle, as you prefer) on the downhill stretches. He'd pull away from me at such times; then he'd deliberately slow down when the course leveled off, and I'd catch up with him on the uphill. And so on. Between shuffles, we talked—and the laps mounted up, and the miles accumulated, and the hours passed.

For four hours or so, Lynne sat at our table and rose to greet me at the completion of each 3.1-mile lap. Then

around midnight she pleaded exhaustion and went to our room. That would have been fine, except a lap later I discovered she'd never retrieved the two big bottles of Coca-Cola from the trunk of the car, and had taken the car keys to the room with her. I drank some water and got under way, concentrating on thinking instead of all of the woman's good qualities.

On the ninth or tenth lap, I remember remarking to Andy that I knew I was starting to tire when the Gatorade began tasting good. He told me I didn't look tired, and I said it didn't taste good yet. "But it's not as bad as it was a few laps back," I admitted.

As far as I know, Wakefield's the only twenty-four-hour race that starts in the evening. The rest, like most marathons and ultras, get under way in the morning. The starting time's a plus for Wakefield's marathon contingent; the summer heat is a lot easier to bear when the sun goes down, and the marathoners can wrap up their race, gobble their pizza, and still make it home at a decent hour.

But is an evening start good or bad for the twenty-four-hour participants? That's hard to say. One very obvious disadvantage is that, barring a prerace afternoon nap, the entrants have already been awake for twelve hours or so by the time the race gets started.

When their usual bedtime hour rolls around, they've still got three-fourths of the race in front of them.

On the other hand, one is psychologically disposed to be most tired during the hours of darkness. With an evening start, ten hours on the course will carry you through to dawn, and the rest of the race will be in daylight, when you're programmed to be awake. In contrast, consider my own experience in Houston; after eighteen punishing hours on the course, it was two in the morning, and everything in me yearned to be in bed. Would I have been better able to shrug off the fatigue if it had been 2:00 P.M. instead of 2:00 A.M.?

Maybe. Or maybe not. Because ultimately one returns to that definition of the race derived from Randall Jarrell. What was it again? Oh, right—a long walk in which something goes wrong.

When dawn broke, I could see what it was going to be this time.

When I first learned of the existence of twenty-four-hour races, I remember being struck by the delight to the spirits I was sure would occur when darkness gave way to dawn. One would be quite literally running to daylight, and wouldn't that give you a wonderful feeling?

Well, no, not really. A sunrise, like a sunset, is a phenomenon I don't tire of viewing. And, because I ordinarily see fewer of the former, they're that much more special. I mentioned one in Spain that I still recall—Lynne and I, reaching the top of a hill, and turning around just in time to see the sun break the horizon. I've witnessed others on cruise ships, and they've never failed to give me a lift.

But during a race dawn is a very gradual thing, a glow in the distant sky, then an incremental lightening, as if someone's got a very slow hand on a celestial rheostat. I can't recall seeing the sun come into view. There's just a moment, after the sky's been light for a while, when it's suddenly up there, a few degrees off the horizon. One may or may not be pleased to see it, but it's not likely to rank high on one's life list of peak experiences.

My first time at Wakefield, the first lightening of the sky took place while I was in my room with my eyes closed. By the time I returned to the course, dawn was already upon us. This time I didn't take a break during the hours of darkness, and I was out there for the return of daylight.

And I looked up, and saw not a cloud in the sky.

It was, no question, an absolutely beautiful morning. It's a few minutes past seven on a similarly beautiful

morning as I write these lines, with the sun up and no more than two or three tiny clouds to be seen against the blue of the sky, but the present morning is in late February, and at this time of year the sun is unequivocally one of the good guys.

Not so in Wakefield in July. Not so when one's faced with the prospect of spending the whole day under it.

The temperature had been just fine all through the night. The rain had cooled things down, and it was a shame it hadn't been able to do anything about the humidity. By dawn I was coated with a layer of salty perspiration residue, and the lack of cloud cover suggested it was all going to get a lot worse.

By six you could feel the sun, and by seven it was already strong. An hour later I'd been on the course for twelve hours, and I wasn't far off Centurion pace. That didn't mean I had a shot at a hundred miles, but it meant that eighty was well within reach, and eighty-five or even ninety wasn't entirely out of the question.

If only they could do something about the sun. Hang a cloud or two in front of it, say.

Around nine I left the course for the first time. I wanted a few minutes out of the heat, and I was even more anxious to get under the shower and wash the caked sweat from my skin. After my shower, and after

I'd put on clean socks and pinned my race number to a clean pair of shorts, I went out again. I had a cup of coffee and something to eat and got back on the course.

I needed another break around noon. I went to the room and stretched out on the bed. I can't recall if I slept, or how long the break lasted, but eventually I was out on the course again.

It just kept getting hotter and hotter. That weekend was the summer's hottest, with temperatures throughout the area reaching ninety-five degrees. That's in the shade, and shade was in short supply on that course. For the remainder of the race, I had to take a break after every three-mile lap, just to get out of the sun. That meant ducking into the food tent and drinking water for five to ten minutes, then walking around in the sun for the forty-five minutes it took to circle the course, then retreating once again to the shelter of the tent.

I had gone twenty laps the previous year, and I was determined to go twenty-one this time around. It was still mathematically possible for me to hit eighty miles, there was plenty of time left, but the heat was unbearable. I did my twentieth lap, and I treated myself to five or ten minutes in the shade, and then I knocked off my twenty-first lap. That brought me to 66.36 miles, an improvement of just over two miles on my performance at Houston.

And I decided that was going to have to be enough. My feet and legs felt fine, and I had a few more laps in me and over four hours to fit them in, but the heat had taken too much out of me, and I was concerned that it might be genuinely dangerous to spend more time under that sun.

I had very nearly run my age: I was sixty-eight, and one more lap would have taken me past that mark. I thought of that after I had well and truly retired form the race, and if it had occurred to me earlier, I probably would have stayed out there and pushed myself through Lap Twenty-two. And if I had done so, I'd have noted that I was within a lap of breaking seventy miles, and I might very well have managed a twenty-third lap on the strength of that.

It was probably just as well I didn't.

Beth, who'd started the race with an injured calf muscle, left the race after twenty laps. Andy had a good race, twenty-four laps for 75.84 miles, but quit early because of the heat. Two runners managed thirty-nine laps (123.24 miles); one finished three minutes ahead of the other, and was therefore the winner.

I felt all right the next morning. My legs were sore and my feet knew I'd spent a lot of time on them, but I was otherwise intact. We packed up our card table

and folding chair and drove home, stopping en route to visit an old friend in southern Columbia County. A few years ago, after an angioplasty, he'd begun going out each morning for a brisk half-hour walk. It was, he'd confided, an easy enough regimen for him. "On a flat surface," he'd said, "I could walk all day long."

Oh?

During the summer I'd entertained thoughts of entering another marathon in September. There were several good candidates, but in the end I decided to pass them all up and wait for the New York City Marathon, scheduled as usual for the first Sunday in November.

I'd earned guaranteed entry. There are several ways to avoid being one of the fifty thousand applicants who get turned away each year. You can be an elite runner; you can be from another country, enrolling through one of the official marathon tour groups; you can essentially buy your way in, contributing a certain amount to a particular charity; you can win a place via the lottery; you can enter the lottery unsuccessfully for two successive years, in which case the third time is

STEP BY STEP · 381

the charm, bringing the consolation prize of automatic acceptance.

Or you can start and finish nine New York Road Runners Club races in the course of the previous calendar year. That gets you in.

And that's what I had done. In 2005 I'd qualified twice over; my ninth NYRRC race, the four-mile Thomas G. Labrecque, was in the record books by late April, and in December I closed out the year with number eighteen, another four-miler in the park. So when the time came I sent in my entry for the marathon, and on the Saturday I picked up my number (#44464), and before dawn Sunday morning I boarded one of the designated buses in front of the main library at Fifth Avenue and Forty-second Street, and in due course got off it at Fort Wadsworth on Staten Island.

The hardest part of the race was the four hours before it got under way. It was a very cold morning, and most of us showed up wearing whatever sweatshirts and warm-up clothes we were willing to see the last of. I have a real Depression Era mentality when it comes to old clothes, and find it curiously difficult to part with them. I knew I was going to toss what I was wearing, and I'd accordingly picked out garments I'd owned for ages and hadn't worn in years. For a hat I'd grabbed the remarkably ugly yellow baseball cap that had been

included in the bag of goodies given to all registrants; the minute I saw it I couldn't wait to throw it away.

I was dressed in layers, and I had gloves on, and I was still freezing. There were bagels and coffee available, but the bagels ran out, and I knew I didn't want to drink too much coffee, as its effects are not all that different from the yerba maté that had made me hydrate all those live oaks in New Orleans.

They've done a brilliant job getting things going, with several corrals shuttling the runners toward the starting line at the Verrazano Bridge. I was careful to position myself way at the rear of my group, and even so, there was only an eleven-minute difference between my gun and net times. That's how long it took me to reach the start, and there was something positively surreal about those eleven minutes, in that I spent them striding, sometimes quickly and sometimes slowly, along a stretch of pavement that made its way through a veritable sea of old clothes.

It was a hell of a sight. Piles and piles of sweats and T-shirts and gloves and stocking caps, enough discarded garments to clothe the impoverished multitudes of the underdeveloped world. (And that, as I understand it, was their destiny; all of our discards were collected and shipped off, and somewhere in some famine-raddled corner of the planet, some indescribably lucky

chap is even now wearing my BUFFALO: CITY OF NO ILLUSIONS sweatshirt. With pride, I can only hope.)

While I'm sure there had been a number of slight modifications, the marathon route was essentially unchanged from the course I'd followed in 1981. There may have been more spectators on the course, but maybe not; the turnout was pretty good back in the day.

Long after I'd left the bridge and hit the streets of Brooklyn, I continued to see discarded clothing at the curb. And by the time I was about to quit Bedford-Stuyvesant for South Williamsburg, I took off that ugly yellow cap and handed it to a very small boy.

It was not unusual for me to start a race wearing a baseball cap I'd decided I was willing to toss. Nor was it unusual for me to finish the race with the cap still on my head, or tucked into the waistband of my shorts.

I mentioned the cap I got in Summit, New Jersey; it advertised the website of Summit's own Jim Cramer, who evidently had more baseball caps than he needed. I can't tell you how many races and long training walks that cap survived. The damn thing had more lives than a cat. I would have worn it in the New York Marathon, and would surely have come home without it, but it was like the biblical sacrifice of Isaac, with a ram providentially appearing as a substitute. In this instance

the Lord sent not a ram but a crappy yellow cap, and TheStreet.Com lived to fight another day.

It's gone now. I can't recall where or when, but the day did come when I took it to a race and heaved it halfway through. I can't say I miss it, and I took a little satisfaction in seeing the last of it, but I'll say this—to this day, it feels a little wasteful.

Walking New York after twenty-five years was like rereading a novel after a similar length of time; I remembered each part of the route as I came to it. There were sections I was able to anticipate—the curve in Greenpoint when you reach Manhattan Avenue, the Queensboro Bridge, the move from Fifth Avenue to the hills of Central Park—but other portions had faded from my memory, and only lit up when I reached them.

I had covered the course the first time by a combination of running and walking, switching to walking when my knee complained around the midway point. This time, of course, I walked all the way. My net time of 6:05:20 meant I'd spent almost an hour and a half more on the course than in 1981, but you couldn't really compare the two; I'd run half of it the first time around, and I'd been twenty-five years younger. My 2006 time also was a good deal slower than Mobile and

New Orleans and Athens, but the nature of the course accounted for at least some of that. All things considered, I was pleased with my effort and satisfied with my time.

After I'd crossed the finish line and had the chip removed from my sneaker laces and a medal hung around my neck, I had a job finding Lynne; there was an area set aside for family reunions, and I'm sure the layout would have been more immediately comprehensible to someone who hadn't just pushed himself through 26.2 miles of New York streets. But we did find each other, and I did a little stretching, and we walked down to Columbus Circle and caught the A train home.

Three weeks after the New York Marathon, I'd have another shot at the Knickerbocker 60K. I didn't even consider it. That same weekend they'd be holding the Ultracentric near Dallas, with a program that would include a twenty-four-hour race with Centurion judging. Marshall King, whom I knew from one of the message boards, had made his Centurion bones there in 2005, and there were sure to be ultrawalkers showing up for this year's event.

But it didn't seem like a good idea for me, not three weeks after New York. I'd wait for Houston in February, and meanwhile I'd make my next race the Las Vegas Marathon, December 10, a proper five weeks after New York.

I don't know that the Knickerbocker was the only local race on offer between the two marathons, but

I found I was no longer all that keen on the shorter races. I had entered only one, the Staten Island Half, between Wakefield and New York, and I'd done so because of an NYRRC incentive. The club held five half-marathons a year, one in each borough, and if you entered four of the five and finished in less than three hours they gave you an iron-on patch. I'd done this in 2005, and hadn't ironed the patch onto anything, but tossed it in the box where I keep all my race numbers. I figured I'd do the same with the 2006 patch.

I'd used the Staten Island race as a premarathon training walk, and just made it in under the three-hour limit. It was my ninth NYRRC race in 2006, which meant I had just earned entry into the 2007 marathon. But by the time I'd completed the 2006 version, I was fairly certain I wouldn't want to do it again the following year. It was a race with many pleasures and satisfactions, but I wasn't sure they outweighed the chilly tedium of those prerace hours in Staten Island.

(Incidentally, nine NYRRC races alone will no longer assure you of guaranteed entry. In early 2008 they announced a rules change; from now on, in addition to running the nine races, you have to serve as a volunteer in at least one race. Too many people were qualifying.)

Las Vegas has been home to my cousin Petie ever since he quit practicing law and settled into a second career as

an advantage gambler, devoting himself to blackjack and poker tournaments. He's grand company, and Lynne was glad to join me for a weekend at the Mandalay Bay while I added Nevada to my marathon list.

The course sent us several miles down the Strip and through the Fremont Street Experience before bringing us the long way home through an unappealing commercial stretch of discount furniture stores and strip malls. It was the Las Vegas the tourist never sees, and advisedly so, and we were bucking a relentless headwind all the way, and those of us at the back of the pack wound up sharing the street with unregulated traffic for the last half-hour or so. Not my favorite marathon, and not my best performance, either, with a net time of 6:03:34, but it was by no means a disaster, and I finished it uninjured and not much the worse for wear. And I got a T-shirt out of it, and logged another state. Nothing wrong with that.

I raced in Central Park a week after Las Vegas, in the ten-mile Hot Chocolate Run, so-called because that's what they served us at a nearby school afterward. That brought me to the end of my second year as a reborn racewalker, and compared to the previous year I'd covered far more ground (375.41 versus 277.2 miles) in considerably fewer races (18 versus 25).

It was the longer races that mattered to me. My eighteen 2006 races included six marathons and two twenty-four-hour events. For over twenty years I'd regarded my record of five marathons in 1981 with awe that verged on disbelief—how could I possibly have accomplished all that in a single year? Now I was older and slower, and I'd racked up more marathons than I had in 1981, and a pair of twenty-four-hour races besides. I'd already had New York and Massachusetts on my marathon life list (along with New Jersey and North Dakota), but this year I'd added Alabama, Louisiana, Texas, Ohio, South Dakota, and Nevada. If I could keep on picking up five new states a year, well, maybe reaching fifty states wasn't entirely out of the question.

So I set about planning my marathon schedule. The Internet has made that infinitely simpler than it ought to be, and once I'd discovered marathonguide.com I no longer needed the listings in *Running Times* or *Runner's World*: I could choose from a complete menu of races here and abroad, could check descriptions and reviews of each race right there on the site, and could follow links to the race's own website and sign up with a few mouse clicks. After all that, having to get out and walk the race by the time-honored method of putting one foot in front of the other seemed curiously primitive.

I picked out my races, starting with the Mississippi Marathon on January 13, then two marathons in February, Surf City in Huntington Beach, California, on the first Sunday and a return to New Orleans on the last. (I hadn't planned on repeating New Orleans this year, because they'd scheduled it before rather than after Mardi Gras, and I didn't want to miss the Houston twenty-four-hour walk. Houston, alas, was quietly canceled; the weekend had always been organized by a society of ultrarunners in Kansas, and I guess they had tired of it. A twenty-four-hour race, you'll recall, is a very long walk in which something goes wrong, and what went wrong this time was that there wasn't going to be a race.)

Once New Orleans had replaced Houston in my schedule, I scrapped my plans to spend the month of March at a writers' colony in Illinois and decided to stay in New Orleans instead until my book was written—to come back with my shield or on it, as it were.

And there would be other twenty-four-hour races. A couple of years ago, Ollie Nanyes had reached a hundred miles on the quarter-mile track at Corn Belt; he didn't earn Centurion recognition because there were no judges on hand, but the accomplishment was his all the same. Corn Belt in May was a possibility, and so was FANS in June in Minnesota.

A third try at Wakefield loomed on the horizon at the end of July. Earlier that month Lynne and I would be on a Cruise West voyage among the Aleutians and on the Bering Sea to the Russian Far East. Just a week before we were to set sail from Anchorage, that city would host the Mayor's Midnight Sun Marathon.

Oh, why not?

Mississippi was first. I flew to Jackson the day before, drove to the motel I'd booked for its location, and discovered I'd chosen well. Not only was it a short drive from the race's starting line, but it was adjacent to a Waffle House. I have come to regard that particular mostly southern chain as the embodiment of the phrase *guilty pleasure*, difficult to resist and impossible to justify.

Unless, of course, one has the rationale of loading carbohydrates before a marathon, or replenishing one's caloric reserves after one. I dutifully sucked up the carbs Friday night, went back to top off the tank first thing in the morning, and got to the starting line hoping to get under way before sugar shock kicked in.

Mississippi was another of the handful of races with a walkers section, and going home with some hardware looked like a safe bet, in that they were going to hand

out ten trophies in that division. They also offered a seven o'clock start for walkers, an hour before the rest of the crowd got under way. (Some runners took advantage of an even earlier start, at six, so that they could get to work on time. It was, all in all, a remarkably user-friendly race.)

If the Internet made it easy to find a race and sign up for it, it also let you know what kind of weather to expect. The site I consulted the week before the race was quite unequivocal. It was going to rain in Jackson, probably starting on Friday, and certainly soaking us good on Saturday.

Well, they were wrong. Friday was overcast and Saturday was sunny. I think it looked like rain on Sunday, but I don't remember if any actually fell, and wouldn't have cared if it did; by then I was hunkered down in my motel room, watching the NFL playoffs and leaving only to answer the siren song of the Waffle House.

There were perhaps twenty of us, mostly walkers, who took advantage of the seven o'clock start. The flat course was a simple out-and-back on the Natchez Trace, a wonderfully scenic limited-access two-lane road that cuts northeast to southwest across the state. I took it easy at the start but upped my pace once I was warmed up.

The small field, virtually all of it walkers, acted as a spur. We'd covered five miles in that first hour, so it was easy to forget there were any others in the race.

I passed one fellow a couple of miles out, and he stayed close enough that I heard his breathing and his footsteps for miles. I'm sure I walked faster for trying to get away from him, even as he walked faster trying to keep up with me. Two miles from the finish he put the hammer down and surged, pausing long enough to hand me the baseball cap that had dropped from my waistband, then powering on to the finish line. I tried, but I couldn't catch him, and finished fifty seconds behind.

In an out-and-back race, you get to see the leaders returning as you approach the midpoint; then, after you've made the turn, you get to see who's behind you. My look at the leaders was unsettling, because some of them wearing walker bibs were not walking. One woman's gait was about as legal as the Andy Cable Shuffle, and another was clearly mixing running and walking, which is a perfectly fine way to finish a marathon, but not if you're competing as a walker.

My response mixed resentment and outrage, and it powered me at least as effectively as those syrup-soaked pancakes I'd had for breakfast.

After the turn, I got to see the people behind me—and there were dozens of them, and most of them were running. The entrants who'd started at eight o'clock, around 140 of them, were fast overtaking us, and we spent the second half of the race with runners— fast ones at first, slow ones toward the end—floating effortlessly past us.

This was a reversal of the usual order of things for me. Typically, I start slow, reach cruising speed five or six miles into the race, and hold that pace to the finish. As a result I tend to pass more people than pass me, especially in the last half of a long race when injured or undertrained runners are reduced to walking.

No matter. I hit the finish line with a net time of 5:26:33—and, since there'd been room for every member of the seven o'clock contingent to toe the line at the start, my net time and my gun time were the same. That was a few minutes slower than Mobile a year ago, and slower too than New Orleans, but it wasn't bad.

Because of the early start we'd had, the race for the runners had not yet reached the four-and-a-half-hour mark, and I had the unusual experience of standing around eating pizza while I watched middle-of-the-pack runners crossing the finish line. In the usual

course of things, by the time I finished they'd have long since packed up and headed for home . . . after scarfing down all the pizza. There was much to be said, I decided, for an early start.

Maybe that's what kept me hanging around the finish line. Usually I pause only long enough to collect my medal and catch my breath, but for a change I was in no rush to get out of there. As always, a good number of my fellows hurried to get into their cars and on their way, but the rest of the small field lingered for the presentation of awards.

I'd had some aches and pains during the last few miles of the race, and I was mildly fatigued at its end, but all in all I felt pretty good. The weather had held, the course had been a treat, and I'd performed better than I'd expected. This wasn't quite enough to transform me into a contender for the Miss Congeniality award—it is not for nothing that my totem animal is the bear—but it did push me far enough in that direction to fall into actual conversations with strangers.

I chatted some with the walker who'd been decent enough to retrieve and return my cap, and relentless enough to beat me to the finish line. His name was John Buckley, he was from Bermuda, and he'd come specifically to add Mississippi to his been-there-walked-there list. Along with states, he was collecting

countries and continents, and it seems to me—I wasn't taking notes—that he'd chalked up marathons in all seven continents. I remember learning that he'd ticked off Antarctica.

He'd been ticked off in turn by the several competitors who'd entered as walkers and mixed in some light running. We agreed that such behavior was reprehensible, falling somewhere on the moral scale between jaywalking and serial murder, but that neither of us found it quite troubling enough to mention it to anyone. Truly strict judging, we acknowledged, would very likely disqualify both of us, so we figured the hell with it.

Aside from the local Mississippians, most of the runners seemed to be Fifty Staters, and some of them knew each other from other races. I overheard one man about my age explaining to a woman just how to get to Mobile. The First Light Marathon was coming up tomorrow, and she was thinking about running it. "You might as well," he advised her. "I mean, seeing as you're in the neighborhood."

I talked to him, and it turned out he would be running Mobile himself, and urged me to drive down and join them. After all, I was in the neighborhood. I told him I'd walked Mobile the previous year, and he nodded, but I got the impression he didn't think that

was sufficient reason to deprive myself of a second shot at it.

Remarkable, I thought, as I returned to the pizza table. Here was a fellow unarguably old enough to load carbs before a game of shuffleboard, and he was going to run two full marathons on successive days, and evidently did this sort of thing almost routinely. He wasn't the fastest creature on two legs, but that wasn't really the point, and he got to the finish line before the pizza was gone, didn't he?

Mississippi on Saturday, Mobile on Sunday. There was a man who could eat all the pizza he wanted.

And so, at least for that day, could I.

It took a while for them to process the results and hand out the awards, and by then there were just a handful of us left. When they read off the winning racewalkers, most of the plaques went unclaimed; they'd be mailed to recipients later. John Buckley stuck around long enough to pick up his award for coming in seventh, and I was right behind him in eighth place. I collected my award and drove back to my motel.

Later in the month, I had occasion to check the race results on the Web. I wanted to make sure my time was as I remembered it. It was, and I noted that I'd been moved up to fifth place, and my Bermudan friend to

fourth. They'd evidently sorted things out and taken three nonwalkers out of the standings, allowing the rest of us to move up.

I just went into the living room and looked at the plaque they gave me in Mississippi. It's on a shelf in plain sight, but I couldn't tell you the last time I noticed it. I wanted to confirm that it said Eighth Place, and it does, and I'll tell you, I can't make myself believe that I'd treasure it more or display it more prominently if it had me in Fifth Place.

Looking at it, what struck me was how much I'd enjoyed that race. The memory had a bittersweet aftertaste to it, though, for I know how unlikely it is that I'll go back to Jackson for another long walk on the Natchez Trace. Even if they continue to stage it, and I continue to enter marathons, the odds are against my returning.

Mobile, too, was a race I'll always remember fondly. The two races are always on the same weekend, enabling the Fifty Staters to do them both in quick succession. I'd done them in successive years, and enjoyed them both, and in all likelihood neither of them will ever see me again.

Because I'm more inclined to choose, if not the less-taken road, at least the one that I myself haven't yet trod. For me to walk marathons in fifty states would

be a sufficiently Herculean task all by itself; I'd make it impossibly difficult if I insisted on entering the same races over and over. When I'd decided on Mississippi, I was at once deciding to forgo Mobile, a race I'd enjoyed and would have liked to repeat. (But not a day later; I may be crazy, but I'm not stupid. Well, not *that* stupid.)

There were marathons I was just as happy to do once and once only. I hadn't liked Las Vegas enough to walk it again, although I'd be glad enough of another visit to the city itself. I might want to repeat the New York Marathon, but not for at least a few years.

But I had good feelings about Mississippi and Mobile and Athens and Deadwood, and the impulse to return year after year to each of them was strong. I could choose to do so, or I could opt for the new and untried.

It is, I suppose, a choice one confronts over and over in life. I've known families who glory in vacationing in the same spot every year, returning again and again to the same hotel, delighting in the fact that the staff remembers them. If they run into the same fellow vacationers, so much the better. The more each year's experience echoes the ones before, the happier they are with it.

And I understand the appeal, I really do. When I picked up my number at Wakefield, the race directors

remembered me, and I walked away with the theme song of *Cheers* echoing in my head. No question, it was nice when everybody knew your name.

Another school of thought holds that the more enjoyable a trip is, the greater the imperative that you avoid trying to replicate it. You had an idyllic weekend in Charleston? Good for you—but don't ever go back, because your second visit will never match up to the enhanced memory you have of the initial experience.

(And memory always improves on reality, highlighting the good, toning down the bad. Whatever we remember, we recall it as better, or at least less horrible, than it was. If it's horrible enough, we forget it altogether. And all of this is just as well; otherwise we'd all kill ourselves.)

For my own part, I decided to look for a middle ground. There weren't all that many twenty-four-hour races, and in my limited experience it seemed to me that my relationship to the course came second to the sheer challenge of the time and distance. And so I would have done Houston again, if the bloody Kansans hadn't canceled the race, and I'd done Wakefield twice and was prepared to do it a third time.

And, while I'd lean toward those states I hadn't yet checked off, I'd try not to let that particular goal keep me out of especially attractive races. I couldn't repeat

the North Dakota Marathon I'd run in Grand Forks in 1981, because they didn't hold that race anymore—but what I'd read about the Fargo Marathon was appealing, and I'd like to enter it one of these years, even if it wouldn't give me a new state. And the same went for a marathon in Brookings, South Dakota; I'd been to the town a couple of times and liked it, and would be glad of another look at the local university's collection of Harvey Dunn paintings—and a long walk through its streets.

And I'd go back to New Orleans. That was Lynne's ancestral home, it was a city we both enjoyed greatly, and I'd had such a fine time there in 2006. A trophy—second place! A time of 5:17! The good thing about the Houston cancellation was that it allowed me to go back to New Orleans.

Who knew it would be a disaster?

B ut you remember that part. For too many miles—
slow, agonizing miles—a two-part mantra echoed
in my head. *It hurts too much to go on; I'm too stupid
to quit.*

You remember as well that I didn't quit, and that
eventually it stopped hurting, allowing me to push
through to the finish. What you won't remember, be-
cause I never mentioned it, is that I won another plaque
for my accomplishment. It turned up in the mail a few
months later, astonishing me with its acknowledgment
that I'd finished in fifth place among male racewalkers.

I guess there were only five of us.

I wrote earlier about the aftermath of the race, how
I stayed on in New Orleans to write a book, *Hit and*

Run, and how I came home to depression, eventually signing up and training for a twenty-four-hour race in Minnesota in the hope that it would have a salutary effect on my mood.

And it worked.

I had two months to get myself in shape for FANS. The months were April and May, and there's no better time to train. Except for the rare days when rain drove me to the treadmill, I did all my training in Hudson River Park, alternating long and short days, and grinding out the miles.

I thought I'd jotted down all of my training hours for that stretch on my calendar, but the calendar shows no entries before April 29. That week I walked fifteen hours, with the longest day Wednesday, May 2, when I put in four hours. The following week I logged twenty hours, or eighty miles, including a pair of four-hour days and one walk of five hours.

I was out there only three times the following week, but my long day extended to six hours, and the week's approximate mileage came to forty-eight. Then I had a seventeen-hour week, with a long day of seven hours. I was focused on time, not distance, but estimated that I was averaging fifteen-minute miles; I trained without paying attention to speed, just going at whatever my cruising pace happened to be, and I know I was

going faster in the second hour than the first, even as I'm willing to believe hour seven was slower than hour six. But no matter how conservatively I wanted to calculate, seven hours walking had to be the equivalent of a marathon.

It wasn't a terribly interesting marathon, consisting as it did of endless repeat loops on the Hudson piers, and walking down around the foot of Manhattan and up along the other side of the island and back again, with another assault of the piers. I walked it on Sunday, May 20, two weeks before the big race, and I took the next day off, and walked an hour the following day and five hours the day after that, and took another day off, and walked four hours before taking another day off.

And then, the last week before the race, I walked three hours on Sunday and three more on Tuesday. And that was that. Now all I had to do was fly to Minneapolis on Friday and walk all day and all night.

I'd had only two short races so far in 2007, both of them in January, one a week before the Mississippi Marathon, the other a week after. The first was the Fred Lebow five-miler, which I was walking for the third year in succession. I walked through a lot of pain—it took me the first four miles to warm up—and my time, while a little better than 2005, was noticeably slower than

2006. The second race, also in Central Park, was the
Manhattan half-marathon, and I really suffered during
the three hours I spent walking it. I probably started
out too rapidly, a fault I found it difficult to avoid in
races shorter than marathon length, and it took me for-
ever to warm up, and I never really got into a com-
fortable rhythm. I'd done the same race on the same
course the previous year, with a net time of 2:36 and
change, and now it was just one year later and my time
was 3:03:40.

I walked off the course profoundly disappointed.
My pace had slowed from 11:38 to a sluggish 14 min-
utes per mile, yet it wasn't as though I'd been taking it
easy and coasting. On the contrary, I'd been pressing
all the way, trying to get to the finish line as quickly as
possible, and well aware that those of us who took more
than three hours might not get our times recorded. I'd
expended a great deal of effort, and all I had to show
for it was a bad performance—and another ugly long-
sleeved white T-shirt.

It seemed to me that I could expect more of the same
in any future short races. While I might have a better
time of it if I managed to warm up more effectively and
start slower, I didn't stand much chance of improving
my times, or even maintaining them. Because I was
having to face up to the inexorable nature of the aging

process, and the surprising realization that the universe wasn't going to make an exception in my case.

No matter how diligently I trained, no matter how hard I pushed myself, the years were going to slow me down. This had been hard to see at first, because when I'd returned to racewalking three years earlier I had improved from one race to the next, as I got into shape, polished my technique, and learned pacing and race strategy.

And, of course, I had denial working for me. I'd reacted with surprise when it took me fourteen minutes longer to walk the Brooklyn Half Marathon than it had in 1981, and wound up telling myself I ought to be within reach of that earlier mark in another year or two. Why, all I had to do was shave a minute per mile off my time in 2005. How hard could that be?

But aging did seem to be real, and worse yet it seemed to apply to me. It seemed to me I could feel the two years since I resumed racing, that they'd already begun to take their toll.

Well, so what? The number of minutes and seconds it took me to cover 3.1 or 5 or 6.2 or 10 miles was, in the first place, of no interest whatsoever to anyone else in the world but me. And did I myself really care all that much? I would never be faster than I was now, but when had I ever been other than slow? As long as I got

a sense of accomplishment out of my races, a feeling of satisfaction irrespective of the numbers on the clock—

And I did—but only in the long races. The sheer unforgiving distance of a marathon made it a triumph to get to the finish line, however long it took. Every time I finished one, I felt as though I'd done something worth doing. It was easy to feel good after the first Mardi Gras Marathon, when I'd been so pleased with my time, but my second go at New Orleans left me with a good feeling of another sort. I'd taken more than an hour longer to cover the same course, but no matter; I'd gone the distance.

That happened with every marathon. If it was in a state that was new to me, the finish line brought me one step closer to the goal of fifty states. (Plus, I suppose, D.C.) If I already had the state on my list, no matter; it was still one more marathon on my record. The ultras I'd endured might allow me to drop the phrase *just a marathon* into my conversation, but never without a drop or two of irony.

After my first race in New Orleans, after I'd seen my time drop in three successive marathons from 5:45 to 5:21 to 5:17, it had been easy for me to envision the improvement continuing—not forever, mind you, but for a while. A year later, it was harder to sustain that vision, and seemed rather more likely that 5:17 would

be a high-water mark, that I'd never again cover that much ground in that little time.

I could, if I wanted, use one of a variety of formulae designed to measure one's performance against one's age; that way I could race not only the clock but the calendar as well, and there were enough different measuring sticks on offer so that I could almost certainly find something that would provide reassurance. This all struck me as a pop science take on *I'm in pretty good shape for the shape I'm in,* and I decided the hell with it.

And in fact I was in pretty good shape, and more likely to stay that way if I kept on doing marathons. I didn't know how long I'd be able to keep at it, but I didn't know how long I'd go on having a pulse, either. As long as I could, I'd go on walking marathons.

And twenty-four-hour races. There would be a point, of course, when I finished with a twenty-four-hour performance equivalent to my 5:17 in New Orleans. So far I'd been in three such events, and I'd done a little better each time. Someday that would no longer be the case.

But for now the twenty-four-hour race still offered room for improvement.

Late Friday afternoon in Minneapolis I drove to the park to pick up my T-shirt and number. At the pre-

race pasta party, I met some of my fellow walkers. Ollie Nanyes had come up from Peoria, and introduced me to Marshall King, the Texan who'd qualified as a Centurion a year and a half earlier at the Ultracentric. I loaded up on pasta and drove back to my hotel.

The goody bag included a parking pass; it would entitle me to park overnight in one of the lots adjacent to the course. Before I went to bed I put it where I'd be sure to remember it, and of course I forgot all about it. I was able to get a spare pass the next morning from one of the race directors, and left my car in a good spot.

The course was a 2.42-mile loop around Lake Nokomis, most of it on asphalt paths through the park. There were a few brief cross-country sections, where they routed you from one path to another, and one significant cross-country stretch that had us going over a significant rise. Someone had posted a sign identifying the thing as Mount Nokomis, with a mock elevation chart that showed the decimal point migrating to the right, depending on which lap one was on. A walker would be hard put to maintain good form while scaling Mount Nokomis, but no one expected you to.

There were other elements of the course that kept it interesting, including a small wooden pedestrian bridge over a trickling creek and a much larger bridge that was part of an automobile route; we didn't have to

contend with traffic, there was plenty of sidewalk, but it was what the organizers referred to apologetically as "one unavoidable stretch of concrete."

The local racewalkers' club had pitched a support tent near the start/finish line, manned by Bruce Leasure, who would be doing the judging. Walkers were encouraged to use the tent, and one local walker, Dave Daubert, kept all his shoes there. He'd brought eight pairs along—all the same make and model, as far as I could tell—and he went through them systematically, changing his shoes every three hours. That struck me as genuinely strange, but I guess it didn't hurt his performance any. When the race ended, Dave had gone the farthest.

Before the race got under way, I was already impressed with the way it was organized. They made you weigh in before the start, and got you back on the scales every four hours; if you lost more than a certain percentage of your body weight, they gave you a chance to eat and drink your way back to normal; if you couldn't manage that, they could pull you out of the race.

I wondered if this was one more goddam thing to worry about, and then I remembered the words of the ultrarunner who'd volunteered in the food tent at Houston, the one where I'd spent far too much time. He'd announced that he'd never been in an ultra with-

out weighing more at the end of the race than he had at the start.

FANS had a food tent, of course, and a medical tent as well, where volunteers were on hand to provide first aid for blisters and, remarkably, massages. The whole enterprise was well thought out and efficiently organized, and that was a plus, but then they blew the whistle or sounded the horn or fired the gun, whatever the hell they did, and from then on we had to get out there and roll up the miles.

Typically, laps are run counterclockwise. That's how milers do it on an oval track, or horses at the Churchill Downs. But circumstances alter cases. At Corn Belt they switch every four hours. At Wakefield laps are clockwise, to make that steep fifty-yard cross-country patch downhill; that way it's no worse than a nuisance.

At FANS, the start is clockwise. Then, after we'd gone perhaps just over four-fifths of a mile or just past Mount Nokomis, they turned us around, had us scale Mount Nokomis a second time, and sent us back to the starting line. We crossed it and kept on going, and the rest of our race was counterclockwise.

(Incidentally, I wonder how long that phrase will remain in use, or even comprehensible. When all the world's clocks are digital, how will we describe our

progress around a track? I may have pondered this question while I circled Lake Nokomis. I had plenty of time for idle thought, and nothing all that important to think about.)

The point of the out-and-back was not to provide us with an extra turn on that hill, but to make a couple of key points in the race coincide with the start/finish line. So we would hit the fifty-mile mark at the completion of the twentieth lap, and five more laps would bring us to a hundred kilometers. (The hundred-mile mark would come a half mile before the end of the forty-first lap.)

The start was at 8:00 A.M., and as this was June the sun was already giving a good account of itself. There was a good amount of cloud cover, though, and this increased until the sky was largely overcast by noon. It looked as though we'd be spared the full heat of a June day, which was a relief, but the trade-off was a strong possibility of rain before the day was over.

It's always something.

Meanwhile, though, I was doing fine. It was a pleasure to be in a race that was long enough to keep me from worrying about time. I found it maddening that I had to stop to pee as often as I did in the early miles of a marathon; here there was a john set up a little more than halfway around the loop course, and I didn't

resent my stops there. In fact, I made it a part of my routine to duck in every other lap, welcoming the brief break.

After the February 2006 race in Houston, Andy Cable had posted an interesting observation on the ultrawalking message board. He'd stopped when he reached one hundred kilometers, although he was sure he'd been capable of quite a few more miles. What took him out of the race, he decided, was that he'd set himself too few goals. His first goal, which he'd achieved, had been to go 100K and take home an Ulli Kamm award. His second goal was to circle that loop fifty times and qualify as a Centurion.

Fifteen hours into the race, it became inescapably evident to him that a hundred miles was out of reach that day. And so, once he'd walked his hundred kilometers, he had no real reason to keep going. It was late, he was tired, his feet were soaked, so why not go back to his hotel and get some sleep?

If he'd had some intermediate goals—seventy miles, eighty miles—he might have stayed on the course a couple of hours longer.

I'd read his post and took it to heart, and set my own goals accordingly. At a minimum, I wanted to win another Ulli Kamm award. After that, I wanted to

extend my personal record beyond the 66.3 miles I'd managed last year at Wakefield. I'd been less than a lap short of walking my age in that second Wakefield race, and would probably have done so if I'd been thinking in those terms, so I added that this time around. I was still sixty-eight, with my birthday a couple of weeks away, so I'd be aiming at that many miles.

After that, 70 miles was a goal. Then 75. Then 78.6—a triple marathon. And then, God willing an' the creek don't rise, eighty.

That didn't mean I'd necessarily slam on the brakes at the eighty-mile mark. Anything beyond that number would be just fine. But eighty seemed like a good dream goal, not entirely unrealistic, not if everything went right, but—well, I won't say it wasn't going to be a walk in the park, because that's precisely what it was going to be. But it would be a very long walk in the park.

I had another goal, a goal of another sort. There was no number attached to it, and it didn't have anything directly to do with distance.

I wanted to keep going for the full twenty-four hours. The secret to distance, it seemed to me, lay in staying on the course. Four miles an hour was the slowest setting I ever chose on the treadmill, and four times

twenty-four is ninety-six; that easy pace would carry a walker to the very brink of Centurion status.

Which is not to say that I could become a Centurion by walking fifteen-minute miles. Everyone slows down in the second half of that long a race. But suppose you walked at that pace for the first twelve hours and slowed to a stroll of three miles an hour for the remaining time. You'd wind up covering eighty-four miles. Why, if you simply *averaged* three miles an hour, poking along at twenty minutes a mile, you'd go seventy-two miles in twenty-four hours—and that was better than I'd managed in my three previous attempts at the distance.

That was the answer, I told myself. Perseverance. Stay on the course, keep putting one foot in front of the other. No naps, because you won't really need one. Just pretend you're back in college, pulling an all-nighter, wired on pharmaceuticals and bad coffee, trying to knock off a term's worth of studying before the sun comes up . . .

Maybe that wasn't the best memory to draw on.

Still, no naps, no long breaks. There'd be plenty of time to sleep when the race was over. If I just managed to keep myself on the course, to go on walking, I didn't have to worry about my pace, didn't have to think about it any more than I did walking unmeasured miles for

hours on end along the Hudson River. All I had to do was put in my hours—not five or six or seven of them this time, but twenty-four. If I took care of the hours, well, the miles would take care of themselves.

Nothing to it, really.

Race conditions were good. I can't remember paying much attention to the weather during the first eight hours or so, and that's what you want in a race, really: weather that doesn't make all that much of an impression. The cloud cover increased as the day wore on, and by late afternoon it was raining, but never hard enough to be a problem. It went on raining off and on through the early evening, which wasn't all that bad, and eventually it stopped, which was even better.

There were a lot of walkers on the course, 27 in a field of 167, but only 8 of us were signed up for the full twenty-four hours. (The other 19, along with 43 runners, would get to go home after twelve hours.) I was glad of their presence, but I didn't see much of them as we all strode along. Once we'd strung out after the start, we were pretty much on our own. Marshall, whose cruising pace is much faster than mine, might cover five laps in the time it took me to do four—but that meant we'd only encounter each other once every couple of hours.

One person I did see with regularity was a young runner, Oz Pearlman. We'd exchanged a few words before the start, managing to establish that we'd both come from New York, and he had a cheerful greeting for me every time he breezed past me, which was something he did with astonishing regularity. I didn't keep count, but it seemed to me as though he were racking up two laps to every one of mine, and if he wasn't winning the race he was certainly among its leaders.

I kept walking, and the laps mounted up. There was a chart near the finish line with the mileage listed for the various laps—the out-and-back start made it impossible to keep track otherwise—so I could note, for example, that my thirteenth lap had brought me to 33.13 miles, and my seventeenth to 42.82.

That's probably where I was around the time the twelve-hour race wrapped up, and you could tell you were in the last hour of the twelve-hour when you saw runners doing short back-and-forth minilaps near the finish line. At Wakefield, only complete laps are counted, and if you complete a lap with less time remaining on the clock for you to manage another 3.16 miles, then your race is over. At Lake Nokomis, they gave you the option during the last hour of walking back and forth on a measured eighth-mile strip, and

you could zip back and forth, back and forth, until the clock ran all the way to the twenty-four-hour mark.

Or, from seven to eight that evening, the twelve-hour mark. I made my way through a batch of them as they tacked on their final fractions, and the next time I came by they were gone, and there were far fewer of us still on the course, and the daylight was pretty much gone.

"Hey, Larry! Looking good!"

It was Oz, passing me once again. He was still running. I was still walking.

Which is not to say that I hadn't thought about stopping.

Not dropping out of the race, nothing like that. Because I was walking well and making good time, and my feet weren't hurting and my legs felt fine. I had every intention of finishing the race, and it looked as though I'd achieve most of my goals with relative ease. A new personal record seemed likely, and a total in excess of eighty miles was by no means out of the question.

But I couldn't help noticing that I was tired. Maybe I could just go lie down for a while, refresh myself with a little nap. A hundred yards or so off the course there was a building with cots you could lie down on, and it seemed to me they'd said something about showers as

well. Or, if I didn't want to go that far, couldn't I just sit in a chair for an hour?

I said as much to Ollie. We ran into each other at the food tent, or somewhere on the course—I don't remember where, but it was an hour or two before the light failed. I remember he said I was making good time, and I said in reply that I figured I was going to have to take a break soon.

"Just slow down," he suggested. "Keep walking, but slow your pace. Do that for a lap or two, and then you can pick it up again."

I said I didn't think I knew how to do that.

"For starters," he said, "stop racewalking. Quit swinging your arms. Just walk."

It turned out to be excellent advice. I made myself do just that for the better part of a lap, and I don't know that it slowed me much, probably no more than a minute a mile. I can't say that it was the equivalent of eight hours of sound sleep, and maybe all it provided was the illusion of a break, but the point is that it kept me on my feet and on the track, and by the time I'd completed that lap I'd gotten past the feeling that I needed a break, that I had to have one, that I couldn't just keep on walking like this forever.

Through the evening hours, I repeated this trick of Ollie's whenever fatigue suggested the idea of a break.

I let my hands drop to my sides, I reduced my hip pivot and let my stride shorten, and my pace slowed accordingly. I rarely did so for more than a few hundred yards, and without conscious volition on my part I'd find I had returned to my form and my usual cruising pace. But I'd have dodged a mental bullet.

Sometimes, evidently, a change is as good as a rest. Sometimes it's better.

The loop course had never been what you'd call crowded, but it thinned out considerably as the night wore on. The end of the twelve-hour race removed 62 entrants from a field of 167, and as the hour grew later, some of the twenty-four-hour crowd decided that enough was enough. Others slipped off for a nap.

I'd been told that a flashlight would be useful out on the course, but of course I neglected to bring one. Ollie had a spare, and gave it to me, and that was reassuring until I had occasion to dig it out of my fanny pack and switch it on, at which point I discovered that, unless I pointed the beam directly at my face, I couldn't determine whether or not the damn thing was on. I guess the batteries had wasted their fragrance on the desert air, because what power remained was barely enough to enable one to locate the thing in a dark room.

That was all right, I knew the course well enough by then and there weren't that many stretches where I'd have needed the light anyway. But between the darkness and the dropouts, I felt a good deal more alone out there; there were fewer people, and it was harder to see them.

This was something I was aware of, but that's not to say that it bothered me. There were plenty of people at the start/finish line, counting my laps, repeating my number when I called it out (as I did each time, to make damn sure my lap got counted), providing food and drink as desired. I'd call it out again as I passed the smaller tent where Bruce Leasure was keeping his own tally of walkers' laps—and standing guard over Dave Daubert's shoe collection. He'd tell me I was looking good, and I'd advise him that I still had a pulse, and off I'd go on another lap. On past the double row of individual tents, where runners could stow their gear and food and stop for a quick nap, on to that first little wooden bridge, and on into the darkness.

All I had to do was keep going, putting one foot in front of the other, and I was going to break my record. In fact it looked as though I'd smash it to bits.

Unless, of course, something went wrong.

My car was parked where I could get to it easily, and I had the keys in my waist pack. (They took up far

too much space there, because the Hertz people, for reasons I've never been able to determine, put two or three copies of the same key on the little ring, along with the remote-control gizmo, and the ring holding them all together is fused, so you can't disassemble it. The need for multiple keys would seem questionable, since to lose one is to lose them all. The only answer I've found is to cut through the ring, tuck the remote into a pouch or pocket, and leave everything else in the car. Think Alexander, and the Gordian knot.)

Sometime after midnight I went to the car, prompted by a sensation of heat on the bottoms of my feet. After sixteen-plus hours, I had blisters threatening to form. I put some tape where it was likely to help, changed my socks, laced up my shoes, and returned to the fray.

I managed another couple of laps, and stopped in at the medical tent. By this time I had substantial blisters on the forepart of each foot. A volunteer did a good job of bandaging them and got me on my feet again.

There are two ways to cope with a blister, aside from simply ignoring it altogether. You can puncture it and expel the fluid before dressing it, or you can leave it intact and protect it with the bandage. The former method relieves the pressure, and thus reduces the pain, but may bring the risk of infection. I probably would have run that risk, given the choice, but I figured

the fellow on duty knew what he was going. He got me on my feet again, and while I remained well aware of the blisters, they didn't keep me from walking. If they slowed me down, it wasn't by much.

At least I could stay in the race. While I was getting my blisters seen to, another medical volunteer was having a look at Oz Pearlman's knee, and I guess it didn't look good. My fellow New Yorker was twenty-four years old, wearing bib number 24 in a twenty-four-hour race; you'd think all of that boded well, and he'd breezed through forty-three laps for 105.78 miles by the time he had to visit the medical tent, but that was as far as he'd go that night. That was still good enough for twelfth place. The fellow who won the race, Paul Hasse, reached 131 miles and change, and I suspect Oz would have gone farther than that if his knee had held up.

Well, something always goes wrong in a twenty-four-hour race. It was about this time that something went wrong for Marshall King, who'd hoped to repeat as a Centurion. He was on pace to do so for the first sixteen hours or so, but his energy levels dropped precipitously sometime after midnight, and he recognized that he just didn't have it on this particular occasion. His twenty-ninth lap was his last one, and he left the course with 71.88 miles.

Something had gone wrong for me, and it had taken the form of blisters, and I was able to walk through them. I was doing well, though not quite as well as I thought—I got my count wrong, thought Lap Twenty-two was actually Twenty-three, and when I realized their count was correct I felt as though I'd just walked an entire 2.4 miles without getting anywhere. Still, I was on pace to make eighty miles, and I'd been able to walk well past midnight without leaving the course or taking a nap. The longest time I'd spent sitting down was the five or ten minutes it took me to get my blisters attended to. I was tired, no question, but I wasn't by any means exhausted, and all I had to do was stay on my feet and keep moving for another five hours, and that was something I was confident I could do.

Shows what I know.

The twenty-fifth lap brought me just past the hundred-kilometer mark. I'd qualified for a second Ulli Kamm award, and there was more coming. One more lap and I'd improve on my race in Houston. One more after that and I'd break my own record set a year ago at Wakefield. A third and I'd have walked my age, and a fourth would put me past seventy miles, and, well, the numbers were there.

I ate something, drank something, paused a moment to receive Bruce's congratulations on the 100K milestone, and kept right on going. And, just past the small wooden bridge, I first noticed that I was leaning forward and bending to the left, and that I was doing this because of pain in my lower back. When I tried to straighten up the pain got worse, and I'd adopted this awkward posture in order to keep walking.

But it's not as though I could walk pain free that way. It was increasingly painful, it hurt with every step I took, and I didn't know what to do about it. I stopped walking and tried to stretch it out, and that didn't seem to do any good; it would feel better for a moment, and once I resumed walking it would be as it had been before, if not worse.

I couldn't figure out where it had come from. I know I have a tendency to lean forward during the later portions of a race; I'm not aware of it while it's going on, but I've been told about it, and have seen photographic evidence. It's especially likely to occur when I'm pushing hard, racing the clock, trying to finish strong. In my best marathon, New Orleans 2006, the racewalker I'd surged past in the final mile made a point of criticizing my posture when we met up afterward. "You were really leaning forward," he said. I responded with the benign smile of the man who'd just whupped his ass.

But I'd never had anything like this before. My lower back, a source of pain for so many people, had never given me trouble, certainly not when I was walking. And what leaning I'd done in the past, in races or training walks, had been entirely unconscious; if I'd became aware I was doing it, I stopped—and then very likely resumed doing it again, unconsciously.

And it had been a simple forward lean. This was more pronounced, and it had me bending to the left as well.

I couldn't figure out what the hell to do about it. I kept walking, and tried everything I could think of to make it better. I put both hands in the small of my back and pressed against the pain, and that helped a little, but it was hard to walk at more than a snail's pace in that position. A little more than halfway through the lap there was a park bench, a long one, that I'd passed twenty-five times already without ever giving a thought to it; this time I stretched out on it on my back with my knees slightly bent, and in that position I finally got some relief. I stayed there for a few minutes, and when I got up and resumed walking I was a good deal better.

But it didn't last. I walked for a few minutes and the pain returned.

I finished the lap, stopped at the medical tent, and found there was a wait of fifteen minutes or so before I

could get a massage. I couldn't see the point in sitting around, and this didn't really feel like something massage would help. I walked on to the walkers' tent and sank into a chair. I could sit without pain, and I did, for a few minutes. Then I made room for myself among Dave's shoes and eased myself down on the ground, lying there and letting my spine straighten out, as it had on the bench.

One more lap and I'd set a new record of 67.04 miles.

I got up and forced myself through another circuit of the course. I stopped two or three times to lie down and stretch, and I didn't wait to do so until I reached that bench. I just tried to pick a few square feet of pavement where I'd be unlikely to get stepped on by another participant. Once or twice someone noticed me and asked if I was all right, and I didn't really know how to answer that one. I wasn't, but to say so would be asking for help, and how was anybody going to help me?

At the end of the lap I stopped again at the walkers' tent and lay down again on the ground. Bruce found me a cup of coffee, and I drank that gratefully, and set out on the lap that would bring me past sixty-nine miles. That was my age and more, as I wouldn't be sixty-nine years old for another three weeks.

Pushing through those 2.4 miles, stopping periodically to lie down and each time making myself get up and go on, I wondered what was such a big deal about walking a distance in miles corresponding to my age in years. It's significant when an aging golfer is able to shoot his age, and it's a goal that, but for the ravages of time, grows more attainable with every passing year—impossible under sixty, less so after seventy, and, if you can still swing a club, rather more likely in one's eighties.

For a walker or runner, it was quite the opposite. Time kept raising the bar, even as age made it harder to get over it. Walking one's age—no challenge at twenty, not much of one at forty—grew ever more difficult.

In another year, I told myself, I'd be one more year older, and have one more mile to cover. So I might as well do it now.

It was somewhere around four in the morning when I finished Lap Twenty-eight. Those last three laps had taken a long time, because I was incapable of moving at a decent pace. I'd now reached the goal one more lap would have given me in the heat of Wakefield, I'd walked my age, but one more lap now would put me over seventy miles, and I sat in the walkers' tent and told Bruce how much I wanted that number.

He pointed out that I was a lot less than a full lap away from it. I had covered 69.46 miles, I was just over half a mile short of 70, and if I couldn't manage another lap just now, well, I didn't have to, not with almost four hours left in the race. I could go lie down somewhere and return to the course in a couple of hours. Ollie had gone off for a nap a while ago, and Dave was lying down, too. I could do that, and maybe my back would be better for it, but even if it wasn't, a couple of hours rest might make it easier for me to push through one final lap.

"And if you wait until seven o'clock," he added, "you won't have to do a full lap, because that's when they start doing minilaps, an eighth of a mile each, and you could just walk back and forth until you get up to seventy."

It sounded like a good idea. I didn't bother hobbling over to the building where they had the cots; it seemed like too challenging a walk just to get there. Besides, I was afraid if I let myself actually lie down in a real bed, I'd never make it back to the track in time. Instead I went to my car and sat behind the wheel. That doesn't sound terribly comfortable, but I found a position in which my back didn't hurt, and right then that was all the comfort I needed.

I slept until a little after six. At some point the rain resumed, but by the time I was up it had tapered off to

a misty drizzle. I headed for Bruce's tent, and within ten steps I could tell there'd been no miraculous sleep cure. My back wasn't any better, and walking was no pleasure.

I got a cup of coffee and something to eat and sat down while Bruce brought me up to date. Dave Daubert and Ollie Nanyes were both back on the course after their naps, a fairly brief lie-down for Dave, a longer break for Ollie. Three local walkers, a man and two women, had dropped out earlier, with totals ranging from twenty-five to fifty-six miles. Marshall, who'd left the course after twenty-nine laps, had not returned.

Barb Curnow, a local walker a year or so younger than I, was still out there. She walked FANS every year, and she never showed much in the way of speed, but the woman never stopped. I'd passed her a couple of times over the hours, but there she was, as indefatigable as the Energizer Bunny, still going and going and going while all I could do was sit there.

At seven I walked over to the start/finish line. Most people who tacked on minilaps did so at the end of a full lap; a runner would complete a circuit of the course at, say, 7:40, decide the twenty remaining minutes wouldn't be enough time for him to get around again, and switch to minilaps until time ran out. There were just a couple of us who began the final hour with

minilaps, and our ranks swelled over time as others joined in.

The course for these short laps extended from the start/finish line for an eighth of a mile, at which point you turned around and headed back again. If I could run this particular fool's errand three times, I'd add three-quarters of a mile to my tally, and that would get me over seventy miles.

It was surprisingly difficult. I walked as rapidly as I could, not because my pace mattered at this point but in an effort to be done with it as soon as possible. The pain was considerable. Here's how unpleasant the whole business was: afterward, when I learned they were counting every eighth of a mile, I realized I could have quit half a lap earlier than I did, could have gone out and back and out and back and out, and left it at that. I'd have wound up with 70.09 miles, and I'd have saved 210 agonizing yards.

At the same time, it was hard to sit on the sidelines while the rest of the final hour played itself out. I don't know when I finished my third and final minilap, but there's no way three-quarters of a mile could have taken me more than twenty minutes at the outside. That left me with forty minutes to watch other entrants fitting in every bit of distance they could before the last minutes ticked away.

I was especially aware of Ollie, so invigorated by his couple of hours of downtime that he kept at it right up to the whistle. It was frustrating to watch him, not because he might overtake me—he'd finish with 66.11 miles—but because I felt I ought to be doing the same, pushing myself clear to the end. I was in no danger of doing so, I was able to recognize that my race was over, but that didn't mean I had to like it.

At the awards presentation, Dave Daubert took first place in the walking division, finishing with 80.76 miles. (That's just slightly more than ten miles per pair of shoes.) Barb Curnow was second with 75.42, and Marshall's twenty-nine laps put him third. I was fourth, Ollie fifth, and three others finished out the field.

Five of us had earned Ulli Kamm awards, and Bruce promised he'd ship them to us. And every entrant had received a finisher's award at registration, a small wooden plaque with a bronze medallion inset; a metal tag inscribed with name and mileage would be mailed to us in due course.

Yeah, right, I thought. That's what they'd told us a year and a half ago in Houston, and wasn't I still waiting for the nameplate for that Ulli Kamm award?

I walked to my car, drove to my hotel, had a shower, and took to my bed. My back didn't bother me, not

now, not while I was lying down, and all in all I felt wonderful. I'd broken my record by almost four miles, I'd walked in miles an age I wouldn't attain until a couple of weeks after next year's FANS race, and I'd achieved almost all of my goals.

I hadn't reached seventy-five miles, let alone the triple marathon or the eighty-mile mark. But I would have managed all of that if something hadn't stabbed me in the back. As for my goal of staying out there for the full twenty-four hours, I'd fallen short by a few hours—but this time I hadn't been driven off the course by fatigue or a failure of will. As far as my mind was concerned, I'd been ready and willing to keep on walking from the first minute to the last. It was my body that had given out, specifically my back, and I could no more castigate myself for that than Oz Pearlman could beat himself up for his injured knee.

Aside from my back, the rest of me seemed to be in pretty good shape. The first aid I'd received had helped my blisters, and one of them seemed in the process of reabsorbing the liquid and mending itself. I opened the other and expressed the fluid, and it looked all right to me. My feet weren't 100 percent, but they weren't all that bad for having gone that far, and I figured they'd be in good enough condition in three weeks' time for the marathon in Anchorage.

My back might be another story. I didn't know what to expect from it.

It was fine the next morning.

I got up, packed, had breakfast, drove to the airport. I didn't racewalk down the concourse, but I walked at my usual pace and in my usual fashion, and my back never gave me the slightest twinge. It felt fine.

Back home in New York, I took a couple of days off, then eased back into light training. My feet were mending nicely, as I'd expected they would; more to the point, my back didn't trouble me at all. At Lake Nokomis, it had crippled me up and made every step a nightmare. Now it was as if I'd never had any trouble with it at all.

I couldn't make sense of this, and still can't. I've walked miles without number since then, and that pain has never returned. I'm not complaining, believe me. I'll be perfectly happy never to go through it again. But what was it? And where the hell did it come from?

It hadn't revealed itself until I'd spent upward of eighteen hours walking more than sixty miles. Until then I never got so much as a twinge of back pain, but once it started it made walking virtually impossible. I can only assume I'd been holding tension in my lower back, somehow clenching something there unwittingly

and certainly involuntarily. It would have been handy to know what it was I'd been doing, so that I could try to avoid doing it again.

But it was gone, whatever its source, and that was cause enough for rejoicing. And I'd gone more than seventy miles, and had stayed on the course until pain forced me off it, and then returned to push myself through a final three-quarters of a mile.

In less than two months it would be time for a third try at Wakefield. They didn't know from mini-laps there, and only counted full ones. I'd gone twenty laps in 2005, twenty-one a year later in the heat. I'd be sixty-nine years old this time, and Lap Twenty-two would give me my age, and one more after that would give me a new record. After that, each lap was a significant milestone: Lap Twenty-four—75.84. Lap Twenty-five—an even 79 miles, and a triple marathon. Lap Twenty-six—82.16 miles.

First, though, it was time to fly to Alaska and pick up another state.

I had to pee.

Well, that was only to be expected. I'd made my usual trips through the Porta John line at the marathon's staging ground, but I'd walked several miles since then, and it was time to answer nature's call. That could be awkward in a race through the crowded streets of a large city, but there was really nothing to it when you were out in the country. And we were on the outskirts of Anchorage, racing along an asphalt path through parkland that was pretty close to wilderness. Take a dozen steps off the pavement and the only witness to your peeing would be the songbirds and the rabbits.

And the moose, and the bears—and that was the problem, because a dozen steps was farther from the path than it was advisable to be. The woods began

perhaps half that many steps away, and one really didn't want to be an uninvited guest at the Teddy Bears' Picnic.

At Athens the previous year—that's in Ohio, you'll recall, not Greece—we'd been on a similar path through parkland, and it had been a small enough race so that privacy was never an issue. There just weren't that many others in the race, and they were all out in front of me. And the slow ones were too busy contending with the course to pay attention to an old guy watering the flowers.

Not so in Anchorage.

For several years, the Mayor's Midnight Sun Marathon had drawn great quantities of America's slowest runners, and some of them couldn't properly be described as runners at all. Almost six hundred men and eight hundred women completed the race, and a substantial proportion of them were running it as a part of Team In Training, a national organization raising funds to combat leukemia and lymphoma, and I have to say its purpose was as laudable as its acronym was unfortunate. All of the Team In Training entrants were decked out in purple shirts, and the staging area before the start was an ocean of purple. There were entrants from every state, except for West Virginia. I don't know what happened to West Virginia.

For most of the Purple People, this was a first marathon, and the race organizers went out of their way to encourage first-timers, keeping the finish line open for a very generous eight and a half hours. It is always a challenge to complete a marathon, but it is rather less formidable a challenge when you've got eight and a half hours available to you. You can still go all out, of course, but you don't have to. You can relax. You can slow down. You can take time to sprinkle the flowers, or even to smell them.

The ranks of the Purple People included more than a handful of flower-smellers. Some of them had binoculars around their necks, so that they could get a good look at the flowers—or, if they were lucky (or unlucky, depending on the outcome) at the moose and bears. More had cameras, and stopped occasionally to take pictures of the glorious landscape, or, less gloriously, of each other. They were in no hurry, many of these purple-clad warriors, and what was wrong with that? They were exerting themselves in a good cause, and when it was all over they'd have finished a marathon.

So there I was, a step or two off the path, facing away from the stream of runners flowing slowly behind me, and staring vaguely off into the distance. And a cheerful young woman in a purple T-shirt interrupted her

running to hurry over and position herself next to me, eager to find out what was commanding my attention.

"Hi," she said. "Are you looking at something wonderful?"

You can imagine the several responses I considered and rejected. What I said, sternly, I'm afraid, was "Go away." And she did. And, a moment later, so did I.

When I registered for the Anchorage race, I did so without knowing if I'd actually be up for it. It was held just three weeks after FANS, and there was no way to guess how much that race might take out of me, and what kind of shape I'd be in three weeks later. I decided it was worth the risk. I had to get to Anchorage anyway, where Lynne and I would embark on our Bering Sea cruise, and, as that Fifty Stater had pointed out after the Mississippi Marathon, as long as I was in the neighborhood I might as well give it a go. If it turned out I wasn't up for a marathon, all I'd lose was the entry fee, plus whatever it cost me to rebook my flight. (If I wasn't racing I really didn't need to arrive ten days early.)

Recovery, as it turned out, was rapid and easy, and I reached Anchorage in decent shape for a marathon. It was late June, and midnight sun was no exaggeration, but I still thought it was curious that they'd hung that

tag on the race. When they call something the Midnight Sun Marathon, you expect to be out there in the middle of the night. Instead we had the typical morning start, and the slowest Purple Person of the bunch was eating postrace pizza a good eight hours before midnight.

The event was well organized. School buses chartered for the occasion picked us all up at our hotels and conveyed us to the start, then scooped us up at the finish and took us home.

I took my time. I didn't stop to take pictures, but neither did I set out to break any records. I'd had only three weeks since my seventy-mile effort in Minnesota, and I thought of this marathon more as a long recovery walk. I took it at cruising speed, and enjoyed the fresh air and the surroundings. Because I don't wear my glasses during races or training walks, my appreciation of the scenery was limited. What I saw was not all that sharply focused, but no less enjoyable for it; viewing the passing landscape without my glasses was rather like looking at Monet with them, and what's so bad about that?

Some runners reported sightings of bears and moose. I did see an eagle, perched on a dead tree and outlined against the sky, but I wouldn't have noticed the bird if someone else hadn't given a cry and pointed him out.

My net time was 6:22:06. I'd gone the twenty-six miles and change, and the usual aches and pains came and went during the race, but in the main I held up well enough and finished in decent shape. The horrible toe pain that I'd endured in two successive marathons, Huntington Beach and New Orleans, didn't show up this time; I'd escaped it in Minnesota as well, and figured a change I'd made in footwear deserved the credit. I'd been more anxious about my lower back, and it never gave me a twinge.

I rode back to my hotel and stood under a hot shower for a while, and a few hours later I walked downtown and ate salmon.

I got up the next morning, booted up my laptop, checked my email, took a deep breath, and started writing.

More specifically, I started writing this book.

I'd been thinking off and on about writing some sort of book about my efforts at racewalking. One thing that held me back was the concern that no one but family members and indulgent friends would have much interest in reading it. It seemed to me that I couldn't assign high priority to such a book, not when I had another book I was contractually committed to write, a book I was already late in delivering. A book I might have

been able to deliver on time, if I wasn't always out there walking day after day. . .

That book was *Hit and Run,* and I completed it in the course of my post-marathon stay in New Orleans. Once I'd turned it in, I realized there was something else I had an urge to write, and it was sometime in April that I began working on this book's opening, actually reworking a message board report I'd posted on the New Orleans race. I got a little work done, but not very much; as my training for FANS picked up, I let the writing go. Now, though, I had a long week all by myself in a city where I didn't know a soul. And training wouldn't be a distraction, because my legs needed a rest at this point more than they needed more miles on them.

And my performance at FANS had me feeling genuinely good about myself as a walker, and my leisurely pace in Anchorage hadn't changed that. So I'd brought my laptop along, and Sunday morning I got to work.

This was not my first venture at memoir. Sometime in the mid-1990's I'd gone to Ragdale, a writers' colony north of Chicago in Lake Forest, Illinois, to work on what would eventually take form as a Bernie Rhodenbarr mystery, *The Burglar in the Library.* I spent a week establishing that I wasn't ready to write

that particular book, then set it aside and wrote some other things—an introduction for the first hardcover edition of *The Canceled Czech,* and a pair of short stories which became chapters in *Hit Man*. It was a productive stay, if not what I'd had in mind when I booked the time, but I still had ten days before I was due to pack up and head home, and I got up one morning and started hitting computer keys, and it was the damnedest thing. I couldn't stop writing.

I'd been toying with the idea of writing a memoir of my beginnings as a writer. I started young, while I was still in college, and spent those early years producing a vast amount of pseudonymous trash, along with my first efforts at crime fiction. I'd written a great deal since about writing, I had a monthly instructional column in *Writer's Digest* from 1977 to 1990, and I'd certainly referenced some of my early experiences in that column and the several books for writers that had grown out of it. But I'd never really told my story, had never been inclined to do so, and had in fact made a point of brushing aside interviewers who wanted me to discuss those early days.

In the months before my Ragdale stay, I'd gotten to the point where I felt that recounting my beginnings was something I might want to do someday. But not yet, certainly. Not until I was ready.

Well, it was beginning to look as though I was ready. Because I batted out something like six thousand words the first day. I couldn't drag myself away from the computer. I barely got to the dinner table on time, and it's rare indeed for me to miss a meal.

I did the same thing the next day, and the day after that. And in eight days I'd produced something in excess of fifty thousand words.

It was an extraordinary experience. I'd start writing about some incident I hadn't really thought about in decades, and almost before I'd finished exploring that particular chamber in my memory, another door would spring open, and I'd be remembering something else I'd forgotten entirely.

I'd had words come at this pace before. Some of us are apt to describe a book as having virtually written itself, but that's not really what happens; if it did, one wouldn't feel so utterly exhausted at day's end. But, tiring or not, I've had books that were written very rapidly, and I don't know that they ever suffered for the speed of their composition. Some of the work I've liked the best, and that was the most favorably received, had a very short gestation period and an easy birth.

But this was different. I found myself working all day and returning to work after dinner, because

I seemed to be incapable of staying away from the computer. One memory would lead to another, and I couldn't shut the process down.

I wrote a little over fifty thousand words in eight days. (If you're not accustomed to thinking of length in terms of word count, this book you're reading is, as I type these very words you're reading now, just over 100,000 words. My daily stint, for the past four very productive weeks, has ranged between a thousand and twelve hundred words.)

I flew home from Ragdale with what I estimated at somewhere between 40 and 50 percent of the projected volume. That didn't mean it was anywhere near half done, as what I'd written was in rough form, and would require more work. It was, in fact, less polished than my usual first-draft copy, because I hadn't taken the time to tweak it as I went along. I'd been too busy writing the damn thing.

But it was readable enough to include in a submission when my agent negotiated a four-volume deal with my publishers. It wasn't by any means a key component, it was the literary equivalent of a player to be named later, but it was designated in the contract, with a specified portion of the advance earmarked for it.

That made it simpler a few years later, when I had to buy it back.

446 · LAWRENCE BLOCK

Because, curiously, I never wrote another word of that book. For the first month or so after I got back to New York I didn't write a word of anything, or do much of anything else, either. I was exhausted, and shortly after I managed to get up each morning, it was all I could do to stretch out on the living room sofa, where I spent most of my time until it was late enough to go to bed. Lynne would pause now and then on her way by to dust me.

I'd known I was going to need some downtime after the effort I'd put in, but this was a lot more than I'd anticipated. I'd worked intensively in the past, it was in fact my preferred way of working, and I went to writers' colonies because they facilitated this kind of total immersion in the work. This was vastly different, and when I thought about it—a few weeks down the line, when I was finally able to think about anything—I realized that the energy debt I'd incurred this time around was not only mental and physical, but emotional as well. You could argue that I'd been through a short course of do-it-yourself psychotherapy, and perhaps I'd turn out to be a better person for it, but in the meantime it was all I could do to chew my food.

When I was ready to get back to writing, I left the memoir alone and went to work on a novel. And for the next several years I didn't even look at the pages

that had poured out of me at Ragdale. My publishers never raised the subject, and why should they? There are books that have bestseller written all over them, and my memoir was not one of them. They'd have been happy to publish it if I ever finished it, but if I didn't, well, that wasn't anything likely to impact adversely on their bottom line. Eventually we negotiated another contract, and applied my advance for the memoir to the new agreement, and the memoir no longer served as a source of guilt. It was by no means the only piece of writing I'd started and never finished, and maybe I'd get back to it someday, and maybe I wouldn't, and who cared?

And here I was in Anchorage, in a writer's colony of my own making, writing another memoir with no guarantee that I'd ever finish it, or that anyone would want to read it if I did.

So what? I was having a good time.

I got up every morning and worked at a measured pace—cruising speed, we ultrawalkers call it—until it was time for lunch. I walked a mile to the seafood restaurant, where I had salmon once or twice a day. (Now and then I'd make one of the day's meals halibut, or king crab. But by and large it seemed too great a sacrifice to have anything but salmon.) Then I walked

back to the hotel, and did a little more work, and read something, and went out for a salmon dinner, and came home and read until bedtime.

The memoir surprised me. I had never anticipated writing about my childhood and adolescence. My earlier effort had been about as impersonal as a thoroughly self-centered narrative could possibly be; I'd taken as my model Erskine Caldwell's *Call It Experience*, in which he announced at the onset his intention to write solely about his life as a writer. His personal life, he announced, was none of anybody's business. I'd decided that was what I wanted to do, and I sat down and set out to do it—not because I wanted to spare the reader anything extraneous, but because I was temperamentally disinclined toward that sort of revelation. It was not for nothing that I had chosen a career as a novelist. I was perfectly happy to tell you everything you might care to know about figments of my imagination, but if you wanted to know something about me, well, too bad.

I guess I'd changed some in the intervening years. Age, I suspect, had more than a little to do with it. And, too, it seemed to me that age made this memoir more appropriate. The first time around, I'd wondered if it mightn't be presumptuous, or at least premature, for me to be writing a memoir. (That was before American letters worked its way into the Age of Relentless

Reminiscence, wherein graduate students earn MFA degrees by writing down their life stories, some of them even factual.)

Now if anything I was a little long in the tooth to be getting into the memoir game, and I couldn't afford to wait too much longer. If I was going to do this, I'd best do it while I still had a memory to draw upon. My times, especially in shorter races, were evidence that I was slowing down, at least out on the pavement. If the same was not yet noticeable at the keyboard, well, it was something to which I could look forward, and not with great enthusiasm. So if I intended to share my memories with the world, now was the time.

It was a less frenzied business than what I'd experienced at Ragdale. I produced three to four thousand words a day, fueled by fresh air and salmon, and my training was largely limited to the two daily roundtrips I made to the restaurant, and a couple of longer walks in the other direction to a supermarket. I did suit up a couple of times for an hour of racewalking at a nearby park, but the rest of my walking was in the interest of getting from one place to another.

While I might not be training all that intensely, the work kept my mind on walking—and the laptop plus the hotel's wi-fi capability made it easy for me

to plan the coming months. I'd already signed up for Wakefield, and now, flushed with success after FANS, I worked out the rest of my schedule for the year.

There were more twenty-four-hour races available in the fall, including one in Wisconsin on a 400-meter track and another around a lake in North Carolina. Then there was the Ultracentric, set this year for Grapevine, Texas. They'd have a walkers' division with Centurion judging there, that's where Marshall King had qualified, and I was pretty sure I wanted to go.

I could conceivably fit in Wisconsin or North Carolina before the mid-November Ultracentric—there were even moments when I imagined myself walking all three—but my enthusiasm stopped a few steps short of mania, and I settled on a less ambitious schedule. We'd return from our cruise in mid-July, and I'd do Wakefield the last weekend of the month. That would leave me five weeks before a marathon in Albuquerque. I have a niece in Albuquerque, my late sister Betsy's daughter, and hadn't seen her in years. I'd also get a chance to see one of my stepbrothers. And I'd always liked northern New Mexico, and the race description was inviting—a small field, a user-friendly course, plus the opportunity to add another state to my collection.

So I signed up for Albuquerque for Labor Day weekend. Afterward I'd have six or seven weeks before

the Ultracentric, where I'd see what I could do. I was hoping for seventy-five miles at Wakefield, and dreaming of eighty; if all went supremely well, I could set a high mark there and improve on it in Texas.

Once again, I was entitled to enter the New York City Marathon. The ten-mile Hot Chocolate race in December had been my tenth NYRRC event of 2006, one more than I needed for guaranteed entry. But I'd already decided to skip it. I'd waited twenty-five years between my first and second efforts, and I could certainly wait a few years before I took a third shot at it.

It was while I was in Anchorage, writing about old walks even as I planned new ones, that I received an email from my cousin Micah Nathan, whose father is my first cousin, David. (That makes Micah my first cousin once removed, or my second cousin, depending on who was holding forth at my grandparents' dinner table. This topic would surface every couple of years, long before Micah was born, and was discussed each time with intensity and conviction. I'm pretty sure Micah's my first cousin once removed, and that any progeny he might sire would be my first cousins twice removed; my daughters, on the other hand, are Micah's second cousins, while my granddaughters . . . oh, never mind.)

Micah lives in Boston, and works as a personal trainer when he's not writing novels and screenplays. I'd let him know how I'd done at FANS, and he was writing to congratulate me, and to let me know that what I was doing was at odds with the ordinary course of things. "You've done four of these all-day events," he pointed out, "and each time you're a little older, and each time you improve on the previous mark. I'm not sure I should tell you this, but that's not the usual order of things."

Lynne flew out on Sunday, and as soon as she got in I whisked her off for a salmon dinner. The next day we met up with Steve and Nancy Schwerner, our friends and frequent travel companions, and the day after that the *Spirit of Oceanus* set sail for two weeks in the Aleutians and the Russian Far East. I got a little writing done during the cruise, but no training to speak of. The ship had a small gym, with a couple of treadmills, but a treadmill's no great pleasure when the ship's cruising, and when it was docked we were off looking at things.

By the time we got home it was the middle of July, and I had just over two weeks before I'd be making my third attempt at Lake Quannapowitt. I don't know what training I did in those two weeks—I didn't make

any notations on my calendar—but I'm sure I didn't walk too often, or too far.

There's not much point in training within two weeks of a long race. The conventional wisdom holds that nothing you do that close to the race is going to help you, but it might hurt you. That's the time when runners and walkers taper off on their training, cutting back on the miles and taking them at an easier pace.

In a sense, I'd been tapering ever since FANS. I hadn't walked much in the weeks before the Anchorage marathon, and I'd walked very little since. FANS and Wakefield were eight weeks apart, and except for the 26.2 marathon miles, I'd scarcely walked at all.

Well, there was nothing I could do about it now. I'd just show up and do the best I could.

26

The good news was that Wakefield wasn't going to be so brutally hot this year. The bad news was that it was likely to rain.

We drove up on Thursday and had dinner that night with Larry Levy, my boyhood friend and companion at the Boy Scout jamboree. We'd be dining with Micah and Rachel Nathan Saturday, and that way Micah would have the chance to be astonished at my having successfully negotiated my fifth twenty-four-hour race and broken my record yet again.

It was good to be back at the Lord Wakefield, good to see some familiar faces when I picked up my T-shirt and number. Beth was back, and Andy, and a few others with familiar names or faces.

One lap an hour, Beth and I told each other. All either of us had to do was manage a single 3.16-mile lap

every hour, and we'd break seventy-five miles and sail past our previous record marks. The trick, then, was to stay on the course. The trick was to keep moving.

I got a good start, not too fast and not too slow. I suppose there must have been something that hurt early on, because there always is, but I can't remember anything specific. I kept walking, and drank plenty of water—Wakefield was humid, as it always seems to be, whether it's hot or cold, fair or raining. The course was reassuringly familiar, and I didn't even mind the short patch of downhill cross-country that came right after the start of each lap. Each time I hit it I was three miles and change farther from the beginning and closer to my goals.

The first five laps took four hours.

That struck me as a reasonable pace, one I ought to be able to sustain almost indefinitely. If I were to keep it up for the duration of the race, I'd finish with thirty laps, and break ninety miles—but I knew that wasn't on the table. A slower pace and more frequent breaks were inevitable as the day wore on.

But if I held my pace for the first half of the race, if I managed five more laps in each of the next four-hour segments, I'd have just over forty-seven miles in the bank with twelve hours to go. I could average twenty-minute miles for the rest of the race, a stroller's pace,

and it would work out to the one-lap-per-mile formula Beth and I had discussed. Fifteen laps in the first half of the race, twelve in the second, added up to what? Twenty-seven laps for 85.4 miles.

Was that really possible? I didn't see how it could be, especially the way I'd been forced to skimp on training. It was, in any case, mathematically possible. Whether or not I could make the numbers come out right was something I'd get to find out.

Meanwhile, the night wore on. A salty film coated my skin as Wakefield's humidity took its toll, and I was grabbing two cups of water at each station, one to drink and one to pour over my head. I'd had five laps at eleven o'clock, and four hours later it was three in the morning and I was up to ten laps. I'd passed the marathon mark and rolled up fifty kilometers, and I still had a full sixteen hours to go.

And the bottoms of my feet were starting to feel warm.

If I had gone straight to our room when I first noticed the telltale warmth, if I'd responded immediately by taping the soles of my feet—well, maybe it would have saved the day and maybe not, and I'll never know. Because I stayed on the course, and when there was no getting around the fact that I'd worked up blisters on

both feet, I kept on walking, perhaps hoping I could crush the damn things into submission. That more walking would somehow toughen my feet, that the liquid in the blisters would be magically reabsorbed, even as the blisters themselves morphed into calluses.

Fat chance.

I guess it must have been shortly before dawn when I returned to my room and took off my shoes and socks. Lynne was sleeping. I opened the blisters, expressed the fluid, ducked under the shower to rinse off the caked sweat, then bandaged my feet the best I could.

I put on clean socks and fresh shoes, and went out and pushed myself through a couple more laps, each slower and more painful than the one before. If I'd been able to continue the pace I'd maintained so easily for the first eight hours, I'd have finished my fifteenth lap around seven in the morning. It was in fact just 9:03 A.M. when I completed that fifteenth lap, for a total of 47.4 miles. The sky was overcast, and a light rain was falling. And I was finished.

I went to the room and fell on the bed. Maybe an hour or so with my eyes closed would refresh me, maybe my feet would be better if I stayed off them for that long.

I slept for a couple of hours, and when I woke up it was raining hard. My feet had somehow failed to

experience anything in the way of miraculous healing, and the drizzle had become a downpour that washed away any thoughts I might have had about getting back out there.

It must have been around two in the afternoon when I went downstairs to see how everybody was doing. The rain had abated, and I may have thought I could fit in a few more laps, but I ruled that out before I was fifty yards from the hotel entrance. My feet were in no condition for any serious walking.

I did walk through the parking lot, though, and got to the scorer's tent just as they were dismantling it. I'd realized that the deluge had been an electrical storm, but hadn't known that the race organizers had become concerned enough about lightning strikes to cut the race short and clear the course somewhere around noon. (The last runner to finish a lap did so at two minutes after one.)

Nobody clocked a hundred miles, though the winner came close, hitting 97.96 miles in seventeen and a half hours. Beth and Andy both had to stop after twenty laps; each had been on pace to clear 80 miles, and had to settle for 63.2. All of this must have been quite dramatic, but it was all over before I knew the first thing about it, and virtually everyone had gone home. One of the remaining handful of volunteers presented me

with a full carton of PowerBar gel packs, seventy-two of the things. I stowed it in the trunk and went back upstairs.

Though the mood was less triumphant than I'd envisioned it, we enjoyed our dinner with Micah and Rachel, and in the morning we drove back to the city, telling each other how fortunate I'd been. Suppose I'd pushed on, fighting my way past the pain of the blisters, somehow forcing myself to go on, only to leave the course anyway because they'd closed it. Wouldn't that have been infuriating?

Or say I hadn't been troubled by blisters to begin with. By noon I'd have been somewhere around the twenty laps Beth and Andy logged. Upward of sixty miles down with seven hours to go—sheesh, I'd have had a fit if anybody tried to pull the pavement out from under me. I'd have felt like killing someone.

The weather had presentenced the event to an inglorious end, and in my own case two wrongs had somehow made a right; my insufficient preparation got me off the course early, sparing me both a soaking and the frustration of a forced withdrawal.

So why didn't I feel lucky?

I dismissed any thoughts I might have entertained about the twenty-four-hour race in North Carolina. And I didn't even look to see what short local races might be on offer at New York Road Runners. There were just two races on my personal calendar for the remainder of 2007—the Labor Day marathon in Albuquerque, for which I'd already enrolled, and the Ultracentric in Texas.

The Ultracentric consists of a variety of races, all on the same weekend and over the same course. There are races lasting six, twelve, twenty-four, and forty-eight hours, along with a half-marathon. At one point back in June, carried away by Andy Cable's example in the six-day event, I'd actually considered trying the forty-eight-hour Ultracentric, but if Wakefield accomplished

nothing else, at least it relieved me of that particular insanity.

I gave my blisters time to heal, and then I began getting out and walking along the Hudson again, tentatively at first. I found the Ultracentric website and signed up for the walking division of the twenty-four-hour race. What I kept neglecting to do, though, was book my flight to Albuquerque, and the day came when I realized I didn't want to go. It would be a fine opportunity to add New Mexico to my marathon list, and a chance to see my niece Jennifer, and meet for the first time her husband and their twin daughters.

But I didn't want to get on a plane, and I didn't want to walk a marathon for which I was imperfectly trained, and the fact that I'd paid an entry fee didn't seem sufficient reason to force myself to go.

Some other time, I thought. And by the last days of August I got serious about training for Texas.

I walked fifty miles the last week of August. I know this because I entered each day's walk in my calendar. Six miles Sunday, four Monday, a long walk of sixteen on Tuesday, four on Wednesday, twelve Thursday, and four miles each on Friday and Saturday. (The distances were estimates, as I made life simpler by counting the time I spent and figuring I averaged fifteen-minute miles.)

Most people who write about walking or running or just about any athletic discipline will stress the importance of keeping a training log. Logs range from a simple notation of time or distance—or, more often, time and distance—to elaborate journal entries in which one records the time of day, the weather, the route taken, and, I suppose, the flora and fauna observed on the trail. All of this data will presumably be of benefit later on to the person jotting it down, not to mention the role it might someday play in the lives of generations yet unborn.

Well, maybe, but I'm inclined to put it right up there with counting your steps. Why on earth would I want to know at some future date that it was threatening to rain at the beginning of a particular walk, but that the sun broke through the cloud cover three miles into my walk, and that I was averaging 14:21 minutes per mile when I spotted the ruby-throated hummingbird?

Nevertheless, I find it useful to keep track of my training, albeit in a minimalist fashion, with nothing noted beyond the time spent walking. If I'm preparing for a race, I may want to increase my mileage a certain amount each week, and then taper off in the weeks immediately preceding the event. A log makes it easy to keep track.

But it has another effect that I've noticed, and that's that I find myself going an extra mile just so that I'll

have one more mile to record in my log. Now nobody else is ever going to see that log, nor will I myself ever look at it again—except now, of course, when I find myself referring to it in order to write about it.

Some years back I knew a fellow who was a man of many parts—a book editor, a ski instructor, and I forget what else. He mentioned that he was in the process of becoming a certified appraiser, something that had nothing much to do with any other aspect of his life as far as I could tell. "I asked a friend if he thought it made any sense for me," he said, "and he told me I really ought to go ahead with it. It wouldn't take too much effort on my part, he pointed out, and it might be interesting in and of itself, and there was one other reason to do it. 'Pat,' he said, 'it's the kind of idiosyncratic accomplishment that'll really dress up an obituary.'"

During my training for the Ultracentric, I didn't give much consideration to the look of my training log—or my obituary, as far as that goes. I rang up fifty miles that first week, and decided I could safely increase my total by 10 percent a week. I'd establish a pattern of alternate long and short days, and I'd keep the short days at an hour for the time being, while I gradually extended my long days. Accordingly I walked fifty-six miles the second week, then sixty-two, seventy, and seventy-eight—which took me to the end of September.

Tuesdays were my longest days, and by the end of the month I'd upped my Tuesday walk from four to seven hours. One of those Tuesdays it rained, and I did my five hours on a treadmill. I had no problem with it, or with the seven hours I put in the last Tuesday of the month.

Twenty-eight miles. "I've done the Moron's Marathon," I told Lynne, after having spent those seven hours at the river's edge, the first four doing repeated circuits of just two piers, the next three striding down to the foot of Manhattan and around the other side, then coming back again.

And I felt fine. My feet were holding up nicely, their bottoms toughening as planned. I'd be tired at the end of a seven-hour walk, but not completely exhausted; my legs would be sore, but not agonizingly so. I was right on schedule, and all I had to do was keep going.

Eighty-four miles the first week of October, with my Tuesday walk extending to seven and a half hours. That was thirty miles, I thought at the time, and all I had to do was throw in an extra fifteen minutes and I'd have completed a fifty-kilometer training walk.

Maybe next week, I told myself.

But the following week the rest of my life got in the way a little, with a Tuesday lunch date forcing me to readjust my schedule. Consequently the long walk for

the week came on Wednesday, and only ran to six and a half hours. Still, that was a marathon, or close to it. And, when the week was over, I'd put in twenty-three hours for a total of ninety-two miles.

Ninety-two miles, and I still had five weeks before the Ultracentric. I could start tapering off now, doing a little less walking each week, and not really training at all the week before the race. And then, when I got to Texas, I ought to be fine.

Eighty miles seemed well within reach. Of course something could always go wrong out on the course, whether it was the kind of rain we'd had at Houston, the murderous heat of Wakefield 2006, or another race-ending electrical storm. Or something could go wrong with me: the kind of foot pain that had cropped up at Huntington Beach and returned with a vengeance in New Orleans, or the back spasms that had pulled me up short twenty hours into the race in Minnesota.

I was fitting in the occasional session at the gym, trying to build core strength as a preventive for back problems. And I didn't think my toes would bother me this time around, because I'd done some extensive experimental surgery—not on my feet, God forbid, but on my shoes. I'd cut the fronts out of a pair of old New Balance shoes—I'd got the idea from Andy Cable, who'd turned up so attired at Wakefield, the

fore portion of each shoe so neatly excised I thought for a moment they'd come that way from the manufacturer. I did all my training in those shoes, or in another similarly mutilated pair, and as a result my toes were never sore. So that was one problem area I could probably forget about, but that didn't mean something else wouldn't flare up.

The hell with it. There was no point in trying to foresee the unforeseeable. If something unavoidable went wrong, so be it—there would be other races. Until then I could relax, knowing I was doing everything I could by way of preparation. I'd be in great shape for the Ultracentric.

All I had to do was continue my training.

That was all I had to do, and I didn't have to do it for that long, either. Just four weeks, really, because I'd be well advised to take the last week off altogether. And the fourth week wouldn't amount to much more than stretching my legs, going out for an hour or so every other day.

Three weeks of real training, with the mileage dropping as I went along. I'd done ninety-two miles, so I could drop down to seventy the following week, say, and then to sixty, and finally to fifty. No speed work, no pushing, nothing but nice easy walking.

The first week, the seventy-mile week, I wound up taking three days off, and when the week was done I'd been out there eight hours, for thirty-two miles.

The second week was five hours. Twenty miles, not the sixty I'd scheduled for myself.

I went out for an hour the first day of the third week. And that was it.

How did this happen?

I can't make sense of it. It's not as though I made a conscious decision to sabotage myself and cut my training short. Early on, whenever I found myself skipping a day, I'd tell myself I'd make it up the next day. Before long, however, I didn't even bother having the intention. My training had ground to a halt, and I dealt with it by not dealing with it. As far as I can recall, I didn't even think about it very much. The calendar I used to log my training miles was on a hook in the bathroom, and I saw it every time I shaved or brushed my teeth, but it wasn't that hard to avoid looking at it.

And, come November, I could turn the page.

The last week of October I'd planned to walk fifty miles, but managed all of four. I'd written a film with Wong Kar-Wai, the brilliant Hong Kong–based director, and while *My Blueberry Nights* had already opened the Cannes Film Festival, I had to furnish some additional

voice-overs prior to its U.S. release. My work had to be completed before the Writers Guild strike commenced on the first of November. Still, that left me plenty of time for an hour or two a day at the river's edge, and that sort of walking is good preparation for writing, giving the mind a chance to wander constructively. One day I sauntered down to the Weinstein Company offices in Tribeca, then walked back after my meeting. I suppose it was around a mile and a half each way, so I covered three miles that day, but I wasn't racewalking and it didn't amount to anything to mark on my calendar.

I spent the first week of November at my daughter Jill's house on Fire Island, using the place as my own private writer's colony. I'd stopped working on the book right before the part about the walk across Spain, and that's what I wrote on Fire Island. I put in long hours, tapping away pretty much from dawn to dusk, but I could have managed a long walk every day, and couldn't have asked for a nicer venue for it. I'd done a long training walk there a month earlier, in the course of a weekend visit, and it was even nicer now, with even fewer people around. I brought my walking gear along, unpacked it on arrival, and packed it up again, unused, for the trip home.

Well, nothing you do in the last two weeks helps anyway, I reminded myself. It was too late for training

to do me any good, and there was always the chance it could hurt me.

It's true, certainly, that heavy mileage right before a race is counterproductive, and that one is best advised to err on the side of caution. Still, it might have been a good idea for me to get out there for an hour a day during those last two weeks, given that I'd done so little in the three weeks that preceded them. Just getting out there and walking might keep my feet from going soft. They'd been soft at Wakefield, that's why they'd blistered, and by putting in so little time in the month before the Ultracentric, I was courting the very same thing again.

I thought of this. But I didn't act on it.

Having stopped training prematurely, I was able to devote myself wholeheartedly to another phase of pre-race preparation.

Carbo loading.

There's no real point in wolfing down carbohydrates before a race, not if you're a slow runner, certainly not if you're walking fifteen-minute miles. Still, most walkers and runners fit in a plate of pasta the night before racing, not because it's likely to improve one's performance but because it's (a) traditional, (b) harmless, and (c) tasty. But even for those speedy

marathoners for whom carbo loading might serve a purpose, it's something you do for a day or two.

From the middle of October right up to race time, I made it a way of life. It wasn't purposeful, but it must have looked that way. I overate consistently, and when I thought about it all I did was slide into depression and self-loathing, and that only served to make me hungry.

I don't know how much weight I may have put on in that final month, because I certainly wasn't fool enough to set foot on a scale, but my clothes were tighter and I felt sluggish. That's never welcome, but it's an especially unhappy state of affairs at a race.

Excess weight impedes performance. Whether you're a slow walker or a fast runner, the more you weigh the slower you go, and the more energy you expend moving your body through the miles. The more you weigh, the greater the impact on your feet—and everything else—of every step you take. The more you weigh, the more the miles and the hours weigh upon you.

There's a widespread assumption among those who don't run or walk great distances that doing so is a guarantee of slimness, and it's not hard to guess where it comes from. The most successful walkers and runners are a lean lot indeed, and it's natural to infer that

running made them so, and to take it a step further and assume that anyone who trains and races as they do is sure to wind up looking like them.

Even when one knows better, it's easy to find oneself thinking along these lines. At Houston in 2006, I got a look at the list of forty-eight-hour entrants, and noted that one fellow had listed the T-shirt he wanted as 3XL. "Sheesh," I told a friend, "he'll probably be a Medium by the time he finishes."

It doesn't work that way. A volunteer at the food tent of that particular race, himself an ultrarunner, allowed as how he'd never finished an ultra without gaining a pound or two. It's just not that hard to ingest more calories than you burn, no matter how long you keep on circling the track.

In my own case, I've always found it easier to keep my weight where I want it when I'm putting in my time on the road or the treadmill. And I've also found that doing so is no guarantee I won't regain whatever I've lost. If exercise is a remarkable thing, appetite is every bit as remarkable, and more than equal to the challenge exercise flings at it.

The edge exercise sometimes provides lies less in the calories it consumes than in the motivation it provides. I got on the treadmill in August of 2004 out of profound dissatisfaction with the shape I was in. I started

walking to lose weight, and—because I was also paying attention to what I ate—I was successful.

And after I'd been doing it for a while, after I'd gone from working out to training to racing, I found I was no longer walking to lose weight so much as I was losing weight in order to walk faster.

When I began training for the Ultracentric, I was not merely intent upon putting miles on my legs and toughening my feet. I was every bit as interested in bringing myself to the starting line in the best possible condition for the ordeal that awaited me, and that meant dropping a few pounds. So when I got into the swing of training that last week of August, I made sure my diet was appropriate. It wasn't all that severe a regimen, and it worked just fine, providing sufficient fuel for high-mileage training while whittling away the pounds.

Until the month before the race, when all at once everything went to hell.

My flight was booked, my hotel reserved and paid in advance.

I wanted to stay home.

Because I knew there was no way I could give a good account of myself. I'd trained with great intensity for two full months, and then I'd somehow done

everything I could short of chopping off a couple of toes to undo that training and render myself unfit for the Ultracentric.

I felt like that woman in the cartoon: "Ohmigod, I forgot to have children!" Except I hadn't been unaware of what I was doing, or not doing. I realized throughout that I was neglecting my training, and the effect this neglect was almost certain to have. And, a day at a time, I persisted in neglect. I was, as far as I could tell, quite powerless to do anything about it.

So why go? I knew I wouldn't walk a good race, and I didn't see how I could possibly enjoy myself. I might not be able to get my money back for the flight or the hotel, but did that mean I had to waste my time and energy, too?

Why not stay home and watch college football? I'd been following it closely this season. Did I really have to be rubbing up a new crop of blisters while Ohio State was playing Michigan?

I did. And I blame Werner Heisenberg.

Not the man. The principle.

Which I grasp but dimly and metaphorically, if at all. But you'll remember I cited Heisenberg's principle earlier to explain what we'd discovered while hunting Buffalos. That the towns were like subatomic particles,

that the mere act of searching for them brought more of them into existence.

Observe an experiment, we are given to understand, and you inevitably affect its outcome. Your presence as observer alters the results.

So why did this impel me to head for Grapevine, Texas, in mid-November? Why, because I was headed there not merely as a reluctant walker but, God help me, as a writer.

The book made me do it.

This book, the one you're reading, the one I so enjoyed writing in Anchorage, after the marathon, before the cruise. The book I added to aboard ship, and took up again back home. Holed up in my daughter's house on Fire Island, assiduously avoiding my training, engulfing three meals a day and snacking between them, I'd written the whole section on our great walk across Spain.

By now it was more than half done, this book of mine. Another month or two would recount how I'd started training on the treadmill in 2004 and resumed racing at the start of the new year. Then all I had to do was bring the story up-to-date, noting my persistence through adversity at FANS, my disappointment in my third try at Wakefield, and, finally, my performance in Grapevine at the Ultracentric. That was the race I'd

been aiming at for the whole year, and it would be a fitting closer for the book, however it might turn out. All I had to do was show up and give it my best shot, and whether I broke my record or the race broke my spirit, I could write honestly about it and wrap up the book.

All of this, though, absolutely required my presence in Texas. I could go there and walk a magnificent race, soaring past eighty miles as if on the wings of angels, and that would furnish the book with a spectacular ending. Or I could give it a brave try and be felled by weather or blisters or stomach cramps or the heart-break of psoriasis, and the book would have an ending of quite another sort, but one that might be every bit as effective if I wrote it well.

Or, well, how's this? "And so when the fateful Friday came up on the calendar, I decided the hell with it, and stayed home instead. I let them run the race without me, so we'll never know how I would have done. That's all. The End."

Impossible. I couldn't do that. I had to get on the goddam plane, had to show up at the goddam race.

The book made me do it.

28

The race was every bit as bad as I feared.

On the Friday before Thanksgiving, I took a cab to Newark Airport and boarded a plane to Dallas. When it landed I collected my wheeled duffel bag, picked up my rental car, and let its GPS guide me to my hotel. I walked into a lobby shrouded in plastic, the air thick with the smog of renovations in progress. I checked in and went to my room, where more renovations were proceeding apace. The cheerful fellow on the desk was quick to give me another room. Not surprisingly, they had plenty of them.

I drove to the race site, picked up my number, had a look around. I went back to my hotel, got a pizza delivered, ate it, and went to bed. I got up in the morning, put on my running gear, and showed up at the start in plenty of time. There were quite a few walkers,

with several of them good prospects for qualifying as Centurions, but the only one I knew was Ollie, and it was good to see him again.

I told him I didn't have much hope for a good performance, and he was sympathetic when I recounted the abrupt manner in which I'd aborted my training. We agreed that the weather would probably be all right, with not much chance of rain. The midday heat would be a burden, and it might get colder than we'd like during the night, but all in all we should be okay.

The course was simple enough, and comfortingly flat. You went out for a mile, turned around, and came back. A lap was an even two miles. Do fifty of them and you were a Centurion. Nothing to it.

I knew I wasn't going to do fifty of those laps, or forty, either. If I did thirty-six I'd break my FANS record. If I did thirty-five I'd walk my age. Twenty-four laps would be a little more than I'd managed in July's Wakefield debacle, and even that seemed out of the question. How could I possibly stay on my feet that long? How could I hope to cover that much ground?

How long did I have to do this before I could give up and drop out and go home?

From the first lap, my legs didn't feel right. What I felt couldn't have amounted to more than the usual aches and pains, but I was overly conscious of them.

Any stiffness and soreness served to confirm what I'd already decided—that I couldn't expect to do well, that I was going to be forced to drop out, that the best I could hope for was to do enough to quit gracefully.

There's a TV boxing commentator who'll sometimes describe a fighter as "doing enough to lose." He means that the fellow's not making the kind of effort he'd need in order to win the fight, but managing to look as though he's trying. I was out there walking my laps, and I was doing enough to quit.

At one point Ollie and I were walking together, and I was singing some version of the blues, lamenting that my future as a racewalker lay largely in the past. I'd come to terms with the idea that I'd never improve on my best marathon performance, that I'd be lucky ever again to get within half an hour of the 5:17 I'd done in New Orleans. I'd only get slower with age.

And, I went on, what made me think I could ever top my 70.24 miles at FANS? I'd never be a Centurion, and I'd never reach eighty miles, either. I'd been on pace for that distance a couple of times, at FANS and at Wakefield, but each time something had gone wrong, and I could expect more of that in the future.

Ollie told me I had an eighty-mile performance in my legs. Age might continue to slow me, and I was probably right that I could never improve my per-

sonal best in the marathon, but one of these times in a twenty-four-hour race I'd manage to put it all together, and I wouldn't be stopped by blisters or a bad back, and neither rain nor heat would take me down. And I might never go a hundred miles, but there was no reason why I couldn't get eighty. Maybe not today, but in some race down the line, when everything went right and, for a change, nothing went wrong.

Well, maybe, I allowed. But not today.

After two or three laps, I began to entertain the thought that this might be a good day after all. I looked at my average lap time, multiplied it out, and wondered if I could put together a respectable total. Maybe I could even set a new record, maybe I could have a shot at eighty miles, maybe—

Then again, maybe not.

It was in the sixth lap that the bottoms of my feet began to bother me. They felt hot, the way they do before blisters form. This time, though, I remembered the lesson I'd learned at Wakefield, and at the lap's end I went straight to my car, where my first aid supplies were waiting. I affixed moleskin pads to the soles of my feet and returned to the course.

That got me through two more laps, but I could tell I wasn't going to be able to keep at it much longer.

The sun was higher in the sky, the heat was mounting, and my feet were hurting me, moleskin or no moleskin. I sank into a chair after the eighth lap and had a chat with Glen Mizer, whom I hadn't seen since we'd both struggled through the New Orleans race back in February. He lived in the area, and would be starting the six-hour race in a little while.

I forced myself back on the course, wondering when I could let myself give up.

Just now, writing this, I poked around online and found my lap times for the Ultracentric. I'd started off slowly, walking 15:32-minute miles, and I'd only gotten slower as the race wore on. By the tenth lap I slowed to a stroll, and at its end I'd taken five hours and thirty-eight minutes to go an even twenty miles. My feet bothered me during the seventh and eighth laps, and I'd really had to force myself through laps nine and ten, and when the tenth lap was finished, so was I.

I announced as much during my final lap to Ollie, and to Dave Gwyn, who was one of the four Centurion judges for the walkers. Both pointed out that it was in fact a twenty-four-hour race, and that if I was hurting I could certainly quit the course for a long break and come back later on. Why, I wondered, were they telling me this? What made them think I could possibly want to return?

I got in my car, drove to my hotel. I bought two liters of Coca-Cola from the vending machine in the lobby, called Domino's from my room, and drank one bottle while I waited for them to bring the pizza and the other between slices. I turned on the TV, found a football game.

At some point I took off my shoes and socks and checked my feet. I decided they didn't look too bad. And I realized they'd pretty much stopped hurting as soon as I left the course.

Six walkers qualified as American Centurions at the Ultracentric that year, three from the Netherlands, one from Australia, and two Americans. A Belgian was seventh, at sixty-two miles; then an American at sixty, and two more, one of them Ollie, at fifty-eight. The sole woman walker in the race was an American who wins events of this sort here and in Europe almost routinely; this time she had an off day, and quit after eighteen miles.

I went home, tossed my dirty clothes in the laundry basket, and hung up my Ultracentric sweatshirt. It was a presentable garment, it even had a hood, and it made a nice change from all those T-shirts, but I couldn't imagine what would prompt me to wear it. I didn't want something to help me remember that race. I'd have been more grateful for help forgetting it.

First, though, I wanted to get it down before I did in fact forget it, and I spent a string of mornings pecking away at my computer. I'd left off writing the book—this book, that is to say—a little ways past the conclusion of the pilgrimage to Santiago, and now I skipped ahead and wrote about what I'd just gone through. It wasn't much fun, and after a few days and a few thousand words, and hardly anything about the race itself but no end of lamenting the weeks preceding it, I gave it up. I told myself I'd get back to it in a while, and then I began to wonder if that was true. Maybe I was done with it.

Maybe I was done with walking.

It did look that way. I didn't much welcome the thought, but it was impossible to dismiss it out of hand. Writing about my preparation for the Ultracentric—or, more to the point, my lack thereof—I'd been struck by the manner in which I'd deliberately (if unconsciously) sabotaged myself. After weeks of intensive training, high-mileage weeks marked by walks of marathon length and longer, I'd abruptly pulled the plug on training and made sure I showed up at the start of the race in the worst possible condition. Just as I'd walked through twenty miles looking forward to the opportunity to quit, so I'd spent the weeks leading up to the race working to guarantee myself such an opportunity.

When I looked back at the year, all I seemed to see was a mix of pain and disappointment and failure. I could find ways to regard my performances at Huntington Beach and New Orleans as heroic, simply for having persisted to the end in spite of the pain. That was one way to look at it, but in the end those were hard races, pain-filled races, and the only pleasure they'd held lay in their having finally ended. Wakefield had been a disaster this time, and the best I could say about it was that I'd been lucky enough to be off the course when it got rained out. And the Ultracentric, well, it had become a failure and a disappointment for me before it had even begun.

I'd resumed racing in January of 2005, and in three years I'd taken part in fifty-two races, including eleven marathons and seven ultras. My list of states in which I'd walked a marathon or ultra stood at fourteen, plus England, Spain, and Canada.

Maybe that was enough.

After all, it wouldn't be the first time I'd stopped. My enthusiasms are often intense, but they tend to be impermanent. I throw myself into them, and they run their course, and the day comes when they no longer hold much interest for me. I could regret this trait, and sometimes did, but it seemed to be the way I was.

I had, after all, been a runner and walker years ago, and trained relentlessly, and entered races obsessively. And then I'd stopped, only to resume in time with as much passion and commitment as I'd ever brought to the sport. If my ardor cooled, I could stop; when the time was right, I could take it up again.

Oh, really? Another twenty-five-year break would have me lacing up my Sauconys at age ninety-four. The good news, I suppose, is that I'd generally win my age group. Assuming I could remember how to walk.

While the rest of 2007 ran out, I mostly sat around and watched it go. I wasn't working on this book or on anything else. I wasn't walking along the Hudson, or showing up at the gym.

What I felt, when I felt anything at all, was a sort of lingering sadness, backed with a measure of dread. That I was apparently discontinuing a practice of walking enormous distances was not alarming all by itself, but it became unsettling in context. Because I could then see it as the next item in a lengthening list of activities that no longer held much joy for me. And several of them were not the sort of transient enthusiasms one routinely picks up and sets down. They were lifelong pleasures that of late had ceased to be pleasurable.

Reading, for instance. I'd been a reader almost as long as I'd been a walker, and it was my strong response to fiction that did much to incline me toward writing it. Over the past decade or so, I'd discovered that it rarely worked for me anymore.

The work I'd been doing for a half century bore some responsibility. Spend your days making sausage and it will reduce your appetite for the product. I'd become overly attuned to how words and sentences were strung together and how stories unfolded, and that made it harder for me to get caught up in what I read.

Age, too, undercut one of fiction's roles. In my youth, one of the functions of the novels I read was that of explaining the world to me; as I grew up, I required less in the way of explanation and resisted a worldview helpfully supplied by some bright young thing fresh out of the Iowa Writers' Workshop.

I could still immerse myself in a book now and then, but it was apt to be by some writer I'd been reading for years, and it helped if I was a captive audience— stuck in a hotel room or a ship's cabin, say, with time on my hands and nothing much else to fill it with. Most of the time, though, I'd pick a book up and read a few chapters and lose interest. I'd know where the author was going with this, and saw no reason why I had to keep him company. Or I'd get halfway through the

thing and set it down with every intention of finishing it, only to find that I never had the slightest interest in picking it up again.

I wasn't that crazy about writing, either.

I could still do it. The book I'd written earlier that year in New Orleans, *Hit and Run*, got stronger than usual reactions from everyone who read it, and it had certainly absorbed me fully while I was working on it. I was in fact happy enough with all of my recent books, and my readers seemed content with what I was writing.

Yet it somehow seemed to me that I was done. I kept at it because it was, after all, what I did—and, not incidentally, because I still needed to make a living. Would I continue to write if I didn't need the money? Maybe, but maybe not. It was impossible to say.

The list of books I'd written no longer fits on a single page, and it was pretty clear to me that I'd long since said everything I had to say, and written all the books I had any deep inner need to write. My Matthew Scudder series, sixteen books long, seemed to have found a natural stopping point, and the character to have earned a comfortable retirement. Bernie Rhodenbarr, my burglar, could probably go on, since he didn't age or change from one book to the next, but I'd just be repeating myself in any further adventures I fashioned for

488 • LAWRENCE BLOCK

him—and it seemed to me I'd done so already in the last book or two. Evan Tanner, my insomniac/secret agent, had taken twenty-eight years off between his seventh and eighth appearances, and I'd decided the fellow had the life cycle of a cicada, and could certainly wait another twenty-eight years before he showed up again.

And as much as I'd lately enjoyed writing about Keller, I had a feeling *Hit and Run* would be hard to follow. My characters were all apparently ready to hang it up.

Maybe they were trying to tell me something.

Ever since we'd met, Lynne and I had shared a passion for travel. And that was waning, too. We didn't have any trips planned, and I'd found myself tossing out cruise and adventure travel brochures after no more than a cursory glance.

Reasons came to mind. Air travel gets more unpleasant all the time, for one thing. For another, we'd been to 135 countries, and there weren't that many places left that we felt an urgent desire to visit. Finally, we'd had three trips in succession that, for one reason or another, had proven disappointing. We didn't feel the need to pawn our suitcases or let our passports expire, but we could see travel playing a less prominent role in our future years.

And there were other pleasures that no longer provided much enjoyment. We hardly ever got to the theater these days, and the prospect of so doing felt almost like punishment. It was all I could do to go to a movie. My Writers Guild membership gets me invitations to no end of screenings, and in the pre-Oscar season my WGAE card gives me free admission to most movie houses. I hardly ever get to a screening, and rarely manage to card my way into a theater. Easier to stay home. Easier to find something on television.

One night not long ago we went to a party. It was a nice enough party, as parties go. We had a few conversations with some reasonably interesting people, and contrived to leave early. Walking home from the subway, I turned to Lynne and said, "I've got to remember never to leave the house."

Of course I was joking. Sort of.

My concern went beyond walking. "When a man is tired of London," Samuel Johnson observed, "he is tired of life." I seemed to have tired of walking—and of reading, of writing, of roaming. Had I observed similar symptoms in a fictional character, I'd have supposed him to be not long for this world. There he was—walking through his house, turning off the lights. Shutting down, preparing for it all to be over.

Was that what I was doing?

The thought saddened me. I had always wanted a long life, if only to find out what happened next. But if I was no longer much inclined to turn the pages of a book to learn what happened next, or to make a similar determination in a book of my own, maybe that lifelong curiosity had run its course.

Sometimes I told myself that my life wasn't ending, that it was merely changing direction, and doing so in a way that was not inappropriate for my years. I still had interests and pleasures, even passions. They were simply different from the ones I'd had before.

For Christmas, Lynne gave me the first two seasons of *The Wire* on DVD. I'd tried the show early on and had been unable to keep the complicated story straight or make out what the characters were saying. Now, watching one episode right after the other, and letting the subtitles clarify the dialog, I got completely caught up in the show. Within two weeks we'd watched both full seasons and ordered seasons three and four.

And my stamp collection continued to hold my interest. Like Keller, my wistful hit man, I'd collected as a child, and into early adulthood. I sold everything when my first marriage ended, and forgot about it, only to return to the hobby in the mid-1990's.

I could spend hours poring over price lists and cata-logs, sitting in auction rooms, working on my albums. It absorbed me completely.

Keller, who took up philately again when he con-templated retirement, elected not to specialize, collect-ing the stamps of the whole world from 1840 to 1940. (The hobby ate into his retirement fund, so he's still working.) My collection was similar, though humbler; I lacked his discretionary income.

But didn't stamp collecting serve as a substitute for the travel that had so obsessed me? Wasn't this a more leisurely and less hectic way to collect all of those far-flung countries?

One way to look at it. Another was to note that my pleasures had become inactive, sedentary, and house-bound. Instead of racing, I took my time. Instead of traveling, I stayed home. Instead of exercising, I watched young men play football. Instead of reading or writing, I looked at TV shows.

Wonderful.

I was depressed, of course, and I knew that sitting around and doing nothing was a recipe for perpetuating the depression—but I didn't seem inclined to do any-thing about it.

Come the first of the year, I told myself, I'd force myself to get moving. For starters, I'd return to the

gym. You don't burn a lot of calories sitting in front of a television set watching more active chaps play football, or sell drugs, or shoot each other. The same thing goes for sitting at a desk and mounting postage stamps in an album. Since those were my pastimes, and since I was eating like an offensive lineman bellying up to the training table, well, I had better do something about it—and I decided I'd somehow find the will once the new year got under way. I'd get back on the treadmill, and I'd cut back on the carbs.

I needed to exercise, because my clothes didn't fit. I needed to get something written because we were running out of cash. I didn't wait for January to sit down at the computer. There was a short story I'd agreed to provide for an anthology, and they'd already paid me half the money in advance, the manipulative bastards, so I really had to write the damn thing. And it would be good to try something that would take days rather than months to finish.

I wrote the story in a week's time, and it turned out okay. That was encouraging, it told me that those muscles still worked, and that I could rise to an occasion when I had to.

January came around, and on the morning of January 2 I got myself out the door and walked the block and a half to my gym. Remarkably, I still

remembered which locker was mine, and the combination of my lock. I worked out that morning, and the next morning, and the morning after that.

And then I stopped.

Well, I told myself, I evidently wasn't ready. Not yet. Besides, the exercise took time and energy that I needed for my work. So I returned instead to the computer, and plunged into work on a novel featuring one of my series characters. I thought of an opening, and wrote that, and then I remembered a plot element I'd thought of years ago, and incorporated that, and the words began to mount up. In a couple of weeks I'd produced around twenty thousand of them.

I wasn't crazy about what I'd written. And I wasn't at all certain what ought to happen next. So I stopped writing, waiting for it to clarify itself in my mind.

Maybe, I thought, I ought to write another short story. Maybe it would be good to write something that I knew I'd be able to finish. I had 75,000 words of a memoir lying around, and I couldn't summon up the slightest interest in writing any more of that. And I now had 20,000 words of a mystery, and it seemed to have run out of gas. Finish something, I urged myself, and sell it to somebody, and bring a few dollars into the house.

So I started a short story. And wrote a couple of hundred words, and returned to it the next day, and wrote

a couple hundred more. And a day or two later I realized that it didn't want to be a short story, that what I'd actually written was the opening of yet another novel, about yet another of my series characters.

And how far would it go before it ran into a wall?

I asked myself that question, and pondered it some, and when it was time to get to work the following morning, I decided not to bother.

I'd been waiting hopefully for January, and it had come and gone. Depression, I'd learned over the years, was a self-limiting syndrome, running its course and moving on, but this time around it seemed to be renewing its own option and extending its reach.

I wasn't going to the gym. I'd done some writing, but that had stopped, and I couldn't see much reason to get back to it. I had twenty thousand words of one book that wasn't going anywhere, and two or three thousand words of another. Neither one throbbed with life.

And, looming in the background, I had perhaps two-thirds of a memoir to which I no longer seemed to feel any connection whatsoever. That was a lot of work to no purpose. But there was a precedent for it. It wouldn't be the first memoir I'd abandoned.

Then something happened.

Around noon on Sunday, the tenth of February, I was one of a few dozen people sitting in a room a few blocks from my apartment. When I stopped drinking thirty years ago, I began attending meetings of a group of like-minded individuals, and over the years this Sunday gathering had become my regular weekly meeting. Unless I was out of town—or racing in Central Park—I was apt to be there.

At some point during the meeting my mind wandered—hardly an uncommon occurrence—and I found myself reflecting on all of the things I wanted and needed to do, and seemed incapable of doing. I had to get to the gym. I had to return to the Atkins diet. I had to resume writing, and get something written.

This was hardly news. I would acknowledge these three imperatives several times a day, day after day, but acknowledgment seemed to be as far as I could go. The days would slip by, and nothing would happen. I sat around doing nothing, and yet I never found time for the things I had to do.

And a thought came to me, as now and then one does. I remembered something I'd heard in a similar meeting, very likely in that very room, almost thirty years earlier. "If you need to find a way to make time for the things you have to do," someone said, "go to more meetings."

How's that for counterintuitive? When I first heard that bit of wisdom, I was reminded of the old story about the fellow who complains to his rabbi about his cramped living conditions. He and his wife and their four children live in a two-room shack, along with his wife's parents and his old grandmother. There's no room, and it's driving him crazy.

"Hmmm," says the rabbi. "You have chickens? Bring the chickens into the house with you."

Guy goes back to the rabbi a few days later, says it's even worse with the chickens. "Really? Hmmm. You have a goat? Bring in the goat."

And so on. I think there was another animal. I'm pretty sure it wasn't a pig. A dog? A cow? Never mind.

Guy goes back again, says it's worse than ever, no room to turn around, and on top of everything it smells from all the animals. "Hmm," says the rabbi. "Go home and take all the animals out of the house."

Guy does, returns beaming. "Rabbi," he says, "you're a genius. There's so much room it's like a castle!"

So. Go to more meetings? Sure, why not? Then when you stop you've got all this free time.

Except that's not how it works. Go to more meetings, and keep on going to more meetings, and somehow you get more accomplished. I don't know why this works. (I don't understand non-Euclidean geometry, either. I mean, how can parallel lines meet? If they do, don't they stop being parallel?)

What I'd learned, years and years ago, was that it worked. I might not know how it worked, or why it should work, but I don't really know how electricity works, and this lack of knowledge doesn't keep me from turning the lights on.

Tomorrow, I told myself, I'll get up at six o'clock and go to the gym. After my workout I'll go to the nine o'clock meeting. And after that I'll come home and spend two hours at the computer. And, oh yeah, while I'm doing all this, I'll eat in a way that would make Dr. Atkins smile with approval.

And that's what I did.

. . .

Monday I put in an hour on the treadmill, and it was a daunting experience. I set out at what once would have been a very easy pace, four miles an hour, fifteen-minute miles, and found I couldn't comfortably maintain it. I had to dial it down. By the hour's end I had worked my way back to fifteen-minute miles. I spent ten or fifteen minutes lifting weights, had a shower, got some coffee, and went to my meeting. At ten o'clock I came home and sat down at my desk.

And did this again the next day, and the day after. I continued in this fashion through Friday, varying the length of my treadmill workouts, never exceeding an hour, and sometimes limiting myself to forty-five minutes. Every morning I went from the gym to the meeting, and from the meeting to my computer, where I worked a little on that short story that wanted to turn into a novel.

It didn't seem to be all that eager, though. I got a little done for the first three days, and Thursday I took a nap instead. Friday I got home from the meeting in time to catch a cab to the airport; Lynne and I were to spend the weekend in Florida, visiting my Aunt Mim.

Mim's the last surviving relative of the generation before mine, and I hadn't seen her since before my

Uncle Hi's death several years ago. The previous fall, before the debacle in Texas, I'd planned a Florida visit at the time of the AIA Marathon, a small race beginning and ending in Fort Lauderdale, and passing right in front of my aunt's apartment building in Pompano Beach. I never did sign up for the race, and abandoned racing altogether. Instead I picked a time when my cousin Peter would be visiting, and that turned out to be the same weekend as the marathon. (Its course did in fact go right past Mim's building, and past the hotel we stayed in a few miles up the beach, and we thought we might get out in time to watch the runners. But by the time we were through with breakfast, they were on their way back to Lauderdale.)

I didn't get to any meetings in Florida. I used the treadmill at the hotel one morning, and the walk to and from Mim's was long enough to make each day a gym day. And I stayed with Atkins, and I relaxed and enjoyed the good company of my aunt and my cousin, and I thought about stuff.

I realized there was a change I had to make in my new regime. The components were all present, but in the wrong order. By the time I got to my desk, I was fatigued from my workout. The fatigue was not unpleasant, but it blunted the mental edge I needed in order to get good work done. If I made writing the first

thing I did, and then went to my meeting, well, I might be mentally tired by the time I got to the gym, but so what? Quick wit and verbal agility were wasted on the treadmill, anyway.

As the weekend wore on, I realized something else, too. What I needed to do was get a book finished, and I had one book—this one—that was much closer to completion than anything else I was working on. Why not return to the memoir?

If I could put in two hours on it each morning before I went to my meeting, I could be done with it in a month or two. Anything else I might write would take longer. More to the point, anything else would be essentially a way of avoiding what I really needed to do, which was finish the memoir. Ever since I stopped working on it, it had been the elephant in the room. I had to deal with it or I could never really deal with anything else.

We flew home Tuesday afternoon. I went to the gym first thing the next morning, and then to my meeting, and spent the afternoon reviewing my work on the memoir and preparing myself to get back to it. That night I set the clock an hour earlier, and at five the next morning I got up and prepared for work. I was at my desk by six, and at the meeting place by eight-thirty, and by then the memoir was a thousand words longer.

I'd had no re-entry problems. I had picked the book up right where I'd left off at the end of my Fire Island stay, somewhere after the end of the Spanish pilgrimage. It was so easy getting back into the flow of the book that I wondered why I'd ever stopped in the first place.

I'm not proud of this, but it took several days before it dawned on me that there just might be a connection between the fact that I was hitting the treadmill every day and my sudden renewed ability to write about my experiences as a walker. It does seem obvious, doesn't it?

I kept to my schedule with the zeal of a convert. I was up every morning at five, at my desk by six. I added a minimum of a thousand words to my work in progress, went to my meeting, went to the gym.

It occurred to me from time to time that it wouldn't kill me to take a day off once a week. I didn't rule it out, but neither did I feel moved to risk any change in my routine. It was working, and I liked the rhythm of my days, with all the afternoon and evening hours at my disposal. Keeping it up seven days a week didn't feel like a strain. I could certainly go on this way until the book was finished.

My treadmill workouts usually ran an hour, but once or twice a week I stopped after forty-five minutes, just

for the sake of variety. The weather was cold enough so that I was never tempted to substitute an outdoor training walk, and I didn't get bored on the treadmill. I'd alternate days when I pushed the pace with days when I took it easy, and once in a while I added incline work.

After a few weeks of this, I found myself thinking about racing. There were NYRRC races in the park, there always are, and the Brooklyn Half Marathon would be coming up soon. I could probably handle five miles in Central Park, or even 13.1 miles through the streets of Brooklyn, but when I thought about it I remembered how I'd stopped enjoying shorter races. They were all about time, and my times were not going to improve, and what did I need with more T-shirts?

I could try FANS again.

The thought came unbidden, and I entertained it and didn't find myself cringing at the prospect. But was I out of my mind? Could I really face the prospect of endless counterclockwise circuits of Lake Nokomis, each of them punctuated by an ascent and descent of Mount Nokomis? Well, maybe I could. Oh, really? Had I forgotten how my back felt in those final laps? Well, no, but neither had I forgotten how it felt afterward, with a new record of 70.24 miles.

Hmmm.

When the FANS flyer had arrived in the mail back in January, I'd dismissed it without a second thought. Not only had I quit walking, apparently forever, but I was scheduled to be in Budapest that week promoting the Hungarian editions of my books.

Now I was actually considering the race, calculating that I had almost three months to get back in shape. And, while I was thinking it over, the Budapest trip washed out.

So the date was open. But did I have enough time to prepare myself?

I saw a way to find out. I could try a marathon sometime in late April. If that didn't work, I'd know better than to attempt FANS.

I got on the Web and found the Salt Lake City Marathon on April 19. Everything about the race sounded good to me, and I'd be adding Utah to my marathon list. I was all set to enter it when, quite out of the blue, I was invited by my Spanish publisher to a literary conference in León. Lynne and I had spent a few days in León during our long walk, and I remembered it as a charming city, and worth another visit. The conference would take place two days before the marathon, so it was one or the other.

I accepted the invitation, with two conditions: that it include Lynne, and that they fly us in business class.

(They don't pay you for these things, so why do them if you're not able to do them in comfort?) My publisher replied immediately that he was sure that would be all right, and I got online again and looked for a race a week later. I found one in Vancouver, Washington.

Then I heard again from Spain. The sponsoring university wouldn't spring for business-class airfare. I felt relief and disappointment in equal parts; on the one hand, I wouldn't get to go to León, and on the other hand I wouldn't have to. Now all I had to do was decide between Utah and Washington.

While I was weighing the merits of the two races, my cousin Micah showed up in New York. I hadn't seen Micah since the aftermath of the Wakefield rainout, had told him in a January email exchange that I'd gotten away from racewalking, and now was able to inform him over dinner that reports of my retirement from the sport, like those of Mark Twain's death, seemed to have been exaggerated.

"I honestly thought I was done with it," I said, and explained how I'd always been a man of intense but impermanent enthusiasms. Micah was such a creature himself, and offered a suggestion. Did I think I might have overtrained? I said I'd thought of that, with all of those high-mileage weeks that had preceded the race

in Texas, but that I hadn't manifested any of the physical symptoms of overtraining.

"It's an interesting thing about overtraining," he said. "In the West we think of it in physical terms. Stress fractures are signs of it, along with other evidence of physical breakdown. But the Eastern Europeans see it differently. Over there, the symptoms of overtraining are all mental and attitudinal. An athlete loses his edge and doesn't have his heart in the game anymore."

We went on to talk about other things—Micah's own writing, and how to keep one's heart in that particular game, among other things. Later I thought about what he'd said, and my October–November efforts at self-sabotage came closer to making sense. I hadn't had stress fractures, or plantar fasciitis. There were no inexplicable pains when I started walking, no muscles in rebellion. Nothing went wrong physically. But something in my mind shifted, and whatever had always put me on the track and propelled me forward was all at once out of commission.

The damned book had got me all the way to Texas anyway. Without it I'd have skipped the race, as I'd skipped the marathon in Albuquerque. The book led me to the starting line, and got me around the two-mile course ten times. But that was as much as it could do, as much as I could do.

. . .

Salt Lake City was a conventional marathon, and looked to be a well-run event. The offering in Vancouver, just across the river from Portland, looked to be something different, a three-day program of walks of varying distances. These walks weren't really races, although some entrants would be trying to get to the finish line as quickly as possible. The majority, though, would just be enjoying the walk, which the sponsors called a *Volksmarch*.

Still, one of the walks was of marathon length. And whether or not they kept track of finishers' times, there would be a clock at the finish line, and, hell, I'd have a watch, wouldn't I?

It might be an interesting experience. I'd been in marathons with people who didn't seem to care how long it took them to finish—the Purple People in Anchorage, for example—but I hadn't yet been in a race that wasn't a race. With virtually all of the participants not runners but walkers, and with most of the walkers just out for a stroll, I might find myself up among the leaders, instead of at my usual spot in the back of the pack.

I could feel the notion settling in, like fog. I tried to keep it at bay, to will it to be gone, and that worked about as well as it does with fog.

Why not do them both?

Well, why not? Logistically, it made a certain amount of sense. I could fly to Salt Lake City for the marathon, then to Las Vegas for a few days with my cousin, then to Portland. And then home, flushed with triumph. Or just flushed.

But did it make any other kind of sense? Well, maybe. I would probably be ready for a marathon by the time Salt Lake City rolled around, if only to let me know whether I had any business entering the twenty-four-hour FANS race in June—and, in the process, helping prepare me for FANS.

I wouldn't be pushing for a fast time in Salt Lake City. I'd seek only to finish the race at a comfortable cruising pace. They offered walkers an early start, so I could take it easy without worrying that they'd close the finish line before I got across it.

If I did take it easy, the race wouldn't necessarily take all that much out of me. It's not distance all by itself that takes a toll. I've been in short races that left me more exhausted than long ones, five-mile and ten-kilometer races that proved much harder to recover from than some marathons.

"This may sound crazy," I said to Lynne, and went on to tell her what I had in mind. Let me just say that it's unsettling when you're prepared to listen to the

voice of reason and hear instead from someone who's as crazy as you are. I suppose I should have expected as much. This was the very woman, you'll recall, who, in response to my gingerly suggestion that we might seek out some of those Buffalos, announced unequivocally that we should go to all of them.

"I think it's a great idea," she said. "If you take it easy, there's no reason you can't do two marathons a week apart. People do that all the time, don't they?"

"Those clowns I met in Mississippi," I remembered, "were going to do Mobile the following day. Twenty hours after they finished one marathon they'd be starting another."

"I don't know that you'd want to go that far," she said. "But a week apart sounds reasonable"—reasonable!—"and you'll enjoy spending a few days in Vegas with Petie. And if you don't feel up to the second race—"

"I'll say the hell with it."

"Exactly."

"If I can actually complete both races, I'll know I'm in good shape for Minnesota in June. If one of them's a disaster, I'll know not to register for FANS. And whatever I wind up doing, I'll just be doing it, you know?"

She thought for a moment, then nodded. "For yourself," she said. "Not for the book."

On Thursday, April 17, I flew to Salt Lake City, and Saturday morning I showed up for the marathon. I'd signed up for an early start time, and they got us off at 6:12, right after the bicycles. The bicycles weren't racing, there were minimum and maximum speed limits for them, and I wasn't ever quite sure why they were there, but then I wondered that about myself as well.

It was cool at the start, but not too cool, and it was bone-dry, with a strong wind blowing. The course was point-to-point, with a substantial net drop in elevation, but there were a couple of uphill stretches that took their toll. I looked at my watch from time to time, and my pace didn't vary much; I covered four miles the first hour and every hour after that until the last, when

I found an energy reserve and picked up speed. I don't know how much the headwinds hurt—the elite runners complained about it, and their times were nothing special. I don't know how much of a role altitude played. I know I had no trouble going the distance, and crossed the finish line with a net time of 6:26.

Nothing hurt. I took the TRAX train back to my hotel, took myself out for a good halibut dinner that night, and went back to my room to watch Joe Calzaghe beat Bernard Hopkins on HBO.

In the morning I went to the hotel gym and put in a half-hour on the treadmill. I did the same the next day, and later on I flew to Vegas, where my cousin Petie picked me up at the airport. I stayed at his house for three nights, and walked each morning on the streets of his gated development. They'd been very recently asphalted, and it was like walking on a rubberized track. I was out there for an hour each morning, getting ready for Vancouver.

Right up until Thursday, I gave myself the option of skipping the second race and flying straight home. I hadn't even registered for the race, you didn't have to sign up in advance, and I could change my ticket and cancel my hotel room if I wanted. But I felt fine, and if the Salt Lake City race had taken anything much out of me, I couldn't detect the lack of it. Thursday afternoon

Petie drove me to the airport, and I flew to Salt Lake City and on to Portland, took a cab across the Columbia River to Vancouver, Washington, and the next morning I put in a half-hour on the treadmill.

My event, slated for Saturday, was a marathon, but it wasn't a race. The whole weekend was billed as a walking festival, and consisted of a whole medley of races that weren't races, but walks of varying distances to be taken at one's own pace. You started whenever you chose within a window of a couple of hours, and you finished when you finished, and nobody was there to record your time.

Or to keep you from getting lost. When you set out they gave you a map and a sheet of detailed instructions, telling you where to turn and what streets you'd need to cross with caution. There was no traffic control, and sometimes you had to wait for the light to change.

A *Volksmarch*, they called it. A German word, the translation of which would seem to be self-evident. It was more like hiking than racing, although one could certainly endeavor to cover the course as rapidly as possible, because once you did, well, you got to stop and go do something else.

Interesting.

To get a sense of what it was going to be like, and for something to do, I signed up for a 5K walk Friday

afternoon. There was a 10K on offer as well, but I decided that might be a little too much the day before a marathon. I got my card stamped—you carried this yellow card with you and presented it at various checkpoints along the way, to prove you'd actually covered the route and not spent an hour or two in a saloon—and I started out, and at one point along the way the 5K walkers zagged while the 10K crowd zigged. The people immediately in front of me turned out to be 10K walkers, and I, alas, zigged when I should have zagged, and went the whole ten kilometers after all.

I figured that was probably stupid, but you could say as much about the whole idea of walking two marathons a week apart, so the hell with it. I got a look at the city—American Vancouver, the natives call it—and decided I liked it. And in the morning I put on my Salt Lake City shirt and a pair of running shorts and showed up at the desk to get my yellow card stamped.

And it was a strange experience, a marathon but not a race, with a follow-the-directions element that gave it points in common with orienteering. I used race-walking technique, and I moved at my cruising pace, and it was humbling to note how many people who wore street clothes and carried backpacks and walked in a very ordinary nonracing fashion somehow managed to move at a faster pace than I. They were just

walking, for God's sake, and they were leaving me in the dust.

The route they'd dreamed up for us was a 21K loop. If you'd signed on for the 21K event, you walked the circuit once and called it a day. For the marathon, you went around twice.

During my first walk around the course, the thought came to me that perhaps once around would be enough. I wasn't making great time, what with having to consult the sheet of directions every couple of blocks, and dig the yellow card out of my waistpack every few miles to get it marked at a checkpoint. In addition to the directions, which were quite explicit, there were small signs posted every now and then on trees and lampposts, orange cardboard rectangles, with arrows on them to indicate the direction one was supposed to go.

Something tugged at my memory, and it took a few miles before I hauled it in. *¡Flechas! ¡Flechas naranjas!* It was the Camino to Santiago all over again, and, sure enough, there was a point where I managed to get lost and start walking around in circles. *¡Ay, perdido!*

It was around the time I got lost, which must have been just past the loop's halfway point, that I began to entertain the idea of stopping after 21K. An inner voice counseled me not to be stupid. What kind of a wuss, it

wanted to know, would fly all the way across the country to walk a half-marathon?

Probably someone only half as stupid as the fellow doing the whole marathon. But I knew I wasn't going to stop. Not unless my legs failed me, not unless I got bad blisters, not unless something came along to take me out of the race. Or the hike. Or the *Volksmarch.* Whatever.

Nothing did. It took me three and a half hours to make it back to the hotel, but by then I'd begun to enjoy the silliness of the event—the map checking, the whole treasure hunt aspect of the thing. I got my passport stamped—that's what people called the yellow card— and I set out again, and this time the route was familiar. I didn't get lost this time, although I came close once or twice, and I relaxed into the walk and enjoyed the fresh air and the scenery. I was wearing my glasses—I had to, if I was going to make out street signs—and consequently I got a better look at the landscape than I normally do in a race or training walk.

No aches and pains, no blisters, no physical aggravation to speak of in the full 26.2 miles. I finished strong, and my unrecorded time was ten or fifteen minutes under seven hours. You couldn't compare it to the time in a real race, you couldn't really compare it to any-

thing, but I was fine with it. I'd walked two marathons a week apart, and nothing hurt, and I wasn't even particularly sore that night or the next day.

Sunday morning I hit the gym and walked a very leisurely half-hour on the treadmill. I'd gone to a meeting the day after the Salt Lake City race, and I found one in Vancouver, and when I got back to the hotel it was nine o'clock and I had time for a final walk. I had a choice, six or eleven kilometers, and I chose six and did the right sort of zigging and zagging for a change. I figured an easy walk of about that distance would ease any residual soreness out of my legs, and it turned out I was right.

Why did it go so well?

I'm damned if I know. I walked up to the starting line in Salt Lake City wondering if I'd prepared adequately. I'd trained every day for ten weeks, but every step of that training was in the gym on the treadmill, and there'd been no weekly long walk to prepare me for 26.2 miles. I'd gone two hours once and an hour and a half another time, and aside from that every day's session had been an hour or less. I hadn't kept track of my training—not doing so had been one of my new disciplines—but I'm pretty sure I didn't rack up much more than twenty miles a week.

Well, that was evidently enough.

516 • LAWRENCE BLOCK

The shoes? I wore the same tired Sauconys I'd been wearing since they carried me around Lake Nokomis back in June. No, I don't think it was the shoes that made the difference.

Attitude? I wasn't trying to set a new personal record. At Salt Lake City and again in Vancouver, it occurred to me from time to time that I'd walked New Orleans the first time in five hours and seventeen minutes. It now seemed to me like an accomplishment I'd achieved in a prior incarnation. Yes, I'd done it, but the year was 1798, and I was a Wexford rebel serving with Kelly, the Boy from Killane, so things were different then.

Was it easier with the pressure off? Well, maybe, but I was still trying to get to the finish line as quickly as I could, and I was able to manage negative laps, doing the second half of each race in less time than the first.

The hell with it. For one reason or another, my body and spirit seemed to like the way I'd prepared for these races—walking every day, never for less than a half-hour, rarely for more than an hour. That's what I'd done, and it had served me well, so that's what I decided I'd keep doing.

This book set out to be an examination of a year of walking, and one thing led to another. It's taken longer

and run longer than I'd anticipated, and, like a race on an ill-marked course, it has occasionally wandered far afield. I never thought my childhood would find its way into this book, or my teen years.

Sitting in that hotel room in Anchorage, I'd known how the book would end—with that twenty-four-hour race in Grapevine, Texas. Triumphantly, I hoped, with another record-breaking performance; if that wasn't in the cards, I figured I'd settle for bittersweet.

Go know. It ends instead in midstride.

And that, it seems to me, is as it should be. Because it's the walking that's important, not the time, not the distance. Not the medals, not the trophies, not the T-shirts.

You must go on. I can't go on. I'll go on.

Right.